Something Coming

Apocalyptic Expectation and Mid-Nineteenth-

Century American Painting

SOMETHING COMING

COMING

Apocalyptic Expectation
and Mid-Nineteenth-Century
American Painting

GAIL E. HUSCH

UNIVERSITY PRESS OF NEW ENGLAND

Hanover and London

University Press of New England, Hanover, NH 03755

© 2000 by University Press of New England

All rights reserved

Printed in the United States of America 5 4 3 2 1

CIP data appear at the end of the book

Published with the generous support of Goucher College.

Contents

Illustrations

Acknowledgments

I am particularly indebted to the faculty of the Department of Art History at the University of Delaware for their unflagging encouragement during the years when the germ of this project took root in my dissertation. I owe special thanks to my dissertation advisor, Wayne Craven, for his wise guidance and good humor, and to Nina Athanassoglou-Kallmyer, Damie Stillman, and Elizabeth Johns of the University of Pennsylvania for their interest and advice as members of my dissertation committee.

If Lois Fink had not graciously opened the resources of the National Museum of American Art to me, and if I hadn't had the generous financial support of the Henry Luce Foundation, I could not have begun my research or writing. I could not have continued my work without the National Endowment for the Humanities Research Fellowship I received in 1994. My semester-long stay as an NEH Research Fellow at the Winterthur Museum, with unlimited access to the library, collections, and grounds was enormously productive; for making it so, I owe a special debt of gratitude to Gretchen Buggeln and Pat Elliott of the Office of Advanced Studies and to the entire staff of the library under the direction of Neville Thompson.

Over the years, the staffs of numerous other libraries and historical societies have provided invaluable assistance and advice: the Archives of American Art, the Historical Society of Pennsylvania, the New-York Historical Society, the New York Public Library, the Manuscripts Division of the Library of Congress, the Morris Library of the University of Delaware, the Cincinnati Historical Society, the Monmouth County Historical Society, the New Jersey Historical Society, the New Haven Colony Historical Society, and the Newington-Cropsey Foundation.

A number of individuals took the time to read and comment on various drafts of this manuscript, and I am indebted to all of them for their insights: Gretchen Buggeln, John Davis, Kenneth Haltman, Roger Stein, Shirley Wajda, and Peter W. Williams. For their unselfish sharing of material and ideas, I am grateful to Kevin Avery, Peter Bardaglio, Gerald Carr, John Driscoll, Barbara Franco, the late David Huntington, Franklin Kelly, the late Florence Levins, Angela Miller, David Morgan, Peter B. Rathbone, J. Gray Sweeney, Mark Thistlethwaite, and Judy Van Skike.

Some of the material presented here appeared in different form in "Freedom's Holy Cause: History, Religious, and Genre Painting in America, 1840–

1860," William Ayres, ed., *Picturing History: American Painting 1770–1930* (New York: Rizzoli in association with the Fraunces Tavern Museum, 1993), and "*Poor White Folks* and *Western Squatters:* James Henry Beard's Images of Emigration," *American Art* 7 (Summer 1993): 14–39. I am grateful to the editors of these publications for their interest and for permission to publish reworked versions.

I feel particularly fortunate to have had Goucher College as my academic home during most of my work on this project. The college allowed me the time, in the form of a leave and a sabbatical, to focus my attention on this book, and has provided generous assistance to help meet publication costs. Quite literally, there would be no book without the support of Goucher College; I offer my special thanks to President Judy Jolley Mohraz, Dean Robert Welch, the members of the Faculty Affairs Committee, and my colleagues in the department of Art and Art History, who are the best anyone could hope for.

I am also very grateful to the staff of the University Press of New England for their patience, helpfulness, and efficiency during all phases of the production of this book.

I could never have completed this project, which at times seemed never-ending, without the loving support and encouragement of my mother, Claire Sullivan, my sister, Jerri Husch, my father, Bertram Husch, my mother-in-law, Catherine Cabana, and my late father-in-law, Raymond Cabana. Above all, I thank my husband, Michael, for all his years of faith and patience.

G.E.H.

Something Coming

Apocalyptic Expectation and Mid-Nineteenth-

Century American Painting

"Wild notes of discord, scorn, and hate,
Peal o'er thy grave, dread Forty-Eight!
Herald and harbinger of doom,
what shall be written on thy tomb?"

—from C.N., "On 1848—An Epitaph," *Littel's Living Age*, 24 March 1849

"The future sometimes lowers, sometimes brightens, ominous-hopeful before us."

—from "Editor's Department," *The Nineteenth Century* 2 (1848)

Introduction

In April 1850, David N. Lord, New York merchant and editor of the *Literary and Theological Journal*, observed that the clergy of numerous denominations were unusually interested, as he put it, in "the great subjects of which the prophetic scriptures teach." And this phenomenon, Lord continued, was not limited to religious leaders. "The attention . . . of the pious and thoughtful generally has been . . . attracted to the subject and a degree of interest excited that probably has never been felt before."[1] Lord was not alone in this perception. "One thing is certain," claimed the author of an article that appeared in a May 1852 issue of the *Literary World*; "the learned and the wise and the pious have of late years bestowed a large amount of study and care upon the Book of Revelation." The Book of Revelation—the Apocalypse—had, this author noted, "a very close relation to the wants of the present time."[2]

A significant number of artists were among the ranks of Lord's "pious and thoughtful" who were drawn to apocalyptic scripture at midcentury. An unusual concentration of paintings that depicted transformative moments of revelation and envisioned divine judgment or millennial promise was produced and exhibited in the United States in the years immediately following 1848. Most were by artists who undertook no similar work either before or after. The majority of these images appeared from 1849 through 1852, and the surge seems to have abated after 1854.[3] A parallel concentration of subjects is evident in contemporary giftbook illustrations.[4] Together, these paintings and prints represent what is arguably the most intense concentration of apocalyptic imagery by the widest assortment of artists in antebellum American art.

The year 1849 seems to have been the peak for this visual expression of prophetic interest. At least four large paintings with apocalyptic subjects were exhibited in 1849 alone. In January, Thomas Pritchard Rossiter's *Miriam Rejoicing over the Destruction of Pharaoh's Host* was on display in Philadelphia. By April, Frederic Edwin Church's *Plague of Darkness* was hanging in the National Academy of Design's annual exhibition. In June, Junius Brutus Stearns presented the Academy with his *Millennium* and was accepted as an Academician. And in October, James Henry Beard's *Last Victim of the Deluge* could be viewed in Cincinnati.

A striking number of paintings with biblical themes of apocalyptic and millennial prophecy continued to be produced and exhibited in the early 1850s. From 1851 to 1853, Rossiter worked on an immense depiction of *Jeremiah (The Babylonian Captivity)* to complement his already completed *Return of the Dove to the Ark* and *Miriam*. In 1850, Peter Rothermel produced an allegory of millennial realization entitled *The Laborer's Vision of the Future*, and J. W. Glass's *Preparing for the Strife—"The Sword of the Lord and of Gideon"* was on exhibition at the American Art-Union. In 1851, Church exhibited *The Deluge*; he had already produced a version in 1846, and Jasper Cropsey painted *The Spirit of Peace* and its pendant, *The Spirit of War*, reworking the theme in his *Millennial Age* of 1854. By early 1852, Asher B. Durand's *God's Judgment upon Gog* was on view at the National Academy.

Most of the people who produced, commissioned, or collected these images belonged, or aspired to belong, to a northern Protestant urban professional and business culture. They supported, or were supported by, established art organizations like the National Academy of Design and the Pennsylvania Academy of the Fine Arts. They were not radical "come-outers," either Shaker, Millerite, or Mormon, and did not exist at the fringes of perceived social, spiritual, or cultural legitimacy, any more than did David Lord or the author of the *Literary World* article.[5]

Why, then, did a significant number of mainstream American artists and illustrators feel compelled to undertake complex biblical images treating the subjects of divine judgment, apocalyptic transformation, and millennial promise in the years immediately following 1848? Or, to put it more generally, why did the Book of Revelation and other apocalyptic scripture have, as the author for the *Literary World* perceived it, "a close relation to the wants of the present time?"

Because, I believe, in the years around 1848, a firmly established American tradition of apocalyptic discourse was reinvigorated by an unusually evocative cluster of historical events that increased anxiety and a sense of lost control: in particular, the Irish Potato Famine; the war with Mexico and resultant sectional conflict over slavery; the revolutions in Europe; the Gold Rush; and a cholera epidemic. In 1848 and the years immediately following, ministers, journalists, poets, and everyday citizens turned, as others had during earlier periods of social upheaval, to the logic and language of biblical apocalypse in a search for order, meaning, and reassurance. As Presbyterian minister and well-known biblical expositor Albert Barnes observed in May 1848, it was "the instinctive promptings of all minds" in unsettled and unsettling times to look to the scriptural prophetic record in order to see whether or not "these very events may not there be shadowed forth in some symbol till now not understood."[6]

The flood of extraordinary events that crashed in upon the year 1848 and spilled over into 1849, together with the already disturbing and exciting changes underway in American society, fueled perceptions of anarchic and uncontrollable change, of impending chaos, and of disorienting fragmentation, intensifying

the need many people felt to assert order and piece together a unified narrative meaningful to that particular moment. Most antebellum Protestant Americans of even negligible piety, we can safely conjecture, believed that history would culminate and time would have an end at some point in the future. But when a number of people are driven to consider, however reluctantly, as they seem to have been in 1848, that "this end and the manner of its accomplishment are imminent and discernable,"[7] the moment becomes truly apocalyptic.

The language and logic of apocalypse was, to pious antebellum Americans including artists and their patrons, the most natural and appropriate means— the only means they knew—to contend with the famines, plagues, and revolutions that confronted them, if not directly, at least through the newspaper. The issues raised by these and other contemporary conditions were precisely the type fundamental to apocalyptic rhetoric: the ultimate meaning of those events that marked the passage of time and united as history; the outcome of elemental struggles between the forces of good and evil, the nature of humanity's responsibility in relation to God's will and authority.

It was a moment that called to duty those artists who aspired to "stand at the altar prophet-like, giving utterance to the inarticulate yearnings and feelings and wants of [their] brethren."[8] All of the apocalyptic works discussed in these pages must be understood as deliberate attempts to fulfill, at a particularly decisive moment, the artist's responsibility as prophetic interpreter, rebuker, and guide—to do more than paint pleasant diversions or reassuring pieties. To see themselves as members of a courageous social vanguard pointing prophet-like to the signs of the times must have appealed to some earnest and ambitious artists, practitioners of a career often viewed by their contemporaries as peripheral to the fundamental needs and wants of American society.

Their paintings sought to effect an emotional response in viewers, in order to provoke and sustain spiritual and thus social action. Most of the artists who produced the apocalyptic works that are the focus of this study, and most of the patrons who commissioned or bought them, were committed to postmillennial optimism; at the same time they acknowledged the fearsome retributive power of Providence and contemplated the possibility that the United States was not fulfilling its millennial obligations. They interpreted natural and social disorder as indications of a necessary cleansing process on the path toward spiritual and social perfection. They were concerned with questions of peace and war, freedom and slavery, and the equality of human beings before God.

These concerns can be identified even in images usually viewed today as idealized spiritual fantasies, as evidence of artistic escape from the messy conflicts of the public world. These paintings and prints, like numerous contemporary sermons, poems, and essays, incorporate the tradition of apocalyptic discourse to affirm and justify the role of providence in human history while

exploring the contribution of mortal humankind and the questions of contemporary society. Examples of apocalyptic rhetoric, they are visually constructed arguments designed to "address real people in their actual, lived situations," to move and persuade their audiences through "an interplay of style, form, and content."[9]

The tendency in some studies of antebellum American art is to read it as the hegemonic construction of the socially powerful, promoting without question the ideology of American leadership, righteousness, and infallibility in, for example, such areas as the pursuit of the war with Mexico and westward expansion. But the apocalyptic images produced by these midcentury artists were not complacent bulwarks of religious conservatism or passive reflections of a battle waged outside their boundaries, and they do not present an uncontested norm of antebellum Protestantism.

Rather, they indicate the range of apparent belief systems at work within the ranks of "typical" postmillennial Americans—the constant adjustments between faith in gradual progress and fear of apocalyptic judgment—which, seen from our distance of a century and a half, might seem minor. But Beard's *Last Victim of the Deluge*, for example, presents an argument against individual defiance which is inextricably linked to his border state background and his Whig and nativist fears of social anarchy; in it he asserts humanity's sinfulness and God's external authority while warning of an imminent end. Beard's painting is the spiritual opposite of Cropsey's *The Spirit of Peace*, which, nurtured in an international environment of social and political liberalism, posits faith in the future based on an ideal of gradual conversion and unimpeded individual freedom, culminating in millennial redemption.

The moment of apocalyptic excitement and its expression and encouragement in visual terms, which occurred in 1848 and shortly afterward, are important and instructive precisely because they are *not* unique. They appeared during a time and in a place—the United States before the Civil War—that was itself unusually rich in apocalyptic anticipation. This book is offered, then, as a case study of art produced during one particularly clear, self-consciously apocalyptic moment, a moment that crystallized and condensed the vaguer yearnings of its time. It provides a window into the workings of apocalypticism as both a shared rhetorical tradition and as an individual reaction to a changing world. And it can illuminate other moments in American art and history that have felt and expressed apocalyptic surges, each one looking to contemporary events as "signs of the times" and each one claiming that "never before" had the feeling been so strong.

Tight chronological boundaries are central to this approach for a number of reasons. Most important is the consideration that nuances of meaning implicit in familiar images are ephemeral and change as external circumstances change.

The same subjects, themes, and visual symbols can carry different associations for the same people at different times. I am concerned with what meanings, for example, the biblical Deluge might have held for its artists and its audiences in 1849 or 1850 or 1851, meanings that it might not have had a decade — or a year — earlier or later.

On the other hand, ostensibly unrelated subjects, themes, and visual symbols can have profound connections with one another during a single passing moment. It is, for example, particularly important to understand these midcentury apocalyptic images in relationship to the many paintings and prints of American history that proliferated in the 1840s and 1850s.

To most antebellum Americans, secular history was inextricably linked to biblical apocalypse: the events of human history were evidence of the providential plan. Thus, each episode in their nation's past had a spiritual and prophetic role to play in the arrival of the millennial kingdom on earth or in the final resolution of the Second Coming. Midcentury American historians, writers, and artists idealized and mythologized scenes of discovery, of settlement, of revolution, and of young nationhood as messages and models for an apparently rudderless present, in which, according to Ernest R. Sandeen, many were "desperate for reassurance that their nation had not strayed from the path laid out for them by providence."[10]

Within the six-year focus of this study, I discuss paintings and prints not only of biblical history, religious allegory, and secular history, but also of genre subjects that share visual and thematic associations.[11] Poems, newspaper editorials, sermons, and examples of popular entertainment have also been included in order to illustrate and analyze intersections of cultural expression in the years around 1848.

Chapter 1 clarifies terminology, and presents the tradition of Christian apocalyptic discourse as one way for antebellum Americans to create order, meaning, and purpose in a world perceived as increasingly complex. In addition, this chapter examines the apocalyptic implications that were perceived in those events and conditions specific to the midcentury. First apprehended as newspaper items and extras, these events become "signs of the times," revelations of the providential plan.

Chapter 2 is a long examination of a small painting, a painting that, because it weaves together so many disparate threads, is at the heart of my argument. Despite its modest size and its secular subject, Frederick Spencer's *Newsboy* — with the evocative phrase "Something Comeing [sic]" located at its center — provides a key to the understanding of every subsequent apocalyptic and millennial image treated in this book.

The Newsboy provides a survey of the preexisting social tensions as well as the specific events that united at midcentury to create a rich field for apocalyptic

expectation. It encapsulates within its dense surface the sense of impending chaos and disorientation often associated with an apocalyptic context, and suggests, as well, an attempt to find meaningful interconnectedness among disparate elements. It meditates on time and history, and it exposes the perception of a fast-approaching and ambiguous future that gripped the United States in the years around 1848. And the image places the newspaper—unmatched exemplar of the *present*—at the center of this perception. In addition, *The Newsboy* provides a sense of where and how art and artists were positioned in a confused and confusing social and cultural landscape, which in turn helps us fathom some of the goals and ambitions of those artists who produced large, complex, and didactic apocalyptic paintings and prints.

Also discussed in chapter 2 are other contemporary genre images that, like *The Newsboy*, presented the newspaper as a visual manifestation of public communication and shared concerns: Martin Johnson Heade's *Roman Newsboys* (1848); William Sidney Mount's *California News (News from the Diggings)* (1850); Richard Caton Woodville's *War News from Mexico* (1848); John Magee's *Reading of an Official Dispatch (War News from Mexico)* (ca. 1849); and *The Emigrant's Dream* (1846). These images make explicit a number of the important events and conditions that are implied rather than explained in *The Newsboy*.

The Newsboy and its companions together suggest how the newspaper, as both a symbol of America's democratization, urbanization, and industrialization and as a public, emotionally charged purveyor of disturbing bits of information, helped to create and reinforce the apocalyptic context of these years. Chapter 2 pays special attention to the perceived role of the newspaper as an important vehicle of prophecy and a sign of millennial fulfillment.

The remaining chapters focus on those paintings produced between 1848 and 1854 that specifically explored the genuine apocalyptic fears and hopes engendered in those years. Rather than discuss in detail every related painting or print—which would have entailed significant redundancy—I have selected several images as the most eloquent and instructive exemplars of the apocalyptic mood of their time and place, including Rossiter's *Return of the Dove to the Ark* (1848) and *Miriam Rejoicing over the Destruction of Pharaoh's Host* (1848); Church's *Plague of Darkness* (1849); Beard's *Last Victim of the Deluge* (1849); Rothermel's *The Laborer's Vision of the Future* (1850); Cropsey's *Spirit of Peace* (1851); and Durand's *God's Judgment upon Gog* (1852).

Most of these paintings (and Spencer's *Newsboy*) marked a departure in subject for their artists. Beard was a portraitist and genre painter who decided in 1849 to produce a despairing episode from the biblical Deluge. In 1850, Rothermel—primarily a painter of historical scenes—was asked by Philadelphia businessman Hector Tyndale to depict a Christian allegory of millennial perfection. In 1851, after years of equivocation, Cropsey, a landscape painter, finally undertook a "higher" form of art. He chose to create an ideal allegory visualizing Isaiah's millennial prophecy, returning to the subject in 1854. And Durand surprised those

accustomed to his pastoral landscapes with a fearsome subject from the Book of
Ezekiel, commissioned by New York merchant Jonathan Sturges and exhibited
at the National Academy in 1852.

Politically and religiously liberal or conservative, reformist or reactionary,
produced in Cincinnati, Philadelphia, or New York, exhibited in the North or
South, East or West, each of these images records the intermingling of a particu-
lar set of circumstances, personalities, and ideologies. And each provides a dif-
ferent perspective on the possible meanings of apocalyptic history to the artist
and to his audiences.

These chapters have been organized in chronological sequence, with each
focal work or works discussed in relation to other contemporary paintings,
prints, and popular entertainments with similar themes or messages. Again, this
arrangement provides a clearer sense of the concentration of experiences that an
artist, patron, or viewer might have brought to the painting. It also indicates how
boundaries between different types of artistic subject matter, between high art
and popular entertainment, and between religion and politics were dissolved or
maintained at specific moments.

Much as I am convinced that the apocalyptic paintings and prints discussed in
this book owe their genesis primarily to the particular nature of their moment, I
do want to acknowledge that some purely artistic factors also contributed to their
appearance. Washington Allston's apocalyptic paintings (particularly *Belshaz-
zar's Feast* [fig. 1], which went on public display in 1844, a year after the artist's
death) continued to influence midcentury artists.[12] And other large-scale paint-
ings with apocalyptic themes and the prints produced after them, such as Benja-
min West's *Death on a Pale Horse* and Rembrandt Peale's *Court of Death*, con-
tinued to intrigue the American viewing public.[13]

Thomas Cole is usually credited with inspiring the crop of allegorical and re-
ligious paintings that appeared in the years after his death in 1848.[14] Without
question, a considerable number of paintings similar to Cole's ideal work in
terms of both subject and style were produced at that time. Cole had long been
a model of poetic genius and piety to many American artists, particularly to
Church, Durand, and Cropsey, all of whom had close personal ties with him.

But these and the other paintings I consider are more than the progeny of a
"Cole revival." When Church, Durand, and Cropsey turned to apocalyptic and
millennial themes in the late 1840s and early 1850s, such subjects spoke elo-
quently to that moment. Their visual language clearly echoed Cole's inflections
not out of thoughtless loyalty but because these artists believed Cole's images
provided a proper format for paintings designed to convey weighty messages.

More significantly, a number of other midcentury apocalyptic images do not
resemble Cole's typical style and were produced by artists like Thomas Pritchard
Rossiter, Junius Brutus Stearns, and James Henry Beard, who were much less

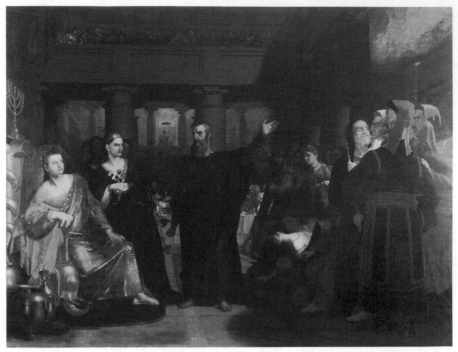

FIG. 1. Washington Allston, *Belshazzar's Feast*, 1817/1843; oil/canvas, 12' ⅛" × 16' ⅛". The Detroit Institute of Art, Detroit, Mich., Gift of Allston Trust. Photograph © The Detroit Institute of Arts.

dependent on his approach. Beard's *Last Victim of the Deluge*, for example, has more in common with Géricault's *Raft of the Medusa* than with anything by Cole. Indeed, a number of thematic and visual parallels exist in European art of the period, a phenomenon that also cannot be explained by Cole's influence. In England—the seedbed for so much American apocalypticism from the seventeenth century onward—John Martin returned to apocalyptic subjects after many years' absence in his three final works: *The Last Judgment, The Great Day of His Wrath* (originally titled *The End of the World*), and *The Plains of Heaven*, all produced between 1851 and 1853. This trilogy was not so much an influence on American artists as evidence of a similar apocalyptic mood in the wake of the 1848 revolutions reinforced by Martin's failed attempts to reform sanitation in the teeming city of London as well as by his anti-Catholicism.[15] Still, as we shall see, the direct influence of John Martin's earlier apocalyptic images on contemporary American artists dealing with such subjects in the years around 1848 was at least as important as that of Cole.[16]

Much of the recent attention accorded antebellum religious art has focused on the works of Cole and those artists—especially Church, Durand, and Cropsey—who are most clearly indebted to him and who best illustrate what has

been posited as the gradual subsuming of biblical reference and religious expression into the language of natural process.[17] (When, for example, a scholar was asked in the 1980s to write an essay about the Bible in American painting, he cited not a single nineteenth-century biblical image between Allston and Eakins; he offered instead a discussion of landscape painting.[18])

And there has been a tendency to treat even nature-based religious paintings as failures—cultural aberrations thankfully supplanted by more aesthetically, expressively, and critically successful pure landscapes. Scholars often discuss these images, as well as religious paintings by the lesser-known artists in this study, as holdovers of a dying tradition of allegory and grand-manner religious art, which the American public could not truly understand or appreciate.[19]

Yet, as we shall see, antebellum artists and audiences harbored social and spiritual beliefs that encouraged—in fact required—an idealizing aesthetic and a universalizing perspective as the only means by which the true scope of contemporary events could be understood or the emotional nature of religious experience explored. Indeed, Protestant as well as Catholic Americans of the antebellum period had access to a wide array of religious imagery—of which the paintings and prints discussed here were but a small part—in such forms as panoramas, dioramas, large-scale paintings intended for traveling exhibition and purchase, church decorations, individual prints, engravings included in giftbooks and annuals, even magic lantern slides used as visual aids in Sunday schools. In most of these forms, the human figure, often combined with natural elements, was the primary bearer of narrative and expression. Well versed in their Bibles, Protestant Americans could and did respond directly to the poses and gestures, the appealing humanity or awe-inspiring power of these familiar characters.[20]

In this study, then, I hope to suggest something of the emotional urgency and intellectual relevance that these images possessed for at least some members of their original audiences. When Hector Tyndale and Jonathan Sturges—two urban businessmen with strong religious and political convictions—commissioned artists to produce large religious paintings, we can only assume that they chose their subject matter deliberately. The results of these partnerships cannot be construed as failed bearers of meanings that would have been more appropriately conveyed through the medium of landscape.

It should come as no surprise that small-scale, easily understood landscapes, portraits, and genre scenes outnumbered complex and physically cumbersome religious paintings in the antebellum United States. But the fact remains that a significant number of such paintings *were* produced—and therefore they must have fulfilled important functions qualitatively different from those offered by other types of imagery. All of the large biblical paintings discussed in this study found purchasers or a sympathetic audience; some were held in higher critical esteem than their artists' contemporary landscapes.

The pictures discussed in this book represent just the surface of a rich lode of

allegorical and religious imagery that runs throughout antebellum American art. Why this lode has barely been mined by modern historians is easy to understand: many of the paintings described in print sources are difficult if not impossible to locate, and, by late-twentieth-century standards much antebellum religious art is, quite simply, bad. For sheer aesthetic pleasure, most art historians would rather look at a fresh and well-painted landscape than a scene from the Bible full of badly drawn, awkward, or sentimental figures.

Victims of changing tastes and careless storage, large-scale biblical paintings and religious allegories have not survived the years in great numbers. Several paintings central to this study—one of them over sixteen feet long—have vanished. Due to the whims of time and chance, we have inherited a distorted view of the artistic concerns of antebellum America. I believe it is more honest to examine than to ignore whatever traces have been left to us, particularly since scholars are just beginning to recognize and explore the complex levels of meaning American religious imagery contains. For these reasons, I have chosen to discuss several images—most significantly, Rothermel's *The Laborer's Vision of the Future*—that are no longer extant or that I have been unable to locate. In each case, written descriptions and, when available, preparatory studies or related drawings and prints provide an admittedly incomplete idea of the work's general theme and composition. But incomplete is better than nothing, particularly since our understanding of the paintings that *do* remain—not only religious, but secular history, genre, and landscape—gains complexity and depth when we consider them in light of their lost companions.

In the years immediately following 1848, artists, often at the behest of patrons, executed paintings that made visible the internal conflicts buffeting Americans as they struggled to justify or to condemn their nation's conduct and to find its place in the scheme of providential history. These paintings are, to use George Landow's terms, "images of crisis," "representative images or codes" analogous to the contemporary situation of the artist and audience.[21] They were born out of the need to locate God and to define human responsibility in a world threatening to spin out of control.

But were the authors of these images and their audiences truly apocalyptic?[22] Did they really believe that God had predetermined the course of history? Were they genuinely concerned with the fulfillment of that providential plan? Did they actually think that they lived in a pivotal moment in cosmic history and stood on the threshold of a dawning millennium? It is tempting to think that, by the middle of the nineteenth century, no one but the most misguided religious fanatic "really" believed that Christ's advent was imminent or that an actual millennial age could be realized on earth. Certainly such rhetoric was, by now, an emotionally powerful but essentially secularized means to justify national ambition or encourage social and moral reform.

It is, of course, impossible to ascertain just how literally each artist and patron, not to mention the wider audience for these paintings, understood the apocalyptic language of their day. Certainly some antebellum Americans interpreted the symbols of apocalypse and millennium figuratively or metaphorically; others must have given up the doctrine of a superintending providence completely and replaced it with the laws of naturalism. But genuine apocalyptic faith seems to have been fundamental to American Protestantism in the first half of the nineteenth century, even to that majority that did not calculate timetables for the end or accept literally every detail of apocalyptic scripture.

Devout mid-nineteenth-century Protestant Americans of all apocalyptic persuasions accepted the notion of biblical inspiration and infallibility, believed in the truth of biblical fact, had faith in the ultimate realization of a perfected society, and expressed their insecurity through fear of imminent destruction.[23] To many pious Americans, including, I believe, the artists and patrons in this study, apocalypse was real and so was the promise of a glorious millennium. The paintings themselves—large, complex, and ambitious beyond the previous efforts of most of their artists—are primary evidence of an abiding faith in their subjects.

Paul Boyer conceives of varying levels of twentieth-century apocalyptic faith—what he calls "prophecy belief"—in a way that helps us understand its counterpart in the years around 1848. Boyer visualizes three concentric circles: at the center lies the core of true-believing devotees; around this core are found those who may be hazy about the details of prophetic interpretation but who nevertheless believe that the Bible provides clues to future events. Forming the outer circle are those individuals who are "superficially secular," with no apparent interest in prophecy belief, but "whose worldview is nevertheless shaped to some degree by residual or latent concepts" of apocalyptic history. He suggests that,

when confronted by particularly troubling world trends, members of this group may listen with more than passing attentiveness to those who offer the Bible as a guide to events, or be particularly receptive to ostensibly secular works that are nevertheless apocalyptic in structure and rhetoric.[24]

Most pious mid-nineteenth-century American Protestants can be safely located in the second of these categories, and nineteenth-century members of the third group were even more imbued with an apocalyptic worldview than their twentieth-century counterparts.

To many of us nearing the turn of the twenty-first century, the anxious search of mid-nineteenth-century Americans for order and structure at a time of vertiginous change may seem quaint and amusing. Their language of biblical apocalypse and their apparent conviction—or at least their fervent hope—that a punishing but just Providence had everything under control might strike us as

outdated and superstitious. But before we dismiss their struggle as an interesting historical footnote, we should recognize our emotional and spiritual kinship.

Recent scholarship has shown us that many Americans still find apocalyptic belief a powerful and satisfying way to create meaning in the modern world.[25] It was and continues to be, Boyer contends, "far more central in American thought than intellectual and cultural historians have recognized."[26] The continuing strength of genuine apocalypticism in twentieth-century America suggests something about the vitality of its earlier roots in the nineteenth.

Even in this apparently skeptical age, the unexpected, the catastrophic, the inexplicable can push a not-so-deeply buried apocalyptic faith to the surface. The approach of the year 2000, for example, has unleashed a flood of interest in apocalyptic speculation. "Our time," O'Leary observes, "provides a fertile ground in which both optimistic and catastrophic predictions of the future proliferate."[27]

We should also remember that not a few modern Americans have at least considered the idea that AIDS is divine punishment on sinful lives, as many nineteenth-century Americans believed of cholera. We should recognize the questions of war and peace raised, for example, by the conflict in the Persian Gulf, as well as the apocalyptic fears it apparently sparked. On 2 February 1991, the *New York Times* reported an upsurge of interest in apocalyptic literature. As the eighty-year-old author of one of these books observed, "I have never seen this kind of interest in prophecy before," the same observation made by David Lord and others in the middle of the nineteenth century.[28]

And if we think back to 1989, our own year of miracles, we can perhaps understand something of the feverish millennial excitement that inspired poets, ministers, artists, and others in the years around 1848.[29] Indeed, the sweeping changes that culminated in Eastern and Central Europe led some to posit the beginning of the "end of history"—a kind of secular millennium in which, instead of the spirit of Christianity, the ideals of liberal democracy would hold universal sway.[30]

The late twentieth century, then, clings to the belief in a governing intelligence that justifies and will ultimately vanquish evil and death, that gives form to the tragedies and triumphs buffeting humanity, and that offers hope of perfect resolution and the end of struggle. Many mid-nineteenth-century Americans held even faster to that faith, as if they sensed that soon a flood of secularism and science would extinguish the beacon of millennial promise and leave them in trackless confusion. All of the apocalyptic images produced by American artists at midcentury and discussed in this book were painted to keep this watch fire burning.

The Apocalyptic Context and the Signs of the Times

The Apocalyptic Context

The world ending in a nuclear fireball, all of humanity writhing in baroque agony; to most modern Americans, the Greek word "apocalypse" conjures such visions. Yet the word itself refers not to cataclysmic destruction, but to the quieter and infinitely more mysterious act of unveiling. Apocalypse and revelation are synonymous: mortal ignorance and blindness, obscuring the truth like a thick curtain, are lifted, and the workings of providence exposed to humanity's awed view.

Apocalyptic language, according to Stephen D. O'Leary, "makes manifest a vision of ultimate destiny, rendering immediate to human audiences the ultimate End of the cosmos in the Last Judgment."[1] The Judeo-Christian prophetic scripture of which David Lord wrote in 1850 is such a revelation and the "great subjects" it teaches encompass questions of time and history, good and evil, freedom and authority, judgment and redemption, death and resurrection. All apocalyptic belief functions primarily as theodicy: a defense of God's beneficence and omnipotence in the face of evil, suffering, and death. It is a "human attempt to explain and justify the phenomenal realities of evil, to locate humanity within a cycle or progression of cosmic time, and to legitimate or subvert the structures of existing power through the resources of myth."[2]

Apocalyptic belief envisions history moving forward along a path determined by God toward resolution in a perfect end outside of time, a world cleansed of evil and untouched by death. All of the apparently random events and conditions experienced by human beings have a place in this all-encompassing plan, although their significance is not easily perceived by weak, blind, and ignorant humanity, who must look to visionary prophets for guidance. Apocalyptic belief holds powerful appeal, Paul Boyer explains, because it is "a way of ordering experience" that "gives a grand, overarching shape to history, and thus ultimate meaning to the lives of individuals caught up in history's stream."[3]

Thus the word "apocalypse" and its variants mean much more than the utter and cataclysmic destruction they have come to connote. An apocalypse, rather

than a violent end, is a revelatory instant of extreme transformation and transition: the destruction of the old world entrapped in time *and* the creation of a new, timeless one. The pivotal event in an apocalyptic conception of time and history, the apocalypse is, according to Barry Brummett, "a *moment* . . . sudden, decisive, and quickly finished (although nothing remains the same thereafter)."[4] In the Christian context of David Lord and his contemporaries, the Second Coming of Christ marks this moment of revelation and transformation—the Apocalypse.

Despite the negative implications of "apocalyptic" in the popular mind, it is a fundamentally hopeful system of belief: however terribly it begins, a new and better order in which righteousness finds its reward will be realized by the end. Intrinsic to all apocalyptic belief is the promise of a millennium, a period of justice, harmony, and order, to be experienced at some point along the predetermined path of history. A millennium is a period or epoch, not a radically transformative moment of revelation.[5] The Christian millennium is briefly described in Revelation 20:1–3 as a finite thousand-year period of peace during which Satan is chained in the bottomless pit and Christ rules with the risen saints.

For pious mid-nineteenth-century American Protestants, the belief that structured their conceptions of time and history was given form in the vivid descriptive language of biblical prophecy. This apocalyptic literature, part of the "accepted canon of Western sacred Scripture," O'Leary writes, formed a "textually embodied community of discourse," a tradition from which shared beliefs, attitudes, and values, as well as form and structure for persuasive argument, grew.[6]

The Old Testament books of Daniel, Jeremiah, Ezekiel, and Isaiah and the New Testament Book of Revelation, in particular, present the divine scheme of history and its ultimate fulfillment in complex and mysterious symbolic language that invites a host of interpretations. Everything natural, human, and divine will find resolution in the end-of-time events unveiled in Revelation and prefigured in the Old Testament books of prophecy:[7] the battles, plagues, famines, and cataclysms destined to precede the Second Advent of Christ and make manifest the elemental struggle of good versus evil; the Millennium, the thousand-year period of peace and harmony with Christ as king; the final battle of good and evil—Gog and Magog—the culmination of which in the Last Judgment and the resurrection of the dead would precede the establishment of a new heaven and a new earth at the end of time. And subjects like the Deluge from Genesis, the Plagues of Egypt from Exodus, and Old Testament stories of the destruction of powerful civilizations by divine judgment, although not from the apocalyptic books of the Bible, also serve as indications of God's plan for human history.

By the middle of the nineteenth century, American Protestantism had long been steeped in a tradition of apocalyptic discourse that had its roots in the English

Reformation. Indeed, English colonization of America began at a time of intense apocalyptic awareness in England, and American Puritans increasingly found prophetic meaning in their own history. After waning under the influence of early eighteenth-century rationalism, apocalyptic speculation intensified with the Great Awakening. Jonathan Edwards, in particular, located the Great Awakening at the center of his apocalyptic timetable and helped transform millennial anticipation "into a dynamic paradigm to explain current events."[8] Both the French and Indian War and the American Revolution were interpreted within this paradigm.

The conviction that God had ordained a special role to America was a powerful force by the late eighteenth century, and concern with the fulfillment of the nation's providential destiny infiltrated and energized democratized popular religion in the early nineteenth century.[9] "Freed of British rule and championing liberty and justice the new nation would inaugurate an era of religious *and civic* purity," Boyer explains. "Though diluted theologically, the apocalyptic component in this broadened view of America's mission remained powerful," reaching its apogee just before and during the Civil War.[10]

Yet various points in American history have experienced (and continue to experience) perceptible surges of apocalyptic interest within this general and pervasive tradition.[11] Like David Lord in 1850, the inhabitants of these times perceive the present to be, in Brummett's words, "a pivotal moment . . . in which history is reaching a state that will both reveal and fulfill [its] underlying . . . purpose."[12] At such times, it seems, more people than usual are motivated to participate in apocalyptic discourse, which in turn strengthens and perpetuates its effect.

Such moments have their genesis, Brummett contends, in "a sense of unexplained and inexplicable *change* and crisis." Emphasizing the importance of personal *perceptions* of such conditions, rather than objective, external measurements, Brummett sees apocalypticism flourishing among those people who believe that social order and authority are collapsing or in danger of collapse. The comfort and promise of control offered by apocalyptic faith has added appeal during such anxious times, when it is used to explain the inexplicable and provide order in seeming chaos.[13]

Rapid social and political changes in the decades following the American Revolution produced the undercurrent of anxiety that, Brummett argues, feeds apocalyptic anticipation. "Americans of all ranks sensed that events of truly apocalyptic significance were unfolding before their eyes," Nathan O. Hatch explains.

Political convulsions seemed cataclysmic [and] the cement of an ordered society seemed to be dissolving. People confronted new kinds of issues: common folk not respecting their betters, organized factions speaking and writing against civil authority, the un-

coupling of church and state, and the abandonment of settled communities. . . . These events seemed so far outside the range of ordinary experience that people rushed to biblical prophecy for help in understanding the troubled times that were upon them.[14]

Some early-nineteenth-century Americans concerned with scriptural prophecy and its fulfillment did not foresee an easy and gradual transition into an American-led millennium. "Most of the traditional outward signs of social and institutional order had been abolished or overturned," Ernest R. Sandeen writes.

Order instead had to be internalized, and that was a difficult and stressful situation. Many people were forced to conclude that the world was nearing its end. That it did not, should not lull us into supposing . . . that the prospects were not considered great by some sensible and intelligent people.[15]

In the early decades of the nineteenth century, apocalyptic fascination was manifest visually by such artists such as Benjamin West, Rembrandt Peale, and Washington Allston.[16] And, as Angela Miller notes, "anxieties about America's future frequently surfaced in catastrophic scenes from the Old Testament, which regularly appeared in giftbook literature and popular prints in the 1830s through the 1850s."[17]

The End of the World, an ambitious painting painted by Francesco Anelli exhibited in New York, Boston, Portland, Maine, and Brooklyn from 1844 through at least 1850 (fig. 2), attests to this continued apocalyptic tradition.[18] Anelli, whose stated aim was "to represent a great catastrophe to the world" and not "a doctrine," claimed he had no wish to engage in arguments with "philosophers" or "naturalists" concerning the particulars of this catastrophe. His enormous painting—filled with dark clouds, bloody skies, and lightning and peopled by terrified sinners, both repentant and unrepentant—offered the light and promise of Christianity as humanity's only spiritual salvation in the face of utter annihilation.

Domestic and international conditions in the years around 1848 gave new urgency to the spiritual tug-of-war troubling many pious nineteenth-century Americans: the struggle between the conception of a transcendent God hurling retribution at a sinful world and belief in an immanent providence working gradually through the hearts of individual human beings. This struggle was at the heart of contemporary disagreements concerning the chronological relationship of the millennium to the apocalypse, the Second Coming of Christ.

Two broad subgenres of Christian apocalyptic discourse were most influential in antebellum America: premillennial and postmillennial. To the premillennialist, the moment of apocalypse—perceived as imminent—would occur *before* the millennium, which then existed outside of history with Christ as its literal king. To the postmillennialist, the Second Coming—perceived as very

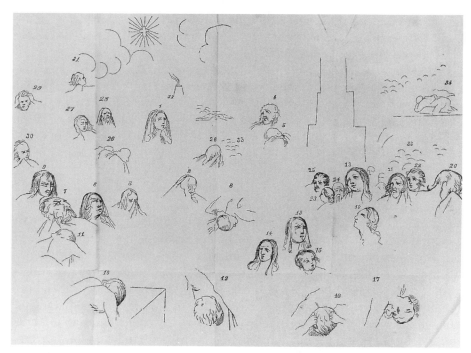

FIG. 2. Francesco Anelli, diagram published in *The End of the World an Original Painting of a Very Larger Size Painted in New York and Lately Finished by F[rancesco]. Anelli*, New York, 1844. © Collection of The New-York Historical Society).

distant in time—would happen only *after* the millennium had been gradually realized within the framework of history.

The premillennialist focused on the immediate, radically transformative, and violently retributive nature of the apocalypse prior to the millennium. The postmillennialist was more concerned with the gradual and progressive realization of the millennium prior to the apocalypse. To the premillennialist, unusual and troubling events in the world around him were signs of the impending apocalypse, which human beings were powerless to effect. To the postmillennialist these same conditions were signals of the dawning millennium, which human endeavor would help to realize.

The traditional characterization of the American postmillennialist is of a cheerful and active optimist, convinced of the perfectibility of human beings and of the progressive reform of society. He or she was a confident member of mainstream Protestant America, scoffing at the fears of the premillennialist. On the other hand, the American premillennialist is limned as a dour pessimist convinced of the absolute sinfulness of the world, content to turn his or her back

on human endeavor and passively wait for a violent End. According to this characterization, he or she existed on the minority fringes of American society, poor, dispossessed, and ridiculed.

There is certainly a core of truth to such characterizations. If millennial beliefs are placed on a continuum, at one extreme would be the "radical supernaturalism" of such groups as the Millerites, who insisted upon the absolute reality of a transcendent order and fixed a specific and imminent date for the Second Advent.[19] To Millerites (and premillennialists in general) this apocalypse would be an exhibition of God's almightiness in complete denial of the ability of humanity to affect the fulfillment of time.

At the other end of the apocalyptic continuum would be those espousers of a new and more liberal configuration of evangelical values, which, according to Ruth Alden Doan, gained strength in the 1830s and 1840s in the face of Millerite supernaturalism. In complete opposition to the basic tenets of premillennialism, this Arminian postmillennialism was based on an assumption of Christian perfectionism and the belief that change was gradual and progressive rather than abrupt and radical. Obstacles were "tests to be overcome on the great and certain march forward," not signs of imminent destruction. The site of this gradual change was within the hearts of individual believers, and "no imposition from outside, but an internal alteration, would provide the foundation for progress." Force was unnecessary and ineffective; "influence [not mere almightiness] was the means to the introduction to the millennium."[20]

To the devout postmillennialist, the divine plan *would* follow its preordained path and the millennium *would* be realized. Those who brazenly tried to impede its progress or blindly ignored its harbingers would find themselves sacrificed before its inexorable power. "Though there may be apparent haltings and relapses in the march of truth, yet there is no real retardation," as the author of an article entitled "The Coming Age" explained in January 1851. "*All* changes and *all* progress must contribute to the promotion of that spiritual kingdom which God has ordained shall triumph and endure. . . . It is God who moves among nations."[21]

A vision of the spiritual kingdom to be realized on earth that postmillennialists anticipated (more specifically, Northern, antislavery postmillennialists) is described, for example, in an article published in the *Episcopal Recorder* in December 1849. The millennium, as this article explained, is

a predicted state of piety for long enduring ages; in which the truth of Christ . . . shall predominate among all nations of living men, making them all Christians. . . . This consummation must occur in this world. . . . In every department of human interest, social and individual, what a reformation, what a melioration, what a metamorphosis; truly a new creation of sentiment, character, and action. . . . Laws will be few. . . . Wars shall cease; slavery be no more; no duelling, no gambling . . . no lewd pleasures, no intemperance, no idleness . . . no corrupt merchandising of commerce, no sectarianism. . . . The age of man will be lengthened; disease will be lessened; the productions of the earth will be abundant.[22]

Belief in the power of the individual to reform himself and society, to con-tribute to the improvement of the human condition, and ultimately to hasten the millennium motivated an army of social reformers as well as a host of mis-sionaries in antebellum America. Most reformers were devout Christians of one evangelical denomination or another whether they fought intemperance, slavery, poverty, ignorance, capital punishment, the exploitation of labor, or the subjugation of women.[23] According to the author of "The Coming Age," in-dividual responsibility and free will were joined by association and mutual en-deavor, exemplified by the efforts of democratic governments or voluntary charitable organizations, to create a force whose mission was to expedite the dawn of the millennium.[24] The snide and sarcastic comments and caricatures that appeared in a variety of secular newspapers and magazines indicate that the millennial optimism fueling antebellum reformism was not universally shared; true believers in social amelioration were subject to ridicule as soft-headed or starry-eyed dreamers.[25]

Indeed, when Lewis Saum combed the diaries and letters of the "common folk"—less educated inhabitants of small towns and isolated rural commu-nities—he found a "recurrent mood of failure and disappointment." This "in-nate sense of relentless providential workings"[26] calls into question the modern assessment of postmillennialism as the commonly received doctrine of the ma-jority of antebellum Protestants. Postmillennialism was perhaps more the pre-rogative of those middle- and upper-class urbanites able to assimilate technolog-ical advances and social change into their spiritual life, and to find success in an increasingly competitive marketplace economy. Or, at least, it was primarily the ideology of those in positions of influence and power whose ideas and beliefs have come down to posterity through published sermons and essays.

Paintings like Rossiter's *Miriam Rejoicing over the Destruction of Pharaoh's Host*, Stearns's *Millennium*, Rothermel's *The Laborer's Vision of the Future*, and Cropsey's *Spirit of Peace* and *Millennial Age* were more than simple reflections of an unquestioned and universal progressive spirit. They were conscious efforts on the part of artists and patrons—like those of preachers and other cultural mythmakers—to foster and encourage this spirit in an often indifferent, even hostile environment. Offered to the troubled world as prophetic visions, as hopeful signs of what was to come, they aspired to encourage humanity "onward and upward" through worldly conditions that, to the skeptic, the pessimist, or the premillennialist, signaled disaster.

Set against each other as polar opposites, these conceptions of antebellum pre- and postmillennial beliefs do seem to reinforce the image of dour pessimist against cheerful optimist. But there is a vast middle ground between the two, and the line between them has begun to blur in the light of recent scholarship, which does not merely contrast "pessimistic, catastrophic, and quietist premil-lennialists" to "optimistic, progressive, and reformist postmillennialists."[27] Some scholars, for example, have examined the relationship of the reformist impulse

to premillennialism, discussing why many believers in the depravity and sinfulness of the world and its violent end began as ardent social and moral reformers.[28]

Antebellum premillennialists should not be viewed as social outcasts and cranks, nor were they all—or even most—members of measurably poor and oppressed groups. According to David L. Rowe, even Millerites "did not significantly differ from the population as a whole."[29] And a far more significant group of antebellum premillennialists did not espouse Millerism and its date-setting literalism. According to Robert Whalen, such mainstream premillennialists— with David Lord as their most influential representative—were clustered in strongly Calvinist denominations with a settled, traditional theology and a well-educated and well-defined ministry. Conservative, fearful of disorder and growing democracy, they were apparently drawn to premillennialism out of growing despair with secularization and irreligion, yet they were socially and economically influential and successful.[30]

By the 1830s, both apocalyptic interpretations were rooted in a common evangelical culture. They shared what Doan identifies as "the four foci" which "expressed antebellum evangelicalism: new birth, Bible, mission, and millennium." According to Doan, both pre- and postmillennialists believed that "the individual needed conversion, and the message of the gospel had to be spread. The end result would be a glorious age of peace and harmony under the rule— spiritual or physical—of Jesus Christ."[31]

All evangelical culture of the mid-nineteenth century faced challenges to authority and tradition, challenges that had to be embraced, withstood, or accommodated. To some, human endeavor as manifest in technological, economic, and social change and in the realm of empirical science undermined faith in an all-powerful God, to others these same developments were evidence of an unfolding divine plan. New ideas about the importance of subjective experience, of influence through moral means, and of progress effected by humanity within history came into conflict with traditional social and clerical control based upon assumptions of an unchanging, impersonal divine authority. As Doan explains,

hope and fear of millennial consummation became confused with technological change, republican politics, and disciplined character. Antebellum evangelicals found it difficult to reconcile appeals to the authority of an earlier generation—Reformation fathers, Puritan fathers, Christian fathers of the republic—with their own experience of feverish competition, booming progress, and reeling change.[32]

Postmillennial evangelicals in the 1830s and 1840s, even more than their premillennial counterparts, had to fashion some kind of rapprochement between the authority of traditional Calvinism and newer conceptions of human perfectibility and natural progress. The nature of this struggle manifested itself in the complex character of antebellum postmillennialism which had to make room for human perfectibility and human depravity, divine immanence and divine

transcendence. As Whalen explains, "a [post]millennialist could believe in catastrophe as well as triumph, Satanic victories as well as the church triumphant, retrogression and defeat as much as human progress. . . . the antebellum American had a wide choice of [post]millennialist beliefs."[33]

"It would be a mistake," James H. Moorhead warns, "to view postmillennialism as "a serene confidence in the uninterrupted improvement of the human condition." Postmillennialism teetered "between progress and apocalypse":

[E]vangelicals . . . betrayed anxieties about a future latent with supernatural judgment and calamity as well as hope. . . . Post-millennialism was a compromise between a progressive, evolutionary view of history and the apocalyptic outlook of the Book of Revelation. . . . It provided the means whereby Protestants could reaffirm traditional eschatological symbols while simultaneously harnessing them to a distinctly modern version of secular improvement.[34]

This culture of antebellum postmillennialism could produce in the same year—1849, as we shall see—both *The Harmony of Christian Love: Representing the Dawn of the Millennium* and *I'll Expire in the Fames of a Perishing World*, an image of Apollyon, the angel of the bottomless pit from the Book of Revelation—not to mention Stearns's *Millennium* and Church's *Plague of Darkness*.

This postmillennial synthesis of progress and apocalypse is evident, for example, in the words of radical social reformer H. H. van Amringe, an American Associationist who melded his vision of the millennium with an Americanized version of the French utopian socialism of Charles Fourier. (According to a recent historian of the movement, Americans' major contribution to Fourierism was "their interpretation of it as a fundamentally religious endeavor.")[35] In "God's Methods in Reforms," published in *Nineteenth Century* in April 1848, van Amringe acknowledged the preeminent role of divine omniscience and predestination in the world's development. "Those who believe in a God should have no doubt that the progressive conditions and salvations of man were, from eternity, in the mind and purpose of the Deity, and that all circumstances are the continual development of his predestination." Individual human beings had been given the freedom to choose good and reject evil in an attempt to perfect the "external relations and conditions of society": "You *must* work out your own salvation; God gives you the power; He has furnished you with talents and faculties; and at every avenue of the mind, He offers Himself for your acceptance."

Yet, van Amringe explained, God urged the human mind onward and upward not only with successive scientific discoveries, technological advances, and the gradual spread of Christian feeling, but also by "the force of impelling external conditions, by conquests and revolutions, by flood and fire." And, van Amringe concluded with all the portentousness of an Old Testament prophet, "fearful is the day near at hand . . . unless God's peaceful method of Reform be adopted by constructing society anew. . . . [I]f the high and mighty . . . do not acquiesce in this

change . . . be assured that dreadful will be their retribution."[36] Just a few changes in vocabulary and this argument for social justice could be a sermon against intemperance, materialism, or religious laxity. Be the sin social or moral, collective or individual, if it subverted the divine plan, its consequences were dire.

This, then, was the general tradition of apocalyptic belief and discourse shared by David Lord, the artists who produced apocalyptic images in mid-nineteenth-century America, and their Protestant contemporaries. But an awareness that biblical prophecy underpinned American conceptions of the nation's place in history and that apocalypticism flourished in antebellum America does not explain why Lord and others noted exceptional apocalyptic interest at mid-century, or why more artists than usual undertook apocalyptic subjects from 1848 through 1852. Again, what relation did the apocalypse have to the needs and wants of *those* particular years?

The perception around 1848 that God's plan for human history had reached a pivotal point was encouraged by the fact that many American and European radical and literal interpreters of prophecy earlier in the century had calculated that the Second Advent of Christ would occur in the 1840s.[37] As a commentator noted in June 1848, although most Americans did not "countenance the absurdity" of William Miller and his followers who waited in vain for the end of the world and Christ's return in 1843 and 1844, they "were not free from the general impression that an important era was at hand. And this impression still rests upon the minds of thousands."[38] It should come as no surprise, then, that Anelli's *End of the World* (completed in 1844) was enthusiastically endorsed by Millerites in 1845 as well as by the Dutch Reformed Church in 1848.

But in the April 1850 issue of the *Theological and Literary Journal* (p. 657), David Lord proposed a more specific relationship between current developments in the secular world and the apparent rise in prophetic debate that he perceived. "The course of events has . . . been adapted to awaken curiosity and invite investigation," he explained, "and the extraordinary occurrences of the last two years, aroused an almost universal apprehension that other great changes were at hand." According to Lord, then, this "universal apprehension" was the result of "extraordinary occurrences" that had begun in 1848.

The year 1848 opened under dark and portentous skies. As the *Christian Watchman* noted on 7 January:

Famine and pestilence have scourged many parts of the old world, and war has been raging on this continent. . . . For the first time in our national history, we are engaged in a war of aggression. . . . The signs of the times . . . foretoken that we are on the eve of great and stirring events.

Philadelphia's *Public Ledger*, a penny press daily more inclined to politics than religion, had a similar observation in January 1848.

Famine and pestilence have converted nations into vast charnel houses, and filled the ear of heaven with their wailing and lamentation,
 And yet the sword of desolation is still drawn. Famine and Pestilence have not ceased their dread work. Well might a prophet exclaim, "Shall we not tremble at thy rebuke, O Lord! Shall not the nations cease to provoke thy terrible judgments?"[39]

"The year 1848," exclaimed an editorial published in January 1849, "has been an era in the annals of the world from which, in ages to come, the philosopher will draw lessons of instruction, the poet his most inspiring themes, the artist his noblest subjects for chisel or pencil, and the preacher some of the most striking proofs of God manifest in history."[40]

That year indeed witnessed the convergence of an unusual number of social upheavals and natural disasters, some which had begun before that year and some effects of which were felt for years after. By the end of 1848, the continuing impact of the Irish Potato Famine was apparent in the form of thousands of immigrants driven to American shores. The United States had recently undertaken its first foreign war, severing diplomatic relations with Mexico in March 1845, declaring war in May 1846, and signing a peace treaty in July 1848. The war with Mexico encouraged territorial acquisition and westward expansion, intensified conflict over the spread of slavery in the United States, and exacerbated dangerous rivalries between North and South. Before exploding into civil war, sectional conflicts threatened disunion; they colored the election of 1848 and all electoral politics thereafter. The Compromise of 1850, designed to assuage tensions between North and South, only intensified them; its infamous Fugitive Slave Act incensed radical abolitionists and disgusted many moderate antislavery sympathizers. In 1848 and for several succeeding years a series of liberal and nationalistic revolutions rocked Europe; the Italian, French, German, and Hungarian struggles excited American sympathies. The discovery of gold in 1848 unleashed an epidemic of gold fever, which, in 1849, coincided with the nation's worst outbreak of cholera since 1832.

Each of these situations brought into sharp focus at least one major concern that had agitated the United States and Europe throughout the first half of the nineteenth century. The Potato Famine plainly exposed the heartless indifference of the rich to the sufferings of the oppressed poor, while the tide of immigrants it brought required the United States to question its own ideas of charity and social justice. In addition, middle- and upper-class fears of social chaos were awakened by this influx of poor Catholics who, popular stereotype had it, were drunken, brawling spendthrifts unfamiliar with the responsibilities of self-government. Both the famine and the cholera epidemic exposed the limitations

of modern science while questioning the relationship of individual and social responsibility to divine will.

The Mexican War and the Gold Rush both raised uncomfortable questions about American ambition and imperialism and about the nation's sense of mission on the North American continent and in the world. The Mexican War stirred debate over the conflicting merits of militarism and pacifism and roused the implacable specter of slavery, which haunted all American attempts at self-definition. The European revolutions exemplified the impassioned search for national autonomy and individual freedom that had shaken the Western world since the late eighteenth century, and they caused the United States to examine its role as model and beacon of civil and religious liberties.

Events and conditions such as these forced Americans to question with unusual fervor their own country's moral rectitude and to wonder whether as a nation they were opposing or fulfilling divine will. Did the prosperity of the United States, its burgeoning democracy, its expanding borders indicate the dawn of the millennium, or did its materialism, its militarism, and its slaveholding invite divine judgment? Fear of cataclysmic civil strife vied in the popular mind with visions of perfect unity. The future, as one commentator noted in 1848, "sometimes lowers, sometimes brightens, ominous-hopeful before us."[41]

To many Americans, these events strengthened incipient apocalypticism, provoking fear of providential retribution and anticipation of the world's end or galvanizing faith in a literally dawning millennium. Apprehended first as pressing concerns of the secular world, the engrossing items and extras that filled the pages of daily newspapers came to be perceived by many as "signs of the times"—indications of the fulfillment of providential history.

The events of 1848 underscored the perception that an intimate relationship existed between politics and apocalyptic faith. "It is a remarkable fact of the present period," began a September 1848 article in the *Christian Watchman and Reflector*,

that the questions which have, of late, agitated the political parties of the country . . . involve the fundamental interests of humanity and religion. They are the questions which relate to Peace and War, Freedom and Slavery, the essential Rights of Man, the equality of all men before the eyes of God. . . . In times past, these themes have been the burden of prophecy, have engaged the pens of the holiest men, and have called forth the prayers of saints. . . . By the wonderful workings of Divine Providence, these questions [now] move the mass of society, agitate parties, and shake the civil state.[42]

The author of a series of articles published in the *Episcopal Recorder* in 1848 asked his readers to consider the political worth of Daniel's sacred visions and their relevance to the guidance of a modern Christian nation. Daniel's visions, he argued, "are political narratives of earthly changes" and indicate the "close union between political and heavenly wisdom." True political wisdom came

only with the knowledge of "the place which each nation holds in the great plan of redemption" and with the "execution of justice on earth."[43] Explicitly apocalyptic in his affirmation of a predetermined path for history, the author also encouraged political activism. Human beings and nations cannot change the course of history, he implied, but they have a responsibility to search for revelations of history's—God's—underlying plan and to act in accordance with its moral imperatives.

To some pious Americans, the events that came together in 1848 provided irrefutable proof of a fundamental yet embattled article of faith: the very existence of a superintending providence. The struggle between traditional belief in an omniscient God and modern acceptance of natural laws of progress was engaged, for example, in a Phi Beta Kappa address delivered in New York in the summer of 1849. According to a published report in the *Literary World*, the speaker, Tayler Lewis (a professor of Greek at New York University), felt compelled to vindicate "the great doctrine of Providence . . . [of] God's providential designs and agency . . . as opposed to . . . naturalism, which regards every important movement of society as the result of great laws existing inherently in humanity and the age." The *Literary World* commented, "It is delightful to the Christian to hear a statement of the good, old-fashioned doctrine of a particular and a superintending providence."[44]

The Signs of the Times

The first hint that the potato blight in Ireland was more serious than usual came in the summer of 1845; by October of that year alarming reports of crop failure were confirmed.[45] As calamity worsened in distant Ireland, the United States began to feel its effects. Thousands of emigrants—"ragged and squalid and lean . . . their hollow eyes all glaring"—fled to the New World hoping to escape starvation and disease, their arrival intensifying nativist fears of social chaos.[46]

Americans searched for meaning in the catastrophic Potato Famine and the disease that followed in its wake; political, agricultural, and social factors were all examined for their contribution to Ireland's agony. Some observers blamed overreliance on one crop; others cited the oppressive rule of greedy landlords and the English. But most discerned the hand of providence; Ireland was suffering for its past sins.

At least one interpretation of these sins was offered by Mrs. Asenath Nicholson, a Vermont native who had visited Ireland:

the Almighty . . . has shown . . . that He sitteth in the heavens, overturning and overturning the nations of the earth. . . . The potato has done its work. . . . It has fed the unpaid millions for more than two centuries, till the scanty wages of the defrauded poor man have entered into the "ears of the Lord of Sabaoth," and he is telling the rich that "their gold and silver is cankered," and that their day is speedily coming.[47]

God punished Ireland and, indirectly, England, for the greedy and unjust be-
havior of its rich and powerful rulers; they, too, would ultimately fall beneath
the avenging sickle.

"As men or nations sow," warned the antislavery *National Era*, referring to
the famine with an all-too pertinent aphorism, "so shall they reap." God smiled
upon the American people, granting them plentiful harvests even while "he is
afflicting many with famine and pestilence." But such apparent evidence of di-
vine favor should not blind Americans to the necessity of constant moral vigi-
lance. This writer, too, warned his countrymen against the sins of ambition, ava-
rice, and covetousness, and acts of injustice and inhumanity (he was certainly
referring to slavery and the Mexican War), for, like Ireland, they would be
"weighed in the balance and found wanting" with no hope of escaping "the in-
dignation of God."[48]

The war with Mexico, declared on 13 May 1846, was an expression of the
country's expansionist energies and belief in Manifest Destiny (itself a mixture
of millennialism, self-interest, and chauvinism).[49] By February 1848, the war was
over and victory declared; California, Nevada, Utah, and most of Arizona had
been added to American territory. The decision to begin the war had met with
general public approval; the *New York Herald* predicted that it would "lay the
foundation of a new age, a new destiny, affecting both this continent and . . . Eu-
rope."[50] Apologists for the war—and there were many—cited a number of secu-
lar justifications, especially economic, for America's aggression, and spread-
eagle patriotism nurtured the "my country right or wrong" spirit that swept the
nation.

But Americans were not unanimous in their support; sizable antiwar senti-
ment was expressed by an array of political, reformist, and religious groups for a
variety of reasons.[51] Some religious denominations were opposed to war on gen-
erally pacifist grounds. Whigs as a party were typically against the war, which
they believed was unjust, unnecessary, and potentially dangerous for the unity of
the nation. Whigs were upset by Democratic president Polk's extreme partisan-
ship even before the conflict, and northern Whigs were generally staunch oppo-
nents of expansionism and denounced an American war of conquest although,
once begun, they voted to support it. Both antislavery Whigs and Democrats as
well as radical abolitionists were even more adamant in their opposition, realiz-
ing that the acquisition of new territory would open the way to an extension of
slavery. Indeed, the possible and then the actual acquisition of land did ignite fe-
rocious debate in 1846, 1847, 1848, and 1849 (and, of course, for years after); the
election of 1848, with its shifting political alignments, only hinted at the national
disharmony that grew daily.[52]

The American war with Mexico was also perceived in terms of divine will and
providential judgment. Many in favor of expansion argued that the United

States was acting as God's instrument of retribution against Catholic Mexico and its sins. Other apologists offered a more exalted vision of their nation's sacred duty to save and extend its Protestant, millennial influence. As the *Home Journal* explained in July 1848, "We vanquish in order to elevate. . . . [I]t is a divine, rather than a mortal trait, thus to exert superior force—not to appropriate a triumph, but to diffuse a blessing. . . . The duty of maintaining uninjured . . . this matchless establishment, which God and our forefathers have given us, is of infinite responsibility."[53] Victory revealed that the United States was indeed fulfilling its preordained role in "God's plan of redemption."

Critics of the war countered that the United States completely misinterpreted its place in this plan. They too envisioned an angry God, but foresaw the United States as recipient rather than instrument of his wrath. American aggression, such a flagrant disregard of divine laws of justice, could not go unchastised. As the author of an article entitled "The Evil to Come" explained, American military success should not be read as a sign of providential blessing. Rather, he warned, "our natural propensity proves our natural depravity. Our apparent success is the most formidable prognostic of coming evil."[54]

That the sins of unbounded pride and ambition were the inevitable consequences of empire building and would lead inevitably to the fall of empire had been the stuff of Calvinist jeremiads throughout American history. But now, with the successful outcome of the Mexican War, the message took on added urgency. The Philadelphia *Public Ledger*, vocally prowar and expansionist, snickered at those who denounced the Mexican War by citing the lessons of history and biblical prophecy:

According to Parson Poundcushion . . . all ancient republics were destroyed by conquest, and the destruction of Rome through the conquest of Carthage, was typical of the destruction of our own through the conquest of Mexico; all of which is foreshadowed in Ezekiel xxviii 19.[55]

For several years after its conclusion, the Mexican War was, for some, a lamentable symbol of America's greed and its deliberate blindness to God's will. In January 1851, for example, D. H. Barlow decried America's sins, particularly her "selfish trading spirit" and her propensity for "waging wars of spoliation on weaker powers. . . . I find myself glancing back," he mourned, "at that old-time appalling doom of the 'chosen people of God.' I cannot but query, 'Are we, in very deed, to betray our transcendent trust, to falsify our lofty mission, and wantonly extinguish our unparalleled hopes?'"[56]

To some Americans, the revolutionary upheavals that first shook Europe in 1848 indicated that the recent victory in Mexico did indeed mark a pivotal moment in the great contest between monarchism and republicanism, a contest

that now raged in Europe. And the fact that the first of these upheavals (the French) erupted on George Washington's birthday was viewed as unmistakable evidence of providential intervention and the linking of American and European destinies.[57]

European revolution, more than any other event or situation, revitalized the specifically political dimension inherent in American and, indeed, in all nineteenth-century apocalyptic interpretation. The nineteenth century, particularly in the Protestant world, was, as Ernest Tuveson observes, "absorbed by the prospect of 'thrones rocking to and fro, earth and heaven shaken'. . . . Political and social changes, not graves opened . . . dominate the day of the Lord; and beyond these events the Good Time."[58]

To many Europeans and Americans, these midcentury revolutions seemed while they were occurring to be the birthpangs of a millennium of republicanism and universal liberty. (To Adventists, the events in Europe were portentous in another way; according to Barbara Franco, "1848 was [clearly] an important year for Adventists. The revolutions in Europe and other natural disasters . . . seemed to point to the end they so ardently awaited."[59]) The apocalyptic implications of European revolution were examined, for example, in a sermon entitled "The Casting Down of Thrones. A Discourse on the Present State of Europe" delivered by Albert Barnes on 14 May 1848 at the First Presbyterian Church in Philadelphia.[60]

Albert Barnes, popular Presbyterian minister and biblical expositor, derived his title from Daniel 7:9—"I beheld till the thrones were cast down, and the Ancient of Days did sit." At no other time in history, Barnes claimed, had change happened so rapidly and with so much promise for the future. "Never were men more impatient to see the next act in the unrolling of the volume where is written the fate of nations—or, in Scripture language, to hear the next blast of the trumpet, or to see the next opening of a seal."[61]

But Barnes, devout believer in the general truth of biblical prophecy though he was, was not ready to link specific modern events to particular prophetic revelations. He was unwillingly to claim that Daniel 7:9 made direct reference to contemporary European revolution. Daniel's prophetic vision did, however, outline the general course of human and apocalyptic history: earthly monarchs had to be vanquished as a prerequisite to the arrival of God's kingdom. "If there is any single phrase that will best characterize the events now occurring," Barnes explained, "it is 'THE CASTING DOWN OF THRONES.'. . . It is appropriate to consider this a stage in the world's progress in the introduction of the reign of God."[62]

A poem entitled "Kings and Thrones Are Falling," which appeared in the *Home Journal* in September 1848, also used apocalyptic imagery to describe the contemporary European situation.[63] As if the Sixth Seal described in Revelation 6:12 had broken, "the Sun has turned to darkness, the Moon is changed to Blood." Hungry mobs invade throne rooms, demanding work and bread, and

kings are driven into exile. Germany arises from sleep like an angry Cyclops, his eye red with rage, while the famished Celt calls his fellows to arms. In France, a maddened crowd tramples Peace and Freedom underfoot and the Seine runs red with blood. Apocalyptic horsemen were loose upon Europe: "And Death is riding grimly forth, and Terror by his side / With blood-stained War and Pestilence, and Famine, hollow-eyed." Yet beyond this horror, a better time awaits, a time when human thought would soar unfettered by priest or king:

> O'er shattered Thrones shall rise
> The kingdom of the Son,
> And Ocean, Earth and Skies
> Proclaim his reign begun . . .

Revolution's millennial promise is unequivocally avowed in an article that appeared in the *Christian Watchman and Reflector*, also in September 1848. The continuation of the intertwined evils of monarchy and Catholicism would be far worse than the terrible convulsions then rocking the "Christian nations." The author scoffed at those who "lament as unmixed evils the present commotions of Europe." Such sinfully distrustful souls would have doubted the "pillar of fire by night and the cloud by day which guided the children of Israel to the promised land." There was no doubt in this observer's mind "that European nations are advancing towards a better future."[64]

The fortunes of papal Rome offered a particularly rich field for apocalyptic speculation, given Protestant antagonism and its venerable identification of the pope as the antichrist. This association was very much alive in antebellum America as a sermon delivered in 1849 by a Baptist minister to an overflow crowd in New York affirms. The sermon, reported in the *Herald* on 18 February, took as its source the first six verses of the seventeenth chapter of Revelation, which describe the Whore of Babylon as a many-headed beast. "The preacher then went on to say," reported the *Herald*, "that the identity of Papal Rome with anti-Christ was mentioned by Luther . . . and all the continental reformers. . . . The same doctrine is still taught . . . by all the most learned professors and clergymen of the present day, connected with the various evangelical denominations of Protestant Christians."[65] This minister, using his own method of prophetic calculation, predicted that the ultimate fall of Babylon—Papal Rome—would occur sometime near the end of the twentieth century.

The precarious situation of the papacy in 1848 reminded many prophetically inclined Americans of a discourse published in 1701 that "proved" that the pope would begin to feel the effects of apocalyptic judgment in 1848. Written by Robert Fleming, a late-seventeenth-century Presbyterian minister and follower of William of Orange, the *Apocalyptic Key, or Pouring out of the Vials* had also excited interest during the first French revolution and, among other such prophetic interpretations, had been a staple of English popular literature.[66] A new edition

of the work was published in New York in late 1848 or early 1849; articles about it appeared, for example, in the *Presbyterian*, the *United States Catholic Magazine*, the *Christian Watchman and Reflector*, and the *Anti-Slavery Standard*.[67]

Any political situation concerning the pope and his temporal power was bound to have apocalyptic overtones to a considerable portion of the American Protestant public. Not everyone, of course, believed the Catholic Church was the literal embodiment of the antichrist. But many did agree, as an article in the *Christian Review* claimed, that "one of the chief obstacles" to the arrival of the millennium "was the church of Rome."[68] Such anti-Catholicism was fundamental to a large segment of American society, which pitted republicanism and Protestantism (as it had done during the Mexican War) against European monarchy and Catholicism. According to this article, European kings and princes were the greatest patrons of the Catholic Church. The casting down of thrones applauded in the United States as the triumph of liberty over despotism also signaled, to many Americans, the weakening of the Catholic Church and the inevitable triumph of Protestantism, which would mark the dawn of the millennium.

If the overturning and casting down of European thrones were signs of God's judgment on sinful despots, what lessons should the United States learn from this continuing unrest? The very real fear that what was happening abroad could happen at home helped fill columns of religious newspapers of various denominations with pleas for greater attention to spiritual matters. The European revolutions, like the Mexican War, focused attention on potential national sins and forced many Americans to look to their own house.

"Here, as in Europe," warned the author of "The Approach of the Millennium as Argued from the Signs of Times," "a struggle between freedom and slavery is at hand."[69] While many citizens of the "model republic" basked smugly in their vaunted freedom and spoke self-righteously of equality as Europe burned in 1848, others recognized the dangerous, perhaps fatal, hubris of such an attitude.

The events of our time . . . are daily fixing our attention . . . on the coming crisis of our own country. . . . Every reader perceives at once that we refer to the question now before Congress, of admitting slavery into the new Territories. . . . While the oppressive dynasties of Europe are falling . . . the General government of this Republic is flaunting its shame in the eyes of all nations, by denying the very lesson which others have caught from our lips and are now carrying out in a course of heroic action. Well might we cry with the prophet, "Be astonished, O ye heavens at this"![70]

On 5 December 1848, President Polk delivered a message to Congress confirming reports that had been filtering in from the West since the summer: gold had indeed been discovered in California, a territory acquired through the Mexican War. Although the discovery had been made at Sutter's Mill on 24 January 1848, easterners did not catch "gold fever" until the end of the year, when this presidential confirmation erased all doubts.[71] And when they did, its effects were virulent.

What did providence have in mind by opening the California gold fields? A sermon preached on 31 December 1848 and reported in the *Home Journal* in January 1849 expressed this puzzlement:

What God's design may be in this it were presumptuous in us to predict; but we may hope they are designs not of trial or judgment merely, but of mercy; great purposes in regard to the spread of his kingdom. But there has never been a nation not irreparably injured by the sudden opening of great wealth in this manner. It remains to be seen what effect will be produced upon us.[72]

Long before gold lured thousands from their homes, the country's apparently boundless prosperity had excited as much apprehension as jubilation. Many were convinced that materialism led to decadence and the inevitable fall of empire.[73]

The lure of easy money and unearned wealth, with its concomitant evils, alarmed those Americans who thought that gold lust and idolatry would lead the nation away from its millennial course. They had no doubt that the discovery of gold would end in national catastrophe, as the *New York Herald* warned in February 1849:

Oh this lust of gold! What unforeseen miseries it is destined to bring. . . . Destiny and God's decrees ever have been, ever will be fulfilled. . . . Blood, murder, starvation . . . God, in mercy, avert the horrid scenes which all prudent, far-seeing men behold in the distance.[74]

Yet to others, the discovery of gold was one more element in a millennial message offered to a nation newly strengthened by military victory and particularly aware of its role as model republic to the entire oppressed world. J. S. Holliday notes that "some Protestant preachers proclaimed the discovery to be the work of God, who had hidden the gold as long as Popery . . . held sway over California."[75] Another commentator observed in April 1849, "It seems clear that God intends to give us here, on this continent, a scope for human energies . . . such has never been seen since the days before the flood. . . . All this seems portended in the coming age."[76]

By early 1849, when the full impact of the discovery was first absorbed, liberal and orthodox interpretations of divine will and human responsibility both acknowledged that the nation was poised on a narrow path. On one side gaped an abyss of greed and violence, easy enough to fall into and marked by the apocalyptic struggle of good and evil. On the other loomed a steep slope leading to millennial heights and paved with gold.

Just a few days before President Polk affirmed the discovery of gold on 5 December 1848 and unleashed gold fever, disquieting evidence indicated that a real and deadly illness threatened the United States: cholera had been found on a

ship entering New York. A few days after Polk's message, the same discovery was made on ships bound for New Orleans.[77] The disease worked its way north through the winter of 1848 and early spring of 1849; the summer of 1849 experienced the full impact of the epidemic in America. Antebellum Americans were, of course, accustomed to the frequent and sudden loss of family and close friends through accident and disease. But cholera's swift course and the sheer number of fatalities intensified the psychological shock. Many were horrified to learn of the death of someone who, the day before, had looked the picture of health.

Since early 1848, American newspapers had been following the westward progress of the disease through Europe, expressing pity for its foreign victims and anticipating its arrival in their own country. In January 1848, the *Harbinger* noted cholera's ravages in Russia and reported that it was soon expected to reach London and Paris. "We should not be surprised," warned the paper, "if this . . . scourge reached our own loved shores during the coming year—so swift is its course."[78] In February 1848, *Holden's Dollar Magazine* reported that, although the cholera was not yet a reality in New York, it had become a "prominent topic of conversation and newspaper comment." Medical experts expected it that summer, after it crossed the Atlantic as it had in 1832.[79] For months before its arrival, then, cholera hovered on the national horizon.

Cholera's cause and cure were unknown, but conventional wisdom held that it was a disease born of urban filth, intemperance, and vice, and that lack of cleanliness and immoderation in food and drink were primary factors in its spread. "The cholera ordinarily comes as a rebuke for the transgression of some law of our physical or moral nature," explained an article published in the *Independent* in June 1849.[80]

The disease was viewed by pious Americans as evidence of God's judgment, both horrific and hopeful, against personal and social sins. "Like all other evils flesh is heir to," a writer for the *United States Catholic Magazine* explained, "the cholera must be viewed in light of an admonition from God, as a means of repairing the faults and deficiencies of the past and providing for the momentous developments of the future."[81] When cholera finally arrived in the United States many were shaken by its implications, particularly since both it and gold fever struck with full force in 1849. "The pious of every sect," Charles Rosenberg observes, "accepted cholera as a chastisement appropriate to a nation sunk in . . . sin."[82]

"We are not simply to regard the general will of God as applicable to all times," the *Independent* admonished in February 1849. "It is our duty [as Christians] to watch the progress of passing events . . . the signs of the times."[83] The Christian's duty was to perceive, as far as human myopia would allow, the will and plan of providence as revealed in the events charted on the newspaper page, and to contribute to the fulfillment of this plan.

That this was not always an easy or even a welcome task for typically rational and modern American minds is explicitly stated in a poem that appeared in

Littell's Living Age on 24 March 1849. Entitled "On 1848—An Epitaph," the poem begins with obvious references to the political revolutions in Europe and hints at the internal strife in the United States:

> From many a tempest-stricken state,
> Wild notes of discord, scorn, and hate,
> Peal o'er thy grave, dread Forty-eight!
> Herald and harbinger of doom,
> what shall be written on thy tomb?[84]

The poet does not doubt that providence is responsible for such a terrible moment in human history, and he realizes the urgent need to decipher God's message: "who shall read thy lesson, Lord?" To this poet, the Day of Midian, a time of mighty struggle among men, seems once more at hand. Brother fights against brother, the righteous against the evil—a type of the final battle of Gog and Magog described in the Apocalypse. The battle of Israelites and Midianites, of the oppressed and the oppressors, ends in the triumph and emancipation of Israel. Millennial light breaks through the darkness of apocalyptic battle; the Good Time has arrived.[85]

But the poet is confused, not sure what is true revelation and what is poetic fancy. He cannot deny that the signs of the times point his mind and soul toward apocalyptic history: "I see the avenging sickle gleam," he writes. But he is aware that such an interpretation of the events of the day is not completely rational, not in step with notions of gradual progress and the efficacy of human endeavor. How can he accept it, the poet asks, when he is surrounded by "the world of business and pleasure we look upon today?" Yet lurking beneath this common-sense exterior is not only a visionary yearning for the realization of a perfect world, but a terrified soul steeped in a heritage of hellfire. His tension in the face of the dilemma is palpable. "Great Lord!" he cries, "is that" (the vision of the Day of Midian, the gleam of the avenging sickle) "or *this*" (his day-to-day life) "a dream?"

Nowhere is this dilemma more eloquently stated than in an unassuming picture by a New York portrait painter. In Frederick Spencer's *The Newsboy* (pl. 1) the enigmatic phrase "something coming" shines like the gleam of the avenging sickle—or a glimpse of the millennial dawn—amid the jostling reality of everyday life.

Something Coming:
Frederick R. Spencer's *Newsboy*

In the second half of 1849, portraitist Frederick R. Spencer undertook, without a commission or a prospective buyer, an uncharacteristic genre painting (pl. 1).[1] He chose to depict a newsboy, denizen of New York's streets, in a setting rich with carefully observed and meticulously rendered details of urban life. Spencer approached the subject with a portrait painter's care, providing his newsboy with the same crisp handling and open and engaging demeanor he gave the professional men and genteel women whose likenesses he painted in Utica, Albany, and New York City.

But the setting in which he placed his robust specimen of American youth — particularly the colorful array of posters and printed announcements behind him — was completely unlike the plain, draped, or landscaped backgrounds of his portraits. Spencer had lived and worked in New York since 1831. A notice high above the newsboy's head announcing the opening of the twenty-fourth annual exhibition of the National Academy of Design reminds us of Spencer's membership in the city's established art world. The *Newsboy*, it seems, was a personally motivated image inspired by experience, not a standardized studio production.

Spencer had been a member of the conservative and gentlemanly American Academy of Fine Arts before its demise, and by 1849 was an active participant in its more liberal artist-run successor, the National Academy. That year (as well as in 1850), Spencer served as the academy's recording secretary, as a member of its governing council, and, in addition to exhibiting as usual, as a member of the committee that organized and arranged the twenty-fourth annual exhibition.[2]

Most of the notices that rub elbows with and partially cover the reference to the National Academy, however, refer to a broader and more complex milieu, one in which the newsboy and his papers, not the artist and his paintings, were the primary conduits of meaning. In its subject matter and visual strategy, *The Newsboy* acknowledges the fiercely contested and increasingly fragmented nature of antebellum intellectual and social culture and the disorderly public spaces it inhabited. And, as we shall see, the newsboy, his papers, and the notices that surround him touch on an impressive array of topical events, from

public follies to national crises, all of which contain within them reminders of social tension.

Spencer's *Newsboy*, with its fresh-faced protagonist and grimy setting, suggests that, like many of his contemporaries, the artist was both attracted to and troubled by the world that bombarded him as he read the daily papers and walked the city streets. *The Newsboy* reveals a nation in the process of change, shifting from an agrarian to an industrial economy, from rural to urban experience, absorbing new means of production and consumption aided by new technologies. The painting confronts the challenge to social order presented by an increasingly heterogeneous population composed of foreign immigrants and native-born Americans, of working, middle and upper classes conscious of their own identities and jealous of the others' influence and power. It acknowledges the perceived erosion of tradition and stability in American society, and it engages debates about individual freedom and external authority.

The painting identifies contemporary events in which questions of the nation's moral righteousness and national destiny were central, in which, for example, militarism and materialism were weighed against pacifism and spirituality. And, finally, *The Newsboy* examines questions of time and history, suggesting that the anxieties of a secular present united to point toward resolution in an apocalyptic future.

All of these threads converge within the space of the newspaper, the site in which antebellum American society met, played out its struggles, and radically transformed itself. Within its modest boundaries, *The Newsboy* examines not only the production and distribution of American newspapers, but their content and structure—and the social implications of this content and structure—as well. The following discussion of the painting focuses in turn on four of its interrelated aspects: the newspaper; the newsboy; the posters; and the phrase "something comeing" and its apocalyptic connotations.

The Newspaper

"In no country are there so many newspapers, and consequently so universal a habit of journal-reading, as in our own," the *United States Democratic Review* noted in March 1849. "The habit of newspaper reading . . . has become an indispensable element of our social existence."[3] Without the proliferation of cheap newspapers in the 1830s and 1840s, this American habit could never have taken such firm hold. Indeed, the paper that Spencer's newsboy grasps as if to offer it to the viewer is clearly identified as the "[New] York Herald"; beneath this he holds a copy of "The Sun" (fig. 3). The *Herald* and the *Sun* were the city's two leading penny press dailies.

Penny papers were smaller in format than their sixpenny rivals and thus more manageable for those readers without access to library tables. Penny

FIG. 3. Frederick R. Spencer, *The Newsboy*, detail of plate 1 (closeup of newspapers held by newsboy, titles).

papers included more advertisements, more local and crime news, and more news of interest to women and laborers than the sixpenny press. Their publishers relied for distribution not on subscriptions (although these were available) but on a new system of circulation borrowed from England. Publishers sold papers to vendors at two-thirds of a cent per copy; these vendors distributed the wares to newsboys who hawked them to the public on the street.[4]

The rapid growth of the mass circulation press was both a cause and a product of the democratization (among white males) that characterized antebellum American society. The access to economic, political, and social news and, potentially, to the power that penny papers offered a broadening electorate cheered some Americans and worried others.[5] The proliferation of newspapers, their wide accessibility, and their apparent popularity were signs, some believed, of the republic's social, intellectual, and economic health and vigor, boding well for its future growth. Newspapers encouraged literacy and an educated citizenry and were essential factors in the worldwide spread of American values.

According to Alexis de Tocqueville, newspapers were the links that bound men together in an egalitarian society of disparate and atomized individuals. "[N]othing but a newspaper can drop the same thought into a thousand minds at the same moment."[6] With no traditional and long-lasting social ties through which shared concerns could be communicated, the newspaper, accessible to all, made it possible for like-minded but disconnected men to associate and, therefore, to act.

But some antebellum observers feared that a flood of newspapers espousing a

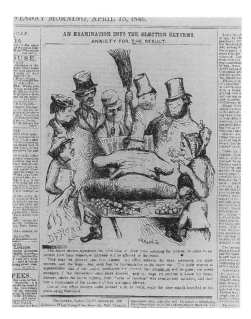

cacophony of conflicting opinions discouraged reasoned argument and social harmony. They argued that penny papers were too party-oriented and promoted vicious political rivalries. A wood engraving that appeared on the front page of the *Herald* in 1846 (fig. 4) presents an image of the American electoral process and the role of the penny press in this process that can only have dismayed conservative hearts. (It also makes concrete the concept of the newspaper as a broad public space in which various groups meet and spar.) An assortment of less than genteel characters form a semicircle around a large seated man holding a copy of the *Herald*, from which he reads the political news they eagerly await. These characters, according to the *Herald*, represent the four social classes whose lives will be most directly affected by the outcome of New York City's municipal elections: office seekers, street sweepers, apple women, and hogs.[7] The office seekers are, of course, anxious to know which of them is the winner—one is pleased and the other horrified—while the apple women and hogs are worried lest a nativist victory destroy their livelihoods. The street sweeper wants a nativist victory, which would increase his work. In other words, the satirist used recognizable character types as emblems of a society whose locus of common interest intersects in the pages of the newspaper but whose disparate elements are motivated by small concerns of self-interest rather than the common good.

Conservative critics decried the content of the penny press and its effect on the intellectual character of the nation. The editors of penny papers were too quick to print unfounded libels, too interested in advertisements and commercial news, and, above all, too willing to wallow in violent crime reports, sexual scandals, and

descriptions of horrible railroad and steamboat accidents.[8] Writing of the *New York Herald*—*the* model of a penny press journal—one observer complained:

these newspapers . . . level, to an undistinguishable [*sic*] mass, the educated, the ignorant, the base. . . . All those vices of the republic which should have been gradually wearing away—the prying, inquisitive, unwholesome growth, of a young and prematurely forced society—have been pampered and bloated to encreased [*sic*] enormity.[9]

Spencer's image of cheap newspapers and their means of distribution (hawked on a public thoroughfare to an undifferentiated mass of consumers) carried within it similar tensions accompanying such a dissolution of traditional boundaries of taste, class, and social expectations. The dirty sidewalk, fire hydrant, and enclosing back wall shoddily constructed of wooden planks locate this marketplace of information in a specifically urban (and consciously male) venue. The trompe l'oeil collage of advertisements, bills, and notices that covers the wall fills it with an unavoidable barrage of commercial clutter, defacing even the surfaces of the flanking classical pilasters.[10] As these defiled vestiges of architectural tradition—and the ineffectual sign to "post no bills"—imply, this was a place with little respect for decorum or authority. Spencer shows us, it seems, a culture "shifting"—to borrow Nathan Hatch's words—"from classical republican values to those of vulgar democratic and entrepreneurial individualism."[11]

But Spencer's background wall does more than define a literal urban space: it also constructs the space of the newspaper itself, transforming its audience from passive viewer to involved reader. The poster-encrusted wall and pilasters in *The Newsboy* run parallel to the picture plane, their sense of insubstantial flatness reinforced by the insistent parallel lines of the steps and the curb. They control their audience, limiting visual access to anything beyond their own obviously constructed universe. There are no comforting glimpses of sky or distant urban vistas in Spencer's painting, as there are in other contemporary images of newsboys.[12]

Acting as a surrogate page, the background wall provides an approximation of the experience to be confronted were the viewer to enter the economic transaction proffered by the newsboy, buy a paper, and (visually) consume it. This wall mimics the newspaper not only in its form, as letters printed on a flat surface with, as one observer remarked, "the fidelity of a daguerreotype,"[13] but also in the type of information these letters joined to convey and the manner in which these discrete items were arranged.

Confronted by *The Newsboy*'s assortment of letters, words, and phrases on a flat surface, visitors to the National Academy of Design in the spring of 1850 must have spent some time in front of it, shoulder to shoulder with friends and strangers. The painting does, as the critic for the *Albion* noted, "bear close exam-

ination."[14] Linked by natural curiosity and their common citizenship in the con-temporary world, Spencer's audience was drawn, more literally than usual, into the communal experience and public space of newspaper reading.

Perhaps the academy visitors who read Spencer's painting shared more than a disinterested acknowledgment of its contents. To some antebellum observers, newspaper reading was an active and perceptually engrossing activity; opening a newspaper was, as Philadelphia lawyer Sidney George Fisher noted in his diary, "like the rising of the curtain at a theatre for a new act in some interesting drama."[15] And it was as much an emotional as an intellectual endeavor, rich in human interest for the empathetic soul. "The circumstances we read of on the page relate to others," Cornelius Mathews observed in 1841, "but somehow we feel that they are part of ourselves." The newspaper, Mathews continued, "is an instrument of many tones, running through the whole scale of humanity . . . from the large interests of nations to the humblest affairs of the smallest individ-uals. . . . [W]e may extract from it matter for mirth, or indignation, or fear, or hope."[16] As we shall see in more detail, *The Newsboy*'s carefully lettered posters include everything from advertisements for boots, hats, and Barnum's Mam-moth Lady, to notices of urban riots and deadly epidemics. They refer to per-sonal interests (Spencer searches for a farm and an honest servant) as well as weighty issues of national concern.

Mathews's use of a musical analogy for the newspaper's range—like a scale of emotions played on an instrument—suggests a level of order and logic which, most observers agreed, modern newspapers did not possess. The shifting of emo-tional tone from mirth to sadness and hope to fear did not happen in an orga-nized way conducive to calm and thoughtful analysis. The *Herald*, one observer noted, was characterized by its

perfectly ridiculous non-arrangement; its jumble in one hopeless mass, of leaders and police-reports, advertisements and abuse and moral reflections, puffings and bankrupt-cies, comicalities and crimes, politicians. . . . [T]hese are the points it has in common with every newspaper in the United States. In none of them is the least effort at arrangement observable. . . . A lengthy advertisement . . . will at any time displace the topic of the day.[17]

Like a newspaper editor, Spencer employed such a strategy of ostensible non-arrangement in *The Newsboy*. The background wall juxtaposes in no apparent order items from the merely entertaining to the deadly serious.

The newspaper's disorganization, as does *The Newsboy*'s, presents a chaotic and "leveled" world governed by no discernable rules in which the reader is of-fered little time for reflection. They both suggest what David S. Reynolds has described as the "carnivalization" of antebellum American culture and lan-guage: a process whereby social distances (if not differences) are suspended and "the sacred is united with the profane, the lofty with the lowly, the great with the insignificant."[18]

To contemporary observers like Tocqueville, the freedom of social, political, and economic opportunity in democratic America led to a particularly American freedom of speech and language, in which, as Reynolds explains, "words were violently stripped from their normal associations and were left to float in ever-changing linguistic space." This fascination with the free, unfixed, and unbounded in meaning is also clear, Reynolds notes, in the linguistic theory of Horace Bushnell, published in 1849 as his *Dissertation on Language*.

Bushnell declared that the only worthwhile authors and philosophers were those who refused to be tied to one symbol and who multiplied paradoxical, figurative expressions of a truth that remains forever indecipherable. When considered in light of Tocqueville's analysis of American language, Bushnell's theory was indelibly American, the product of a restless democratic culture in which multiple meanings proliferated and unambiguous language was automatically nullified.[19]

Spencer's wall is a visualized verbal exemplar of a restless democratic culture that encouraged multiplicity of meanings, ambiguity, and discontinuity. Such a disorienting linguistic and social environment is suggested in the overlapping of posters, which truncates some words into single letters or ostensibly meaningless syllables and which covers what the viewer is certain must lie beneath but cannot see, and in the illusion of torn areas, which remove information, and of dog-eared corners, which hide it.

And, centered high over the head of the young vendor and running almost the entire width of the wall, are the two enigmatic words that promise "SOMETHING COMEING." The phrase attests to a truth yet provides only a teasingly ambiguous subject and indeterminate predicate as clues. It floats free of the restrictions and the securities of specific meaning. Even time is conflated and confused: is this an announcement of something already come and gone, happening now, or yet to appear?

Yet *The Newsboy* does not give itself over to absolute indeterminacy. Its essential symmetry as well as the strict rectilinearity and parallelism of its posters serve to anchor its disparate and disconnected elements into some vestige of pattern. Unquestionably, Spencer, by force of visual will, sought to regularize and contain the jostling carnival of contemporary urban experience. And, as we shall see, thematically logical relationships can be constructed between individual posters and among the entire group. Here as with the newspaper (likewise the actual experience of life) it was up to the individual, if he or she required the stability of traditional order and rational meaning, to discover or invent whatever narrative might be implicit in such a barrage of information.

Indeed, some observers noted that each disparate item, event, and issue reported so chaotically in the pages of the newspaper had a role in defining the character of the present. "I have often remarked that a newspaper . . . is a mirror in which

may be sometimes seen a rapid panoramic exhibition of society," a writer for the *Episcopal Review* observed in 1849, "a sort of picture of the times."[20] By that date, advanced technologies in communication and transportation had transformed news reporting; the contemporary panorama now passed by with astonishing speed.

Never before, it seemed, had information moved so quickly, had news been so "new." "Newspapers have become the most agreeable of all reading, so exciting & wonderful are the movements and events of the age," Fisher noted in his diary in 1849. "By the magic aid of steam & Morse's telegraph . . . everything that occurs of the slightest public importance is almost instantly known throughout the civilized world." Never before, Fisher implies, had the affairs of the present and their retelling in the pages of the newspaper wielded such thrall and rendered history so irrelevant. "The picture thus daily presented to our view of the exciting present and the vast working of society is so interesting & so instructive that even the eloquent pages which describe the past are forsaken for . . . the New York Herald."[21]

The fascination with the specific character of one's own existence, hour to hour and day to day, as manifest in voracious newspaper reading, suggests a society immersed in questions of continual process and ongoing change. "We are always looking restlessly *ahead*," a journalist observed in 1845; "We forget what is past and we bend forward to what is future."[22] What news would the *next* day's paper bring, what succeeding image appear in the unfolding panorama? Like a fragment of modern advertising, Spencer's "Something Comeing" dangles the promise of an exciting tomorrow.

Yet, for all its obvious place in the construction of the present with its intimations of futurity—or rather, precisely because of this function—the newspaper also marked the passage of time and the creation of history. Experiencing the immediate present through the medium of the newspaper was itself a process that required the literal investment of a reader's time. And even though the daily paper had, then as now, a moment of glory as ephemeral as a mayfly's life, old news was never completely discarded. The contents of each succeeding daily paper united in the public mind to construct the outlines of a new past, however briefly recalled.

The Newsboy clearly acknowledges the newspaper's contribution to a transformed sense of immediacy and futurity, and its role in a present that narcissistically witnesses its own creation and its almost simultaneous demise. So, too, does it acknowledge the newspaper's immersion in time. The disparate elements on its back wall can be assimilated only as gradual accumulations and accretions of information, emotion, and experience. Their messages and meanings, like those on a newspaper's page, unfold gradually.

In fact, *The Newsboy*'s posters do not reflect one day or even one particular month in 1849. Many of the items refer to concerns that surfaced prior to the Astor Place riot of 10 May 1849—announced in the only dated poster, located

slightly left of center—and a number became prominent after this date. Like a series of individual pages, torn up and plastered, layer upon layer as more topical events partially obscured those of the recent past, this wall suggests a verbal equivalent of today's year-end television montage. Both attempt to encapsulate the character of a moment still perceived as contemporary but rapidly passing into history.

Spencer juxtaposed a precisely dated and clearly identified incident (the Astor Place riot) with the cryptic letters "T DIS CON," with all their implications of disconnectedness.[23] Such snippets of words and partially hidden notices suggest not only the carnivalization and indeterminacy of modern urban life and language, but the vagaries of memory and the speed with which the familiar is rendered mysterious by time. These cryptic clues, as well as the peeling and disintegration of some posters, reminds the reader-viewer of the cumulative but ultimately ephemeral nature of a newspaper's contents. They indicate the rapidly changing fabric of contemporary public life, the private emotions it engenders, and the need to adjust constantly one's understanding of its implications and its ultimate meaning.

The Newsboy

The newsboy who sits in front of this rapidly changing "picture of the times" offers papers that *do* contain the immediate present. Indeed, his daily papers, fresh from the steam press, are, for the briefest of moments, the only site of the absolutely contemporary. To many observers, the young newsboy served as the consummate emblem of the technologically driven modern world, embodying characteristics of the papers he sold. "The nineteenth century, thirsting for information and excitement, finds its Ganymede in the newsboy," humorist Joseph C. Neal observed in 1843. "He is its walking idea, its symbol, its personification."[24]

The newsboy was still its walking idea ten years later when he appeared prominently in a lithograph by John P. Oertel entitled Things as They Were, and Things as They Are (fig. 5).[25] The decisive break between past and present is marked by a statue of Johann Gutenberg. The modern era begins when ideas are easily reproducible and widely transmitted; the newspaper and its vendor are offered here as the ultimate expressions of "things as they are."

Gutenberg stands with his back to a past represented by an individual monk laboriously transcribing a holy book. He is replaced in the present by the interrelated men and machines necessary for the production of a newspaper: the telegraph, which relays the news, the printing-telegraph machine, which receives it, the reporter, who transcribes it, and, most clearly, the newsboy, who distributes it. Carrying an armload of penny papers and waving a copy emblazoned "EXTRA," a newsboy, mouth open in a raucous yell, strides brashly across a branch that spans a precipitous drop.

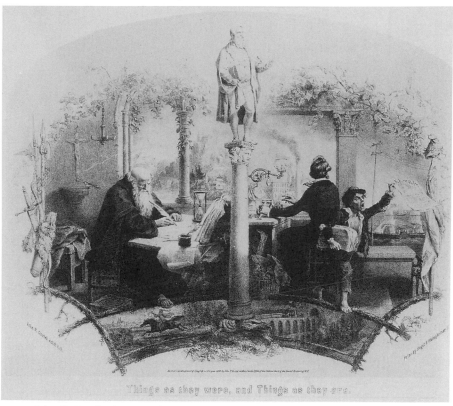

FIG. 5. John P. Oertel, *Things as They Were, and Things as They Are*, 1853; lithograph, published by Nagel & Weingartner, New York. The Library of Congress. LC-USZ62-19456.

Rather than a skilled artisan producing lasting goods, this newsboy was middleman in the exchange of a product whose material worth lay in its inevitable obsolescence. He personified a system which turned knowledge into information and information into a marketable commodity.[26] Depending on one's perspective, the newsboy could represent the best or the worst aspects of modern American society as manifest on the "leveling" consequences of the penny press. To some, the newsboy signified the energy and self-reliance which made upward mobility possible in an egalitarian society; to others he personified the rudeness, disrespect, and ignorance of tradition which characterized modern America.[27]

"Who so diligent at business, as he?" the author of an essay entitled "The Newsboy" asked his readers. Despite his rude exterior, "are there not frequently high hopes, plans for distinction, perhaps honor, and an honest desire to better his condition . . . ?"[28] This essayist admired what he perceived as the typical newsboy's courage in the face of adversity, offering him as a model of industry and thrift.

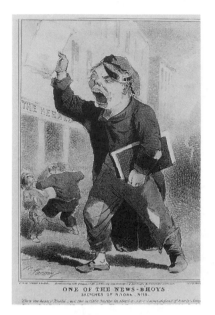

FIG. 6. N. Sarony, *One of the News B'hoys. Sketches of N. York, No. 18*, 1847; lithograph published by Sarony & Major, New York. The Library of Congress. LC-USZ62-5217.

Spencer's newsboy seems an ideal specimen of this honest and indefatigable exemplar of American promise. Confidently relaxed, his youthful cap at a jaunty angle, he grasps a sheet and confronts the viewer—his customer, not his master—with an open and unabashed gaze that bespeaks no servility or inferiority. His obviously worn but neat clothing has pretensions to fashion (particularly the plaid vest and cravat and, the large handkerchief securely tied through a buttonhole)[29] which suggest an elision of social class and the possibility of upward mobility. Like a street aristocrat, Spencer's boy wields easy mastery over the faithful dog at his feet.

But the newsboy as a type had an equally well-established reputation for rowdiness, an aspect of his public persona that, at first glance, seems absent from Spencer's example. According to the essay cited above, the newsboy was despised by most and regarded as "ignorant, debased, and vicious." He was held responsible for all "the disputes, and quarrels, and petty riots about news offices, exchanges, or street corners."[30]

The disreputable and violent aspect of the newsboy's perceived character, while not immediately apparent in Spencer's image, is made abundantly clear in a lithograph entitled "One of the News-B'hoys," published by Sarony & Major in 1847 (fig. 6). Although he shares with Spencer's newsboy the characteristic costume of patched clothes, rakish cap, and well-worn footwear, Sarony's caricatured main figure—to say nothing of the boys behind him who brawl outside the *Herald* office—is loud, crude, and unappealing, more like Oertel's barefoot and barechested ragamuffin than Spencer's dapper youth.

The title of this print identifies the newsboy with another New York character type, the Bowery b'hoy, who was, according to Willis Turner, "a low-life dandy, the first characteristic product of urban slums in the United States."[31] Denizens of the Bowery, as opposed to the more respectable Broadway, b'hoys were typically young unmarried men and boys who worked as laborers or apprentices. They (and their female counterparts, g'hals) were members of a youth culture united by flamboyant dress, manners, and speech. B'hoys frequented the city's volunteer fire companies, the urban street gangs of their day, finding excitement in "running with the machines" and instigating "musses." Admired by some observers (particularly those with radical democratic leanings) as perfect specimens of hearty Anglo-Americanism, cheerfully dedicated to labor, loyal to friends, and devoted to fair play, b'hoys were acknowledged by all to be rude in behavior and sometimes ridiculous in fashion and attitude. As a group, they were rabidly nativist and xenophobic, fiercely patriotic and touchily class-conscious, participating in antebellum anti-Catholic, anti-abolition, and, as we shall see, class-oriented mobs.

For all the obvious wholesomeness of Spencer's fresh-faced newsboy, his appearance has more than hint of b'hoy dandyism. A watercolor by Nicolino Calyo entitled *The Soap-Locks*, produced in New York around 1847 (fig. 7), provides what seems to be a clear precedent for Spencer's figure and, in particular,

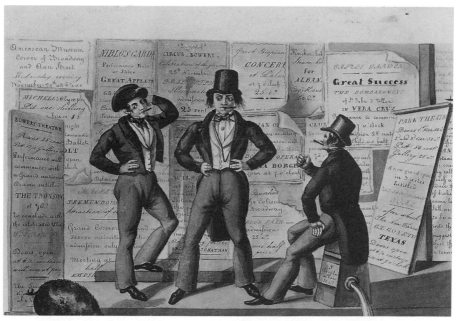

FIG. 7. Nicolino Calyo, *The Soap-Locks*, ca. 1847; watercolor/paper, 11" × 14". © Collection of The New-York Historical Society.

his setting.[32] In Calyo's watercolor, three Bowery b'hoys lounge in front of a wall covered with bills that announce a wide range of popular amusements, including plays, circuses, concerts, and panoramas. The image takes its title from the hairstyle generally favored by b'hoys: greased and curled at the temples into "soap-locks."

Spencer's newsboy, like Calyo's lefthand figure, affects such soap-locks under a youthful cap. The newsboy's patterned silk neckcloth and vest, although shabbier, also echoes the dress of these full-fledged Bowery loungers. The newsboy's full pantaloons turned up at the bottom and worn over boots were also typical aspects of b'hoy dress, although they do not appear in Calyo's watercolor.[33] Soaplocks, turned-up trousers, and boots are seen, for example, in an 1848 lithograph of the actor Frank Chanfrau in the character of Mose the fireboy, the archetypical b'hoy (fig. 8).

The hydrant that figures prominently in both *The Soap-Locks* and *The Newsboy* was an essential tool of the volunteer fire companies and the b'hoys who accompanied them; a youth seated on a hydrant is also depicted in the far right of the lithograph of Mose.[34] The potential of b'hoys for violence was expressed through analogy with one of these street fixtures by Nathaniel P. Willis, a Whig, in his *Home Journal* in May 1849. Give b'hoys any pretext, any reason for dissatisfaction, he wrote, and see what happens: "let there be but a symptom of a handle for the B'hoys to express their dissent and the undercurrent breaks through like an uncapped hydrant."[35]

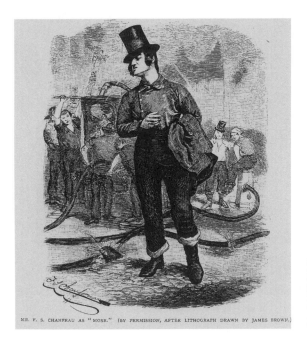

MR. F. S. CHANFRAU AS "MOSE." (BY PERMISSION, AFTER LITHOGRAPH DRAWN BY JAMES BROWN.)

FIG. 8. After lithograph drawn by James Brown, "Mr. F. S. Chanfrau as *Mose*," published in Benjamin Baker, *A Glance at New York*, 1848. The Harvard Theatre Collection, The Hougton Library.

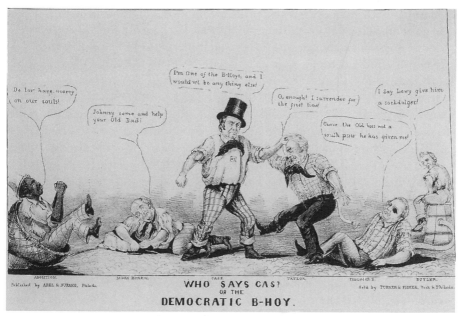

FIG. 9. Anon., *Who Says Gas? or, The Democratic B'hoy*, 1848; lithograph, published by Abel & Durang, Philadelphia. The Library of Congress. LC-USZ62-89721.

The association of b'hoys—and attendant younger boys sitting on hydrants—with the Democratic party is illustrated in a political print published in 1848 (fig. 9).[36] In it, the Democratic nominee Lewis Cass, dressed as a b'hoy, bests his Whig rival Zachary Taylor in a fistfight. To the right, Cass's running mate, William O. Butler, is perched on a hydrant.

With these details of costume and setting, then, Spencer set his boy firmly in the context of the Bowery and its independent and barely controllable inhabitants. Spencer's newsboy has a decidedly democratic (if not specifically Democratic) affiliation. Such a figure gives human form to the dangers threatening the social order that some Americans—perhaps Spencer himself—saw lurking in the social leveling fostered by the penny press, the upwardly mobile ambitions of young laborers like the newsboy, and the ethnic and class antagonisms exemplified by b'hoy culture. Indeed, a small poster announcing a "School For Boys" located to the newsboy's left reminds its viewers of the reformist impulses of more respectable classes directed towards New York's unregulated street youths.

The Newsboy's central background plane symmetrically flanked by two pilasters, its shallow receding space limited by this plane, and its projecting stage-like foreground call to mind another site of public culture, other than the streets themselves, in which Bowery boys in general (as *The Soap-Locks* makes

abundantly clear) and newsboys in particular were significant actors. "The most extraordinary feature, perhaps, in the whole history of the Newsboy, is his profound passion for the Theatre," observed the *Tribune* in December 1848, "At the very opening of the doors [of the Chatham or the Olympic Theatres] he throws himself into the pit."[37]

Serving equally well as a painted flat or as a surrogate newspaper sheet, Spencer's background wall and pilasters frame the newsboy, who confronts his audience with all the aplomb of an experienced actor at center stage. Newsboys did, indeed, figure as minor characters and elements of local color in such plays as *A Glance at New York*, which opened at the Olympic Theatre in February 1848, the first of a series of popular works to feature Mose and Lize, the archetypical b'hoy and g'hal. The play opened with a "View of Steamboat Pier, foot of Barclay Street. A number of Newsboys, Porters, Applewomen, etc. . . ." And in an expanded version of the play, entitled *New York as It Is*, one scene featured Mose exchanging barbs with a newsboy.[38]

Spencer's visual strategy suggests an analogous relationship between the actual world of the theater and the constructed world of the penny newspaper as encapsulations of contemporary society. "The theater in the first half of the nineteenth century," Lawrence Levine observes, "constituted a microcosm . . . of the relations between various socioeconomic groups in America."[39] The theater was the most significant literal space in which disparate segments of American society had traditionally drawn together in a public arena, united by common activities and interests and governed by a tacit understanding of proper hierarchical relationships.

By the 1830s, however, members of this theatrical audience were increasingly at odds over questions of style and rules of decorum, which masked more fundamental issues of social authority and economic power. By the 1840s, the world of the theater had become more (although not exclusively) the playground of a broadening lower-class audience, while the elite increasingly focused their patronage on symphonic performances, the Italian opera, and art galleries.[40]

Both the world of the newspaper and the world of the theater served as sites where—for all the rhetoric of an egalitarian republic—conflicts were fought in taste, fashion, manners, in conceptions of correct and moral behavior, and in the boundaries of individual liberties. Spencer, in the confines of his *Newsboy*, seems to have recognized these tensions as well as the places in which they were most clearly and publicly expressed, by visually uniting the theater, the newspaper, and, in one figure, the image of young America as newspaper salesman, theatrical customer, and theatrical character—all within an identifiably Bowery context.

The Bowery, by the time Spencer produced his *Newsboy*, was more than the name of a specific street in New York City. To conservative critics of American life, it represented a state of mind, of culture, and of society. If Broadway represented the world of respectability and New York's Five Points slum the opposite extreme, Peter G. Buckley explains, "the Bowery presented an area of confusion,

a socially promiscuous zone that fell between the sunshine of respectability and the sites of outright degradation." To many Americans "the Bowery was not a localized danger. If the temptations of the new commercial culture had been restricted to a single locality or class, it would not have occasioned such concern or commentary."[41]

The Newsboy presents a critique of this pervasive commercial culture, this "Boweryization" of America, not only in the type of the newsboy and his paper, but in the events and conditions acknowledged in its posters. With them, Spencer constructed the image of a society in confusion, slipping uncomfortably close to—perhaps even beyond—the edges of degradation. Although a number of the posters refer to specific Bowery/Broadway conflicts, the implications of these conflicts reverberate far beyond the streets of New York.

The Posters

Spencer confronted his audience with the literal results of the dangerous intersection of working-class and genteel cultures in the volatile social space of an increasingly segregated theatrical world. Amid the visual cacophony of the back wall (fig. 10), the word "RIOT"—red, boldly lettered, and centrally placed—draws immediate attention. As the poster on which it is printed clearly states, this particular riot occurred at the Astor Place Opera House on 10 May 1849; a "full account" is promised here, as it was in the newspapers of New York and other cities.

According to Levine, the Astor Place riot "was a struggle for power and cultural authority within theatrical space," both "an indication of and a catalyst for the cultural changes that came to characterize the United States at the end of the century."[42] It had its beginnings in a feud between the American actor Edwin Forrest and the English tragedian William Macready. Forrest, whose acting style was considered crude by English audiences and polite American society, had been booed while on a tour of England. He and his supporters resolved to provide Macready with an equally negative reception when the latter performed in the United States.[43]

The rivalry came to a head during Macready's performance of Macbeth at the newly opened and fashionable Astor Place Opera House on May 10. That night, an anti-Macready mob, armed with paving stones, tried to force its way into the theater. After attempting to disperse it with warning shots, militiamen fired into the crowd—which included as many curious onlookers as active participants—killing approximately twenty-two people. The chaotic scene, depicted in a lithograph published by Nathaniel Currier (fig. 11), was deeply disturbing to a city that prided itself on avoidance of mob violence; newly elected Whig mayor Caleb Woodhull issued a proclamation calling on the "Friends of Order" to maintain peace in the city. His plea for civility and rational behavior is

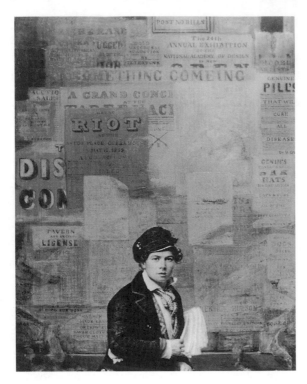

FIG. 10. Frederick R. Spencer, *The Newsboy*, detail of plate 1 (back wall above newsboy's head, between two pilasters).

included in *The Newsboy* by means of a small white poster that overlaps the notice of the riot.

According to an article first published in the Boston *Atlas* and reprinted in the *Herald* on 16 May 1849, class animosity fueled the riot:

> The class known as the Bowery boys, although not without their good traits of character, are naturally the opponents of the higher, or more wealthy classes. . . . The Bowery boys have a natural dislike and enmity to the frequenters of the opera house. The very fact that no person was admitted within it, unless in full dress and with white kid gloves, was enough to arouse the passions of those men who nightly fill the pits of the Bowery and the Chatham . . . in their red shirts and their pockets filled with pea-nuts and pig-tail.[44]

Many who made up the Astor Place mob were of the same age, class, and value orientation as the typical Bowery b'hoy; contemporary newspapers stressed his involvement in the violence.[45]

Indeed, Forrest was the Bowery b'hoys' hero, an embodiment in his public persona and in his acting of their self-proclaimed virtues. According to Levine, Forrest's "vigorous acting style, his militant love of his country, his outspoken belief in its citizenry, and his frequent articulation of the possibilities of self-improvement and social mobility endeared him to the American people." On

the other hand, "Macready's cerebral acting style, his aristocratic demeanor, and his identification with the wealthy gentry made him appear Forrest's diametric opposite."[46]

Forrest's "American" style of presentation was not the only factor that won him support among the Bowery b'hoys. The type of play in which he appeared also contributed to his popularity. As the previously mentioned *Atlas* article explained:

> Forrest had long been a pet of the Bowery boys. . . . His prize plays are suited to their tastes. . . . In each of these plays, Mr. Forrest appears as the champion of the masses—as one who is oppressed and ground down by the iron heel of tyranny and despotism. . . . Mr. Macready, on the other hand, is identified in the public mind as one who has little sympathy with the masses.

Rivalry between the American and the British actor, then, was anything but petty to Forrest's champions; larger issues of social equality and national independence seemed at stake.

George G. Foster, a Democratic chronicler of popular culture, offered as justification for the riot the fact that members of Forrest's working-class audience were themselves victims pushed to the limit by aristocratic oppression. Foster noted the b'hoy's disdain for "sucklings of foppery and fashion," who, by

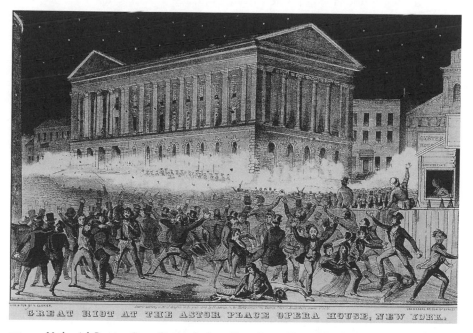

GREAT RIOT AT THE ASTOR PLACE OPERA HOUSE, NEW YORK.

FIG. 11. Nathaniel Currier, *Great Riot at the Astor Place Opera House, New York on Thursday Evening, May 10, 1849*; 1849; lithograph published by Nathaniel Currier. The Library of Congress. LC-USZ62-42326.

accident or deliberate dishonesty, had managed to amass a little money. The b'hoy watched as these idlers lived in ostentatious luxury, producing nothing and enjoying all "while he produces all and enjoys nothing. Is it not natural that all this should rankle in his heart until he becomes impatient, unjust and reckless, and sometimes even is led to wreak personal vengeance upon the obnoxious class?"[47]

To many observers, the clash of civil authority and working-class vengeance that bloodied Astor Place seemed all the more portentous when viewed in relation to the revolutions then disrupting Europe. News of the February 1848 insurrection in Paris reached New York on March 18 of that year. Most Americans, both native-born and recent immigrants, reacted jubilantly to word of this relatively genteel revolution. They attended concerts, sang the *Marseillaise*, and passed out proclamations and resolutions in support of the uprising. The subsequent revolutions in Germany, Italy, and Hungary elicited similar outpourings of popular support and sympathy.

Plays were hastily written and staged to capitalize on the American public's enthusiasm for distant revolution. By 25 March 1848, for example, a "new national drama" entitled *The Insurrection of Paris* was performed at New York's Bowery Theatre.[48] On 15 May, the Olympic Theatre offered an extravaganza called *An Olympic Extra, Announcing the Arrival of the Kings of Europe* (note that the wording of the title is borrowed from newspaper jargon).[49] But the opening on 11 September 1848 of a new drama entitled *The Destruction of the Bastille, or Terror's Reign* indicates a growing anxiety about the disruptive nature of revolution and its potential for social anarchy, which followed in the wake of the violent suppression of a Parisian worker's uprising in June 1848.[50]

The *Herald* laid part of the blame for the Astor Place riot at the feet of "French socialism and kindred abominations" as disseminated through sympathetic newspapers like Horace Greeley's *Tribune*. Such newspapers created "a feeling of hostility between rich and poor. . . . Who can tell how deeply those seeds of disorder, discontent, and rebellion against the established order of society. . . may not have sunk into the minds of certain classes of our own community?"[51]

Spencer's young newsboy, balanced on an as-yet capped fire hydrant, was representative of just such a "certain class." He was part of the boisterous peanut-shucking audience of young male laborers who frequented the Bowery district theaters and made up the core of Forrest's admirers and defenders. Perhaps the level gaze he directs back at those people examining him under the auspices of the National Academy exhibition—people more likely to frequent the Astor Place Opera House than the Chatham or the Bowery theatres—has, if not menace, a self-assurance born of potentially disruptive power. The same dissolving of clear social boundaries implicit in the figure of the newsboy, a dissolution that promised but did not always deliver a more prosperous future to diligent workers, also suggests the type of class antagonism and civic disorder made apparent in the Astor Place riot.

FIG. 12. Martin Johnson Heade, *Roman Newsboys* (1953.68), 1848; oil/canvas, 28½" × 24⅜". The Toledo Museum of art; Purchased with funds from the Florence Scott Libby Bequest in Memory of her Father, Maurice A. Scott.

Obviously, Spencer's concern was with this local riot and not with European revolution, to which he makes no overt reference in *The Newsboy*. Yet, as we have seen, timely and troubling questions about the nature of authority—who wields it and who aspires to wield it—and the stability of existing governments are raised by his red-lettered "RIOT." Such questions are directly addressed in Martin Johnson Heade's *Roman Newsboys* (fig. 12). Heade, like Spencer, underscored the role of the popular press in encouraging political debate and, more clearly than Spencer, manifested its potential for subversive and revolutionary expression.

Heade produced the painting in Rome in 1848, during the turmoil caused by the Risorgimento movement, which favored the establishment of a democratic republic in place of the rule of Pope Pius IX. The torn and effaced posters, the hastily scrawled slogans and caricatures that cover the rough plaster wall behind the newsboys suggest the changeable nature of the pope's fortunes by 1848. When Pius IX took office as spiritual and temporal leader of the Papal States in 1846 and began a program of constitutional reform, Protestant Americans as well as liberal Italians wished him well. But the Pope's subsequent rejection of democratic reforms and his acceptance of foreign aggression toward Rome earned him immediate hatred and the epithet "pirlone"—hypocrite.[52]

Yet Heade's ragged newsboys are not identical in their dress, implying that both vendors might not share such approbation. The standing boy's cap is decorated with the pope's name—Pio IX—hinting at an allegiance to the pontiff and

traditional Roman Catholic authority perhaps not entirely abandoned. On the other hand, the seated boy offers papers emblazoned with the word "pirlone," and the republican associations of his cap's red band would have been immediately apparent to contemporary viewers.

A sense of imminent decision and, particularly, of the precariousness of the Roman political situation is conveyed though the one-legged, leaning position of the standing figure and by the seated newsboy on his high and slippery perch. For the moment, at least, this purveyor of republican sentiments is elevated on a plebeian throne. The uncertainty of Rome's future is suggested by a mysterious and slightly ominous shadow in the extreme left of the composition. It is the shadow, perhaps, of that unknown person to whom both newsboys offer their papers.

Albeit within a different social and political context, Spencer's *Newsboy* conveys a similar sense of precariousness. Its "RIOT" is a recognition that the United States was, in fact, no "model republic." The nation, no less than European monarchies, papacies, or short-lived republics, faced its own set of dangers. More particularly, it exposes the very real fears of those who perceived themselves to be guardians of the cultural high ground, in whose company we can certainly envision Spencer. Were the "lower" tastes and intellects to be drawn forcibly upward or were the "higher" to be wrestled continually downward? Or—most horrifying to consider—would the two extremes pull apart so violently as to disrupt irrevocably the "order of society?"

Such disturbing questions had infiltrated even the supposedly rarefied world of art with particular force by the end of 1849. With the poster reporting that "The 24th Annual Exhibition of The National Academy of Design is Now Open," Spencer acknowledged that he and his fellow academicians had no choice but to confront the diverse expectations of urban, commercial America. Although tensions within the art world did not culminate in a riot, they almost killed the National Academy.

Spencer's sign reminds its readers of the most crucial activity of the academy, both in terms of its educational mission and its literal survival: the public exhibition of art. The academy's annual exhibition, to which it charged an entrance fee of twenty-five cents per person, was its only source of revenue.[53] Although the twenty-fourth annual exhibition opened on 3 April in the academy's Broadway gallery, it was hardly successful. By the time it closed on 7 July, it had attracted an average of only 135 paying visitors per day, netting the failing academy a mere $2,753.47—over $1,700 less than the year before.[54] Apparently, competition from the American Art-Union had eaten so deeply into attendance that, by September 1849, the academy was, as Charles Ingham wrote desperately to Asher B. Durand, "struggling for existence." Every exertion was necessary, Ingham warned, to save the academy from its "deadly enemies of the Art-Union."[55]

Although the American Art-Union and the National Academy shared a simi-
lar goal of encouraging the development of American art, they had become
"deadly enemies" over ideological differences and, more important, economic
realities.[56] The American Art-Union (established in 1839 as the Apollo Associa-
tion) was far more aggressive in its democratizing zeal than the National Acad-
emy and actively encouraged the production, distribution, and sale of work by
living American artists to a widening social spectrum of purchasers. Like the Eu-
ropean art unions on which it was based, the American Art-Union sold subscrip-
tions to the public for five dollars per year. This revenue was used to purchase
works of art by living artists, which were distributed to subscribers by lots at the
end of the year, and to produce an annual engraving given to all subscribers.[57]

To many members of the academy and other interested observers, the "art
union principle" artificially stimulated the production of art, resulting in a sur-
plus of hastily rendered items. "[I]t does not tend to the elevation and perfection
of Art, but to the fostering of mediocrity," the *Harbinger* noted in 1847; "This is
almost a necessary consequence, indeed, from the mode of its organization and
operations, which always places it on the level of the popular culture, and never
above it."[58]

But far worse, in terms of its effect on the academy, was the art union's equally
successful attempt to democratize the exhibition of art. In 1845 it opened a gal-
lery without, as the *Literary World* described it, "that ancient landmark of '25
cents admission' which had existed so long, a perpetual barrier between specta-
cles and spectators."[59] By 1847, the art union was able to build a spacious new
gallery at 497 Broadway while maintaining this policy of free admission.

Members of the American Art-Union Committee proudly reported in 1847
that several thousand people a day had visited their room. "Among them have al-
ways been many citizens of the laboring classes, to whom the expenditure re-
quired to visit other exhibitions"—this can only have been a dig at the National
Academy—"is an indulgence which they cannot conveniently afford."[60] An arti-
cle in the *Knickerbocker* in November 1848 supported the art union's claim of a
heterogeneous audience: "The retired merchant from Fifth Avenue, the scholar
from the University, the poor workman, the news-boy . . . all frequent the Art-
Union."[61] Rather than lowering the tone of the exhibition, the committee ob-
served, working-class visitors, affected by art's refining influence, "quietly and
decorously" viewed the pictures.[62]

By early 1849, then, the National Academy was in dire straits. Exhibition reve-
nues for the 1848 exhibition had dropped alarmingly in the face of art union
competition. The annual report of the academy's council—of which Spencer
was a member—was delivered in May 1849, shortly after the opening of the
twenty-fourth annual exhibition, and it seethed with resentment and wounded
pride: "[I]t is no longer a question that the seductive influence of Free Exhibi-
tions, encouraged and sustained by far other motives than the love of Art, is the
primary cause of our embarrassment. To this we owe the decline of our revenue."

The council gingerly tendered the suggestion that, in order to survive, the academy might have to incorporate some element of the art union principle into the "structure of the academy." Much as it disliked this principle, which created "a demand for Art beyond the power of Art" and "degrad[ed] its standard and retard[ed] its development," it would be better for the academy to claim control than to let it remain in ignorant hands.[63]

The council also grudgingly recognized that the academy needed to "render our Exhibition Room more easy of access, and put on all suitable extrinsic decorations to attract the *multitude*, instead of relying on the inherent beauties of Art, perceptible only to the enlightened few." The academy, established in 1825 by a group of professional artists dissatisfied with the conservative administration of the gentlemen amateurs who directed the existing American Academy, had long prided itself on its free and egalitarian American character. Yet, when confronted with an ostensibly more democratic and more commercially adventurous method to encourage American artists and find a market for their work, the academy found itself in an uncomfortable position of reaction. With little enthusiasm, it considered entering the modern world of commercial competition, where the surface charms of advertising counted for more, it seemed, than the intrinsic worth of art.

There is irony, then, in the almost obliterated word "OPEN" in Spencer's poster. Certainly, in the art world of New York of the late 1840s, the American Art-Union and not the National Academy had better right to that claim. Not only was the art union "open for business" and likely to remain so, it was "open to the public" in rhetoric and practice in a manner that the academy could not hope and ostensibly did not want to match. The academy was closed and closing, as it clung to the aesthetic high road and touted its concern for artistic standards and ideals. Yet the academy, its eyes opened as never before by the disastrous twenty-fourth annual exhibition, recognized the distasteful necessity of opening the rest of its body and practices to the "habits and susceptibilities of the community"—even a community dazzled more by gaslight than by fine art.

A small white notice placed directly to the right of the academy announcement is an indication that it had other and more noxious rivals for public attention than the American Art-Union. The "Model Artists" to which this notice referred were "a new species of entertainment . . . living statuary."[64] Such exhibitions of scantily clad men and, especially, women posing as famous statues or paintings seem to have appeared on American shores in 1847, scandalizing polite society and rallying guardians of public decency. To some observers, such fleshly entertainments signified not only uncultivated taste, but a breach in public order and a breakdown of civil authority.[65]

The *Herald* reported on 5 February 1849,

We understand that the exhibitions of model artists, which created so great a sensation last year, and shocked the feelings of the community to such an extent, have been again

revived in several places in this city, with even less drapery . . . than ever. Such sights ought not to be tolerated in a civilized and Christian community. . . . Where are the authorities of New York? Is there to be no end of these shameless exhibitions?[66]

Exhibiting almost naked women as Powers's *Greek Slave* and Titian's *Venus* allowed entrepreneurs to cloak their enterprises in the de-eroticizing and moralizing guise of "high art," making a mockery of both the academic ideals and educational practices upheld by such authorities as the National Academy of Design. Since admission to the model artists was also twenty-five cents, it did not, like the American Art-Union, provided populist access to an alternative spectacle. Indeed, much of the audience for model artists, or so the *Herald* reported, consisted of "several hundred fashionable old rakes and ineffable scoundrels about town—some of them bankers and brokers in Wall Street, over sixty years of age."[67] The contrast of the National Academy and the model artists exhibitions—both "art" shows costing twenty-five cents—posits, instead, questions of taste in a commercial and speculative society where possession of money was no measure of intellect or refinement.

The differing levels of artistic hierarchy, the contrast between the taste of the art union's "multitude" and the academy's "enlightened few" and, even more so, between the world of fine art and that of the model artists, is also embedded in the visual strategy of Spencer's painting. As we have seen, a reviewer for the *Tribune* remarked that the placards on Spencer's wall were "lettered with the fidelity of a daguerreotype." Although this comment suggests respect for the artist's technical skill, when viewed from an academic perspective it subtly diminishes his accomplishment. The kind of trompe l'oeil illusionism evoked by such a description was devalued in a tradition favoring idealized and ennobling visual approaches. Trompe l'oeil paintings were denounced by the arbiters of conservative aesthetic taste as unintellectual, appealing to more popular culture, to the materialistic instincts of the uneducated or the unrefined. Such condescension is apparent in a comment by the *Albion*'s critic, who observed that *The Newsboy*, although bearing close examination, "did not challenge it."[68]

The figure of the newsboy in Spencer's painting is not treated with the same sense of actuality as the background wall. He could never be mistaken for the "real" thing and, when compared to such caricatures as "One of the News B'hoys," might even be interpreted as an idealizing treatment of an urban type. On the other hand, the posters are, in fact, almost what they seem to be: two-dimensional surfaces inscribed with legible letters. Spencer mixed the accessible "democratic" implications of trompe l'oeil illusionism with the traditional techniques of proper academic painting—another indication of the carnivalization of culture, both in his painting and in society, of which it is emblematic. We see, in the painting's very surface, a clash between the "real" world of the newspaper and the model artists and the "ideal" world of the National Academy of Design.

Other signs on Spencer's wall also refer to sites of public entertainment.[69] But the social tensions played out in the world of urban spectacle (a world in which the academy was firmly embedded) were not Spencer's only concerns. While "Model Artists" elbows it on the right, the academy notice is jostled on its left by the sign of a different type of public immorality and civic disorder. "Gold Watches at Auction by Peter Funk" reminded its readers of the fraudulent auctions and the swindlers who organized them plaguing New York at the time. "Beware of Mock Auctions," the *Herald* warned on 12 March 1849, "where Peter Funks congregate . . . these dens of knaves, where roguery and ruffianism go hand in hand with unblushing effrontery, are still flourishing."[70] According to this report, country storekeepers visiting the city to buy stock were often lured by low prices to bid at such "swindle shops"—despite warnings by the press. An exorbitant bill, which he was forced to pay, surprised the duped merchant at the end of the transaction.

The slick city swindler and the country merchant too eager for a bargain both suggest a nation of commercial speculators driven to reap as large a reward as possible, no matter what the cost to honesty or integrity. And by 1849, those Americans determined to get rich quick had a new outlet for their ambitions. "The great event of the day," Fisher noted in his diary on 26 February 1849, "is the discovery recently made of large quantities of gold in our newly & dishonestly acquired territories—New Mexico & California. . . . [T]he excitement produced is unparalleled. Many thousands have abandoned their pursuits & gone. . . . Every paper has a column devoted to advertizements [*sic*] of vessels & parties going to the 'gold regions.'"[71]

Spencer cynically acknowledges this excitement and the disruption it produced in a centrally placed poster announcing passage to the California gold fields on a ship named "Humbug" captained by "A. Swindler" and owned by "A. Shark." (Two other bills in the painting also advertise transportation to or housing in California.) Perhaps it was no accident that Spencer located this advertisement beneath the illustrated notice of Barnum's five-hundred-pound "Mammoth Lady"—a formidable example of human overabundance hawked by the "Prince of Humbugs" himself. His references to "swindler" and "shark" suggest that the artist, like many others, was concerned about gold's negative effect on an already questionable American commercial character; we should note that Peter Funk sells *gold* watches at his mock auction.

William Sidney Mount's *California News (News from the Gold Diggings)*, painted in 1850 (fig. 13), captures the heady excitement and reckless spirit, implicit in Spencer's posters, that gripped America in the Gold Rush years.[72] Mount's painting gives human form to one of the issues engaged in *The Newsboy*: the disruptive influence that the desire for gold had, many observers believed, upon American public order, agrarian virtues, and domestic stability.

Set in an Eastern post office or tavern, Mount's room, like Spencer's wall, is

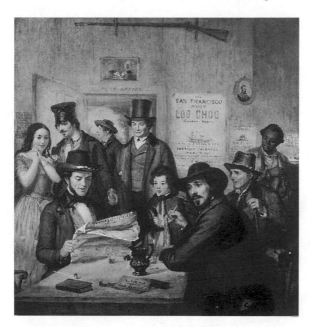

FIG. 13. *California News*, 1850, William Sidney Mount. Oil on canvas, 54.5 × 51.4 cm (21½" × 20¼"). Gift of Mr. and Mrs. Ward Melville, 1955. The Museums at Stony Brook.

plastered with advertisements for passage to California as well as a notice announcing a "farm for sale." A young man in the left of the composition seems to regale his female companion with stories of potential wealth—her eyes fairly glitter in response—perhaps to convince her to accompany him on the arduous trip west, or to defend his decision to leave home. Over the doorway, a picture of pigs at a trough serves, as does Spencer's Mammoth Lady, as an allegory of human greed. Mount was anxious about the effects of the discovery of gold on the nation's character. He pondered the implications of this new national treasure, which seemed to encourage reckless speculation and materialism, long decried as serious American character flaws, rather than the "Anglo-Saxon" virtues of patient industry and thrift. "I hope," Mount wrote in his diary in 1848," it may turn out [more] a blessing to the country—than a curse."[73] Such a curse was visualized, for example, in a lithograph entitled *Things as They Are* published in 1849 (fig. 14).[74] In it, one man cuts another's throat for a bag of gold, a body lies senseless on the ground, and two men attack each other with knives.

Fisher's reference in his diary to California and New Mexico as "newly & dishonestly acquired territories" reminds us that American access to gold depended on its recent victory in the Mexican War. (The bearded young man in Mount's *California News* wears what appears to be a Mexican War military shako, suggestive of the number of veteran volunteers who tried their luck at the diggings.) Indeed, a notice calling for "Recruits for the United States Army" located in the

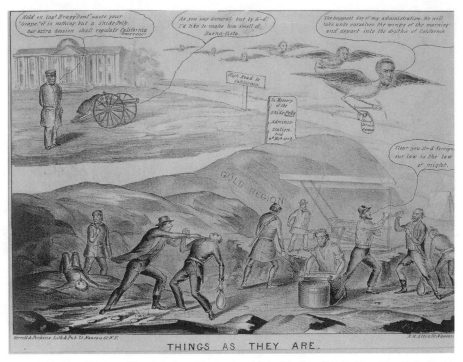

FIG. 14. Perkins, *Things as They Are*, 1849; lithograph published by Serrell & Perkins, New York. The Library of Congress. LC-USZ62-11466.

extreme right of *The Newsboy* is a souvenir of the nation's first foreign war of aggression, another example of what many perceived to be America's rampant greed and acquisitiveness.

Many opponents of the war were concerned when Congress authorized an increase in the size of the regular army (in addition to volunteers and militiamen); the poster in *The Newsboy* seeks recruits for this expanded army (fig. 15). In the war's wake, debate turned to the country's proper stance in peacetime. In 1848, for example, Horace Greeley warned that a large standing army was a "relic of barbarism," and worried that the United States, encouraged by its success in Mexico, was changing from a peaceful to a militaristic nation.[75]

The regular soldier—the United States Army recruit—was a generally unpopular figure in antebellum America, viewed as an economic and personal failure, who fled to the army as a last resort. There he hid, as Marcus Cunliffe explains, with all the other "misfits, bad hats, transgressors and broken men" at the fringes of society.[76] To respectable Americans like Spencer and his peers, the army, like the gold fields of California, was a world beyond the pale of civilization and moral control. An advertisement for guns and another for dirks and bowie knives, with their frontier connotations, reinforce the perception expressed in *The Newsboy* of an increasingly violent current in American society.

As with European revolution, Spencer's *Newsboy* does not openly engage the Mexican War. But, again as with political revolution, the war is inextricably embedded in its layered surface and was part of the common experience and knowledge its contemporary audience brought to the painting. Richard Caton Woodville's *War News from Mexico* (fig. 16) can serve, like Heade's *Roman Newsboys* and Mount's *California News*, to clarify some of the issues and concerns raised in *The Newsboy*.

Woodville's *War News from Mexico* was conceived and produced in 1848 while the artist was studying in Düsseldorf and was exhibited at the American Art-Union in 1849.[77] On its face a humorous genre scene, *War News from Mexico* depicts the electric excitement that animated the nation as martial victories were reported, by telegraph, with astonishing speed.[78] Like a more sophisticated version of the *Herald* cartoon illustrated in figure 4, *War News from Mexico* recognizes the power of the newspaper to unite people in a community of shared interests and instant information, while exacerbating the tensions of political and social rivalry, raising questions about American cohesiveness and shared values. And, like Spencer's *Newsboy*, *War News from Mexico* suggests—through its limited background, its emphasis on overlapping rectilinear planes, and its foregrounded figures—the newspaper's immediacy and the intensity of focus it required of its audience.

FIG. 15. Frederick R. Spencer, *The Newsboy*, detail of plate 1 (right pilaster).

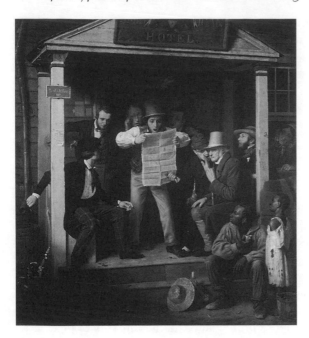

FIG. 16. Richard Caton Wood-
ville, *War News from Mexico*,
1848; oil/canvas, 27" × 24¼". The
Manoogian Collection, on loan to the
National Gallery of Art, Washington.
Photograph © Board of Trustees,
National Gallery of Art, Washington.

The white male citizens who gather around the newspaper reader on the
porch of "The American Hotel" greet news of American victory with varying de-
grees of enthusiasm.[79] The young bearded man on the left, of all the white males
in the group, seems curiously detached. He looks, in fact, not at the reader but
down toward the seated man in the left foreground as if anxiously gauging his re-
action. Uneasiness and ambiguity are apparent in the attitudes of several of the
characters, most particularly the old man in knee britches, a living reminder of
the glorious days of 1776. Few would have disputed that his generation's war had
been a high-minded struggle for freedom. But, as we have seen, not everyone
agreed that the American adventure in Mexico was a similarly admirable cause.

Supporters of the war with Mexico attempted to validate the present by link-
ing it to the glorious past; by providing the Mexican War with the credentials of
the struggle for independence, they hoped to legitimize Manifest Destiny and
imperialism. But antiwar activists just as frequently contrasted the Revolutionary
War, as a noble struggle for freedom, with the Mexican War, an aggressive war of
imperialism that they believed negated all that republics stood for. Critics of the
war saw the spread of slavery, sectional divisiveness, and greedy imperialism as
serious threats to the nation's ability to carry on the legacy of the Revolutionary
generation.[80]

The successful outcome of the war with Mexico had, by 1848, raised inflam-
matory questions about the extension of slavery into newly acquired territories;
the black man and young girl placed so prominently in the foreground can only
signal Woodville's recognition of this issue.[81] With these impoverished black

figures, the troubled countenance of the man in knee britches, and the anxious young man on the left, the painting is far from a jolly celebration of national unity. Perhaps the peacock feather that sweeps incongruously from the straw hat in the foreground serves, in part, as an emblem of human vanity and pride.

Glorious dreams (a vision of imperial greatness) and uncomfortable reality (a divided and threatened nation) rub elbows in Woodville's America. The fading white paint and missing capital suggest instability within the very structure of the "American Hotel," an erosion of its aspirations to republican (male) inclusiveness. The simple, homespun Greco-Roman idealism of the wooden portico begins to decay beneath the onslaught of modern American imperialism and its attendant social conflicts. (We might remember here the defaced classical pilasters in *The Newsboy*, with their similar suggestions of a devolving American tradition.)

Woodville's version of the American reaction to news from the Mexican War, with its emphasis on male endeavor and acquisition and their consequences, had little place for women. But war news from Mexico could also be situated within a private and specifically feminized context. John L. Magee's *Reading of an Official Dispatch (Mexican War News)*, exhibited like Woodville's *War News from Mexico* at the American Art-Union in 1849, depicts the disruption of familial order in the wake of the Mexican War.[82]

Word of the loss of a beloved family member has just arrived in the pages of a newspaper. The distraught wife and child, supported by relatives, weep beneath a portrait of the now-deceased soldier in his military finery. The young boy dressed in miniature military regalia, seated in the far right of the composition, pauses as if to reflect on the folly of his make-believe soldiering and on the potential cost of the real endeavor. The half-closed window shade, which both encloses the domestic group and permits a view of the outside world, suggests both the private and public levels of loss.

The national implications of patriotic sacrifice are reinforced by an engraving of Trumbull's Declaration of Independence which hangs on the wall next to the soldier's portrait. Offering a measure of comfort or additional bitterness, the engraving suggests that the dashing young man—obviously full of promise and beloved by family and friends—died either for a legitimate republican cause or for an antirepublican folly.

Magee's painting demonstrates in some small way the reality of death that underlay American victories and territorial expansion.[83] Both Magee's and Woodville's images of war news indicate the bitterness and disharmony that were as much a part of the war's continuing legacy as national pride and gold-filled western lands. This is the legacy that must be considered when reading Spencer's advertisements for California steamers and army recruits.

Other, more modest opportunities were available to contemporary viewers of Spencer's *The Newsboy*. A blue poster in the upper right of the painting offers, for one dollar, "A Portrait of Father Mathew/The Great Apostle of Temper-

ance." With this small advertisement, Spencer acknowledged controversies about the effect of alcohol on social order and about its proper regulation, controversies based in differing notions of individual responsibility and external authority.

Father Mathew, an Irish Capucin priest, was invited to the United States in 1849 by the American Temperance Union to administer the pledge of total abstinence to Irish immigrants.[84] Like many antebellum reformers, Father Mathew believed, as the *Herald* reported, "that the genuine reformer must begin with the individual, and the means of regeneration which he employs are the weapons of reason, of argument, of moral suasion, of Christian charity."[85]

But by the time of Mathew's visit American temperance circles were divided between such advocates of "moral suasion" and those who felt that stronger and more authoritarian methods were required. A large notice for a "Tavern and Excise License" located to the left of the newsboy, identifies the parameters of this debate and government's place within it. Licensing acknowledged an individual's right to drink intoxicants while providing a measure of civic control over and financial benefit from their sale. This stance incensed militant prohibitionists who believed that it provided legal sanction for drunkenness.[86] Supporters of total abstinence sought to influence political parties and ensure the passage of antidrink legislation. "It was no longer a matter solely or even principally of convincing people to reform themselves," Elizabeth Malcolm explains, "but one of convincing governments to enforce reform on behalf of their people. Moral suasion . . . was rejected during the 1840s in favor of legislative coercion."[87]

The Newsboy provides no clear indication of partisan support for either view. More important than assessing Spencer's attitude toward temperance, however, is to recognize the struggle encoded within the painting between the potential for human perfectibility and the rewards of individual freedom, and the need for an external authority's regulation and control.(This conflict is implicit, in fact, in all of the issues already discussed in connection with *The Newsboy*, and will be in every issue raised by images in the following chapters.)

The particular association of Irish immigrants with drunkenness and all of its attendant social and moral evils is explicit in Spencer's advertisement for Father Mathew, which suggests as well the desire of many native-born Americans to assimilate immigrants into a code of middle-class Protestant expectations and behaviors.[88] And at the basis of any understanding of Irish immigration in the late 1840s was the memory and the continuing reality of the horrible famine.

The physical and psychological toll of the famine was explored, for example, in "The Emigrant's Dream," published in *Yankee Doodle* on 19 December 1846 (fig. 17).[89] *The Emigrant's Dream* presented in visual terms the themes of homesickness and mourning for a dying people expressed in numerous popular

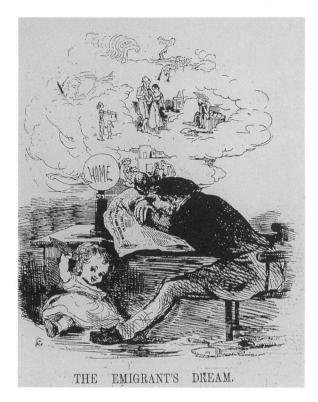

THE EMIGRANT'S DREAM.

FIG. 17. "The Emigrant's Dream," published in *Yankee Doodle*, 19 December 1846. University of Delaware Library, Newark, Delaware.

American songs, poems, and plays.[90] In it, an Irish emigrant to the United States sits slumped over a newspaper whose headline proclaims "DISTRESS [*sic*] NEWS FROM IRELAND."

Although this information was not intended for the emigrant's private examination and reaction, as it would have been in a letter, it elicited a deeply personal reaction. The man dreams of his family hearth, his sweetheart, and his native land before the famine. Ghastly images of his now-skeletal and despairing countrymen fill the remainder of the dream—sketchy versions of images published, for example, in the *Illustrated London News* (fig. 18)—while the sacks carried by figures in the upper portion refer to Indian cornmeal imported from the United States as famine relief.[91] Indeed, the rosy, well-fed child seated on the floor in the foreground holds an ear of corn, indicative of American plenty. The empathetic American newspaper reader of such reports might have experienced a range of emotional reactions from melancholy nostalgia, to horrified pity, to pride in national charity.[92]

Although most Americans were probably sympathetic to Ireland's plight in the abstract, many more were alarmed by the influx of impoverished and, more distressingly, Catholic immigrants that they witnessed or read about. Indeed,

FIG. 18. "Bridget O'Donnel and Children,"
published in *The Illustrated London News*, 22
December 1849. University of Delaware Library,
Newark, Delaware.

poor immigrants to the United States were often perceived as carriers of disrup-
tive influences more fatal than Catholicism and intemperance. A small green
poster advertising "A Cure For the Cholera," located in the far right of *The
Newsboy* reminds us that, by the summer of 1849, the United States, including
New York, was in the grip of a virulent epidemic. Some observers, like the patri-
cian Philip Hone, believed that European immigrants, "Irish and Germans . . .
filthy, intemperate, unused to the comforts of life and regardless of its proprie-
ties," had brought the disease with them to American ports.[93]

Spencer probably began *The Newsboy* in the midst of the epidemic,[94] and he
reminds his viewers of the quacks and charlatans who preyed on people's fear
and hope and promised what they could not deliver. By 10 June 1849 the *Herald*
noted the "progress of the cholera" in the city and printed the text of a cholera
prayer. By 17 July, it reported "Cholera Increasing—Almost a Panic," com-
menting uneasily that the wealthy and respectable as well as the poor and in-
temperate were falling victim. (Apparently cholera was as much a social le-
veller as the penny press.) "New York has become a charnel house," Hone
lamented in his diary on 28 July. By September, New York and the nation had
begun to recover.[95]

* * *

A modest bill pasted on the pilaster in the extreme left of the composition indicates that F. R. Spencer seeks "A Farm . . . About 50 Acres" (fig. 19), reminding us again of the artist's personal as well as professional immersion in contemporary concerns and anxieties. In it, we sense a tongue-in-cheek but sincere desire for a pleasant rural retreat far from the distractions and violence of modern urban life announced in the other posters. Spencer did not present himself as one of those lured by the glitter of California gold, which uprooted so many from their homes and disturbed so many domestic circles (we should remember the notice of a "farm for sale" that Mount included in *California News*), or as a potential army enlistee. Instead, he associated himself with an agrarian environment, which, from the vantage point of a midcentury New Yorker, spoke more of America's stable past than its unsettled present.

"Whereas the self-made man was a modern creature of cities, a commercial adventurer who perfectly embodied the American passion for ascent and acquisition," Hedy da Costa Nunes observes, "the farmer personified their simultaneous longing for stability and tradition."[96] Stability and tradition, the agrarian foundation of America's national vision, are nowhere evident in Spencer's evocation of the Bowery of modern life with its continually changing excitements, its self-

FIG. 19. Frederick R. Spencer, *The Newsboy*, detail of plate 1 (left pilaster).

made newsboys, its California-bound adventurers, its hordes of drunken or dis-
eased immigrants, its humbugs, sharks, and swindlers, except in this nostalgic note.

What *The Newsboy* does present, to borrow from Levine's description of the
United States in the nineteenth century, is "an industrializing, urbanizing na-
tion absorbing . . . immigrants from alien cultures and experiencing an almost
incomprehensible degree of structural change and spatial mobility." The paint-
ing, like the country in general, is imbued with a "sense of anarchic change, of
looming chaos, of fragmentation, which seemed to imperil the very basis of tra-
ditional order," a sense that was not confined to a handful of aristocrats but
shared by many members of the industrial and business middle class.[97]

"Something Comeing"

Each of the signs so far discussed—and most of the remaining ones around
them—are clearly linked to a specific and identifiable event, condition, or issue
already at work in contemporary American society. What then, do we make of
"SOMETHING COMEING"?[98] Blending easily with the posters that surround it (but
subtly distinguished by the color of its ground from its neighbors) perhaps it, too,
merely announces the coming of a popular amusement—a grand concert or an
exhibition at the American Museum.

But the phrase and its presentation offer a paradox of clarity and obscurity un-
like any of the other posters, and they suggest something more general and more
significant than a concert or an exhibition. We are frustrated by a sense that, hid-
den beneath at least five layers of old paper, lies a full report of this anticipated
arrival. At the same time, we are teased by the possibility that the identity and ar-
rival time of "something" are hidden in plain sight, encoded in the surrounding
fragments of information. We are impatient for the veils that obscure truth to be
lifted. The image creates the desire for revelation, but refuses to satisfy it.

The Newsboy, as we have seen, presents its audience with a reconstruction of
the immediate past and a construction of the ephemeral present. But the paint-
ing does not similarly embody the future; "SOMETHING COMEING" only draws at-
tention to its imminence and its ambiguity. "All things seem to be hastening to-
wards some great result. . . . The world is moving towards *some* point at railway
speed," a journalist commented in February 1849.[99] Spencer, it seems, agreed.

To many antebellum Americans, the future was breathing down the neck of
the present, propelled by the juggernaut of technological progress. "We're going
at a rapid rate / And everything is moving," a poem published in May 1848 begins,
and ends with the popular railroad analogy sounding a decidedly worried note:

> We're rushing in at rail-road speed,
> (Look out, friends, when you hear the bell!)
> But where the terminus will be
> 'Twould take a conjuror to tell![100]

Indeed, a speeding train thunders toward a dark and mysterious tunnel below the striding and shouting newsboy in Oertel's print.

Each broad cultural, political, economic, and technological change and each discrete event brought together in *The Newsboy* contributed to and reinforced this sense of a world racing toward some unspecified "great result." Yet some of Spencer's contemporaries, while sharing this general urgency, might have had more specific visions of the approaching future, more concrete understandings of what, indeed, was coming.

Some in Spencer's audience, even after considering *The Newsboy's* image of an imperfect present, might yet have asserted that "there's a good time coming," echoing the refrain of one of the most popular and ubiquitous songs of the 1840s and 1850s:

> There's a good time coming, boys,
> A good time coming:
> We may not live to see the day,
> But earth shall glisten in the ray
> Of the good time coming.[101]

Charles Mackay, the Scottish poet who wrote "The Good Time Coming," envisioned a time when war, religious hostilities, poverty, greed, and intemperance had disappeared. "The phrase [there's a good time coming] and the tune . . . drove every other musical pest out of the streets," he recalled; "Nothing was heard for many months but that eternal refrain." "The Good Time Coming" was, according to poet and reformer John Greenleaf Whittier, "the music of the march of Human Progress," and its optimistic promise quickly entered contemporary American usage.[102]

To some Americans, change meant progress and progress meant improvement; the terminus at the end of the railway journey would be a better world. To true believers in the doctrine of progress, humanity moved on an upward path through history, each successive age more enlightened than the one before. The diffusion of political, social, and religious knowledge, which resulted in large part from the harnessing of steam in engines and printing presses and from the telegraph—all technologies united within the newspaper—was, to many observers, the most important indication of this coming "good time."

Although some Americans looked upon developments in science and technology, mass transportation, and communication with skepticism and even disapproval, devout postmillennialists heralded them as among the most potent signs of an approaching millennium.[103] "The Newspaper Press," an article published in the *Independent* in December 1848, posits a relationship between such technology and apocalyptic scripture:

When it was announced to Daniel that many should run to and fro, and knowledge should be increased, we do not suppose the finger of prophetic inspiration pointed to Cunard steamers, to Morse's telegraph, to Whitney's railroad, or to Hoe's patent steampress.

. . . Yet the common interpretation of this prediction, that which makes it teach that at some future period the facilities for the general diffusion of knowledge shall be greatly multiplied is . . . admissible. . . . Upon this interpretation, all those inventions and improvements of our own time, which facilitate the diffusion of knowledge, fall within the general scope of this prediction.[104]

The author refers here to Daniel 12:2–3, which treats the great tribulation preceding the end of time and the general resurrection. In the Book of Daniel, knowledge specifically means the revelation of apocalyptic history. The prophet is admonished to "shut up the words, and seal the book, until the end of time. Many shall run to and fro and knowledge shall increase" (Dn. 12:4).

An even bolder and more specific apocalyptic claim is put forward in the article "The Approach of the Millennium as Argued from the Signs of the Times," published in June 1848. According to its author, Daniel's book is indeed opening and the latter days are at hand:

The Scriptures seem to teach that previous to the dawn of the Millennium "knowledge will be increased." "Many will run to and fro," and a wonderful degree of mental culture attained. . . . We argue that the general diffusion of knowledge peculiar to our times, is an indication of the speedy establishment of holiness on earth . . . the distant parts of the earth are brought nearer together.[105]

The technological collapsing of space and time afforded by such inventions as the telegraph, the train, the steam engine, and the steam press was millennially significant because it afforded the widespread transmission of knowledge through mass circulation newspapers and other inexpensive publications. And, some argued, a free press served the same exhortative function for the modern world as prophecy did for the ancient. "Liberty of Prophesying was to Israel very much what Liberty of the Press is to us," the author of an article published in the *Nineteenth Century* claimed in 1849.

There could be no stagnation in the national mind, no permanent unrebuked perversion of the national institutions, so long as any man . . . was free to come forward and speak out. . . . The prophetic institution would give definiteness, body, consistency, to those vague conceptions of the millennium.[106]

A free press in the form of cheap and accessible newspapers was considered, then, the most important prerequisite for a righteous nation and a flourishing democracy.[107] And such a vigorous and just democracy was as essential to the destiny of all humanity as it was to the United States. "In Democracy," a commentator noted in 1851,

we see the hope of the world. . . .This will be but the beginning, as the great secular agent of Christianity in bettering man's earthly estate. . . . It will "break every oppressor's rod." . . . Nor are these . . . the mere phantasies of the dreaming visionary, the distinct

utterances of Holy Writ . . . all point to a coming "Golden Age," to a second and still brighter Eden on earth.[108]

Even Oertel's seemingly critical image indicates signs of positive intellectual and social change from the past to the present and, by implication, into the future. In the far left of the composition, a trophy composed of medieval weapons of war forms a border to the ostensibly serene and rural "things as they were." In contrast, the trophy that forms the border to "things as they are" consists of a liberty cap encircled by a laurel wreath and placed on top of a flag-draped pole. The age of railroads, steamships, and, above all, newspapers was also, it seems, the age of democracy and liberty. In this context, Spencer's newsboy could have been perceived as a sign of advancement and a promise of better things to come.

Hand in hand with democracy—in fact, walking slightly ahead but still linked— was envisioned the onward march of the Christian gospel. The press, in cooperation with the railroad, telegraph, and steamship, facilitated the spread of universal Protestantism, which most Americans believed to be the surest and most direct road to the millennium.[109] The role of missionary activity in the fulfillment of millennial expectation is made clear, for example, in a print entitled *The Harmony of Christian Love; Representing the Dawn of the Millennium* (fig. 20), which was designed by the Philadelphia engraver John Sartain and published for the American Home Missionary Society in 1849.[110]

The image depicts a group of Protestant clergymen amicably gathered in a semicircle around an open Bible; the variety of denominations they represent is an obvious call for nonsectarianism. A light-filled break in the dark clouds above bathes them in its radiance; a dove hovers within. A black man, his eyes heavenward and his arms outstretched toward the light, kneels in the middle foreground in a posture of servitude tempered by the potential of an upright stance. In the left of the composition, an American Indian drops his weapons and stands transfixed by the luminous vision. To the right, behind a palm tree and separated somewhat by an implication of intervening time and space, hordes of turbaned Moslems gaze in the direction of the light while a dark-haired woman at their head clasps her hands in prayer. A young child sits in the left foreground, its arms embracing a lion and a lamb symbolizing Isaiah's prophecy of peace. A broken sword, a broken spear, and a plowshare lie nearby.

The conflation of space (Western oak meets Eastern palm, Indian moves toward Moslem) and of time (some of the ministers are in the garb of colonial divines and some are in nineteenth-century dress) accentuates the visionary quality of the print and the spiritual metamorphosis that, it posits, would be necessary to transform earthly existence. The slave would be freed, the heathen converted, and ultimate peace ensue when all have been reborn in the harmonious light of the Christian—specifically Protestant—gospel.[111]

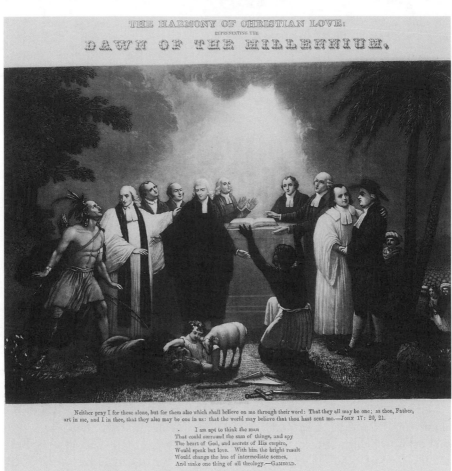

THE HARMONY OF CHRISTIAN LOVE:
REPRESENTING THE
DAWN OF THE MILLENNIUM.

Neither pray I for these alone, but for them also which shall believe on me through their word: That they all may be one; as thou, Father,
art in me, and I in thee, that they also may be one in us: that the world may believe that thou hast sent me.—JOHN 17: 20, 21.

I am apt to think the man
That could surround the sum of things, and spy
The heart of God, and secrets of His empire,
Would speak but love. With him the bright result
Would change the hue of intermediate scenes,
And make one thing of all theology.—GAMBOLD.

☞ DEVOTED TO THE HOME MISSIONARY CAUSE.

Entered according to Act of Congress, in the year 1849, by J. Sartain, in the Clerk's Office, of the District Court, for the Eastern District of Pennsylvania

FIG. 20. John Sartain, *The Harmony of Christian Love: Representing the Dawn of the Millennium*, 1849;
engraving, published for the American Home Missionary Society. The Library of Congress.

Protestant postmillennialism was, of course, a fundamental source and continu-
ing support for the intertwined doctrines of reform and progress. But it was also
a source for those who worried as much about violent conflict as peaceful reso-
lution. For some people steeped in the narrative logic of apocalyptic history,
Mackay's "good time" was less compelling than the violent engagement of good
against evil and evil's ultimate defeat and punishment, which would necessarily
precede it. Some anticipated a future in which the type of conflicts and tensions
explored in *The Newsboy* would grow stronger, more violent, and more explo-
sive before any resolution was to be had. To this view, time's railroad was and
would continue to be littered with the burning hulks of innumerable wrecked
trains.

Some of Spencer's contemporaries, then, might have assigned meaning to his ambiguous phrase in very different terms than a far-off "good time," yet still have remained within a general apocalyptic framework. In fact, a verse from another contemporary song, "The Boys of the Bowery Pit" (sung to the tune of "The Newsboys"), refers explicitly to the violent and retributive aspects of this framework, while warning of their imminent arrival:

> But presently the Actors are seen looking at the wings,
> As if they were watching for Somebody or Somethings,
> The Gallus Boys are Wide-Awake,they know what's coming now—
> For J. R. Scott is coming, and then there's such a Row.[112]

Admittedly, these lines are scarcely intelligible to modern readers, yet even we can recognize their obvious affinity to Spencer's "SOMETHING COMEING."[113] Who was this Somebody—"J. R. Scott"—and what was this Something—"such a Row"—that the Bowery boys so eagerly anticipated? To make sense of the verse and to understand its relationship to *The Newsboy* and the painting's broader context, we must return to the world of those audiences "who nightly fill[ed] the pits of the the Bowery and the Chatham, to witness their performances of highly wrought melodramas."[114]

The "highly wrought melodramas" that were the speciality of the working-class Bowery and Chatham theaters have been identified by Bruce McConachie as "apocalyptic" in their structure, thematic emphasis, and emotional effect. Such apocalyptic melodrama shared features of plot and characterization with other melodramas of the Jacksonian period. They all began with a vision of harmony and happiness disrupted by a villain's machinations. They ended with the "banishment of evil and the restoration and transcendental elevation of the initial vision."[115] Action was driven by a sharply delineated struggle between good and evil, characterization was limited to elemental moral types, and dialogue was generic and hyperbolic.

Apocalyptic melodrama, however, was distinguished by its "reliance on extravagant scenic spectacle, . . . [its] focus on the righteous quest of an Avenger, its depiction of good and evil ritual activities, and especially its climactic scene of catastrophic final judgment." These features, not specific subject matter, characterized apocalyptic melodrama, which could depict the wild West, piracy on the high seas, or the Protestant Reformation in France.

According to McConachie, apocalyptic melodramas like *The Last Days of Pompeii* or *Nick of the Woods* appealed to a working-class audience increasingly affected by the forces of market capitalism and frustrated by what its members perceived as a decline in their economic and social status.[116] They were not, generally speaking, those people who would have wholeheartedly joined with Whittier in a chorus of "The Good Time Coming."

Apocalyptic melodrama not only provided a means of release for its audience's frustration, McConachie explains, but also "helped to shape and to

reinforce the symbolic universe" of many a discontented young worker. It assuaged "his nagging fears about status and exploitation through plays containing potent metaphors of the evil he perceived, the vengeance he longed to express, and the final justice he hoped to witness." The Astor Place riot, McConachie argues, like most preindustrial urban riots, "mirrored the essential structural elements of apocalyptic melodrama," with hatred focused on the villain Macready and hope on the avenger Forrest.[117]

"The Boys of the Bowery Pit" was not, of course, written with Forrest and the Astor Place riot in mind. John R. Scott was another popular Bowery actor who, like Forrest, specialized in avenger roles. But the song acknowledges the general fascination with apocalyptic melodrama and, more important, with the symbolic universe it envisioned, which gripped working-class audiences in the 1830s and 1840s. Anticipation is high—everyone in the theater, from the actors on the stage to the b'hoys in the audience, know that "Somebody or Something" is "coming now." The somebody is J. R. Scott the avenger, and the something is the "Row"—the ferocious spectacle of apocalyptic retribution made possible by the magic of gaslight, carpentry, and paint—which he, as conduit of divine vengeance, calls down upon guilty and innocent alike.

Despite the obviously secular environment in which it appeared, McConachie argues, apocalyptic melodrama had a powerfully religious appeal to its working-class audiences. Its plays "mobilized fears and raised expectations that were . . . forthrightly religious," he explains, "Their edge-of-seat, apocalyptic climax, especially, warned their spectators to look to their souls and prepare for God's wrath."[118]

In a context and for an audience far removed from the rowdy pit of a Bowery theater, the *Odd-Fellows' Offering, for 1849* contained an image that also would have reminded its viewers to consider their fates. The *Offering*, a genteel annual intended for holiday giving and available to the public by the end of 1848, included a wood engraving depicting a macabre skull-faced figure hurling destruction at architectural symbols of lost empire (fig. 21). He is Apollyon, the Angel of Destruction described in Revelation 60:11—the ultimate avenger exulting in the final row. A fitting reminder of "dread Forty-eight" and an apt emblem for the newly born 1849, its unidentified designer (in all likelihood Benson John Lossing)[119] obviously modeled the apocalyptic rider on Benjamin West's well-known *Death on a Pale Horse.*

Apollyon gallops astride a wild-eyed, smoke-snorting horse through a sky black with billowing clouds. A ship struck by one of his lightning bolts sinks behind him; beneath him flames consume a world turned upside down. Two Egyptian pyramids flank the Roman Colosseum in the center of the inferno; to their right, post-and-lintel structures suggest the Ancient Near East and Greece. On the far left, a dome and spire call to mind the architecture of Catholicism.

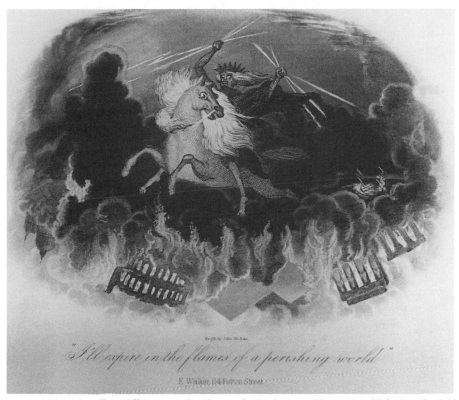

FIG. 21. Anon., "Apollyon (I'll Expire in the Flames of a Perishing World)," 1848; published in *The Odd-Fellows' Offering, for 1849*, 1848. The Library of Congress.

A poem, "Apollyon: or, The Destroyer" by James Linen (dated New York, May 1848), accompanied this terrifying vision:

> Lo! Man shuddered and trembled when Sin gave me birth,
> And Omnipotence crowned me dark lord of the earth;
> In my right hand he placed a dread sceptre to wave
> O'er his creatures, all guilty, and doomed to the grave.
> Unseen as the whirlwinds that freely pass over
> Wild regions that wisdom has yet to discover,
> I sweep through the bounds of all peopled creation,
> Jehovah's grand agent of dire desolation.

In stanza after stanza, the gloating and bloodthirsty Apollyon, spawn of sin and father of murder, describes his victory over all the nations and empires of the earth—Egypt, Babylon, Nineveh, Persia, Greece, Rome—and all the people—princes, peasants, slaves, masters, lovers, maidens, mothers, children, misers, drunkards, heroes—which fall helplessly before his storms, pestilences, volcanoes, and fires. And they continue to fall:

> Ever onward in triumph my course I shall speed,
> Through the mazes of times, on my lightning-winged steed,
> And when the systems and suns from their sphere shall be hurled
> I'll expire in the flames of a perishing world.

The image of Apollyon and this bleak poem, with their visions of sinful humanity helpless before Jehovah's wrath, doomed to annihilation amid the ultimate destruction of the natural world, did not appear in a premillennialist or Adventist publication. The International Order of Odd-Fellows and such members as Lossing were staunchly reform-minded postmillennialists who acknowledged the necessity of human endeavor as well as the power of the Almighty.[120]

This engraving and poem are, in fact, rare examples of Odd-Fellow giftbook pieces that do not discern a millennial promise in the embers of God's wrath, and they speak volumes about the mood of their moment. By the end of 1848, the blood of revolution, war, famine, and pestilence and the dangers of unbridled greed reminded the devout of all Protestant persuasions that the end of the world—no matter where one placed the millennium—would be heralded by cataclysms on a cosmic scale affecting all people and all nations.

Even those Americans who did join the chorus of "The Good Time Coming" must have understood its implications of providential design, although in the song they concentrated on the ameliorating effects of divine love and human perfectibility rather than on the terrifying experience of divine anger. Indeed, Mackay's "Good Time" was as far from the "Row" promised in "The Boys of the Bowery Pit" as the *Harmony of Christian Love: The Dawn of the Millennium* was from the approach of Apollyon: that is, they were two sides of the same coin.

Almost completely obscured beneath the notice of the Astor Place riot in *The Newsboy* is a poster for the Broadway Tabernacle, as respectable a venue as could be found in midcentury New York. There, on 29 April 1849, interested listeners could have heard the Reverend Joseph P. Thompson reflect on the subject of "Ancient Nineveh, a Lecture suggested by the recent discovery of the ruins of that city."[121] Thompson's lecture and its setting were genteel, edifying, and educational Broadway counterparts to the rowdy working-class atmosphere and the cathartic apocalyptic melodramas produced at Bowery theaters.

Henry Austen Layard, a British archaeologist who had been excavating the site of what he believed to be the ancient city of Nineveh since 1845, published his findings in the immensely popular *Nineveh and Its Remains*. "In these days when the fulfillment of prophecy is engaging so much attention," a reviewer for the London *Times* observed in February 1849, "the work of Mr. Layard will be found to afford many extraordinary proofs of the truth of biblical history."[122] Americans were among Layard's most avid admirers; his close friend the American painter Miner Kellogg noted his countrymen's "deep interest in your discoveries."[123]

Thompson, an antislavery Congregationalist minister in charge of the Tabernacle and one of the chief editorial writers for the *Independent*, acknowledged the historical interest of Layard's discoveries. But, he explained, "it is not to gratify literary taste or curiosity . . . that I introduce this theme into the pulpit."[124] The ruins of Nineveh, ancient relics of a powerful Assyrian empire, Thompson explained, were reminders of how far the human race had progressed in knowledge, freedom, and happiness, and they documented the progressively diminishing power of absolute rulers and the incremental elevation of the masses. "We wait for a time when we shall witness the full application of the spirit of Christianity to the social and economical condition of men," Thompson prophesied. "We wait for the time when brutality and sensuality, as characterized [in the ruins of Nineveh] shall have utterly faded away, and men shall wear the aspect of love."

Besides serving as progressive millennial harbingers, Thompson explained, the ruins provided objective verification of biblical truth, particularly the reality and the omnipotence of divine judgment. Events and people reported in the historical and prophetic books of the Bible were now subject to the scientific scrutiny of an empirical modern age. The uncovering of the remains of Nineveh gave the apocalyptic prophecies of Jeremiah, Ezekiel, Hosea, Micah, Nahum, and Isaiah unimpeachable support.

Such confirmation could only strengthen the conviction that, as Thompson explained,

the favor of God is necessary to national prosperity. There *is* such a Providence in the government of this world. . . . Nineveh has gone; Babylon has gone; Tyre has gone; Thebes has gone; the Assyrian Empire has gone; the old Mede-Persian Empire has gone; the Grecian Empire has gone; the Roman Empire has gone; and Jerusalem . . . has also gone.

Thompson's litany recalls the burning emblems of ancient and modern civilizations visualized in the Odd-Fellows' print of *Apollyon*. Thompson presented his audience with an awful question "shall the nation prosper that forgets God?" — and asked them to remember that "these monuments of the dim Past [warn] you lest you forsake God and perish also."

Such a question might very well have troubled Spencer months before he completed his *Newsboy*. As a member of the hanging committee for the twenty-fourth annual exhibition in March 1849, Spencer helped to place Frederic Church's *Plague of Darkness* on the walls of the gallery. A violent spectacle of divine retribution, the painting, like the print *Apollyon* and Thompson's sermon, suggested that "high-brow" audiences had their own need for the symbolic universe and the emotional release of apocalyptic melodrama. (Church's painting is now represented only by a preparatory drawing for the figure of Moses [fig 22].)

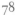
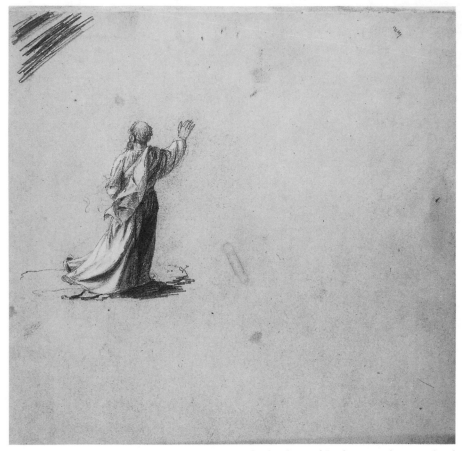

FIG. 22. Frederic Edwin Church, *Moses, Figure Study for the Plague of Darkness*, ca. 1849; pencil and white chalk on paper, 7¼" × 7¼". New York State Office of Parks, Recreation and Historic Preservation, Olana State Historic Site.

In fact, alert visitors to the twenty-fourth annual exhibition would have seen, scattered among the landscapes, portraits, fancy pieces, and genre scenes, additional evidence that Apollyon was galloping through the devastated landscape of a perishing world. Several works other than Church's *Plague of Darkness* presented the pitiful helplessness of humanity in the face of providence's retributive thunderbolts, indicating that to some antebellum Americans the patriarchal Old Testament rod of punishment had not been abandoned—and would not be spared.

John Carlin's *The Destruction of Pompeii* (unlocated) probably focused, like contemporary apocalyptic melodrama, on a chaotic scene of universal destruction, imagining the earthly perspective of helpless sinners enveloped in a hellish chaos of darkness and heat, rather than the superintending vantage point of

Church's Moses.[125] Charles Deas—an artist known then as now for his often violent images of western life—contributed *A Vision* (unlocated), described as a horrific evocation of Death and Despair, with red-eyed sufferers struggling in the embrace of fanged serpents.[126] And the leper colony depicted in Paul Peter Duggan's *Lazar House in the Tropics* (fig. 23) gained religious and specifically apocalyptic implications through the lines from *Paradise Lost* that accompanied it in the exhibition catalogue.[127]

Disparate as they were in subject, the paintings exhibited at the twenty-fourth exhibition by Church, Carlin, Deas, and Duggan were united by common themes of guilt, retribution, and human suffering. To one degree or another, they taught the lesson that all people—each individual and all nations—bore responsibility for their actions, would be held accountable for their sins, and would ultimately fall victim to Apollyon's lightning bolts. Yet, in June of that same year, Junius Brutus Stearns presented his *Millennium*, a transcription of Isaiah's redemptive prophecy of the "good time," to the National Academy where Spencer, as a member of the council, must have seen it (pl. 2). As in *The Harmony of Christian Love: The Dawn of the Millennium*, Stearns's vision posited the transformation of human existence through the progress of Christian love.

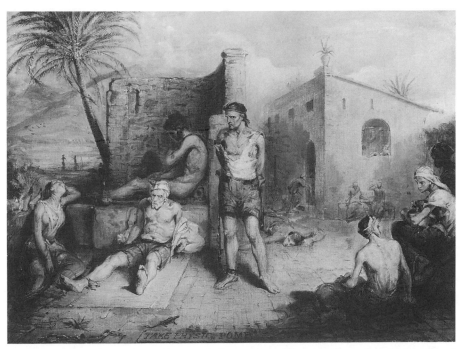

FIG. 23. Paul Peter Duggan, *Lazar House in the Tropics*, 1849; oil/canvas, 18" × 24½". National Academy of Design, New York City.

The Newsboy, like "The Good Time Coming" and "The Boys of the Bowery Pit," is undeniably secular and might seem to have little to do with these biblical and allegorical paintings, or with Thompson's sermon on the ruins of Nineveh. Yet all three secular expressions partake of a common language, which, in its vocabulary, syntax, and narrative purpose, serves as a springboard into the cosmic realms denoted by their religious counterparts. Spencer's *The Newsboy*—no less than Church's *Plague of Darkness* or Stearns's *Millennium*—presents a society that, by the waning months of 1849, found itself poised at the edge of apocalypse, nervously anticipating "something comeing." Was it the "Good Time" or the "Row" that approached?

1848/1849: Thomas P. Rossiter, *Miriam Rejoicing* and *The Return of the Dove to the Ark*

Frederic Church's Plague of Darkness was not the first ambitious painting chronicling the Israelites' liberation from Egyptian bondage to be displayed in early 1849. By January 13, Thomas Pritchard Rossiter had "just finished a large picture representing miriam springing to the summit of a promontory, to 'sound the loud timbrel o'er Egypt's dark sea.'"1 In Miriam the Prophetess (Miriam Rejoicing over the Destruction of Pharaoh's Host) the sister of Moses and Aaron leads the Israelite women in celebratory song as the Egyptian army drowns in the Red Sea below. The seven-by-nine-foot painting was the second in a pair of Old Testament subjects Rossiter designed specifically for traveling exhibition; it joined his Return of the Dove to the Ark (The Triumph of Faith), which had already been shown in the artist's New York studio that fall and was in Philadelphia by December 1848.2

All that remains of *Miriam* other than written descriptions is a small engraving of the same subject which appeared in *The Women of the Scriptures* (fig. 24), a giftbook edited by Episcopal minister Horatio Hastings Weld and available to the public by November 1848.3 A published description of the painting indicates that Rossiter used this print as its model:

The prophetess is . . . rushing to the height of a cliff which overlooks the engulfed [sic] host struggling in the waters below, and raising her timbrel in triumph. Another Judean maid is half prostrate before her, looking over the edge of the cliff; and in the background, rises another eminence, occupied by a group which is shadowed forth by the "pillar of cloud by day."4

The artist was able to include more narrative detail in the painting, however, adding a recognizable group of figures on what is visible in the engraving only as a distant pair of peaks. According to Rossiter, this group was formed by "Moses and Aaron, the former stretching his rod over the sea."5 The painting's expanded scope included Moses's active agency as well as Egyptian powerlessness and Miriam's reactive celebration. (Rossiter's *Opening of the Wilderness* [pl. 3] although painted nearly a decade later, might suggest how the artist manipulated

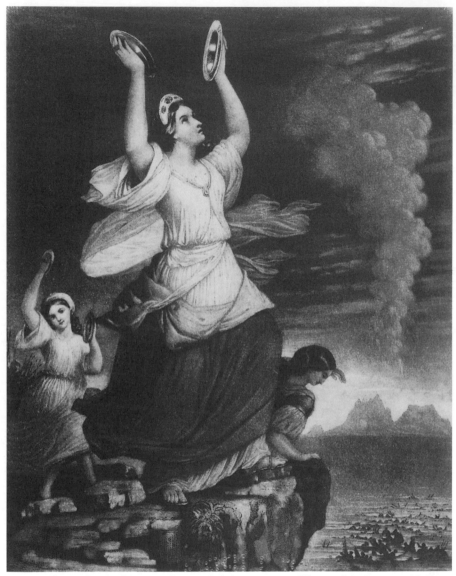

FIG. 24. Thomas Pritchard Rossiter, "Miriam," 1848, engraving in *Women of the Scriptures* (1848), related to unlocated painting *Miriam Rejoicing over the Destruction of Pharoah's Host*, 1848/1849. Education, Philosophy and Religion Department, The Free Library of Philadelphia.

light interacting with vaporous plumes in the earlier biblical image, and perhaps an echo of Miriam appears in the figure of Terpsichore in Rossiter's *Muses and Graces* [1859], pl. 4.)[6]

Although Rossiter produced eleven illustrations for *The Women of the Scriptures*, Miriam was the only one of its subjects he subsequently expanded into an

ambitious exhibition piece. The artist might have been guided in this decision by an understanding that, of all the episodes in biblical history presented as lessons to the nation, few were more compelling to mid-nineteenth-century Americans than the intertwined destinies of Egypt and Israel. The Hebrew Commonwealth established by Moses through the will of providence had long served as historic antecedent and symbolic prototype of the American republic.

The particular relevance of such national identification was evident in a series of lectures concerning "Moses's strong attachment to a republic and his settled aversion to tyranny," presented in the summer of 1848.[7] The second lecture closed with a fantasy of the ancient patriarch visiting an assembly of present-day Americans. The venerable prophet "boldly recount[ed] his labors and achievements as the inspired lawgiver" and then charged his listeners with a weighty mission:

While conquest and servitude, boundless luxury and oppression were the order of the day with the nations around me, I was enabled to establish freedom and secure unbounded prosperity upon the ruins of such evil – cling to these principles which I first established and gave form, and which you have adopted, and give them to the world, and the happy result shall outstrip your fondest hopes.

This imagined charge to the American people conveys the depth of national vanity at a time when much of Europe was in turmoil. Yet "Moses's" words also contain a veiled but insistent warning to a slaveholding nation recently victorious in a war of expansion and, some would say, in thrall to Mammon.

The story of Exodus is rich in vivid examples of the consequences of disobeying divine injunction; in his *Plague of Darkness*, Church chose to illustrate the ninth visitation sent by God to convince a stubborn Pharaoh to free the Israelites from bondage.[8] According to the *Bulletin of the American Art-Union*, Church's *Plague of Darkness* was remarkable in its grandeur of effect, its originality of design, and, especially, its treatment of a sky heavy with "supernatural darkness" yet touched by "last lingering rays of light."[9]

The *Albion*, however, called Church's painting a "hodge-podge . . . reminiscence of Martin and Danby"[10] and, judging from the *Bulletin*'s description, Martin's cataclysmic dramas, such as *The Seventh Plague of Egypt* (1823; fig. 25) provided the low horizon, the "long lines of massive architecture," and the foreground eminence on which "the Great Law-giver" stood, not to mention the sublime lighting effects. And, although Church's Martin-inspired version would have inverted the proportion of figure to landscape, John Gadsby Chapman's "The Plague of Darkness" (fig. 26) can also help approximate the theme and mood of the lost painting. Published in *The Opal* for 1846, Chapman's engraving shared with Church's painting a low horizon, a row of architecture establish-

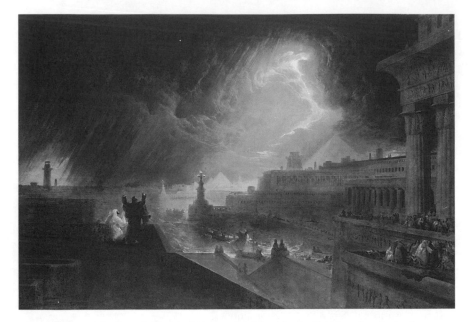

FIG. 25. 60.1157, *The Seventh Plague of Egypt*, 1823, John Martin (British, 1789–1854); oil on canvas, 144.1 × 214.0 cm (56¹⁵⁄₁₆" × 84⅛"). Museum of Fine Arts, Boston, Francis Welch Fund.

ing depth and scale, the dramatic contrast of dark clouds with a remnant of clear sky, and the robed figure of Moses dominating a foreground crag.

American clergymen often used the plague of darkness visited upon Egypt as a metaphor for individual states of spiritual blindness and confusion. Yet "we who interpret scripture so literally . . . are apt to apply [biblical passages] to those great evils and enormities, that seem almost coeval with the human race," a Brooklyn minister observed in an essay accompanying Chapman's "Plague of Darkness." "Reformers at different eras apply themselves to one of the many abuses of life and have a right to that use of texts which will best illustrate their position."[11]

The Egyptians called down the wrath of the Almighty, this minister explained, by misusing royal prerogative and creating a system of slavery. Such evil could not last forever. "Sooner or later are all violations of the great laws of human justice met with that retribution to be expected from the very nature of things." The Egyptian plagues, with Moses as conduit of divine anger and liberator of an oppressed people, were potent and recognizable symbols of providential vengeance against an oppressive and heretical monarchy.

In 1848 and 1849, the overturning and casting down of European thrones were the most obvious signs of God's judgment on sinful despots. Many American ministers and religious journalists who sermonized on the European revolutions

identified the political and social sins that had called down divine retribution. To some Americans, for example, Louis Philippe engineered his own downfall by disregarding Christian doctrine and human liberty, mistreating his subjects and consigning them to poverty and ignorance. In his case, providential judgment came not in the form of plagues, famine, flood, or war, but as a terrifying new social force—communism.[12]

Church's *Plague of Darkness* delineated the ninth chastisement brought upon Pharaoh and his people for their disregard of God's law.[13] But, as Odd-Fellow essayist Benson Lossing noted, the Egyptians forgot "the late terrible visitations of offended Deity," feasting and reveling until "a pestilence smote all the first-born in the land of Egypt."[14] This last and most terrible plague convinced Pharaoh to liberate the Israelites. Yet the tyrant soon regretted his decision, pursuing Moses and his people as they fled into the wilderness towards the Red Sea. With Pharaoh and his soldiers closing in and defeat imminent, Moses invoked faith in the Lord's salvation. He raised his rod, the waters parted, and the people of Israel emerged unscathed as Pharaoh's army drowned in the surging waters.

Rossiter chose to illustrate that moment in the narrative "when the last of the Israelites have reached the eastern shore of the Red Sea" and are "witnessing the destruction of the Egyptian host" in his painting of Miriam.[15] The prophetess, having caught the refrain of her brother Moses's triumphal song, leads the Israelite women in a celebration of their deliverance.[16] The encapsulation of redemption within destruction is fundamental to the subject's apocalyptic meaning; it

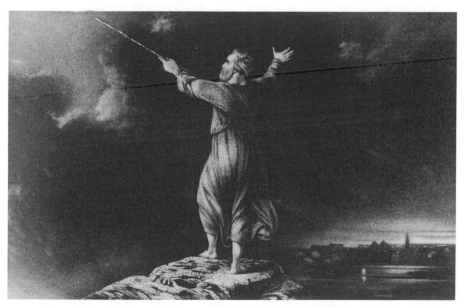

FIG. 26. John Gadsby Chapman, "Plague of Darkness," 1846; engraving published in *The Opal for 1846*. Private Collection.

is a moment of extreme transformation and transition, a revelation of what is to be history's culmination, as a new order arises from the grave of the old.[17]

Edward Beecher, a liberal Congregationalist minister, discussed such implications of the subject in an article published in 1847. "Not only is it a scene of national redemption and of judgment on a haughty human foe of God," he explained, "but a bright foreshadowing of the future destinies of the universe."[18] The pillar of cloud that rises in the right side of Rossiter's engraving indicates the still-continuing movement forward in time, foreshadowing a promised land yet to be attained. According to Beecher, an advocate of the complete reconstruction of society through the ideals of righteous living, brotherly love, and personal consecration, "the main end of these terrific events was not wrath, but redemption of the people of God, and good-will towards man."

The sequential arrangement of two natural conditions—calm after storm, light after darkness—indicates historical as well as religious and natural process and change. The image of light breaking through dark clouds, used repeatedly in both literary and artistic expressions of progressive faith, indicated an enlightened age emerging from past ignorance and wrong as well as a lost soul experiencing spiritual conversion. The sublime in nature also served as an emblem of divine justice, which purified and chastened humanity in order to make it worthy and receptive of God's mercy. Rossiter employed such natural symbols, including a "waste of waters" at the foot of "the remote peaks" of Egyptian mountains and, most important, "a zenith sun: which marks "the hour of triumph" and "pours a flood of light over the vanquished and the saved."[19]

In Rossiter's painting, Miriam supplants Moses, who is relegated to the rear, on the typical foregrounded prophetic outcropping. Rossiter cannot dismiss the importance of Moses, the agent whose upraised arms calls down the wrath of heaven, living embodiment of the power of a patriarchal Old Testament God. Yet Miriam's feminized and more purely human function interests him more. Reacting in joy to events she is powerless to control, her arms extend from earth to heaven in an exuberant dance of released tension.

Rossiter's Miriam is clearly a sister to Washington Allston's *Miriam the Prophetess Singing Her Song of Triumph on the Destruction of Pharaoh and His Host in the Red Sea* (1821; fig. 27). Rossiter must have been familiar with the works of America's best-known and revered artist of poetic and prophetic images as he embarked on his own career as scriptural painter.[20] Both depictions of Miriam share a low perspective, which forces viewers to gaze upward at the isolated central figure of the prophetess, who, with upturned eyes and gesture, directs attention toward a dramatically lit sky. In both images, the swells of the Red Sea and the drowned soldiers are dwarfed by Miriam's overwhelming presence and by the divine immanence surrounding her.

According to David Bjelajac, Allston's *Miriam* was an attempt by the artist to translate into visual terms the religious feelings inspired by sacred music, in keeping with a new emphasis even among more conservative Protestants on

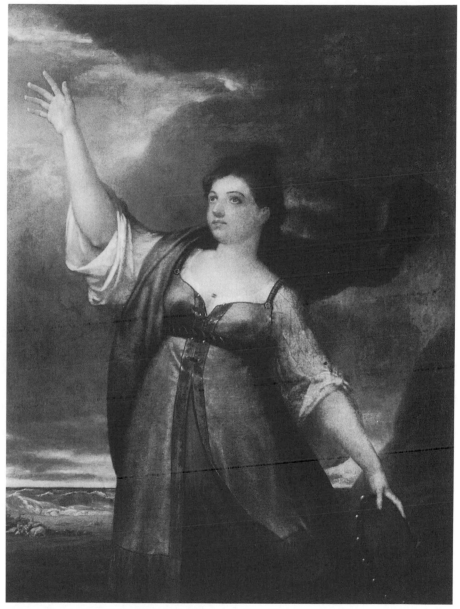

FIG. 27. Washington Allston, *Miriam the Prophetess*, 1821; oil/canvas, 72" × 48". The Farnsworth Art Museum, Rockland, Maine.

emotional expressions of faith.[21] The painting was "conceived not only as a frozen oratorio but as an icon of sacred music, of congregational hymn singing and worship," intended to unite its audience as if their individual voices and spirits were joined in sacred song.[22]

Perhaps Rossiter, too, aimed to unite the arts of music, poetry, and painting in a represented act of worshipful song, and to encourage a subjective reaction in members of his audience. After all, as an observer noted in January 1848, it was "the high mission of [pictures] to wake feelings that words cannot reach."[23] One observer described how the figure of Miriam literally animated the familiar biblical words, conveying them so powerfully that image and text became inseparable: "The prophetess gives vent to her feelings of exultation in an ecstasy of rejoicing: her attitude, upraised arms clashing the cymbals; her excited features, eyes, and frenzied action, breathe inspiration. One reads on the canvas, almost as if in characters, the sacred writings."[24]

Yet Rossiter's depiction of the prophetess included more narrative details than Allston's, such as the distinct pillar of cloud that serves as a literal sign of God's presence and of his promise for the future. Miriam's context is also broadened by the other figures in the scene, including the two Judean maids—one directing attention toward the vanquished Egyptians, the other echoing and reinforcing Miriam's exuberance—and (in the painting), Moses and Aaron on the distant peak. In Rossiter's version, Miriam's mouth is slightly open, as if physically forming notes and words, while that of Allston's prophetess is firmly shut, indicating the spiritual and immaterial nature of her sacred voice.[25]

Rossiter apparently offered his viewers more concrete, if imagined, evidence of biblical "truth" than Allston, reminding them of the significance of this episode in the panorama of history. Rossiter's interpretation, in that regard, was closer to John Martin's *Pharaoh's Host Drowned by the Red Sea*, reproduced here from an engraving in *The Odd-Fellows' Offering, for 1850* (fig. 28), than to Allston's version. Martin literally gives center stage to Moses, with little attention directed to Miriam and her maidens, who appear to be the small, dancing figures in the middleground. Rossiter obviously reverses the emphasis, according their expression of faith and thanksgiving a pivotal role in the grand scheme of providential history and its fulfillment.

By selecting Miriam and her maidens as his primary narrative and symbolic vehicles, Rossiter argued for the importance of woman's leadership in the spiritual development of the nation at a time when such feminine agency was the subject of growing debate.[26] The painting makes a claim for woman's innate spiritual sensitivity as well as her active role in the progress of human destiny. Rossiter removed the subject from the domestic environment of a private giftbook, enlarged in scope as well as size, and sent it into the public world of commercial exhibition.

In an essay in his *Women of the Scriptures*, H. H. Weld argued for the respect due to woman and her sacred role. Woman's quick, intuitive, and affectionate ability to discern the truth should be admired and heeded, not despised and belittled. While it was true that male and female held properly to their different spheres, both fulfilled God-given duties and responsibilities of equal importance. And, Weld argued, women held a special place not just in the home, but

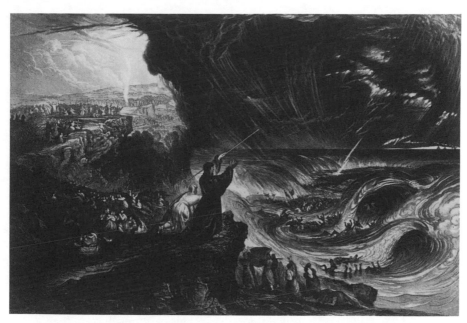

FIG. 28. After John Martin, "Pharaoh's Host Drowned in the Red Sea," 1848; engraving published in *The Odd-Fellows' Offering, for 1850*. The Library of Congress.

also in the course of sacred history. "Woman does not appear in the narrative as the mere adjunct and domestic satellite of man. Nor is her history an episode in his. . . . She acts with him and upon him—his active partner and joint actor."[27]

Woman's significant and active—albeit secondary—participation in biblical history was emphasized also by Clara Lucas Balfour in her essay "Miriam," which accompanied Rossiter's engraving in *The Women of the Scriptures*. Balfour noted that although Moses was the first to compose a "noble song" in celebration of his triumph over the Egyptians,

the second poetic composition on record was inspired by the genius, and uttered by the lip, of woman. . . . the deep spiritual aspirations and glowing enthusiasm of her fervid nature, sprang up in exulting thanksgivings to her deliverer God, not as a mere trembling woman rejoicing in individual or relative safety, but as a rapturous adoring saint, recognizing the Lord's hand, and pouring out her full heart to him.[28]

Such a paradigm of female heroic enthusiasm, of a completely engaged and unselfconscious prophetic and poetic genius must surely have been the note Rossiter hoped to sound in his monumental depiction of Miriam.

His *Babylonian Captivity*, a third apocalyptic scriptural painting, which Rossiter completed by 1853, also gave women a significant visionary and specifically millennial role. In a complex multifigured composition dominated by the prophet Jeremiah, only one figure—a woman—noticed that the prophet Daniel

was called away to read the handwriting on Belshazzar's wall, and she was able to recognize his departure as a hopeful sign. This woman, dressed in crimson and blue—the "family colors of the Virgin, indicating a progenitor of Christ"— served as a link in the "chain to the fulfillment of the many prophecies for the coming well-being of her nation."[29]

The double-edged appreciation of woman's place evident in Weld and Balfour and in Rossiter's images certainly reinforced the "separate sphere" ideology, which attempted to limit the range of antebellum American women's social, intellectual, and political activity. Yet their emphasis on the fundamental worth of "feminine" sensibilities and on woman's individual, active agency in events of world-changing significance could also have served as a counterweight to more restrictive messages. They offered models of leadership and a sense of participation in the world's millennial destiny to the girls and women in their audience.

On 11 April 1849—three months after Rossiter completed *Miriam*, eight days after Church's *Plague of Darkness* went on view at the twenty-fourth annual exhibition of the National Academy of Design, and two and a half weeks before Reverend Thompson expounded upon the lessons of Nineveh from the stage of the Broadway Tabernacle—a new cantata was offered in that same auditorium. *Eleutheria—Festival of Freedom*, with words by the sculptor Horatio Stone and music by George Henry Curtis, expressed the intimate symbolic relationship understood by many Americans between the biblical story of Exodus, the role of the United States in the progress of freedom, and contemporary European revolutions. According to the New York *Post*, *Eleutheria* illustrated "the course of freedom, including its religious as well as political elements, from the escape of Israel out of Egyptian bondage to its triumph in America, and . . . influence upon the old world in 1848."[30]

Rossiter's *Miriam*, Church's *Plague of Darkness*, and the cantata were all conceived and executed at approximately the same time, which is evidence of common concerns and their expression in a similar language, if not necessarily of direct influence between any of the artists and their work. The cantata makes explicit certain associations that the works' shared biblical imagery held for some in their audiences. Embedded in Rossiter's and Church's biblical narratives are references to the same issues of freedom and slavery, liberty and despotism, national punishment and national reward treated in the contemporary *Eleutheria*.

The cantata's four characters, Christiana, Sybil, Victor, and the Seer, recounted the popular and venerable Western European conception of *translatio imperii*: the course of empire moving westward from Egypt through Greece and Rome to Europe and then to the United States. The first part of the composition, using the language of natural metaphor, likens the awakening of liberty's joyous spirit to a spring thaw. The Seer describes the role of the prophet as re-

former of human injustice, and Sybil reminds her listeners that the universal freedom, charity, and brotherhood foretold by the ancient prophet had yet to be realized; the people still mourned in the darkness of bondage.

This supplication to God on behalf of suffering humanity is given a temporal foundation, as the Seer recites:

In bondage the children of Israel sighed, and would depart from the land of Egypt; but Pharaoh's heart was hardened . . . and [he] oppressed them the more, till their cry went up to God. Then Moses, his servant, arose and led them from Egypt through the Red Sea.

The Seer rejoices that God's servant Moses broke the yoke of bondage, led his people triumphantly through the Red Sea, and guided them with the aid of the "fiery cloud pillar forelighting the land where they hoped to be free." They praise God, as avenger and warrior, and hopes are high as the Seer evokes a vision of agrarian plenty and peace.

But this state of society was not to be immediately realized. "[O]ppression arose in their midst," Sybil explained, "and their covenants were broken; and the prophets mourned by reason of their sins." The Seer took up the lament: "They hearkened not unto the Lord, who proclaimed liberty to every one." And the chorus concluded: "Then his judgment came upon them, / And in dark captivity they fell."[31]

The second part of the cantata began with a lament that the Israelites were again held in slavery—the Babylonian Captivity—because they ignored God's injunctions and practiced the iniquity themselves. Hope for liberty was renewed, however, as "gleaming faintly in the west" the light of freedom dawned over Greece. But the classical world soon dimmed, its idols fell, and freedom's name was lost until resurrected by the promise of the Christian gospel. The torch passed to Luther (this Protestant conception of the march of freedom gave little credit to the Catholic Church) who quickly transferred its care to England. And then, of course, the light and promise of freedom was transported to the New World.

Emigrants and pilgrims—modern Israelites crossing a new Red Sea—made their perilous but God-protected journey to freedom. All four characters sang:

> Stormy oceans far divide them
> From oppression's iron hand.
> Cross'd their Red Sea, Heav'n will guide
> them
> Through their blooming promis'd land.

Yet the plan was not complete; the colonies did not enjoy perfect freedom. The new world trembled at the approach of tyranny and Sybil warned that "the despot's banner / Glooms their hope-lit sky." Victor then recounted how the

incipient American republic proclaimed that "All souls inherit / Equal rights from Heaven!" and how Washington appeared to "flame Freedom's quenchless fire."

The cantata's finale brought the progress of freedom to the present, a time when its flame burned with particular heat:

> The power of tyrants
> Now hopelessly wanes.
> Joy, joy to our own,
> And all nations afar;
> Even now is it melting
> From millions their chains.
> .
> Rise, rise all ye nations!
> In one brother band,
> Awake and march onward
> To Freedom's bright goal.
> .
> Awake! For thy coming
> The near future waits—
> Millennial glory
> Unfoldeth its gates!

Stone's *Eleutheria* celebrated modern revolution through biblical analogy and rejoiced in the overthrow of European monarchy. Some evidence exists to suggest that Rossiter, too, would have been awake to such associations when he conceived of and produced his scene from Exodus. A poem he wrote in Rome entitled "The Old and New," which he sent in March 1842 to his friend Thomas Cole, supports the progressive amelioration of man's condition. In it, Rossiter reveals his distaste for European monarchies and aristocracy in general, which he associated with war, and he glorifies the grandeur and freedom of the American wilderness.[32] In 1847, the *Literary World* published another poem by Rossiter in which he acknowledged the attractions of Old Europe while rejoicing in his return to the "Home of the mighty free."[33]

Such general sentiments might have taken on more specific relevance to Rossiter in 1848. In a letter dated 18 September 1848, Francis Alexander, a mutual friend of Rossiter and John F. Kensett, reminded Kensett of the days they and Rossiter traveled together in Europe. Then, with excitement supplanting nostalgia, Alexander returned to the present. "What rows in Europe," he exclaims, "I suspect they have scarce begun." Alexander called the uprisings "revolts of the belly" caused by "centuries of misrule and monopoly" by feudal governments that "[ground] the face of the poor,"[34] sentiments similar to those expressed in Rossiter's poem. Rossiter's sympathy with the cause of European revolution is also suggested by the fact that, in 1851, he was one of a group of artists who, excited by "the great effort that has been going on . . . in Europe, for the good of

mankind," offered their services for the New York reception of the Hungarian revolutionary Louis Kossuth.[35]

In his *Eleutheria*, Horatio Stone did not pretend that the European revolutions, following America's lead as they did, marked the final realization of universal freedom. Nor did the destruction of Pharaoh's army in the Red Sea as depicted by Rossiter mean that the Israelites had reached their Promised Land. Both Rossiter's painting and Stone's cantata encouraged their audiences to continue onward along a path that now, more than ever, seemed to lead inexorably to the millennium of perfect social and spiritual liberty.

Yet some in those audiences must have identified slavery as America's greatest roadblock along this millennial path. At this point in the nation's history, all discussions of freedom, whether in the context of European, American, or biblical history, implicitly reminded many Northerners that slavery tarnished the brilliance of their model republic in the eyes of the world and, more important, God. The United States, like its ancient type, Israel, was also capable of inciting His wrath and calling down its own Babylonian Captivity. To those open to such a message, Rossiter's painting and Stone's cantata could have served as prophetic exhortations for the future of the slaveholding United States.

Although Stone's *Eleutheria: Festival of Freedom* made no overt reference to American slavery, the author's personal antislavery position was explicit in a book of poems entitled *Freedom*, which he published in 1863.[36] His "Freedom," included in this volume, was a long allegorical poem using similar imagery and echoing the liberal sentiments of the earlier *Eleutheria*. But in "Freedom," Stone was finally able to rejoice that, after years of disregard for God's will, the country was obeying its own "law of life—Equality of rights." The "nation's consecrated ark" was rescued and its unique covenant saved. Not until fourteen years later, in the midst of the Civil War and with the abolition of slavery, did Stone finally glimpse the millennial freedom he had only hoped for in 1849.

Perhaps some of those white Americans who saw *Miriam* on display or heard *Eleutheria* performed in 1849 were aware that the Old Testament story of Hebrew enslavement by the Egyptians had particular meaning to antebellum blacks, who identified themselves as the children of Israel oppressed by an American Pharaoh.[37] As Lawrence Levine observes, "over and over [slave spirituals] dwelt upon the spectacle of the Red Sea opening to allow the Hebrew slaves past before inundating the mighty armies of Pharoah."[38] Although most Northern whites were probably unfamiliar with such slave spirituals as "Go Down, Moses," black abolitionists often used Exodus analogies, which offered hope for the "Israelites" and retribution for the armies of "Pharoah," in speeches and in publications that would have been accessible to white audiences.[39]

At the end of the *Home Journal*'s notice of *Miriam*, its author (most likely one of the magazine's editors, Nathaniel Parker Willis) appended an intriguing postscript, which shows that Rossiter's apparently straightforward biblical image did in fact trigger thoughts of slavery:

Apropos—Rossiter would have better pleased the *amalgamationists* if he had chosen an-
other period of Miriam's history—*for we read in the twelfth chapter of Numbers that she
was suddenly struck with leprosy for speaking ill of Moses on account of his marriage "with
an Ethiopian woman."* The sudden discovery by Moses and Aaron of the instantaneous
judgment upon their sister would be a grand subject for a picture.[40]

What are we to make of this jarring reference to amalgamationists—supposed
advocates of the sexual union and intermarriage of the races—at the end of a
laudatory and politically neutral discussion of Rossiter's scriptural painting? No-
where in his preceding discussion of its artistic merits does the author suggest
any topical associations for Rossiter's picture of Miriam rejoicing. Yet, with the
word "apropos" as a slender bridge, the author takes an abrupt and deliberate de-
tour into the contested territory of slavery and race. If nothing else, the connec-
tion of two such apparently unrelated phenomena—biblical painting and radi-
cal abolitionism—demonstrates that to some antebellum Americans, in fact, the
phenomena were *not* unrelated. There are volumes of unspoken but shared as-
sumptions and experiences, understood by Americans in 1848 and 1849 but lost
to us now, packed into that "apropos."

Just as eloquent is the *absence* of explicit commentary in the main body of the
reviewer's text. If something about amalgamation is in fact "apropos" to
Rossiter's painting, why doesn't the reviewer make it explicit? Is it because the
associations with contemporary concerns were so clear that they didn't need to
be pointed out or identified, or that the reviewer was loathe to make explicit
what those who chose to appreciate Rossiter's *Miriam* solely for its religious mes-
sage and/or its aesthetic pleasures would rather leave alone?

Whatever the case, Rossiter's depiction of the celebratory Miriam—without
explanatory text or explicit symbol—struck a note for one viewer that resonated
with racial anxiety at its most profound and virulent. Amalgamation was a hor-
rific abstraction and an unthinkable reality to most white Americans, whatever
their region or position on slavery. Charges that abolitionists supported racial
mixing, either explicitly or indirectly by advocating freedom and equality for
blacks, were often used by detractors to further radicalize the abolitionist cause
in the public mind.[41] A vision, albeit later in date, of the supposed outcome of
abolitionist-supported racial mixing is illustrated in a print entitled *Miscegena-
tion; or the Millennium of Abolitionism* (fig. 29), in which grotesquely carica-
tured black men and women consort in public with white partners.

Josiah Priest, an extreme racist Southern supporter of slavery, claimed in
1851 that "we have often heard abolitionists remark, that the time will come,
when all mankind will be of one color."[42] Priest voiced what was surely the po-
sition of most white Americans, Northern or Southern: "how is it possible that
any white man on the face of the earth can be found, who in his heart is willing
to have the race become one by amalgamation?" To Priest, "such a desire seems
a kind of monstrosity, a hideous nightmare" because "the races are two kinds of

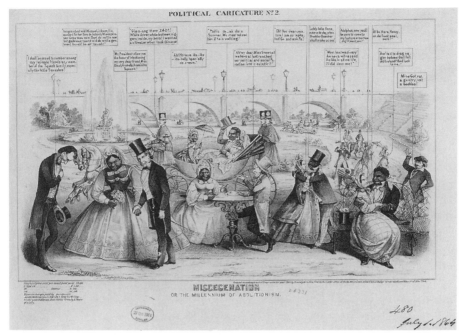

FIG. 29. Anon., *Miscegenation, or the Millennium of Abolitionism*, 1864; lithograph published by New York Bromly & Co., New York. The Library of Congress. LC-USZ62-8840.

men, constituted entirely different, in both body and soul . . . there can be no union or fellowship between the two, on the ground of common equality."[43]

Yet a few white American abolitionists did support racial amalgamation, demonstrating that Priest's fears were not unfounded. Richard Hildreth, for example, advocated miscegenation as "the means which nature takes gradually to extinguish the inferior race, and to substitute a new mixed race in the place of it."[44] By the 1850s, the black contribution to racial mixture could be viewed more positively by some white abolitionists, as a means to smooth the harsher edges of Anglo-Saxon character.[45]

The *Home Journal*'s mention of amalgamation in reference to Rossiter's painting seems both more understandable and more appropriate if we consider that the artist's *Return of the Dove to the Ark* had recently preceded *Miriam* on exhibit in New York and Philadelphia. The earlier work had received positive attention from N. P. Willis in the *Home Journal*. Perhaps this painting and its implied racial message united in the reviewer's imagination and memory with the celebration of freedom depicted in *Miriam*.

The themes of providential deliverance and human thanksgiving central to Rossiter's *Miriam* were fundamental also to his *Return of the Dove to the Ark*, which was briefly on display in New York by October 1848 before traveling to Philadelphia in December.[46] According to Rossiter, the painting represented

the moment "when the Dove, returning from its second errand, appears in sight, with the Olive Branch; betokening the Deluge has ceased, and the waters have commenced subsiding."[47] Noah and his family are gathered on the deck of the ark to view the dove and the bow of the covenant. The surrounding water—like the water in *Miriam*—is an instrument of divine chastisement, while the rainbow—similar to *Miriam's* cloud and pillar of fire—is a natural sign of millennial promise.

The expression of gratitude for divine favor manifest in *The Return of the Dove to the Ark* would have had particular meaning to the men and women of a country recently victorious in battle and (as yet) untouched by the famine, pestilence, and revolution scourging Europe. An editorial written by H. H. Weld for Thanksgiving Day 1848 described the blessings for which Americans owed thanks: "the restoration of peace [the Mexican War officially ended in July 1848], an abundant ingathering of the fruits of the earth, freedom from the ravages of pestilence, a continued possession of political, civil, and religious liberty, with hopeful prospects for the future."[48]

The subject's contemporary emotional appeal is evident in the words of one viewer whose sense of time, place, and identity was utterly transformed by the painting, despite what he or she acknowledged to be its technical weaknesses. "[The painting] was neither allegory nor history," this viewer explained, "but present experience. Time had moved backward . . . and we stood on the deck of that lone vessel . . . we felt the throb and glow of hope. . . . We make no pretensions to be critics of Art; we can only tell what it makes us *feel*."[49]

Yet another message besides the need to maintain faith and hope through the darkest of hours is implicitly conveyed through the faces and features of Noah and his family. According to Rossiter's description of the painting published in the Pennsylvania Academy broadside, Noah stood somewhat apart from the other figures, pointing out the returning dove to the painting's "principal group" composed of Noah's wife, the eldest son Japheth, and Shem's wife. Members of the painting's "secondary group"—Ham's wife, Japheth's wife and Shem, the middle son—are riveted by the bow of promise. Ham, "the youngest and least interesting of the sons," stood behind his father.

According to his description, Rossiter clearly differentiated Noah's sons and daughters-in-law by physical characteristics, pointing out their racial variety:

[Ham's] hair and features are of the Ethiopian cast, though his complexion is less swarthy than that race, more resembling the Coptic or Egyptian. . . . Japhet and his wife personify the Oriental race—Shem the Caucasian family, of which his wife represents the Greek branch—while the wife of Ham partakes slightly of the Gypsy or Indian character.[50]

Such attention to racial variety was not Rossiter's attempt to illustrate biblical text literally, since nothing in the text describes or differentiates the physical or racial characteristics of Noah, his wife, or his children. Nor was such variety

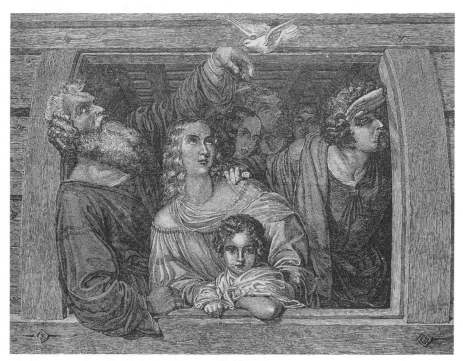

FIG. 30. Anon., "The Return of the Dove to the Ark," published in the *London Illustrated News*, 1 December 1849. University of Delaware Library, Newark, Delaware.

typically emphasized in contemporary Noachian images that included several or all members his family (see, for example, "The Return of the Dove," which appeared in the *London Illustrated News in* December 1849 (fig. 30), or *Noah's Sacrifice* by Daniel Maclise).[51] The choice to unite clearly differentiated Caucasian, Oriental, and darker-skinned human types in celebration of, as Rossiter explained, "The Triumph of Faith," seems to have been the artist's own.[52]

By the time Rossiter painted *The Return of the Dove to the Ark* in 1848, theories of racial difference and, specifically, of the origin and meaning of such difference were surfacing as hotly contested issues. At the heart of the matter lay a fundamental question: did all human beings—Caucasian, Oriental, Ethiopian, Indian, Gypsy—spring from the same forebears? Were all human beings united, then, by common brotherhood and sisterhood, capable of fellow feeling? Or were they, in fact, so fundamentally different as to constitute separate species, divided not only by facial and body features, hair, and skin color, but, more significantly, by innate intellectual, spiritual, and moral capabilities?

Clearly, answers to such questions had everything to do with the defense or denunciation of slavery. The extreme voiced by people like Josiah Priest held that absolutely no common ground existed on which black and white could meet as fellow human beings. At the other end of the spectrum, abolitionists

were, in George Frederickson's words, "idealistic Christian reformers" who believed that "Christian brotherhood was actually and immediately attainable."[53]

In a sermon entitled "National Righteousness," preached in a Methodist church in New York on Thanksgiving Day 1848, the Reverend D. W. Clark identified slavery as an example of the nation's denial of providential justice. He asked his listeners to consider the enslaved blacks. "Are they not our brethren? Bone of our bone, flesh of our flesh? Hath not God made of one flesh all the nations of the earth? . . . By what authority and for what purpose does man dare enslave his fellowman?" One reason alone could be used to support such iniquity, Clark argued. "The only ground on which this system can be justified is the claim that the colored race are a distinct and inferior species, and belong not to the human race."[54]

In fact, the increasingly vocal abolitionist movement of the 1830s did encourage proslavery advocates in the 1840s to use "scientific" arguments as a means to codify and support their own ideology. Simply put, the argument pitted monogenesis (belief in a common human origin) against polygenesis (belief in separate racial origins).[55] The more apparently empirical and objective evidence that polygenists could produce to show how distant blacks (or Indians) were from whites—especially if it showed that they constituted a completely different species—the greater justification there was, of course, for treating those blacks (or Indians) as something less than fully human. One of the most contentious topics under discussion was the possibility of amalgamation; if it could be proved that the union of different races produced viable, healthy offspring, a blow was struck on behalf of monogenesis. Sterile or nonviable offspring scored for polygenesis.

For most Americans, however, scientific evidence was not enough: nature had to be reconciled with biblical faith. Polygenesis in particular troubled devout white Americans, Northern and Southern, pro- and antislavery alike. To believers in the scriptural account of Genesis, any challenge to the notion of a single creation with Adam as the first father of humanity and Noah as the second was a direct insult to the sacred text. Those polygenists who wanted *both* a single creation *and* a distinct, irrevocable, and impassable division between the black and white races had to come up with ways to explain their position.

One such strategy was devised by William Frederick Van Amringe, a New York lawyer whose *An Investigation of the Theories of the Natural History of Man* was published in that city in 1848.[56] According to Van Amringe, all human beings sprang from Adam and all human beings except Noah and his family were destroyed in the Flood; *all* subsequent human beings descended from Noah's sons and their wives. Despite the current existence of four distinct racial species (the white, black, yellow, and red), he asserted that "Noah and his family must have been white."[57] According to an article written in support of Van Amringe's position, T. P. Kettell elaborated: "When Noah and his sons came forth of the ark . . . according to the scriptural account . . . all members of the family, that is to say, the whole human race, were of the same stock."[58]

How then, did the races we know today come into being? By the direct intervention of the Almighty. But why did God feel the need to separate what had originally been an all-white family into distinct races? Because, Van Amringe explained, the Almighty always fulfills his promises, his assertions, and his curses. According to Genesis 9:24–27, Noah, after realizing that his youngest son Ham had dishonored him and that Shem and Japheth had acted respectfully, cursed Canaan, the son of Ham, saying that he would be "a slave of slaves . . . to his brothers." Noah also blessed Shem, and asserted that "God would enlarge Japheth." (This passage is central to biblically based proslavery arguments, which identified Japheth as progenitor of the Caucasian race.) Van Amringe located the origin of the fourth race, the red, in that fact the Ishmael, the son of Abraham by Hagar, was driven into the wilderness.[59]

Kettell, even more clearly than Van Amringe, emphasized that *no* difference in physical and mental character existed before God blessed Shem and Japheth and cursed the son of Ham. The basis for this belief in racial difference is founded on the righteousness of Shem and Japheth and on the willfully sinful behavior of Ham; racial difference is divinely ordained and its ramifications and results are *deserved*.

According to Kettell and Van Amringe, these divine curses, blessings, and assertions could only be fulfilled if the descendants of each man were kept distinct, if the physical changes marking different races made it impossible to intermarry. These physical characteristics, joined by geographic distance, formed an "almost perfect barrier to an amalgamation of the different species. . . . [The] races have never commingled and are incapable of producing a mixed race."[60] Indeed, central to Van Amringe's theory was the notion that different standards of sexual beauty existed among the four human "species," tastes so naturally strong as to present "insuperable bars to amalgamation."[61]

Kettell continued his discussion of the subject in the September 1850 issue of the *United States Magazine and Democratic Review*, explaining in more detail than Van Amringe how and when the races were divided. Although the curse of Canaan (Ham's son), which appears in Genesis 9:25, made the racial divisions necessary, it was not until the episode recounted in Genesis 11:7–9 that God began the actual process of division and differentiation. Kettell interprets the confusion of languages that God miraculously produced in response to the building of the Tower of Babel to encompass changes also in the mental capabilities and habits of different peoples, as well as in radical physical changes.[62]

In October 1851, an article by Van Amringe appeared in the same magazine, intended as a rejoinder to those who, for various reasons, insisted on the unity of the human species, not only in its origin, but also in the face of its racial variety. Van Amringe warned of the danger of such beliefs: "philanthropic amalgamation abolitionists would degrade the white species and destroy the dark species because all naturalists admit the fact that a mixed race is inferior to the white race."[63] Van Amringe vehemently denied one clergyman's assertion that "we

know that the different races of man freely and *permanently amalgamate.*"[64] He could, however, agree with another about the "original unity" of the races but *not* about their "equal humanity" because, Van Amringe writes, "original unity" refers to Adam as progenitor but "equal humanity" denies the effects of God's blessing to Shem, his promise to Japheth, and his curse of Canaan. Racial differences are in themselves unassailable testimony to the unequal humanity of Noah's descendants.[65]

In his war against the unity of the races, Van Amringe took particular aim against one of the most respected advocates of the opposing position, James Cowles Prichard. Prichard, an English doctor whose ethnological explorations were based on his unwavering Christian belief in the unity of all human races, was either supported or repudiated in all the books and articles on the subject that proliferated in the United States in the late 1840s and the 1850s.[66] To Prichard, the question of racial unity or diversity was more than a scientific puzzle. Acceptance of the unity of the races was fundamental to his understanding of religion and humanity and he saw it as a powerful means to fight proslavery rationalizations.[67]

Prichard's most popularizing book (although not his earliest or most developed), *The Natural History of Man: Comprising Inquiries into the Modifying Influence of Physical and Moral Agencies on the Different Tribes of the Human Family* appeared first in 1843 and then in three subsequent editions (1845, 1848, and 1855). Each edition was generously illustrated with, among other images, examples of skulls as well as living racial types.

By 1859, at least, Rossiter was actively interested in the literature of ethnology; by 1863 we can be certain that he was familiar with Prichard. It is tempting to suppose that the artist was already familiar with the first or second edition of Prichard's *Natural History of Man* by the time he began *The Return of the Dove to the Ark*; the theme of his image finds some intriguing parallels in Prichard's arguments.[68]

In support of his belief that "it pleased the Almighty Creator to make of one blood all the nations of the earth," Prichard cited humanity's common "psychical" as well as physical nature. "There are, indeed, certain habits of mankind which . . . may be regarded as universal characters." Foremost among these was the religious impulse: "the same inward convictions, the same sentiments of subjection to invisible powers, and . . . of accountableness or responsibility to unseen avengers of wrong and agents of retributive justice."[69]

Much as Prichard was committed to the common brotherhood of all humanity, he "accepted the reality of the inherited mental differences which mid-nineteenth century Englishmen took for granted in distinguishing themselves from dark-skinned savages," and he believed Christianity to be the pinnacle of civilized achievement.[70] The fact that, according to his evidence, all human beings could open "the eyes of the mind to the more clear and luminous views which Christianity unfolds" that proved "the same inward and mental nature is to be recognized in all the races of men."[71]

Like Prichard's book, Rossiter's painting, with its assortment of pre-Babel racial types, presented an argument not only for the original unity of humankind, but also for a familial connection among the races. It suggested (without necessarily advocating) the possibility of amalgamation and it indicated their common protection under God's covenantal bow of promise. All of the races depicted by Rossiter shared, albeit in differing degrees, wonderment and awe at signs of God's deliverance, all of them participated—some more prominently than others—in the triumph of faith in the face of providential fury. All of the races were capable of spiritual understanding and all were, by implication, open to Christian redemption.[72]

The millennial significance of such a belief is manifest, for example, in *The Harmony of Christian Love: Representing the Dawn of the Millennium* (fig. 20), designed by the abolitionist artist John Sartain and published for the American Home Missionary Society in 1849.[73] Sartain's engraving thematically completes a circle begun in Rossiter's *Return of the Dove to the Ark*. In the painting, the parents of the Caucasian, the Oriental, the Gypsy/Indian, and the Ethiopian races, not yet disseminated throughout the world, first begin to grasp the meaning of divine revelation. In the engraving, their progeny are reunited in millennial fulfillment, drawn back to that revelation, now specifically Christian (in fact, Protestant), toward which they gaze again in wonderment. This is quite a different argument than the one presented by Van Amringe or by Josiah Nott, a polygenist Alabama doctor accused by a monogenist foe of degrading Southern slaves "into a different species, incapable of receiving the truths of Christianity."[74]

It would be gratifying to demonstrate that Rossiter—a Yankee born in New Haven, trained in the studio of the abolitionist Nathaniel Jocelyn, soon to marry into an abolitionist family—believed in the complete equality of all human beings and, like John Sartain, vehemently opposed slavery.[75] That Rossiter, like Prichard and most white Americans, even abolitionists, accepted a hierarchy of mental capabilities that distinguished the light from the dark would not preclude such an identification. But that Rossiter accepted the biblical curse of Ham's son Canaan as explanation for these differences (unlike Prichard who credited gradualist natural causes or even divine intervention) suggests that the artist believed slavery to have a role in the divine plan.[76]

Ham was the least prominent actor in Rossiter's drama; partially hidden by his father, he stood apart from the painting's two prominent groupings and conveyed only "the surprise of curiosity."[77] The half-hidden place of Ham within this celebration of panracial hope and faith was a clear sign of Rossiter's acceptance of notions of black inferiority, as made explicit in the pamphlet published around 1851, although not in the Pennsylvania Academy's 1848 broadside.

In this description, each of the figures in *The Return of the Dove to the Ark* was assigned an intellectual as well as a racial character. Shem's wife, for example,

was given "a speculative mind," the wife of Ham "an investigating, perceptive mind." Ham, however, displayed "no animation on his countenance, no marks of noble intellect, as in his brothers." As if in explanation, Rossiter quoted Genesis 9:25, "Cursed be Canaan; a servant of servants shall he be to his brethren."[78]

Rossiter, in fact, seems to have constructed a visual argument analogous to that presented by one of America's staunchest Southern proponents of monogenesis, Rev. Thomas Smyth, a Presbyterian, slaveholding minister in Charleston, South Carolina.[79] Smyth was a "Christian racist" who held that, while never to equal whites, blacks had an intellectual, spiritual, and moral nature that distinguished them from animals and joined all humanity in common brotherhood.[80]

According to Smyth, "there is no ground . . . to question the truth of Scripture history of the original unity and equality of all men." Indeed, he perceived signs of awakening progress in "the black race in this country," effected by "the direct and efficient inculcation of moral and religious truth, and their enjoyment of the social and religious blessings of Christian cultivation."[81] Smyth taught scripture to slaves, interpreting slavery as an evil made good by providence, a means to spread the gospel and hasten the millennium, and he acknowledged the possibility and the reality of racial amalgamation. Like Rossiter, Smyth accepted the curse of Ham, as justification for the continued enslavement of Christian blacks, whom he believed had the same moral nature as Christian whites.[82]

To Smyth, acceptance of the unity of the human race was essential because it formed the basis for the fulfillment of the divine plan. Paul and all other ministers were commanded by Old and New Testament alike to preach the gospel of grace and mercy to all people of every tongue and tribe, each of them sinners in need of salvation. Indeed, Smyth explained,

the gospel must stand or fall with the doctrine of the unity of the races. For if, as it is alleged, the Caucasian race ALONE have any interest in the revelations, the promises and the threatenings of the Bible, then it follows that the gospel ought not to be preached to any other than TRUE AND GENUINE CAUCASIAN men. But where are these to be found? Amid the incalculable intermixture of races which has taken place among men since the beginning of time, where is the one who can prove he is pure Caucasian? THERE IS NOT ONE. And, therefore, there is not one who can dare either to preach or to hear the gospel. The gospel becomes an empty sound, and all religion is at an end.[83]

When Rossiter began *The Return of the Dove to the Ark* in April 1848 and when he completed it that fall, racial unity or diversity was just emerging as a subject of heated public debate (witness Clark's sermon and Van Amringe's book). Rossiter did not necessarily intend to present a monogenist argument and clearly did not envision the work as an argument against slavery; the descent of all humanity from Noah and his sons—with Ham as cursed progenitor of the black race—was an orthodox Christian belief, North and South.

Nevertheless, Rossiter's *Return of the Dove to the Ark* came down on the side of monogenesis precisely at that moment when the unity of the races was called into question; his depiction of a racially mixed group was obviously in conflict

with Van Amringe's polygenist argument for an all-white Noachic family, for example. Accompanied by *Miriam* and then by *Jeremiah*, the painting traveled throughout the country in the late 1840s and the 1850s, when the controversy was most fully engaged and when a substantial number of Americans, Northern as well as Southern, had access to new arguments "disproving" the humanity of the darker races; no polygenist could have accepted the painting's racial implications.

Clearly Rossiter envisioned a broadly based audience for *The Return of the Dove to the Ark* as well as for *Miriam*. In November 1848, the New York *Tribune* reported his intention to exhibit *The Return of the Dove to the Ark* "through the South, during the coming Winter" although, like *Miriam* a year later, the painting went first to Philadelphia.[84] The painting's racial message obviously depended on the understanding of the individuals who viewed it. Without the explanation provided by Rossiter's accompanying pamphlet, which appeared at the earliest in 1851, each viewer was left to apprehend or not Ham's mental inferiority and ascribe it to the biblical curse or to environmental influences.[85] While the author of an ecstatic review in the *Pennsylvania Freeman*, an abolitionist newspaper, might have perceived Rossiter's *Return of the Dove to the Ark* as an illustration of slavery's fundamentally unchristian nature, Smyth and other "benevolent" slaveholders, as well as like-minded Northerners (perhaps Rossiter himself) could have found in it support for their relatively humane conception of slavery and its relationships.

When, in 1859, Rossiter produced his first large painting based on the life of Washington (see note 68), whom he obviously worshiped, he included a number of slaves in the image, including a black woman who blows on the fuse of a toy cannon. In his accompanying pamphlet, Rossiter praised Washington as a "Good Master" (to his estate and its entire family, not specifically to his slaves), and noted that "his negroes were treated with peculiar kindness" and that he "visit[ed] them in sickness and health, measuring carefully each one's capabilities."[86] Perhaps to Rossiter, Washington and his plantation presented the model of such benevolent slavery, in which each slave's humanity and individuality was recognized and rewarded. Yet we can still wonder why, in 1859, Rossiter felt compelled to include the detail of the toy cannon whose explosion is fanned by a black slave.

When Rossiter's *Return of the Dove to the Ark* was on view in Charleston, South Carolina, in April 1855, a writer for the *Charleston Daily Courier* noted "the Venerable NOAH, with his Sons and Son's wives, personifying—The Caucasian, the Oriental and Gypsy Tribes," with no mention made of Ham and the Ethiopian race.[87] All of the notices for the paintings that appeared in the Charleston paper (notices closer to puff pieces than to serious reviews) mentioned their spiritual influence, their astonishing realism, and their artistic beauty with never a hint that, in the heart of the South, any controversy might be found in an image of Noah's family that showed a darker-skinned Ham as brother to a white-skinned Shem.[88]

Rossiter was an ambitious artist steeped in the traditions of academic art, having studied and traveled in Europe from 1840 through 1846. The two large biblical paintings he conceived and produced in 1848 were certainly planned to enhance his reputation as a serious artist and to achieve popular and financial success. To interpret either *The Return of the Dove to the Ark* or *Miriam Rejoicing over the Destruction of Pharoah's Host* as primarily about race and slavery seriously misrepresents their role in Rossiter's professional life and their place in American public culture.

They were, of course, images intended to make money for the artist as they traveled the country. No doubt he sent them out of New York in anticipation of more generous receipts among a less artistically sophisticated and perhaps more pious audience. As biblical scenes, they were first and foremost respectable entertainments that any clergyman could safely recommend for the enjoyment and edification of women and children as well as men.

Yet, as the *Home Journal's* comment about "pleasing amalgamationists" demonstrates, sometimes the veneer of polite deference toward scriptural imagery was breached. Any number of other, more dangerous associations could be triggered by images illustrating the unity of all human beings in faith and under the protection of God, the joyfulness of a people released from slavery, and the divine retribution visited on their oppressors.

How conscious was Rossiter of the relevant and dangerous implications of such themes at the time he chose to paint them? How many viewers considered such issues privately or expressed them to friends and family? Unfortunately, we are not going to find answers to such questions in the polite review notices published in mainstream newspapers and magazines or in those notices designed to drum up business. The deeply ingrained notion that art—especially figural religious painting in the grand style—should offer exemplars of physical and spiritual beauty in order to refine and elevate served, not to blind its audience to the contemporary implications of the subject matter, but rather to silence most impulses to voice such associations.

Elizabeth Johns raises a similar issue in her discussion of antiabolitionist meaning in William Sidney Mount's genre painting, and suggests two compelling explanations for such silences (the first in the realm of conscious decision making, the other operating outside of conscious intent) which I believe can apply to religious imagery as well. Although Johns convincingly argues for antiabolitionist symbolism in *Farmers Nooning*, for example, Mount's reviewers did not mention the issue in print. Johns questions whether this silence was the result of the inflammatory nature of the issue and a desire not to alienate readers or because "the very duplicity of Mount's images, like the multiple implications of the spoken language, both compressed and discharged his viewer's tensions, making it unnecessary that they speak directly of them."[89]

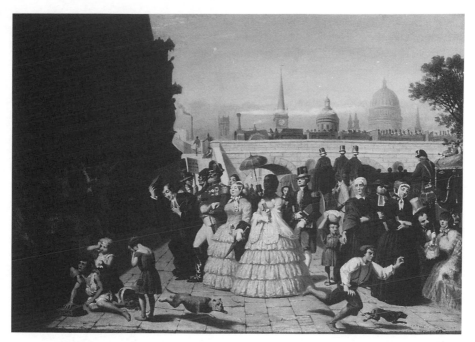

FIG. 31. Thomas Pritchard Rossiter, *Such Is Life—Scene During the Crimean War* (acc. no. 61.21), 1855; oil/canvas, 19½" × 27¼". The Newark Museum/Art Resource NY.

Rossiter's faith in biblical authority and Christian redemption was undoubtedly sincere, and his decision to paint important scriptural images for public display throughout the country was not merely a bid for fortune, fame, and critical acclaim. Indeed, in the 1860s Rossiter kept conceiving and painting large scriptural paintings even in the face of critical disdain.[90] He had a mission to fulfill with these paintings, a responsibility that he outlined in an article written from Paris in 1855 but pertinent to his earlier undertakings.

In it, the artist explained his academically informed hierarchy of artistic subjects, from the elevated "Epic"—to which his scriptural subjects clearly belonged—to the less weighty but more plentiful "Informing and Entertaining."[91] Theme rather than technique was Rossiter's primary standard of judgment. Although sensitive to the visual pleasures of painting, it was, he continued, "sentiment which touched the heart and roused the mind into healthy suggestive reflections" that earned his greatest approbation.

Rossiter admired Couture's *Romans of the Decadence*, noting its vigorous execution and harmonious tone. But he decried the painting's orgiastic subject, which included no hint of a Nemesis to punish its excesses. "What right-minded man or woman would like to stand and contemplate such a besotten company, and what reform will it engender, seen on canvas? As the story is depicted, where is the moral sequence?"

Rossiter acknowledged contemporary relevance in Couture's image of the decadent Roman Empire, seeing its "exaggerated orgy" as "perhaps as illustrative of 1855 as *Anno Domini* 1."[92] That he was sufficiently moved by some of the evils of contemporary society to comment on them in satirical genre painting is evident, for example, in *Such Is Life: Scene during the Crimean War* painted and exhibited in Paris in 1855 (fig. 31). The image skewers religious hypocrisy, contrasting the bloated self-satisfaction of well-to-do Londoners, pandered to by obsequious clergymen who ignore the ragged children, women, and Crimean War veterans surrounding them.[93]

When Rossiter painted *The Return of the Dove to the Ark* and *Miriam Rejoicing over the Destruction of Pharaoh's Host* in 1848, and when he first exhibited them together in 1849, he must have hoped to touch the hearts and rouse the minds of a diverse population at a time when talk of war, revolution, and slavery filled the air and when many felt that they and the nation were in particular need of moral and spiritual regeneration. Above all, the two paintings offered emotionally engaging models of faith during times of crisis and of thanksgiving for providential deliverance, and they underscored the necessity for nations as well as individuals to watch for signs of divine judgment and guidance.

1849: James H. Beard and
The Last Victim of the Deluge

Early in June 1849, James Henry Beard, one of Cincinnati's best-known portrait and genre painters, returned home from a sojourn in the South.[1] Beard had probably ventured as far as New Orleans, where he maintained an additional studio. The late spring of 1849 was not a particularly auspicious time to be traveling upriver toward Ohio, however, and he must have passed through areas terrified by the possibility or horrified by the reality of cholera.

Although cholera had been identified in New Orleans by late 1848, the spring and summer of 1849, from May through August, saw the height of the epidemic in Cincinnati, Louisville, St. Louis, and other midwestern and southern cities.[2] "All wordly matters have now given way in this city to the one absorbing dread of the cholera," the *St. Louis Union* observed in July. "This terrible destroyer of the human race seems to increase in violence in this city daily, until we can scarcely look at its ravages without a shudder of terror."[3]

In his Cincinnati studio, sometime during those weeks from early June through the last week of August when cholera's terrors were most vivid, Beard began a large and uncharacteristic painting whose subject treated the violent destruction of the human race.[4] (Frederick Spencer was, in all likelihood, painting his *The Newsboy* in New York at the very same time.) Beard produced *The Last Victim of the Deluge* (fig. 32) without a patron, hoping eventually to sell it; in the second half of 1849 he took it on a tour from Cincinnati to New Orleans, a route likely retracing the path he had followed a few months earlier. The tour continued through 1850, arriving in New York by May.[5]

Beard was an avid reader of poetry and a self-styled romantic "genius" who began to explore literary themes in the late 1840s. His turn to a large-scale biblical subject was certainly the attempt of an ambitious artist to create something inarguably poetic and high-minded.[6] But his choice in 1849 of the biblical Deluge and his particularly pitiless interpretation of the subject must have been affected by the despairing mood generated by the cholera epidemic. *The Last Victim of the Deluge* expresses what was perhaps Beard's own pessimistic estimation of human nature, as well as an admonition to his countrymen.

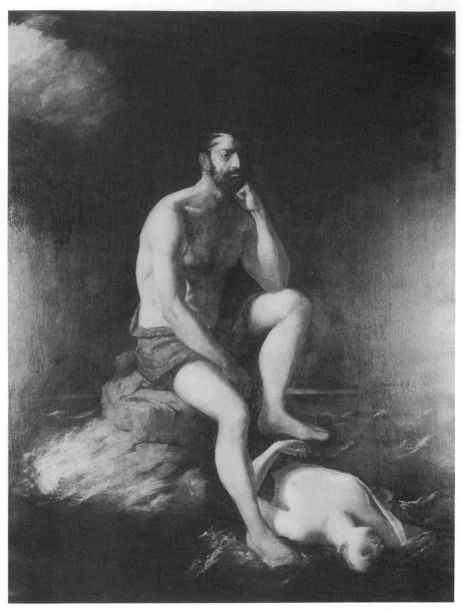

FIG. 32. James Henry Beard, *The Last Victim of the Deluge*, 1849; oil/canvas, 96½″ × 72″. Cincinnati Art Museum, Museum purchase: Gift of the American Art Society, and by exchange. Photograph before conservation.

Although little known today, James Henry Beard fought to maintain a place in the public eye from his artistic debut in Cincinnati until his death in New York. His family moved first from Connecticut to Buffalo and then, when Beard was eight years old, to Painesville in Ohio's Western Reserve, home to the state's largest concentration of transplanted New Englanders and a Whig stronghold. At seventeen, Beard left Painesville for the intinerant life of a keelboat hand and occassional painter. In the early 1830s, he established himself as an artist in Cincinnati; in 1833 he married Mary Caroline Carter, daughter of a New England–born river trader who ran flatboats to New Orleans.

Sensitive to the exigencies of party politics and national affairs as well as to his own artistic ambitions, Beard was at once a loyal Whig partisan and a home-grown Jeremiah. The artist's Yankee lineage, his Ohio upbringing, his constant traveling from free state to slave state and back, and his ties to Northern as well as Southern patrons exposed him to the sectional and economic tensions disrupting American society.

Beard's awareness of the tenuous nature of American unity probably encouraged his attachment to the Whig party, with its dread of social chaos and national disintegration. An adherent to the Whig principles of order, unity, and social control, Beard also sympathized with the nativist worry that immigration threatened American social and political institutions. His support in 1860 of the Constitutional Union Party, a coalition of conservative Whigs and nativists who condemned sectionalism, suggests that he continued to fear for America's stability. In light of these concerns, Beard's *Last Victim of the Deluge* can be interpreted as a prophetic warning to an errant nation.

The biblical Deluge offered Beard, as it had generations of Christian artists, a particularly vivid example of divine punishment of the sins of humanity through the unleashed forces of nature. Like the drowning of Pharoah's host in the Red Sea, the Deluge was a clear instance of unbridled providential vengeance, while Noah, his ark, and the covenant God made with him after the flood paralleled the freed Israelites and their ark of the covenant. Just as it provoked fear, the Deluge offered hope in a variety of spiritual and temporal situations.[7]

American artists of the late eighteenth and early nineteenth centuries shared with their European counterparts a romantic fascination with the horrific, emotional aspects of the Deluge, sometimes placing a more typically French emphasis on the human figure and sometimes showing a more typically English interest in sublime landscape effects.[8] Around 1786, during his second visit to England, John Trumbull, for example, produced a study for *The Last Family Who Perished in the Deluge*. In 1838 and 1839, Trumbull finally realized the sketch in a large oil painting (fig. 33). Thomas Cole painted *The Deluge* (1829) and *The Subsiding of the Waters of the Deluge* (1830), probably, Ellwood Parry

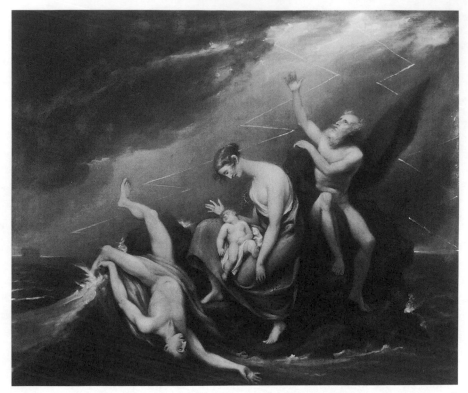

FIG. 33. John Trumbull, *The Last Family Who Perished in the Deluge*, 1838–1839; oil/canvas, 42″ × 50⅞″. Yale University Art Gallery, Trumbull Collection.

argues, in response to the very favorable reviews accorded John Martin's mezzo-tint of *The Deluge*, on display in New York in 1828.[9] Henry Cheever Pratt exhibited a Deluge in 1831, as did Edward B. Purcell in 1839.

The subject seems to have drifted out of popularity among American artists in the early 1840s, but reappeared in the second half of that decade. John C. Hagen, an artist who was a member of the International Order of Odd-Fellows, exhibited his *The Last Day of the Deluge* in 1845; perhaps the order's frequent use of the ark and the rainbow as emblems of divine and human benevolence influenced his choice of subject.[10] Frederic Edwin Church exhibited a *Deluge* in 1846—in all likelihood related to his teacher Cole's earlier example—and another version in 1851. Hannington's Sacred Dioramas of the Creation of the World and the Deluge were on view at Stoppani Hall on Broadway in mid-July of 1847 and September of 1848.[11] In late 1848, Thomas P. Rossitter showed his *Return of the Dove to the Ark* (discussed in chapter 3), indicating interest in related post-Deluge subjects.

Deluge and post-Deluge subjects frequently appeared in giftbook illustrations in the second half of the 1840s. John Gadsby Chapman designed an image

of the last survivor of the Deluge for *The Opal* for 1847 (fig. 34) ; Peter F. Rother-
mel produced *Noah's Sacrifice* for *Scenes from the Lives of the Patriarchs and
Prophets*, published in 1847, as well as *The First Storm* (a scene depicting the be-
ginning of the cataclymsic rain) for *The Opal* for 1848. Martin's *Noah's Sacrifice
(The Covenant)* was included in the design of the title-page of *The Odd-Fellows'
Offering, for 1850*.[12]

Beard's *Last Victim of the Deluge*, then, followed a continuing Anglo-American
tradition of Deluge scenes as well as a specific midcentury surge of interest in
the subject. But his visual approach did not follow the John Martin/Thomas
Cole emphasis on sublime natural elements nor did he focus on the pitiful help-
lessness of victims, characteristics that by midcentury were typical of American
paintings of the subject; see, for example, sketches for Frederic Church's 1851
version (pl. 5 and fig. 35).[13]

Two large, solitary figures inhabit Beard's bleak and reductive landscape of
rock, water, and sky. In the center of the composition a bearded man sits on a
rocky mound, his chin resting heavily on his folded left hand in the traditional

FIG. 34. John Gadsby Chapman, "The Deluge," 1847; engraving published in *The Opal* for 1847. Univer-
sity of Delaware Library, Newark, Delaware.

FIG. 35. Frederic Edwin Church, *Study for The Deluge*, ca. 1851; pencil/paper, 9⅞" × 14⅞". New York State Office of Parks, Recreation and Historic Preservation, Olana State Historic Site.

attitude of melancholy. Lying at—almost beneath—his foot and half submerged in dark and choppy water, is the corpse of a woman with her head thrown back and her mouth agape.

All attention in Beard's painting is focused on the physical and mental state of the final, doomed survivor of the apocalyptic cataclysm. The last man's complete mental self-absorption and physical impotence are evident in his closed posture, clenched fist, and fixed stare. He neither mourns his lost companion nor laments his own approaching demise. His back is resolutely turned to the circle of light behind him, and he does not implore God for mercy, pity, or forgiveness. No panoramic sweep of landscape accentuates the cosmic scope of the event, nor is the viewer entertained by exciting, pathetic, or moralizing anecdote. Heavy, clumsily handled, and thickly dark in tone, the painting offers little consolation to a sensitive viewer. The low horizon and huge expanse of oppressive sky dwarf the ark into insignificance, and the lurid burst of light emphasizes the leaden form of the figure, providing little sense of transcendence or redemption. The image conveys pessimistic rebellion in the face of divine judgment, which contrasts with the more conventional piety and sentimentalism of Deluge scenes such as those by Trumbull, Cole, Chapman, or Church.

Chapman's image of the Deluge offers a telling comparison to Beard's, since both focus on a single male survivor trapped on a rocky outcropping. But Chapman's survivor actively clings to the rock, grasping salvation for as long as

possible. His countenance is bathed in radiance; with eyes heavenward and an expression of meek acceptance, Chapman's figure acknowledges divine power. The ark, however distant and hazy in the left background, is significantly closer and more distinct than Beard's thin dark sliver.

Beard's *Last Victim* subverts the traditional image of the Deluge as a type of divine justice followed by rebirth and redemption as expressed, for example, in Rossiter's *Return of the Dove to the Ark*, on display in New York by October 1848, or on the title page of the *Odd-Fellows' Offering, for 1850* (New York, 1849), which reproduced John Martin's *God's Covenant with Noah* (fig. 36).[14] Above all, Beard eschews easy sympathy. He does not stress the sufferings of the weak and the innocent nor the heroism of the doomed. Instead, mortal defiance grips the last man even as the waters of divine vengeance lap at his feet. Beard's willful victim consciously and blasphemously repudiates his punishment, thereby underscoring its necessity and its justice.

The *Cincinnati Gazette* described Beard's painting at length and observed that "'The Last Victim' bears upon his countenance an expression which, to

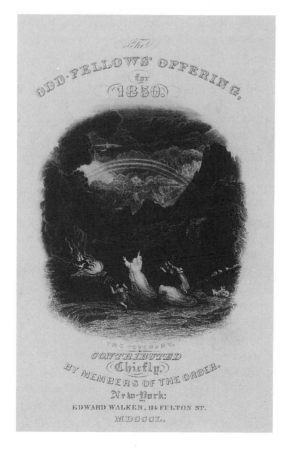

FIG. 36. Title page for *The Odd-Fellows' Offering, for 1850*, 1849; with engraving after John Martin, "God's Covenant with Noah." The Library of Congress.

every beholder, must declare, '*It is over—I have made my last struggle.*' It is the very picture of resolute despair."[15] Other contemporary viewers of Beard's *Last Victim* saw in it a bleakness beyond despair. One commentator imagined the terrible scenes leading up to the last man's awful predicament. Now, with his wife dead at his feet, the face of the last victim "is fixed and rigid and his eyes gaze on vacancy, without an object, past or future. . . . There is no fear there, but there is no hope! It is not despair, it is not defiance, nor resignation—nor yet expectancy, but a sullen, passionless and pulseless *awaiting* his inevitable doom."[16]

Beard's image recalls no past and offers no future, only a frozen eternity in a trackless space of total isolation.[17] What vision could have been more nightmarish to those midcentury Americans convinced of the "good time" coming? Beard's victim turns away, in willful, stubborn blindness, from the light of promise and redemption, the light which glows, for example, at the center of Sartain's *Harmony of Christian Love: Representing the Dawn of the Millennium*.

To one contemporary observer, the last victim's heaven-defying impiety recalled Prometheus, a proud, unconquerable soul hurling defiance back at the divine cause of his misery, heroic in his strength of mortal will but ultimately doomed.[18] To this midcentury American, at least, Beard's painting questioned the limits of self-direction and independence in a culture which affected but did not practice disdain of such limits. As Sacvan Bercovitch observed, "Prometheus . . . like Cain, Satan, Faust, and other romantic heroes, was a rebel, an individualist who defied providence and the divine plan. In America, self-assertion was legitimated only insofar as it represented the norms of culture."[19] Once outside the norms and strict controls of an ordered society, the individual would, it was feared, run wild and sweep away all softer, domesticating influences—including the femininized power of love and moral suasion, whose demise is suggested in Beard's painting by the woman's corpse which seems strangely weighted down by the last man's foot.

In Rossiter's *Miriam* the prophetess and her female companions offered their heartfelt gratitude to a terrible but just God. In the same artist's *Babylonian Captivity* it was a woman, and only a woman, who made explicit the typological meaning of the entire composition, linking the destruction of Babylon and the liberation of the Israelites to its apocalyptic Christian conclusion. It was a woman who led the group of Moslems toward the light of Christianity in *The Harmony of Christian Love: Representing the Dawn of the Millennium*, just as it was, conversely, the corpse of a woman who lay silent in the desolate wasteland of impiety surrounding Beard's *Last Victim*.

Beard's conception of a central, solitary male figure, resting his dark, brooding face on a clenched fist, has more in common visually and thematically with John Vanderlyn's *Marius amid the Ruins of Carthage* (1807; engraved in 1842; fig. 37), than with typical depictions of the Deluge. Both evoke thoughts of the force of mortal ambition, the instability of human grandeur, of man's inability to relinquish dreams of defiance and revenge even in the face of absolute defeat,

FIG. 37. S. A. Schoff, engraving after John Vanderlyn, "Marius amid the Ruins of Carthage," 1842; 15½" × 11½". New York State Office of Parks, Recreation and Historic Preservation, Senate House State Historic Site.

and of frustrated power and misspent strength. They are both explicitly "masculine" in their fierce but misguided resolution.

It is intriguing to consider whether Beard began, or was inspired to begin, his image of impiety and its deserts on 3 August 1849, the day designated by President Zachary Taylor for "national prayer, fasting, and humiliation" in the face of the cholera epidemic. (The earliest mention that Beard's painting was in progress appeared in the *Cincinnati Gazette* on 28 August.) Whatever the specific relationship of dates between the national observance and Beard's painting, their correspondence offers an evocative context in which to read *The Last Victim* as a fast day sermon in paint.

Such a presidential decree publically acknowledged the primary power of God's externally applied and violent judgment: only his mercy—not human restraint, goodness, or charity—could save America from destruction. According to historian Charles E. Dickson, the first national day of fasting, prayer, and humiliation, called by President John Adams in the spring of 1798, was a reprise of a conservative Puritan-style convention that had already fallen out of public favor. And, Dickson observed, "after the defeat of Adams' administration political leaders rarely called upon their fellow Americans to seek God's forgiveness for their corporate and individual transgressions." According to Dickson, political, constitutional, intellectual, and sociological changes had fostered a blander

American civil religion. "Political leaders could appeal to the least common denominator in their large and and complicated society by publicly thanking Providence for singling out America for special favors, but they could no longer call the nation to repentance."[20]

Indeed, Rossiter's *Return of the Dove to the Ark* was on display in either New York or Philadelphia on 24 November 1848, a date both states designated as Thanksgiving Day. On such a day, the painting would have had particular meaning to a country recently victorious in battle and (as yet) untouched by the famine, pestilence, and revolution scourging Europe.[21] But the summer of 1849 was not the fall of 1848—and Beard's *Last Victim of the Deluge* was not *The Return of the Dove to the Ark*.

President Taylor's national day of fasting and prayer indicated that the supposedly superannuated Calvinism of a colonial past was far from purged from American civil religion. At least in the minds of some devout Protestants, Catholics, and Jews, mortal beings had no choice as 1849 ran its course but to fall to their knees, as America's mythic Puritan ancestors had done, acknowledge their sins, and plead for mercy in the face of events too great for their ken.[22] Many Americans, with their families, friends, and nation writhing in cholera's terrible grip, felt compelled to prostrate themselves before an angry god.

The idea and the practice of a national fast day had political as well as religious implications, calling into question the role of the national government in the moral and religious beliefs and actions of its individual citizens. Democratic president Andrew Jackson had refused to call a national fast day during the cholera epidemic of 1832, while in 1849 Whig president Zachary Taylor did so with enthusiasm. Many vocal opponents of Taylor's national fast were against any governmentally imposed religious observance. According to Rosenberg, free-thinking artisans, mechanics, and workers opposed the fast as "a scheme of the orthodox to reunite Church and State," arguing that the president had no executive power to justify his action.[23]

But Beard was a Whig, and given the evidence of his *The Last Victim of the Deluge*, we can imagine his sympathetic participation in the national event. Beyond vague speculation, we can approximate Beard's attitudes toward the fast day and the broader religious and political issues it encompassed, through the published opinions of his close friend and supporter, George D. Prentice, editor of the *Louisville Journal*.

Prentice's background and political affiliations paralleled Beard's in many respects. He was, like Beard, born of New England parentage. Both artist and editor assimilated themselves into a border state environment, both were staunch Whigs and loyal supporters of Henry Clay, both had nativist sympathies, and both were members of the Constitutional Union Party in 1860. Prentice and his newspaper offer the best evidence, in the absence of Beard's own words, of attitudes and beliefs that the artist and the editor might have privately shared and publicly expressed.

An editorial that appeared in Prentice's *Journal* on the day of the fast proved that he, like a considerable number of his fellow citizens, heeded President Taylor's call for national prostration. Those who had faith in God's just and terrific retribution against the wrongs, sins, and crimes of humanity needed no convincing that, as the editorial put it, "the pestilence that is now overhanging this country, like a black and baleful cloud, flashing its deadly bolts on the heads of thousands, and leaving the traces of incurable sorrow on so many hearts, is not to be regarded as the mere creature of chance."

The editorial referred specifically to the biblical Deluge, claiming that "the destruction of the antediluvian races, the overthrow of the Cities of the Plain, the doom that overwhelmed Egypt, Assyria, and even the city of Jerusalem, all show that war, pestilence, famine and water, and fire have . . . been used by Jehovah as instruments for the chastisement of human guilt."[24] Certainly the United States and its citizens were as deserving of punishment as any biblical race or nation. "There has been enough abuse of our high and peculiar privileges," the editorial admonished, "enough daring iniquity in this nation to warrant those who believe that the Almighty does scourge guilty nations with pestilence, to conclude that He . . . is now chastising guilt in our afflicted country."

National irreligion, Prentice argued, inevitably called down retribution. No nation could prosper whose citizens did not recognize "the dependence of man on the mercy and condescension of his Creator and the duty and efficiency of prayer." One of the major sins of antediluvian humanity, clearly illustrated in Beard's *Last Victim*, was its heaven-defying impiety. An irreligious nation would ultimately fail because its social and political policies would be naturally vicious. Prentice warned,

There is no instance on record, from the days of the patriarchs to the present time, in which national degradation has not invariably followed in the wake of national crime. Whether swift or slow, the judgments of heaven have ever been turned against those nations which have exhibited an utter disregard of the everlasting principles of justice, right and truth.

Whigs like Beard and his friend Prentice had no trouble finding signs of American iniquity. The United States had committed sins against providential law—many of them in the name of Manifest Destiny—and was now suffering the consequences. Prentice's editorials and Beard's *Last Victim* both admonished Americans to pay heed to divine portents.

What were these iniquities and injustices—evidence of irreligion and of the disregard of justice, right, and truth—in which the United States had indulged? What terrible wrongs had the nation committed in recent years serious enough to deserve the providential plague of 1849? Beard's genre paintings and Prentice's editorials of the 1840s make clear what the two friends understood to be the nature of these national wrongs.

Despite elements of humor, in paintings like *The Long Bill* (1840) and *Ohio Land Speculator* (1840; fig. 38) Beard severely criticized America's greedy, speculative spirit. Among the most pervasive and insidious of national sins decried by American prophets was the money-grubbing materialism that they believed blighted the individual and collective American soul. A particularly wretched example of this greedy spirit surfaced during the cholera epidemic of 1849. Owners and officers of steamboats continued to crowd their vessels with many more passengers than they could adequately provide for, conditions that facilitated the spread of disease and resulted in widespread mortality, especially among poor emigrants. Prentice's *Journal* decried the practice in an editorial published in May 1849: "Steamboat follows steamboat crammed to their utmost capacity with human beings, on whom the officers of the boat know that death and disease must begin their fearful work. Under such circumstances, are not these officers responsible before high Heaven?"[25]

Beard, a frequent passenger on the steamboats that traveled the Ohio and Mississippi Rivers, certainly had firsthand experience with such conditions. And he was quite clearly aware of other, more troubling signs of national degradation. Slavery, westward expansion and its effect on the spread of slavery and on settled domestic life, the mistreatment of the Indian, and a war of national aggression were all issues explicitly or implicitly engaged in Beard's genre images prior to *The Last Victim*.

Completed in August 1845, *North Carolina Emigrants: Poor White Folks* (pl. 6)[26] depicts a family traveling from North Carolina to Ohio; a signboard marks the route. The scene has a dreary, broken, and wretched spirit unlike most other American images of emigration and it introduces the note of resigned despair apparent later in *The Last Victim*. The sullen and slovenly father, exhausted mother with a child in her arms, pale daughter, and barefoot son wait listlessly beside a water trough while their cow takes a drink. A mangy dog gnaws on the bones of a long-dead animal, while the rib cage and jawbone of another, larger animal lie in the lower left of the composition. A river with a ghostlike tree on its bank flows behind the group, and the ground is barren and sere.

Many who viewed the painting in 1845 and 1846 in Cincinnati, Louisville, Washington, and New York were struck by the power of its subject. One observer described the emigrant and his careworn countenance as "the very picture of sorrow and despair." A commentator for the *Cincinnati Gazette* noted that all the figures except the young boy were suffering from fever and ague. The crepe on the father's hat reminded this viewer that the family had already lost a member to sickness.[27]

New York critics accorded the painting special attention when it was on display at the National Academy of Design, and they noted the public interest it attracted. But most agreed that the artist had pushed the bounds of artistic

FIG. 38. James Henry Beard, *Ohio Land Speculator*, 1840; oil/canvas, 19½" × 24" (49.5 × 61 cm). Purchased with funds from Friends of the Art Museum. Utah Museum of Fine Arts Permanent Collection. Acc. 1977.001.

propriety. A critic for the *Anglo-American* noted that *North Carolina Emigrants* was "EMPHATICALLY a striking picture; for squalid poverty and direct hunger are but too faithfully written on the countenances of the principal figures."[28]

Yet *North Carolina Emigrants: Poor White Folks* was more than a heartrending depiction of poverty's toll. To New York writer Charles Briggs, it was, even more, an "eloquent sermon on Anti-Slavery." As Briggs saw it,

The poor folks have turned their backs upon the Rip van Winkle State, where everything sleeps but the lash of the slave-driver, and are bound for Ohio. It is too late for the father and mother, the blight of Slavery has paralyzed the strong arm of the man and destroyed the spirit of the woman . . .[29]

Most public sympathy for the poor in antebellum America was saved for the helpless victims of fortune or another's cruelty, especially innocent widows and orphans. Able-bodied men who failed to support themselves and their families were usually chastized as lazy, thriftless, and probably drunkards. But the condition of the white laborer in the slaveholding South was perceived by many Northerners to be a different situation. Slavery undermined the dignity of labor

and its potential for social mobility, the very cornerstone, they believed, of American egalitarianism, progress, and democracy.[30]

To Briggs, the mortal damage done to Southern health and spirit by the sin of slavery had a divine logic.

To inhabitants of a free State, or a State where semi-freedom is enjoyed, the spectacle of such poor folks in a region where the soil is fruitful, the climate mild, and the people few is exceedingly puzzling, and wholly incomprehensible . . . until [they] reflect on the enormous wickedness of the slave-dealer, and remember that God is just, and that no evil can go unrequited. . . . [E]very evil which we practice towards others . . . will rebound upon our-selves.

If, and only if, the family removed itself from the taint of slavery, could the "good time"—the peace and prosperity Americans thought to be their destiny—be attained. Beard's emigrant mother and father were living symbols of divine justice, and their as-yet unspoiled children millennial harbingers.

However much he deplored the institution of slavery, Briggs was not an abolitionist.[31] Neither, it seems, was Beard or Prentice. Like Whigs generally, they were opposed to slavery and its extension into western territories but did not demand immediate abolition.[32] Beard's sympathy, judging from *Poor White Folks*, lay not with the enslaved black, but with what he perceived as the degraded Anglo-Saxon American who suffered the economic effects of slavery.

Prentice's position on slavery as represented in his *Journal* offers insights into Beard's. Prentice looked forward to the day when Kentucky would hold no slaves within its borders. He had no consideration for the plight of the enslaved blacks nor did he believe in what he termed their "alleged rights." Prentice disliked the institution of slavery because it encouraged social unrest, retarded the industrial growth of the South, and created white poverty, and he espoused gradual emancipation and colonization as the only way to end slavery while safeguarding the well-being of Southern whites.[33]

Beard's *North Carolina Emigrants*, the image of a family moving westward as well as northward, naturally raised the issues of annexation and the expansion of slavery into new territories so timely in 1845 and 1846. The artist probably did not wish to encourage western migration, and he clearly indicated that this family was bound for Ohio, not Texas, Oregon, or California. In 1845, Prentice's *Journal* prophesied that if Congress voted to annex Texas, there would be "immediate war, the dishonor of violated public faith, the reproach of the world, the condemnation of history, and, in the distant future, ruin to this fair union." The *Journal* also chastised abolitionists for their part in dividing Whig votes and permitting the election in 1844 of the Democrat James K. Polk, an ardent expansionist, over

the Whig Henry Clay. Upon the heads of these men "rests the sin of the extend-ing the area of slavery."[34]

But Prentice discouraged expansion for reasons other than the spread of slav-ery. "Would that a wall were built up about us . . . on the west that the living tide might be staid [*sic*], and that our people might subside into civilization."[35] To Prentice, safety, security, and the very foundations of civilized behavior existed only within already established free state boundaries. A painting entitled *West-ern Raftsmen* (fig. 39), which Beard executed in New York immediately after his successful *North Carolina Emigrants*, underscored the fear of lawlessness and disorder implicit in Prentice's desire for a retaining and regulating wall of geog-raphy and behavior.

Beard's *Western Raftsmen* seemed deliberately to refute the expansionist ar-gument that Yankee virtues could be successfully transplanted along western riv-ers. A central log cabin, apparently deserted, draws attention from the flatboat and its crew. A gaping hole in the cabin's roof has been hastily covered with rough planks. The structure reeks of decay—vines are beginning to sprout on the roof and in the chimney—and it looks as precarious as the large tree whose

FIG. 39. James Henry Beard, *Western Raftsmen*, 1846; oil/canvas, 27⅞" × 36". Diplomatic Reception Rooms, United States Department of State. Photography by Will Brown.

exposed roots cling to a bluff. No women or children are present to suggest settled domesticity, feminine moral virtue, or youthful promise—we should remember the dead woman in *The Last Victim*. While other artists of the time presented rude cabins as harbingers of American civilization, Beard's structure is melancholy testimony to thwarted dreams.

The flatboat, beached and tethered in the lower left of the composition, is in only slightly better repair than the disreputable cabin. Two members of the crew lounge idly, while another plays the fiddle and the fourth, a black man, dances. A bearded backwoodsman stands on the beach. Flanked by two dogs, he leans on his rifle, ankles crossed (much like the father in *North Carolina Emigrants*), and sullenly regards a man on horseback. Light is concentrated around the cabin; the sun appears to be setting, placing all the human figures in a shadowy depression. No gainful activity is apparent, and even the music making on top of the flatboat lacks merriment. Beard's *Western Raftsmen* has none of the carefully controlled good humor and innocent vigor of George Caleb Bingham's contemporary *Jolly Flatboatmen*.

Beard underscored the debilitating effect that the itinerant ways of the boatmen had on domestic life. He also depicted whites and blacks interacting as equals in a way that would have been disturbing to many viewers at the time. The black dancer and white fiddler are united in pose and gesture as well as by their common activity. The dancer is even slightly elevated, although he is also isolated from his fellows by the diagonal placement of the oar. The unrestrained world of indolence and indulgence these boatmen share lies beyond the pale of middle-class morality and its suggests a typically "western" place—Prentice's worst nightmare—where lines between race and class were uncomfortably blurred.

The *Louisville Journal* condemned the rootlessness that lured Americans beyond the geographic and, by implication, moral borders of national civilization. "It is this migratory spirit . . . this worse than savage destitution of the love of home . . . that is tempting the people of this country to pass beyond its bounds."[36] Beard's unpromising western scene evokes a similarly unstable and frighteningly amorphous social and moral landscape, one that bode as ill for the nation's future as the degraded parents in *North Carolina Emigrants*.

Early in 1847, Beard produced another painting with an even stronger antiexpansionist message: *The Last of the Red Man*, exhibited at the National Academy of Design in the spring. Visual representations of the "doomed Indian" began to appear in American art in the 1840s, evidence of, according to Julie Schimmel, "an increased need to resolve Indian-white conflict."[37] In 1847, the New York art world saw an unusual number of paintings and prints on the theme. Asher B. Durand's *Indian Vespers: Last of the Mohicans* appeared at the National Academy along with Beard's *Last of the Red Man*. Also that year, the American Art-Union chose Tompkins Harrison Matteson's *The Last of the Race* (fig. 40) to be engraved for

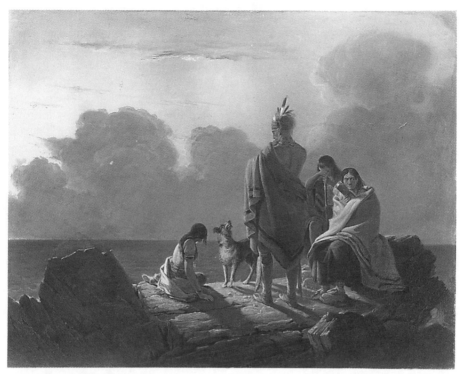

FIG. 40. Tompkins Harrison Matteson, *The Last of the Race*, 1847; oil/canvas, 39¼" × 50⅛". © Collection of The New-York Historical Society, New York. Gift of Edwin W. Orvis on behalf of his family.

distribution. *The Odd-Fellows' Offering, for 1848*, published in late 1847, includes a version of Matteson's image, a poem by F. J. Otterson entitled "The Last of the Their Race," and Charles Fenno Hoffman's "Sonnet: The Last of the Race." An 1847 edition of William Cullen Bryant's poems includes "An Indian at the Burial Place of His Fathers," illustrated by Emmanuel Leutze.

Although Beard's painting has not been located, we can glean its subject and treatment from a number of published and unpublished descriptions. As in *North Carolina Emigrants* and *Western Raftsmen*, Beard chose a topical subject charged with dangerous implications, which he deliberately emphasized. More than Beard's earlier paintings, *The Last of the Red Man* demonstrated the terrible human consequences of westward expansion and acquisition. A description of the image appeared in Prentice's *Journal*:

A family of Indians is represented on a rock on the extremist verge of the Pacific coast. They have momentarily rested when they discover the approach of that civilization which has driven them to their present retreat, in the form of the white man, steadily pursuing them. In their despair they are about seeking the peace denied them on earth in the wild waters of the ocean, dashing at the base of the rocks on which they rest.[38]

Like the group in *North Carolina Emigrants*, the family in *The Last of the Red Man* has been driven into exile by greed and social pressures beyond its control. But while hope motivates the poor white family, despair drives the Indian.

By the mid-1840s, some Americans were concerned that greed cloaked in the rhetoric of Manifest Destiny was inducing the United States to renege on its pledges to relocated tribes. Yet most of the visual representations of the doomed Indian that appeared in New York in 1847 did not burn with indignation over white injustice. Rather, they expressed gentle melancholy and resigned acceptance, evoking romantic associations of humanity's inevitable fall and decay. The old, savage way of the Indian, however noble, was destined to be pushed into oblivion by the march of time and forces of progress.[39] Durand's *Indian Vespers*, Leutze's engraving, and Matteson's *Last of the Race* all express this view. Matteson's Indian family waits submissively at the water's edge. Only the woman raises her head in impotent defiance; the central male figure bows his in defeat.

Beard's version of the subject also showed an Indian family driven to land's end. Judging from written descriptions, however, it had an aggressive edge totally absent from the others. Beard recalled the painting in his autobiography:

The picture was of an Indian reclining and his squaw was standing beside him, with a child in her arms and a boy perhaps twelve years of age, standing in front of her. She was listening and looking intently East. The light came from behind them—the Western sun, the setting sun. The Indian was listening, one hand grasping his bow, the quiver near by, and he had hold of his last arrow, drawing it out of the quiver, and the little fellow stood there with his arrow and bow drawn ready.

In Beard's image the beleaguered Indian family turned to confront its pursuers. Desperate human beings forced to choose between the murder of their attackers or their own death, they wait with drawn arrows instead of bowed heads. Beard apparently used ironic symbols to suggest his indignation. "Under the ledge of the rock was an old eagle's nest," he recalled, "where Liberty once rested—and the pipe of peace, broken in two, was lying there."[40] Human beings hunted like wild beasts, promises broken, peace defiled, liberty betrayed in the land of the free—Beard's image, it seems, denounced the shame of America's Indian policy. It implied that all white people, as they pushed the ancient tribes aside in their westward rush, bore responsibility for this destruction.

Beard's New York critics disliked his *Last of the Red Man*, usually citing aesthetic faults. But discomfort with the subject and irritation with breached propriety are also apparent in their comments. The *Anglo-American* observed, "There is we think too much alarm and apprehension expressed in the faces and actions of the whole group." The *Literary World* called the painting "a total failure . . . a commercial mistake. . . . No gentleman will ever purchase the picture to be hung in his house. It is vulgar."[41] The real irritation in these and other critical reactions seems to have been with the artist's brutal treatment of an unhappy

subject usually made palatable by sentiment. The path of the tormented family in *The Last of the Red Man* led to violent destruction, not to the potential freedom and prosperity offered in *North Carolina Emigrants*.

The image sugggested by *The Last of the Red Man* of desperate but defiant people, driven by external forces to the final refuge of a rock and faced with imminent watery death, offers an intriguing parallel to Beard's *Last Victim of the Deluge*. The theme of racial extinction binds them: the last Indian family points to the last human being to perish in the Deluge.[42]

An editorial decrying mistreatment of the Indian had appeared in Prentice's *Journal* in September 1845:

The rapacity with which the Government seized on [Choctaw] territory and the brutality of the warfare that has been waged on their persons would have sunk Sodom and Gomorrah deeper in degradation. . . . The record of Indian wrongs is full and black with acts of the most atrocious nature.

The *Journal* warned of divine retribution against such injustice, motivated not by the inevitable workings of glorious progress but by the basest of human greed. "Jefferson long ago said that, when he remembered the treatment of the Indians at the hands of this Government and reflected that justice was one of the attributes of Omnipotence, he trembled for his country. And well he might tremble at such a time."[43] Beard's *Last of the Red Man*, with its deserted eagle's nest and broken peace pipe, held a similar warning.

To conservative Whigs like Prentice and Beard, bloody aggression would join speculation, westward expansion, the spread of slavery, and the mistreatment of the Indian in the litany of national sins. Prentice's *Journal* decried the war with Mexico as an unjust act waged against a weaker republic, and Ohio Whigs like Beard shared their national party's general displeasure with American involvement in military combat. According to Maizlish, they argued that the administration's policy "threatened the moral purity of the entire nation . . . [and] hurt the nation's international reputation for moderation, wisdom and justice."[44]

The war against Mexico inflamed sectional tensions and by 1849 the threat of disunion had raised the fears of many Whigs to a hysterical pitch. One such jeremiad was reported in Prentice's *Journal* on 31 August 1849:

Oh, that those who, for any reason, talk lightly of dissolving this Union, would consider the immensely greater evils such a rupture would inevitably cause, the awful guilt it would bring upon themselves! . . . [N]o lover of law could ever kindle the torch of such incendiary slaughter, no lover of freedom plot for such general slavery, no lover of God and man undermine the eminent watch-tower whose light is now shedding over the world such bright promise of universal brotherhood.[45]

By 1860, as we have seen, both Prentice and Beard allied themselves to a party that espoused the maintenance of the Union above all other considerations. Headstrong individuality in national affairs would lead, many Whigs believed, to a rupture of national unity and a chaos of bloodshed.

A fearful warning is clearly embodied in the gloomy waters of Beard's *Last Victim*. It is surely hinted at in the ravaged features of the North Carolina emigrants, in the squalor of the western raftsmen, and in the desperation of the last Indian family. These images and the themes of bitter sectional division, rootlessness, and violent displacement that they portray reveal Beard's vision of a nation apparently doomed by its disregard for justice, right, and truth.

The only means to national salvation, according to an editorial published in the *Journal* on 21 August 1849, was "the progress of society, aided by the enlightening and elevating power of the Christian religion."[46] Prentice (and, we can assume, Beard) soon had the opportunity to examine a visual exemplar of this progress. A biblical panorama went on display in Louisville in late August and early September 1849,[47] just when Beard, across the river in Cincinnati, was putting the finishing touches on his scriptural painting.

The Lousiville panorama apparently delineated the course of spiritual liberation from the old dispensation to the new and illustrated the gradual and steady progress of religion. It began with "The Departure of the Israelites" and "Belshazzar's Feast," two examples of the providentially effected release of the Israelites from social and spiritual despotism. It culminated in "The Transfiguration of Christ," the triumph of the benevolent influence of an enlightening and elevating Christianity, which was considered by the *Journal* to be the prerequisite of liberal government.

Prentice's *Journal* encouraged the citizens of Louisville to visit the display. "In a community like ours, this work, which is acknowledged to be closely connected with our present and future existence, should be particularly well patronised."[48] The *Journal*'s admonition that "even he who disbelieves the Holy Writ, should not permit it to leave the city without attending the exhibition" suggests that the author was thinking in social and political as well as spiritual terms.

To Prentice and others like him, the panorama preached a conservative message of patience, restraint, and the necessity of faith in the ultimate power of Christian influence. Beard's *Last Victim*, a horrifying sermon on the antiprogressive consequences of unchristian selfishness, irreligion, and ambition, seems to have taught a complementary lesson. It was a lesson aimed perhaps at those unruly segments of American society—speculators, slaveholders, annexationists, imperialists, secessionists, *and* radical abolitionists—whose sins had invited the terrible retribution of cholera then scourging the nation.

❧ 5

1850: Peter F. Rothermel, Hector Tyndale, and *The Laborer's Vision of the Future*

On the last day of December 1850, members of the Philadelphia Art Union met for their third annual distribution of prizes. In honor of the occasion, Henry S. Patterson, a manager of the art union and a young medical doctor, delivered an address in which he exhorted American citizens to demand and American artists to produce a distinctively American art.[1] Yet Patterson did not envision galleries of wilderness or pastoral scenes, of humorous "Brother Jonathans" or "Young Americans" at work or play. He advocated an art that would be American in spirit and influence rather than merely in subject. Such fundamentally American art was necessary because the world stood "at the beginning of a new era in human history."

Patterson's sense of epochal transformation and his urgent appeal to the artists of America were expressions of a personal commitment to social reform. He was, among other activities and affiliations, both a dedicated Odd-Fellow and a contributor to the *Nineteenth Century*, Philadelphia's Associationist journal, whose editors counted him a member of "the noble army of Progress, [a] pioneer of the onward march of humanity."[2]

Patterson must have seemed to sympathetic Philadelphians a living exemplar of the figure in John Sartain's title page for the *Nineteenth Century* (fig. 41). Emblem of the ever hopeful but often misunderstood social reformer, this figure ascends a rocky slope, his left arm raised in a gesture of hope toward a burst of light breaking through dark and ominous clouds.[3] The light to which the young man points is the promise of a glorious future already apparent on the gloomy face of the present. This crusading and determined youth is presented as a pioneer, a prophet in the vanguard of the blind and timid mass of humanity.[4] He wears a Byronic open collar, suggestive of a poetic spirit.

According to Patterson, the true artist was just such a prophet. He was not a copyist of nature but a "poet and creator" whose mission was to reveal new beauty and new regions of the ideal.

To such an artist how many glorious subjects are presented by the free and generous spirit of our time, its stern rebuke of all oppression, spiritual and temporal, its proud assertion of

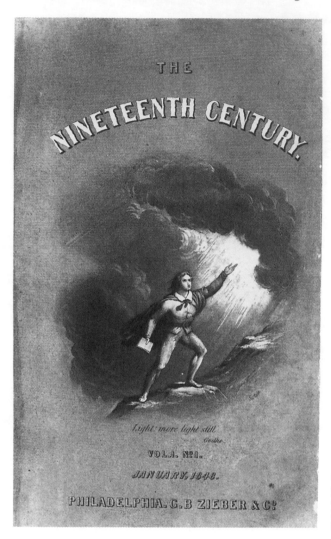

FIG. 41. John Sartain, title page for *The Nineteenth Century*, 1848. Literature Department, The Free Library of Philadelphia.

man's equal rights, its noble uplifting of down-trodden humanity, its resistless claim for the ascendancy of the sweet charities of life over the hard and destructive elements of our nature! How peculiarly American would it be—standing out in the sunlight of an exalted Christian spiritualism.

Patterson had, in fact, a particular painting in mind when he described such a truly American art of social responsibility and spiritual hope. "There is now, in [Philadelphia]. . . a picture which illustrates beautifully the thought I have been endeavoring . . . to convey. . . . The picture of *The Laborer's Vision of the Future*, painted by P. F. Rothermel, Esq., for a gentleman of this city [is] now

on exhibition at the Art Union Gallery." To Patterson, Rothermel's image was "a full expression of the spirit and prophecy of our time."

Philadelphia merchant Joseph Sill had seen the painting in progress in Rothermel's studio, and briefly described it in his diary on 26 November 1850. The large picture was populated by a number of allegorical figures, including "two persons, a man and a woman, the latter with a little child in her lap, who are both overcome by toil; but the man is upheld with aspirations after better things, by a vision in the Heavens. . . . Among the figures seen in the Heavens are Christ; the Labourer; the Evil Spirit etc. etc."[5]

A product of the joint efforts of artist Peter Frederick Rothermel and merchant Hector Tyndale, *The Laborer's Vision of the Future* was enthusiastically endorsed by members of its Philadelphia audience. The painting stood as a major document of antebellum art in the service of social reform and an eloquent testament to the millennial yearnings of its time. Although unfortunately lost, it is possible, using extant descriptions and a related drawing (fig. 42), to reconstruct its general composition, to glean its message of human perfectibility and social amelioration, and to suggest what it might have meant to its viewers, its patron, and its artist as 1850 turned to 1851.[6]

The Laborer's Vision was an "allegorical or metaphorical" image, "a painted poem," whose rhetorical strategy required the simultaneous visualization of distinct spatial environments, temporal realms, and states of physical and spiritual being. Its meaning "challeng[ed] the understanding" of the viewer as he or she followed the imagery from "stanza to stanza."[7]

In a vertically oriented space, the three figures of the laboring family occupied the left foreground. The father was robust while the mother sank to the ground with their sickly infant in her arms. The laborer extended one hand toward his wife and rested the other on a tool, apparently one fitted for the hard labor of breaking ground.[8] The *Philadelphia Art Union Reporter* perceived that the man and his wife were engaged in "breaking a road." Clearly, Rothermel's family was not meant to evoke the idealizing myths and pastoral virtues associated with American agricultural workers, nor the wonders of modern labor-saving technology.[9]

Rothermel's painting, it seems, hardly celebrated the hard-earned fruits of toil. "The implements indicate the rudest labor, and his clothing the hardest condition of the toiler," "Senior," writing for the *National Era*, observed. The setting in which the members of this laboring family were placed reinforced the poverty of their condition: Thomas Dunn English called it "a barren highway," "Senior" described it as "a rocky bluff," and the *Reporter* found it "bold [and] rugged." These descriptions call to mind such contemporary European images of poverty as Gustave Courbet's *Stonebreakers* (1849), and, more evocatively, George Watts's *The Irish Famine* (1849–1850; fig. 43), with its destitute family trapped in a rocky wasteland.[10]

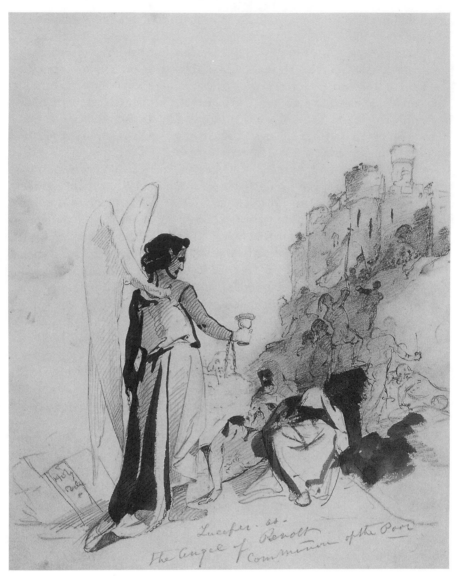

FIG. 42. Peter Frederick Rothermel, *Lucifer as the Angel of Revolt*, ca. 1850; ink, wash, graphite/paper, 11¼" × 8⅞". Private Collection.

According to the *Art Union Reporter*, *The Laborer's Vision* depicted "that hard and cheerless lot which is forced upon a portion of mankind by the false governments of the world at large, where so many are delvers of the earth, hewers of wood, and drawers of water while others fatten and luxuriate upon their products." The fainting wife and the nursing infant were included to "illustrate the oppression under which the poorer classes perform the drudgery of the world."

But the upturned face and gaze of the male laborer guided viewers out of the cheerless realm of the present and toward the "bright and beautiful realization of his hopes—the embodiment of his faith" located in the top third of the composition.[11] The unrealized condition of this "dream-region" was conveyed by the amorphous clouds that supported it, connecting yet separating it from the rocky reality of the landscape below; one region's ceiling was the other one's floor.

These clouds, all descriptions agree, were borne in on the back of a partially hidden figure of Time and they supported the assortment of personages that comprised the laborer's vision of hope and faith—the "apocalyptic panorama." Central to this vision, marking its midpoint and forming the apex of a pyramid, was the Cross. Beneath the cross stood the figure of Christ, with the transfigured images of the laboring man and woman to the left; in other words, standing at Christ's right hand. Also on the left was a group representing, depending on the interpretation of the viewer, education or intellectual labor.[12]

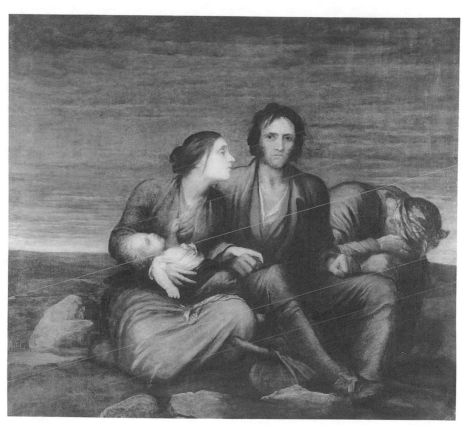

FIG. 43. George Frederick Watts, *The Irish Famine*, ca. 1849–1850; oil/canvas, 71" × 78". Trustees of the Watts Gallery, Compton, Surrey, UK/Bridgeman Art Library, London/New York.

To the right of the central cross (on Christ's left-hand side) were personifications and emblems of a variety of social and moral wrongs now vanquished; rejoicing above them, a "train of spirits" swept up into the "higher heavens." Chief among the defeated evils was a kneeling figure with batlike wings covering his face and a coiled serpent falling from his arm—Satan in the act of surrendering the "emblems of his previous dominion, the crown and scepter of earthly power." Behind him, a personification of War gave up his sword, the figure of Avarice offered his treasure, and the Demon of Slavery held out his broken chains.

Perhaps Rothermel and his patron Tyndale were familiar with *Le Christ* (1837), Ary Scheffer's controversial yet immensely popular image of Christ flanked by emblematic figures of the poor and enslaved, including a black figure. The image was familiar to Americans; Nathaniel Currier produced three lithographic versions (fig. 44), and a speaker acknowledged its popularity in an address before the Philadelphia Art Union on 7 May 1849.[13] Scheffer's image, or one of Currier's versions of it, might well have offered a precedent for certain visual and thematic aspects of *The Laborer's Vision of the Future*.

Scheffer's image was interpreted by those Americans and Europeans wishing to avoid controversy as a lesson in Christian consolation, Christ providing spiritual succor to the unhappy. But it was known as "Le Christ liberateur" as well as

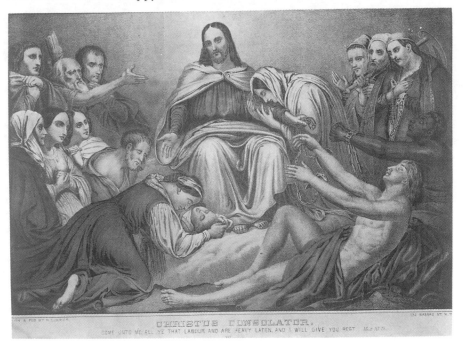

FIG. 44. Nathaniel Currier, after Ary Scheffer, *Christus Consolator*, undated; lithograph, 8⅞" × 12⅜". The Library of Congress. LC-USZ62-2869.

"Le Christ consolateur" and it held, particularly for sympathetic American viewers, this more incendiary message. It was mentioned appreciatively, for example, in the *National Anti-Slavery Standard* in October 1846.[14]

The lengthy encomium to *The Laborer's Vision* by "Senior" appeared in two antislavery publications, indicating that the vanquished Demon of Slavery in Rothermel's painting could be and was understood as specifically relevant to the United States and its future.[15] Indeed, as an article by Horace Greeley published in the *Nineteenth Century* in 1848 makes clear, all of the vanquished sins and evils represented in *The Laborer's Vision* were decried by reformers as characteristic of the United States as well as Europe:

While War is still upheld and sanctioned by the direct teachings . . . of the most enlightened nations in Christendom; while Slavery shakes its manacles in sight of our country's Capitol . . . it becomes us not to boast the moral elevation of our age. Still more when in the face of our wondrous inventions of labor-saving machinery . . . we find a large proportion even of the industrious and frugal still . . . pinched with hunger . . .[16]

Conceptually as well as visually, it would seem to have been a huge leap from the rocky foreground inhabited by Rothermel's laboring family to the distant realm of this apocalyptic panorama. The middle third of the composition apparently served as a bridge. As "Senior" explained, the left middleground gave "space to the atmosphere, grand and deep, and appropriate pitch and height to the cloud scene." The right middleground contained "a feudal castle, with crumbling turrets, whose base is upon the mound or ridge of the lower background scene." Its purpose was "at once [to] carry the eye from the principal figure below to the point in which the interest of the picture and the hope of its subject issues."

But this crumbling castle served as more than a visual link between the lower and upper segments of the composition: it brought the influence of the past to bear on the character of the present and the condition of the future. According to Patterson, it represented "the crumbling ruins of a barbarous past thunder[ing] in their fall." And to "Senior" it "symbolize[s] the despotism which has hitherto oppressed [the laborer], and give[s] the promise of its downfall and his ultimate deliverance. The towers which presumptuously pierced the sky are tumbling as the skirts of time sweep outward." Despotism—hallmark of those "false governments of the world at large" mentioned in the *Art Union Reporter*—was, through the symbol of a medieval castle, identified as the major cause of the laborer's oppressed condition.

Ruined castles and towers were, of course, popular romantic icons, reminders of the inexorable decay of man's endeavors and the world's ceaseless change. But the ruin also had social and political implications, suggestive of overwhelming revolutionary upheaval, and as a symbol of such it bespoke greater immediacy when depicted, as Rothermel apparently did, in the midst of its crashing demise.[17] That Rothermel's crumbling turrets likely reminded viewers specifically

of the 1848 revolutions is evident from a comment about those revolutions that appeared in the *New-York Daily Tribune* on 1 May 1848: "A grand era this; the Day of Judgment of Despotism!'" the *Tribune* cried, "Before the Jericho trumpets of the People the towers of the Metternichs and Frederick Williams, the Bastilles of the Louis Philippes and Nicholases are falling into ruins."[18]

The only known image from Rothermel's hand with a possible relationship to *The Laborer's Vision* is an undated drawing inscribed with the words "Lucifer As / the Angel of Revolt / Communion of the *Poor*" (fig. 42).[19] The drawing also depicts a turreted castle set high on a rocky cliff, and it specifically allegorizes those social and moral conditions that many at the time believed fed the spirit of revolution, suggesting that Rothermel produced it at a moment of strong interest in European uprisings. Those elements that it apparently shared with *The Laborer's Vision*—the castle, the paupers in the foreground, and the figure of Lucifer—all support a contention that the two images were conceptually, visually, and chronologically linked.

In the drawing, Lucifer appears as a dark angel with a shackle and chain around his visible ankle and chains hanging from his wrists. A large Bible lies, discarded, behind him. In the painting, as we have seen, a bat-winged figure knelt at Christ's feet, identified by all observers who mentioned him as Lucifer or Satan. To one commentator, this Lucifer specifically represented "the element of evil, oppression, and social tyranny."[20]

In Rothermel's drawing, Lucifer offers a chalice to a foreground group of figures, the suffering Poor. One sits, head bowed, in an attitude of abject despair, another reclines listlessly with a plaintive face and upturned eyes. Behind them is a mass of figures, which seems also to have drunk from the fallen angel's unholy chalice, and from it imbibed the spirit of Revolt. Perhaps Lucifer's "communion of the Poor" is bitter communion with "oppression and social tyranny"—the unbearable conditions that have finally driven the long-suffering masses to revolution.

The mob in Rothermel's drawing makes its way toward a castle, that clearly understood emblem of despotism, in order to bring down its turrets and reduce it to rubble. One figure in the left of the group holds what appears to be the faint outline of a knife, while others carry martial banners. Evil works its influence and by so doing unleashes a current of violence capable of surging out of control. Certainly the poor in Rothermel's drawing are not portrayed as diabolical agents—they are hapless victims—but neither can they be read as valiant heroes. Revolution is a two-edged sword: a force nurtured by tyranny and contributing perhaps to its downfall, but just as likely to disintegrate into a mindless delirium of destruction.

The source and means of true liberation, a liberation capable of lifting the weight of oppression from the backs of the poor and breaking the chains that

bind the Angel of Revolt himself, is evident in Rothermel's drawing as the holy book lying ignored at Lucifer's feet. Without its guidance, the drawing suggests, no new world can appear on the ruins of the besieged castle, and the Angel of Revolt can never be transformed—as he was in *The Laborer's Vision*—into the Angel of Freedom.

The Laborer's Vision seems to have presented an alternative to the image of social change depicted in "Lucifer as the Angel of Revolt," one certainly more appealing to its postmillennial Philadelphia audience, perhaps hinting at why Rothermel never produced the subject of the drawing as a painting either for himself or a patron, or even used it as an element of *The Laborer's Vision*. Violent revolution, it seems, was neither the model that Rothermel and his supporters chose to encourage in 1850, nor the villain they chose to condemn.

"Lucifer as the Angel of Revolt" suggests a possible narrative implied by the crumbling castle in *The Laborer's Vision*: that of violent revolt as an often understandable and potent means of social transformation. But no such explicit image of revolution appeared in *The Laborer's Vision*. The poor and oppressed figures in the painting did not succumb to satanic influence, but looked toward the image of Christ for their salvation. And the castle fell without the help of an impoverished mob incited by the Angel of Revolt; it was brought down by other, invisible forces.

Some viewers of the painting believed the castle was destroyed by the continuous and cumulative power of the human spirit. The *Art Union Reporter*, for example, described the painting's middleground scene in detail, noting that over the bleak foreground a noble landscape was

dimly lighted by the rising sun, whose rays . . . gleam upon the falling turrets of a feudal castle, which stands in relief against the iris of the awakening skies significant of that dawn of the moral world when error shall crumble beneath the overwhelming influence of enlightened reason and liberal institutions.

Here the feudal castle served not only as a visual embodiment of a despotic, barbarous, and oppressive past, but of the moral sin and error that ruled this past and still exerted its influence over the present.[21] The castle was succumbing not to revolution, but to the gradual and progressive evolution of human understanding. The natural metaphors of dawn and sunlight represented the first gleams of reason and liberality, which would eventually triumph in universally free, moral, and humanitarian government.

Ignorance, poverty, greed, oppression, human bondage, and war could all be eradicated if, *The Laborer's Vision* taught (as "The Angel of Revolt" did not), earthly relationships of humanity were improved. And the primary way to improve them and to realize the "good time" was to follow the example and precepts of Christianity. The centrality of Christ and the cross of his sacrifice rather than Lucifer as the Angel of Revolt in *The Laborer's Vision* indicates the force of

social Christianity in mid-nineteenth-century America, and of the importance of the gospel as a tool of reform. Christ—the Great Reformer—was the personal and spiritual model of most American advocates of social change.[22] "It is incumbent on us to do what in us lies for the downfall of all institutions and social usages not in unison with the law of Christ," D. H. Barlow reminded readers of *Graham's Magazine* in 1851.[23]

To viewers like Thomas Dunn English and Joseph Sill, the author of the notice in the *Public Ledger* reprinted in *Sartain's Union Magazine*, *The Laborer's Vision* preached the lesson of the Beatitudes. It was an image of humble piety and forbearance in anticipation of a heavenly reward, an admonition to, in effect, resist communion with Lucifer. But to the painting's most enthusiastic advocates, it was a call to condemn the evils of contemporary society and transform the temporal world, as active in its message as "Lucifer as the Angel of Revolt." To the *Art Union Reporter*, for example, its apocalyptic vision "shall be the result of a better administration of human interests in the 'good time coming.'" And to "Senior," the red light of the rising sun gilded the lower face of the traverse beam of the cross with a "glory that intimates an earthly millennium, and interprets the symbols into a promise for the present life."[24]

Rothermel's apocalyptic allegory was not a lonely aberration in mid-nineteenth-century American art; unfortunately, most related examples have, like *The Laborer's Vision*, disappeared. Yet the traces that remain of paintings like Rembrandt Lockwood's *Last Judgment* and Thomas Buchanan Read's *The Spirit of the Age*, together with those of Rothermel's *Laborer's Vision*, demonstrate how frequently painters expressed midcentury anxieties and aspirations in a visual language that defied laws of time and space and gave ideal human form to spiritual and social abstractions.

Rembrandt Lockwood's twenty-seven-by-seventeen-foot *Last Judgment* (now known through a preparatory drawing, ca. 1850; fig. 45) was begun in Munich in 1845 and underway in Newark, New Jersey, when Rothermel finished *The Laborer's Vision*.[25] Rothermel could very well have known of Lockwood's painting; whether he did or not, *The Last Judgment* seems visually analogous to aspects of *The Laborer's Vision*, particularly in its shift from a rocky landscape to a cloudy heaven in which a "train of spirits" sweeps upward.

The Last Judgment marks that point at the end of time and history when all righteousness is rewarded and all evil punished, immediately before the establishment of the New Jerusalem; it is not surprising that Lockwood's immense painting was, after its public exhibition, purchased for Philadelphia's Catholic cathedral. But this was clearly a Last Judgment for the revolutionary mid-nineteenth century, in which the United States was awarded a particularly holy place.

On the ground below the central cloud-borne figure of Christ sat George Washington, identified by the *Philadelphia Art Union Reporter* as "the type of

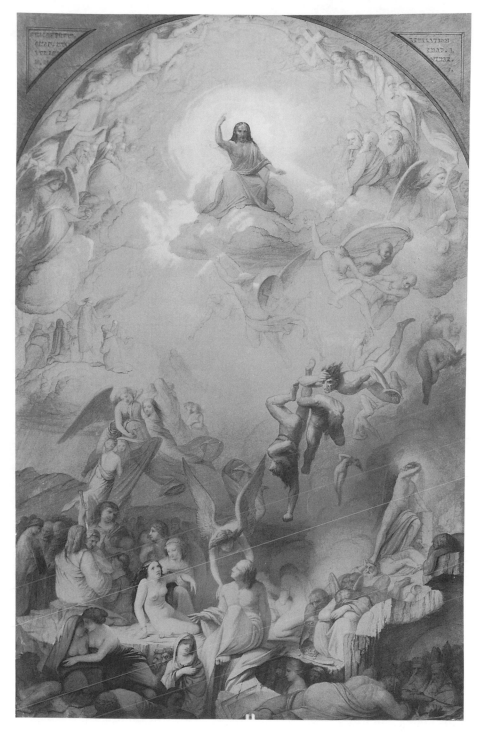

FIG. 45. Rembrandt Lockwood, *Study for "The Last Judgment"* (acc. no. 65.154), ca. 1850; pencil, was/paper, 37" × 24". The Newark Museum/Art Resource NY.

Civil Liberty." Washington personified the human counterpart to divine justice; the influence of the democratic government he embodied was essential to the ultimate redemption of humanity. Below Washington on the left appeared exemplars of the different races of mankind while to the right Despotism reclined at Washington's feet, "his crown broken, his robe stained with the blood of the weak . . . fettered in his own chains." (Rothermel's Lucifer as the Angel of Revolt was enchained as well, and in *The Laborer's Vision* he handed over his broken crown and scepter.) According to the *Reporter*, "above him in contrast are figures emblematic of Liberty and Slavery."[26]

Lockwood's contrast of liberty and slavery and his inclusion of two types of temporal government, the triumphant Civil Liberty and the vanquished Despotism, leave no doubt that this, like Rothermel's *Laborer's Vision*, was as much political as religious allegory, although temporally placed beyond the reach of mortal humans. The sins that are punished and the righteousness that finds its reward are social, not individual.

In *The Spirit of the Age*, painted in the same months of 1850 as Rothermel's *Laborer's Vision*, artist and poet Thomas Buchanan Read identified such millennial aspirations as the motivating impulse of his own time, aspirations fulfilled in the reformers' apocalypses imagined by both Lockwood and Rothermel.[27] According to a description published in the *Bulletin of the American Art-Union*, a large female personification of Justice, dressed in white with a wreath around her head, dominated the composition. Her right hand rested on a Bible held by the figure of Religion, "signifying that all real strength is founded upon the word of God." The left hand of Justice clasped that of Peace, who was in the act of crowning War, a bent figure breaking a sword over his knee. In the far left of the composition a North American Indian in blanket and moccasins leaned against a plough. Placed between the Indian and the trio of Justice, Religion, and Peace, "a recumbent slave just starting from bondage . . . is seen touching the hem of Justice."[28]

To Read, then, the guiding spirit of the nineteenth century was a progressive amelioration of humanity's condition, a process that civilized and domesticated the "savage" Indian, freed the slave, and weakened the power of war. Read conceived of himself and his fellow poets and artists as prophets of social justice helping to hasten the dawn of the millennium, a conception amply illustrated in his early poems denouncing the Mexican War and American slavery and celebrating the European revolutions.[29]

The Spirit of the Age, along with its companion allegory, *The Blacksmith Shop of the Nineteenth Century* (discussed in the following chapter) were sold to an English gentleman. But Read was commissioned by James Claghorn of Philadelphia to produce replicas of both works for an unnamed American patron. As the nineteenth century marked its midpoint, then, such ostensibly un-American and esoteric flights of fancy as those painted by Read and Rothermel conveyed serious, specific meanings to a significant number of enthusiastic champions.[30]

* * *

Hector Tyndale, the Philadelphia merchant who commisioned *The Laborer's Vision* from Rothermel, was one such enthusiastic champion of allegorical art. He was also, as we shall see, a firm believer in the amelioration of humanity's earthly condition, and evidence suggests that he rather than Rothermel deserves primary credit for the painting's program.

Tyndale's father, Robinson, emigrated from Ireland early in the nineteenth century and married Sarah Thorn, a Philadelphia native and member of the Society of Friends. Hector, born in Philadelphia on 25 March 1821, was educated in that city and had ambitions for a military career, which were discouraged but not squelched by his Quaker mother. Rather than attend West Point as he desired, Hector entered his father's business. In August 1842 he married Julia Nowlen of Philadelphia and in 1845 became partners in a glass and china importing firm with his brother-in-law Edward P. Mitchell.[31]

Sarah Tyndale appears to have been an important influence on her son's moral and ethical orientation. A Quaker, she was also, in the 1840s and 1850s, a supporter of the Associationist North American Phalanx and then the Raritan Bay Union, an ardent abolitionist, and a lover of the arts.[32] Hector's own involvement in political, social, and moral issues, while not identical to his mother's, is evident from a variety of sources.

According to his friend John McLaughlin, "in the 'irrepressible conflict' which then [in the early 1850s] agitated the country [Tyndale] was active in favor of Free Soil and Free Speech."[33] Tyndale supported the rising Republican Party; in 1856 he championed the candidacy of John C. Fremont and was a member of the Republican City Executive Committee. In 1868 Tyndale was nominated as Republican candidate for mayor of Philadelphia, a contest he lost.

McLaughlin continues, "all anti-slavery movements had his earnest sympathy and active support." McLaughlin, writing in 1882, two years after Tyndale's death, hastened to add that his friend was "not what was termed an abolitionist," a denial that illustrates the fanaticism associated with that term as well as the biographer's desire to distance his subject from its onus. But the fact that in December 1859, Tyndale escorted John Brown's wife to Virginia to witness her husband's execution and then returned with her to Philadelphia with the body—unpopular and potentially dangerous tasks—indicates the strength of his feelings against slavery.[34]

Tyndale's continuing antipathy to the institution of slavery, his visible condemnation of it, and his sympathy with those who fought against it, however violently, is clear enough in his affiliations and actions. The vanquished Demon of Slavery who holds up his broken chains in *The Laborer's Vision*, then, must certainly have referred, at least in Tyndale's mind, to American chattel slavery as well as more general notions of oppression.[35]

Tyndale's Republican affiliation, although postdating his commission of *The Laborer's Vision*, provides other insights into the genesis of painting. Central to

the platform of the Republican Party in the mid–1850s was, as Clifford E. Clark, Jr., explains, "the middle-class notion that free labor, as the source of social mobility and economic independence, was absolutely necessary to a functioning democracy."[36] These tenets grew largely out of the Free-Soil Party of the late 1840s and early 1850s; Tyndale, as we have seen, was a Free-Soiler before he became a Republican. Labor—degraded and not free—is the focus of his commissioned allegory. The promise of democracy would only be realized when war, slavery, and selfish greed no longer affected the condition of labor, when labor could earn its way along an upward path of economic, social, intellectual, and spiritual amelioration.

Unitarian minister William Henry Furness (well known in Philadelphia and elsewhere for his fervent antislavery sermons of the 1840s and 1850s and an actor in the John Brown drama of 1859) testified to Tyndale's moral and spiritual character in his Easter sermon of 20 March 1880, the day after Tyndale's death:

[He was] a man of no ordinary simplicity and elevation of character; a lover of Freedom and Humanity from early youth—in righteous cause knowing no fear. At a time when it was at the peril of his life, he "confessed with his mouth" his faith in the Right, which is one with the truth of Christ.[37]

Furness's eulogy suggests a nonsectarian (though generally Protestant), nondogmatic religious and social liberal. According to McLaughlin, Tyndale countered attacks on his religious character in the mayoral race of 1868 with these words: "Although not the member of any church, I am not an irreligious man, as all my friends will attest."[38]

But Tyndale's involvement with Republican politics and the affairs of John Brown, his service in the Union army, and his unsuccessful mayoral candidacy were all in the future when, sometime in 1850, he asked the young Philadelphia artist Peter Rothermel to paint *The Laborer's Vision of the Future*. At this point, Tyndale was an antislavery Free-Soiler, and he was also a manager of the Mercantile Beneficial Association of Philadelphia. Tyndale's involvement with that organization affords the clearest evidence, in his own words, of his social and spiritual beliefs at the time the painting was commissioned, and it goes a long way toward explaining why he commissioned the work in the first place.

The Mercantile Beneficial Association of Philadelphia, organized in April 1842 and incorporated in 1844, was, like groups from Odd-Fellows to Associationists, fruit of the nineteenth-century American spirit of association, that yearning for and belief in cooperation and community as a counterweight to rampant competition and individualism. Like the Odd-Fellows, the Mercantile Beneficial Association was established to provide financial relief for its members, in this case merchants and clerks, and to alleviate bodily and spiritual distress.[39]

Several of the association's twenty managers wanted to broaden the scope of the group's activities. According to the association's ninth annual report (published in November 1851), it decided to offer lectures, addresses, and debates for the benefit of the approximately four hundred members who paid their annual three-dollar dues. A large rented room in a building on the corner of Tenth and Filbert Streets became the association's first meeting place; it was open nightly for the social and intellectual advancement of the group's merchants and clerks.

On 8 May 1850, Hector Tyndale presented an address before the association in celebration of its expanded mission and its new room. (His selection for this honor suggests that he was a prime mover behind the enterprise.) It was an enterprise, Tyndale hoped, that would bring the community of business into closer harmony.[40] In Tyndale's view, this community included anyone, "however humble may appear to be their rank, who may be engaged in trade, in the interchange of products, whether of the ground, of the hand, or of the brain."

The Mercantile Beneficial Association was to be no mere social club. Tyndale dreamed of a mutually cooperative social brotherhood where barriers of wealth and class dissolved, and his words demonstrate a firm conviction that individual moral changes united to effect worldwide social progress. Although he eschewed membership in an organized church, Tyndale, this address makes clear, has faith in a direct and humanitarian Christianity. Christ, in this speech as in *The Laborer's Vision*, is the model and source of all moral qualities toward which humanity should aspire.

Tyndale imagined the spread of universal benevolence as if by an expanding ripple of water, moving from one human consciousness to another. "It is from this room we will hope that with [our Father's aid] a beginning will be made in the elevation of the mercantile character." If the character of Philadelphia's merchants were elevated, Tyndale prophesied, so would be that of the entire community in which they lived, and beyond that, the entire state. And, he continued,

if successful now, not here will this change stop, but throughout this brotherhood of states will this ever widening circle roll, and still extending, with the free thoughts that always radiate from the truth, however humble, it will progress throughout the world. These may appear as visions, and so they are now, but time and labor bring all things nearer to us.

In this way, a single conversation among brother merchants, a single address delivered in a single hall, even a single painting, all had an effect on humanity's ultimate destiny. "The character of the mind, and through that our very religion," Tyndale explained, "is influenced by the circumstances around us; soil, climate, food, clothing, household furniture, our works of art, all have their influences on the spirit of man. This being so, then he, who modifies them, will act upon the sentiment and thought of man." It is tempting to speculate that Tyndale commissioned *The Laborer's Vision of the Future* expressly for the new

meeting room of the Mercantile Beneficial Association and that the painting hung there as visual exemplar and agent of elevation.

Professing dislike of abstractions, Tyndale stated that the merchant should never be a visionary, although he recognized that many would call his own principles utopian and impractical. He vigorously denied these labels. "It is your real practical man," he explained, "who believes what he receives as truth, and believing, strives to bring it into practical uses." Tyndale considered himself a pragmatic businessman who believed in his ability and the ability of his fellow merchants to effect change in an imperfect world of greed and conflict. Rothermel's painting, presenting its patron's beliefs in visual form, was one concrete way to promote truth through the practical application of principles.[41]

All forms of labor, Tyndale explained, "are equally necessary and honorable, and all should be in harmony" because "the Father of us all is the centre of all labor." This truth "ought to be a part of our religion." The merchant must not be merely a businessman, a money maker, an exploiter of labor for his own gain. He should take his place on "the battlefield of life" as a member of "the serried ranks of labor," answerable to the "wishes of our commanders-in-chief—the people." The merchant's true role was as aide to—not master of—the laborer. "It is impossible that the producer whose constant attention is required by his vocation, can leave his field, his anvil, or his loom, to carry his products to the world, seeking for a market."

The merchant was, or should be, the connecting link of civilization, the essential cord that united the laborer who produced with the consumer who required his products. The merchant connected distant lands and served as a conduit for the material goods and, thus, for the ideas of diverse nations and cultures. As Tyndale explained, "the merchant is he who weaves the many wants of mankind . . . into one homogeneous web. . . . Peace, universal peace, and love among mankind can be aided by our efforts."

Given his exalted view of the merchant's millennial role, why, we might wonder, did Tyndale give labor and not commerce pride of place in his millennial allegory? Why not commission *The Merchant's Vision of the Future*? To put it another way, why would Tyndale wish to display such solidarity with and understanding of the plight of labor at a time when he was so obviously concerned with the elevation of mercantile character? Perhaps the answer lies in a sensitivity to contemporary critiques of that very mercantile character.

Although there is no evidence that Tyndale was an Associationist, despite his mother's financial and moral support of the movement, he was doubtless aware of and sympathetic with its denunciations of modern society. But he cannot have been comfortable with Associationism's conception of the merchant. In his address to the Mercantile Beneficial Association, Tyndale, successful merchant with a stake in industrial capitalism, as well as social critic, offered what was in effect a rebuttal to those who, like most Associationists, wanted to dismantle rather than reform America's competitive order.

European and American Fourierists agreed that grasping and fraudulent merchants, as well as bankers and speculators, epitomized modern civilization. "American Associationists echoed [Fourier's] disdain for middlemen . . . they made an invidious distinction between real 'producers' of wealth and 'nonproducing' distributors of it, between 'virtue' and 'commerce.'"[42] Tyndale, as we have seen, argued for the mutually beneficial relationship of producers and distributors, and the compatibility of virtue and commerce.

In a specifically Americanized Fourierist critique, Associationists "stressed the moral and psychological damage rather than the strictly economic injustices of competitive capitalism."[43] Tyndale, too, recognized that such damage occurred and that selfishness, dishonesty, and avarice were often "the result of trade upon individuals." But his efforts were precisely to illustrate that such effects could be successfully counteracted. One means to counteract them was to remind members of the mercantile community of their solidarity with labor and to illustrate how they, too, could and should be agents in the Christian struggle against avarice, slavery, and war. With *The Laborer's Vision of the Future*, Tyndale demonstrated to the spectrum of reformers in Philadelphia, as well as to the members of the Mercantile Beneficial Association, that commerce *could* respect, love, and support labor and *would* be there to help usher in the "good time."

Indeed, were a struggling American artisan or factory girl to have viewed *The Laborer's Vision* he or she may well have been moved by its apocalyptic promise. In millennialism, according to historian Jama Lazerow, antebellum labor's "critique and vision came together in its most developed form," since it "embodied both a critique of this world and a vision of a new one." Many labor activists, Lazerow explains, shared a social vision that "sought not individual redemption alone but the deliverance of humanity," based upon a belief in Christian brotherhood that "spoke not only for the laboring classes but for the community as a whole. . . . [T]he vision of the coming kingdom as articulated by antebellum labor activists was a leveling one, on accordance with biblical prediction."[44]

There was a close alliance, then, between the rhetoric of some working-class labor activists (and the beliefs that generated it) and the rhetoric of reform-minded members of the business middle-class like Tyndale—though the two parties might have deep-seated and irreconcilable antagonisms. Sharing faith in the necessity of Christian means to effect social change, both appealed to moral precepts of brotherly love, thereby floating above the surface of class tensions. Neither wished to exacerbate social strife; they focused on the power of Christian love and called on individual stores of mercy and charity.[45] This melding of the critical and the conciliatory is a significant aspect of the didactic strategy of Tyndale's *Laborer's Vision* and of postmillennialist social reform in general.

But what of the laborer whose skill gave form to Tyndale's ideas? Was Peter Frederick Rothermel a mere hired hand with no understanding of his patron's

beliefs? As Philadelphia's foremost history painter, Rothermel was the logical choice for any patron who wished to commission a large, multi-figured allegorical work.[46] Yet Tyndale's selection of Rothermel was motivated by more than convenience or reputation: the merchant also commissioned Rothermel to paint his portrait and bought many of his works, suggesting an intellectual, aesthetic, or personal affinity between artist and patron.[47]

Two paintings that Rothermel executed almost contemporaneously with *The Laborer's Vision*, suggest that the artist did, in fact, sympathize with the message of *The Laborer's Vision*, and that the complex allegory signified more to him than a means to make money, please an important patron, and exercise his skill as an artist of intellectual and spiritual art. *Murray's Defense of Toleration* (1849–1850) and *Patrick Henry in the Virginia House of Burgesses, Delivering His Famous Speech against the Stamp Act* (1851) provide evidence of the artist's (as distinct from his patron's) social concerns at the time. In addition, they share certain thematic and visual elements with *The Laborer's Vision*.

Murray's Defense of Toleration, now known only through engravings (fig. 46), depicted an incident from the life of Mary, Queen of Scots, in which the Earl of Murray prevented a mob of fellow Protestants from disrupting a Catholic mass.[48] One observer recognized the contemporary relevance of Rothermel's painting at a time when anti-Catholicism was emerging as a strong political force. Considering "the antagonistic position of two Religions—the Protestant and the Roman Catholic—still standing in our day in the same attitude of rivalry and defiance," this subject was not to be dismissed as an insignificant incident from a long-buried past.[49] Through its depiction, Rothermel publicly argued for broad-mindedness and liberalism in the face of rabid sectarianism. This painting must have been one of several pictures by Rothermel that, according to an article in the *American Whig Review*, "illustrat[ed] the progress of freedom of thought and opinion."[50]

Murray's Defense of Toleration contained more than an apparent plea for religious tolerance, however. Thomas Dunn English noticed "a keen stroke of satire . . . on the right of the picture. A famished woman, with a sickly child, crouches in a corner, dismayed at the fierce strife." This pathetic mother and child call to mind the similar pair in Rothermel's *Laborer's Vision*, and both maternal groups must have shared an emotional bond with *Factory Life* (1852), Rothermel's small drawing of a cotton mill worker and her children (fig. 47).[51]

In *Murray's Defense of Toleration*, Protestant religious zealots were blinded by sectarian fanaticism to a silent plea for Christian charity. The painting's vocabulary was historical but its meaning contemporary. Acceptance of a universal religion of love, charity, and tolerance was more important than upholding conservative traditions, which reinforced sectarian barriers, hardened the human heart, and promoted violent conflict. Although the painting's message does not exactly parallel that of *The Laborer's Vision*, it conveys a similar critical spirit and a similar faith in the social value of spiritual virtues.

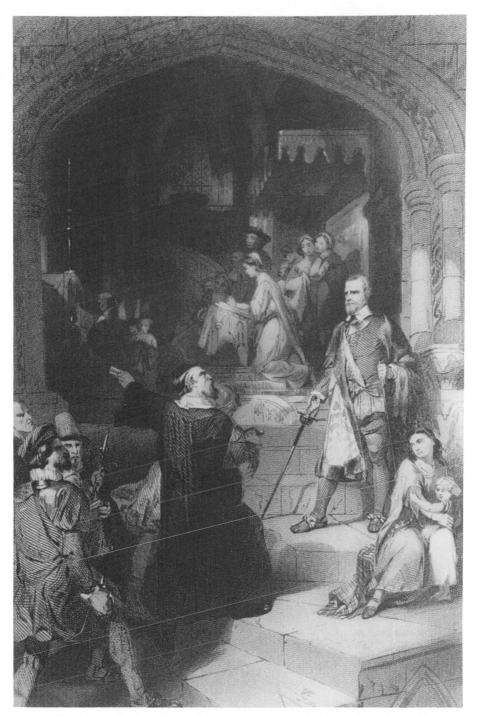

FIG. 46. Alfred Jones after Peter Frederick Rothermel, *Murray's Defense of Toleration*; etching published in *American Art-Union Bulletin*, September 1851. © Collection of The New-York Historical Society.

FIG. 47. Peter Frederick Rothermel, *Factory Life*, 1852; ink, wash/paper, 8⅞" × 11¼". Private Collection.

Rothermel's began his best-known painting of the early 1850s, *Patrick Henry in the Virginia House of Burgesses, Delivering His Famous Speech against the Stamp Act* (pl. 7), approximately three months after he had completed *The Laborer's Vision of the Future*. It, even more than *Murray's Defense of Toleration*, provides a thematic counterpoint to that allegory.[52] Although the painting's subject was certainly calculated to spark pride in American history, it is not merely a patriotic tribute to long-dead revolutionary heroes. The crumbling feudal castle of Despotism thunders as loudly in *Patrick Henry* as it did in *The Laborer's Vision*. Like *The Laborer's Vision*, it is a devout statement of faith in the approaching millennium produced in the wake of the 1848 revolutions. Rothermel's *Patrick Henry* treats the progress of apocalyptic history in a manner that complements the message of *The Laborer's Vision*, by providing a specifically American context for that coming millennium.

In the early months of 1851, the managers of the Philadelphia Art Union decided to add a new feature to their plan: to commission annually an original painting from a prominent artist, have it engraved for subscribers, and award it as a prize.[53] The managers of the art union undertook this project because they were, in the words of their resolution, "deeply impressed with the utility, necessity, wisdom and moral influence of cherishing a national spirit, in the patronage of the Arts of Design, in the United States, and a national pride in the excellence of her living artists." Perhaps Patterson's call for a truly American art, delivered at the end of December 1850, had helped spark interest in an art that was American in spirit and influence.

Rothermel was selected to produce the first of these pictures.[54] By January 1852, the seven-by-six-foot painting of Patrick Henry was complete, and the *Art*

Union Reporter pronounced it a "splendid effort of genius."[55] In June 1852 the art union published a key to the figures and an explanation of the subject (fig. 48).[56] According to this pamphlet, Rothermel's painting commemorates that daring moment in May 1765 when Patrick Henry, before the Virginia House of

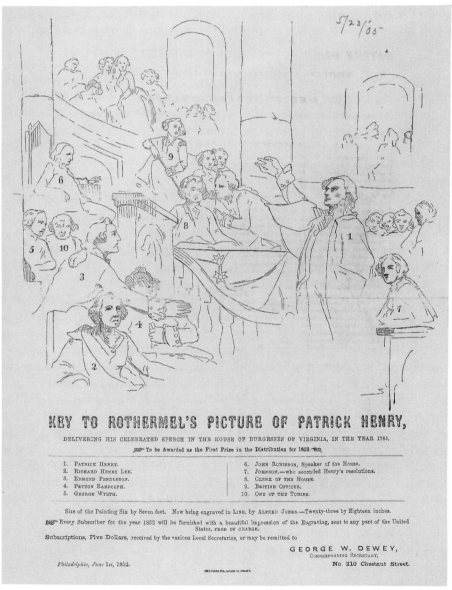

FIG. 48. "Key to Rothermel's Picture of Patrick Henry." [B.B.C. Wn* 681 V.1] from the Painting by Rothermel, Peter Frederick, 1817–1895, engraved by Alfred Jones for the ABT Union of Philadelphia, 1852. The Historical Society of Pennsylvania. Historical Society of Pennsylvania (HSP), Peter Frederick Rothermel.

Burgesses, announced his resolutions in opposition to the hated Stamp Act, the first direct tax levied by the British parliament upon the American colonists who saw it as evidence of tyranny. "'Ceasar had his Brutus!" Henry cried,

"Charles the First his Cromwell, and George the Third _____." At this moment the speaker cried "treason!" and "treason, treason!" was re-echoed in every part of the House. Henry faltered not an instant, but rising to a loftier attitude, and fixing on the Speaker an eye of the most determined fire, he finished the sentence with the firmest emphasis— "may profit by their example! If this be treason, make the most of it."[57]

Patrick Henry, his right arm raised, dominates the vertical arrangement. He addresses the cringing figure of John Robinson, Speaker of the House, located in the upper left. In the middle of the composition, the clerk of the house looks on in consternation while a member approaches to whisper "impeachment" in his ear. In the left foreground, Edmund Pendleton, a distinguished lawyer, extends his hand as if to silence the inflammatory Henry. Seated in front of Pendleton, Richard Henry Lee grips his chair and gazes out of the composition. All around, other figures stare, some infuriated by Henry's audacity, others galvanized by his courage. Women, alarmed by the cries of treason, are hurriedly leaving their seats in the gallery. A mysterious glove, its owner not identified by any visual clue, lies directly in the center of the painting's foreground and suggests that this is a moment of dangerous challenge.

Rothermel originally envisioned a horizontal format and a simpler composition for the painting.[58] The vertical orientation of the finished work emphasizes the drama of the moment, though it plays havoc with the architectural reality of the House of Burgesses in Williamsburg. Rothermel placed women, who were not allowed into the chamber of the House, in an imaginary gallery. Like peripheral but presiding angels, brightly lit and in the direct line of Henry's eloquently raised arm, they register alarm and interest in the proceedings and obliquely acknowledge a feminine contribution—albeit supportive—to Revolutionary struggle.

Rothermel also took liberties with the figure of Patrick Henry. The artist admitted that the red cloak was historically inaccurate, and he gave Henry a powdered wig instead of a more likely, and more modest, brown one. The red cloak and white wig add a dimension of authority and dignity to the figure that stricter realism might have muted.[59] Still, Rothermel clothed his hero in plain dark vest, breeches, and stockings, which contrast with the gorgeous apparel of most of the other burgesses. Apparently, Rothermel wished to indicate Henry's modest egalitarianism and his dislike of aristocratic privilege, as well as the inherent nobility and grandeur of a born leader.

The theme of *Patrick Henry* affirms a fundamental tenet of American self-definition—the country's God-given custodianship of individual liberties—at a moment when Americans, concerned with the developments in Europe, were

particularly aware of their providential mission. We will remember that on 14 May 1848, Albert Barnes presented his sermon entitled "The Casting Down of Thrones: A Discourse on the Present State of Europe" at the First Presbyterian Church in Philadelphia. In it, Barnes made clear the debt that many Americans felt Europe (particularly France) owed them: "She has caught the love of liberty from our example . . . and seeks to enjoy a republic modeled after the fashion of our own." In his view, the American and European revolutions were all stages in the world's progress toward the millennium.[60]

Barnes's phrase "the casting down of thrones" suggests an illuminating thematic parallel to Rothermel's *Patrick Henry* as well as to the imagery of a crumbling feudal castle at the heart of *The Laborer's Vision* and "The Angel of Revolt." Rothermel, it should be noted, was married in a Presbyterian church in Philadelphia in 1844.[61] This is not to claim a direct connection between Rothermel's paintings and Barnes's sermon, but rather to acknowledge that they are almost contemporary products of a similar social and religious milieu.

Like Barnes's sermon, Rothermel's painting links his nation's successful eighteenth-century revolution to the mid-nineteenth-century European upheavals then running their course. This relationship, implicit in the painting, becomes clearer when Rothermel's work is compared to an almost contemporary European painting. Mark Thistlethwaite has observed that Belgian artist Godefroid Guffens's *Rouget de Lisle Singing the "Marseillaise"* (fig. 49) was one possible inspiration for Rothermel's *Patrick Henry*.[62] Dated 1849 and on view in Philadelphia since 1849 or 1850, Guffens's image was itself a reaction to the 1848 French revolution. It depicts that moment when young Rouget de Lisle first sang his new composition, "the celebrated Marseillaise hymn."[63] An article in *Graham's Magazine* attributed the popularity of Guffens's painting to its subject, which "appeals to that feeling so quickly aroused in every American heart . . . the hatred of tyranny and oppression."[64] Rothermel's Patrick Henry and Guffens's Rouget de Lisle are brothers united against tyranny. Both paintings focus on a brave young leader whose inspired face, upraised arm, and impassioned words send shock waves through his transfixed listeners.[65]

And both paintings lead the viewer's imagination into the future. To the mid-nineteenth-century mind, the historical past illuminated and informed the present and both past and present had significance only if they carried a prophetic message. "As we look at the picture," *Graham's Magazine* observed about *Rouget de Lisle*, "we can almost hear the terrific, rolling thunder of the wildest storm that ever swept over humanity; that fearful hour of reckoning approaches, which shall atone to heaven for earth's crying sins of oppression endured for years." That hour of reckoning—an apocalypse in the guise of revolution—is also glimpsed in Rothermel's *Patrick Henry*.

Like Barnes's sermon, Rothermel's *Patrick Henry* recognizes the apocalyptic implications the nineteenth century saw in these and all revolutionary struggles. The prophetic dimension of Rothermel's painting is manifest in the figures of

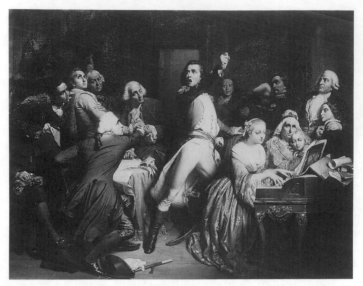

FIG. 49. Godefroid Guffens, *Rouget de Lisle Singing "The Marseillaise,"* 1849; oil on canvas, 52" × 67". Acc. No.: 1851.1. Courtesy of the Pennsylvania Academy of the Fine Arts, Philadelphia. Academy purchase.

Patrick Henry and the Speaker of the House, probably inspired, as Thistle-thwaite has observed, by the prophet Daniel and King Belshazzar in Washington Allston's *Belshazzar's Feast* (fig. 1). Patrick Henry, symbol of American mission and agent of divine admonition, warns the English monarchy of its impending defeat, just as Daniel prophesied the fall of Babylon. Poised against a dark and shadowy backdrop, with the same pose and fervor as Allston's Daniel, Henry gestures toward a brilliant, empty expanse of wall. Rothermel's Speaker, like Allston's Belshazzar, draws back in alarm from the warning. *Graham's Magazine* described Rothermel's figure of Henry in language that emphasizes a message of divine justice: "The impassioned orator stands erect and self-possessed, his open hand aloft, as though a thunderbolt has just passed from his fingers."[66]

Just as Rothermel's *Patrick Henry* recognizes American leadership in the progress of freedom, it also suggests the still-unfolding nature of this progress. The casting down of thrones evoked in Barnes's sermon is implied in Henry's accusatory gesture. In *Patrick Henry* we can discern the first tremors of an apocalyptic earthquake destined to crumble all thrones and castles to dust—castles like the one at the center of *The Laborer's Vision of the Future.* In his *Patrick Henry*, Rothermel has reconstructed, as Barnes put it, "an epoch in the history of the world—a step in the progress towards that period when 'thrones' are everywhere cast down, and when universal liberty shall prevail."[67]

This approaching millennium of universal liberty is implied in Rothermel's composition by the figure of Richard Henry Lee, who, like Henry, opposed the

Stamp Act. While the cowering Robinson is small and almost lost in the shadows, Lee shares compositional weight with Henry. Both wear warm, richly colored drapery and are linked by subtle parallel gestures.

Yet, while all other eyes are pinned on Henry's powerful form, Lee has his back toward the excitement. Lee's gaze and position lead the painting out of Revolutionary America into the mid-nineteenth-century and beyond. Although he focuses above it, an ominous shadow darkens the empty space before him. He grips the edge of the table and the arm of his chair with almost painful force. He concentrates on an internal vision inspired by the import of Henry's prophetic words and action. Rothermel's figure of Lee, his body frozen in tense anticipation as he gazes into the future, suggests the mingling of hope and fear characteristic of the times.

"Lee sees by a sort of prophetic intuition," wrote the reporter for *Graham's Magazine*, "the full import of this inspired oratory. His very face, under the magic of Rothermel's genius, is a long perspective of war, desolation, heroic deeds, and the thick-coming glories of ultimate civic and religious liberty."[68] Lee imagined the struggle and sacrifices that would have to be endured. More important, he saw beyond to the blessings of liberty that would eventually be realized. Millennial perfection, which Rothermel placed among the clouds in *The Laborer's Vision of the Future,* may be the ultimate civic and religious liberty that Lee perceives beyond scenes of war and discord. Such an image might be called "Richard Henry Lee's Vision of the Future."

Few Americans believed that this "ultimate civic and religious liberty" had yet been attained, even in the progressive United States—*especially* in the United States. As Barnes ruefully acknowledged, "*our* principles of liberty strangely stopped before we reached . . . universal emancipation . . . and millions are still held in bondage." But Barnes did not despair because "they that rejoice with France; they that exult with the hope that Europe will be emancipated . . . are holding up a sentiment which will yet emancipate every human being from oppression and bondage. And to that the world is coming."

Perhaps Rothermel chose Lee to serve as the prophet who envisioned a state of "ultimate civil and religious liberty" because of his pioneering opposition to slavery as well as his support of Henry. Lee's first important speech before the Virginia House of Burgesses, delivered in November 1759, was an impassioned plea for the abolition of slavery. He argued that blacks as well as whites were "entitled to liberty and freedom by the great law of nature," and he implored his fellow burgesses, as Christians, to "convince the world that we know and practice our true interests, and that we pay proper regard to the dictates of justice and humanity!"[70]

Rothermel's *Patrick Henry* is a double portrait of American prophecy in action. Patrick Henry, a plebeian Daniel amid the richly aristocratic House of Burgesses, thunders a warning to despotism as embodied in the power of George III. He fills the timid with courage and literally points the way onward and upward.

Henry is the prophet as the voice of divine warning, urging the present to act in order to save and sanctify the future. On the other hand, Lee the visionary seer is outwardly removed and ostensibly passive as he inwardly paints a glorious social millennium to be realized after the inevitable period of violence and upheaval.

In Lee, the art union pamphlet observed, "the artist has embodied the poetic sentiment of the occasion—that foreseeing, prophetic genius, which could trace upon the airy future, the impending consequences of those words." Lee's intense expression "seems to wrap his gaze in the divinity of a soul." Those qualities most associated with artistic genius were also used to characterize Richard Henry Lee and make him the perfect embodiment of prophecy.[71]

Late in life, according to a biographer, Rothermel wrote of the courage necessary to sustain the true artist in his lonely mission. This artist must have a "love of nature and of the truth, a firm determination to do the best, to express from his own standpoint, his own vision, paramount, and then in spite of laughter from friends and sneers from enemies."[72] Isolated from the excited and confused crowd, yet intensely alive to the portentous signs of the times, the artist-prophet recognizes the grand scope, the cosmic implications, the social as well as spiritual promise of these signs.

In *Patrick Henry*, Rothermel visualized the struggle of liberty and despotism at a specific moment of the American past, yet he did so in a manner that carried the struggle into the American present and toward a destiny of "ultimate civil and religious liberty." In narrative sequence and causality, *Patrick Henry* precedes *The Laborer's Vision*—the latter would not be possible without the former—yet the history painting grew out of Rothermel's sympathy with the revolutionary spirit of his day, reinforced and encouraged by his experience with religious allegory. Merging secular and sacred, the national and the universal, Rothermel's two visions of apocalyptic transformation demonstrate how the nation's past served as compass of its future.

1851: Jasper F. Cropsey and *The Spirit of Peace*

In the spring of 1851, Jasper Francis Cropsey began work on a pair of "epico-allegorical" paintings larger and more complex than any he had previously undertaken (pls. 8 and 9). He did so without the security of a commission because, as he explained, "an artist to do justice to himself and his art should seek to express on his canvas the highest intellectual expressions."[1] Since the general public and most patrons were more appreciative of an "every-day kind of art," Cropsey wrote, "at my leisure I engaged upon these pictures—my first efforts in this class of art."[2] Using natural, historical, and, especially, Christian associations and symbols (many of which also appeared in Rothermel's slightly earlier *Laborer's Vision of the Future*), Cropsey contrasted the fiery blast of war with the cool repose and quiet industry of peace.

In *The Spirit of War*, a forbidding medieval castle with flame-lit windows rises from a bed of jagged rocks and sprawls across the painting's middleground, "presenting" in Cropsey's words, "a stern visage of defiance and awe."[3] His turreted castle is clearly analogous to the structure emblematic of despotism that crumbled in the center of Rothermel's painted allegory and appeared in his related drawing.

Cropsey's immense tower is echoed by a fantastic outcropping of the snow-covered mountain in the distance; the natural and the man-made are united in vertiginous sublimity. Lowering clouds choke the background and accentuate the orange glow of a hamlet burning in the left middleground. Knights on horseback gallop across a bridge toward yet another battle, while in a cave located in the right of the painting, a wizard, Cropsey tells us, practices his "evil incantations" in keeping "with the instincts of the times." A young goatherd runs to the castle for protection and in the extreme left foreground an exhausted mother and her infant cower on the ground. "Pastoral life and Domestic Happiness find only desolation in war," Cropsey observed; "Its stern mountains promise no prosperity to agriculture, and no where is there the genial impulses we seek in peace."

The idyllic Mediterranean coastline of Cropsey's *Spirit of Peace* evokes a completely different time, place, and spiritual condition. The painting's rolling, verdant terrain dotted with graceful palm trees and venerable olive groves offers

respite from the awful sublimity of *War*'s alpine crags and gnarled, blasted trees. The golden haze, the central tholos temple, and the robes worn by the figures suggest that *Peace*—certainly indebted, as is *The Spirit of War*, to works by Thomas Cole[4]—expresses nostalgic yearning for a long-departed golden age.

Rather than lamenting a lost classical arcadia, however, Cropsey's *Peace* looks forward to the realization of a Christ-centered earthly millennium, a vision reinforced by Cropsey's reworking of the subject as the *Millennial Age* (1854; pl. 10). Temporally and spiritually, Cropsey's *Spirit of Peace* is analogous to the "apocalyptic panorama" with Christ at its center that dominated the upper section of Rothermel's *Laborer's Vision of the Future*.

Visual clues link Cropsey's pair of images and indicate their chronological relationship: *Peace* is a sequel to *War*. The ruins of medieval buildings with pointed arches are visible in the left middleground of *Peace*. The diagonal foreground path traveled by the armored knights in *War* is in *Peace* walked by another goatherd and his flock, untroubled by strife and destruction. The mother and child sprawled helplessly on the ground in *War* stand placidly in *Peace*, the mother holding her distaff.

"We perceive a great change has come over that which was once the scene of war," Cropsey explained, "All the strife and incidents of it have passed away, leaving as it were its ruins to cover the ground." *War*'s crumbling and overgrown tomb sits in the extreme right foreground of the painting. Carved on its sides is "rude sculpture" depicting, on the right, a knight riding to battle, and on the left "the figure of Death bearing . . . torches and treading on the dead."

The vast, asymmetrical pile of rock and castle at the heart of *War* is replaced in *Peace* by a harmoniously round classical structure that serves as this painting's central architectural emblem. "Rising above all . . . is the Temple of Peace . . . occupying a commanding position and prospect over a fruitful country, growing city, and open sea." Its design and ornament incorporated elements generally associated with "peace and plenty" as well as with more specifically Christian beliefs, such as the wheat sheaves and palm branches that are "carved" along the cornice. Flowering lily stems are visible among the acanthus leaves on the capitals and at regular intervals along the frieze. Cropsey made special note of the red bands of porphyry that girdle the frieze and the top of each column, identifying them as symbolic "belts of love in contradistinction to war's red emblems of destruction and death."[5]

Most important, however, is the temple's frieze containing scenes from the life of Christ. The first compartment fully visible on the right depicts "angels proclaiming the birth of the prince of Peace"—the First Advent—and includes the barely legible inscription "On Earth Peace." The next complete scene shows a seated Christ delivering his Sermon on the Mount and contains the words "Blessed are the Peace Makers." The compartment furthest left depicts Christ's triumphant entry into Jerusalem with the words "Peace in Heaven," clearly prefiguring the millennial promise of Christ's Second Advent.

In the center of the temple Cropsey depicted an "altar of Angels, [each] holding an open book with letters of gold." And closely abutting the temple was "an emblem of prophetic fulfillment," a sculpture in the round mounted on a square base with roundels carved in relief. The combined subjects of this structure—which parallels war's tomb in its size and shape—suggest the message written in the altar's open books. The figures of lion, lamb, and little child are emblems of the Messianic Age described in Isaiah 11:6: "And the wolf shall dwell with the lamb, and the leopard shall lie down with the kid, and the calf and the lion and fatling together, and a little child shall lead them."

A childlike figure hammering at an anvil appears in the relief below this group and refers to Isaiah 2:4, which describes the age of peace to follow the judgment of the Lord: "He shall judge between the nations, and shall decide for many peoples; and they shall beat their swords into plowshares, and their spears into pruning hooks; nation shall not lift up sword against nation, neither shall they learn war any more."

On all sides of Cropsey's Temple of Peace, landscape elements and groups of figures illustrate the blessings to be enjoyed in the millennial state of peace symbolized by Isaiah's child and beasts and the blacksmith's anvil. Commerce, domestic happiness, pastoral repose, rustic fraternity, and enjoyment all flourish and are made visible in the thriving town, distant ships, and the groups of working, dancing, and resting figures whose banner—visible just slightly right of center—displays "the dove with the olive branch." According to the artist, white-bearded History, for the edification of his brother Science, points to the lessons of the past written in his book and on the tomb of war behind him as the sun sinks in a cloudless sky above a sea of untroubled blue.

The Spirit of Peace tells "the tale of happy and perpetual change that has followed the stern and desolate times of human strife. Man's peace is made with man and his Creator and from the altar of his heart assends [*sic*] unceasing and acceptable incense to Him who came to proclaim peace on Earth." The Temple of Peace, its smoky puffs of incense blending with the perfect sky, serves as an architectural metaphor for the human heart converted and transformed by Christian love. By placing it in an expansive and populous setting, Cropsey seems, like postmillennial reformers, to have acknowledged the social ramifications of personal spiritual experience and to have recognized its potential to effect change for the common good.

Cropsey was concerned that the message of *War* and *Peace* be clearly understood and he was frustrated that practical considerations forced him to compromise its legibility. The artist apologized to "Mr. M." for his lengthy descriptions of the two paintings and for his enthusiasm, realizing that "you will not be able to find all the things I have hinted at. . . . Had I chosen larger canvases I might have given more force to many points of detail, but I wished the

pictures to be in a limit of size not beyond our dwelling houses or private galleries." Notwithstanding Cropsey's self-acknowledged dependence on the marketplace, it is clear that his *Spirit of War* and, particularly, *Spirit of Peace* were moral and social exemplars with carefully planned and deeply felt didactic messages, not generalized fantasies designed primarily for their visual or sentimental appeal.

In fact, the hope of universal peace achieved through the influence of the Christian gospel, which Cropsey labored so mightily to convey, had particular relevance when he began the paintings in the spring of 1851. Many of the symbols and rhetorical devices in the paintings were also used by midcentury American and English peace reformers. Beginning in 1845, the Anglo-American peace reform movement experienced a resurgence of activity, which peaked in 1851.[6]

Two specific events joined in 1851 to encourage such enthusiasm. In July, the annual international Peace Congress, which convened in London, attracted the largest gathering of peace reformers to date.[7] But even more significant was the opening in May of London's Crystal Palace, the much-anticipated Exposition of the Industry of all Nations. More than a celebration of technological progress and international competition, to reformers like Horace Greeley the exposition was "the clearest expression yet given to the spirit and aspiration of our time . . . the first practical Peace Congress ever held."[8]

The exposition's guiding ideal was expressed in a large painting displayed in the Fine Arts Court (fig. 50). According to the *Illustrated London News*, this allegorical tableau depicted "the Goddess of Peace sit[ting] placidly upon a colossal animal—the emblem of majesty taming might; her brow is wreathed with corn, indicative of her companion, Plenty, and above is the star of her divinity." In one hand she held an olive branch while the other rested on a rudder, "emblematic of the great increase of civilization." At her feet lay the discarded and discredited materials of war.[9] Nightly illuminations reinforced this message, entertaining visitors with images illustrating "the great idea of the age—Peace contrasted with War."[10]

The example of diverse nations uniting to celebrate the fruits of progress in technology, industry, and agriculture, and to provide a practical demonstration of peaceful coexistence and cooperation had, of course, millennial implications. In May 1851, Benson Lossing wrote an article for *The Odd-Fellows' Offering* in which he visualized a future millennium jointly ruled by Love and Peace.[11] Anxious to know if his vision would be fulfilled, Lossing turned to the world of reality around him to "view passing events and seek confirmatory lessons." And he found them.

While I write the portals of the "Crystal Palace," . . . the initial temple dedicated to Universal Brotherhood—are wide open to receive holy . . . offerings of the nations, prepared for the altar by Science and Labor, the high-priests of the new dispensation. . . . Every

FIG. 50. Engraving after Armitage, "Peace," published in the *Illustrated London News*, 31 May 1851. Courtesy University of Delaware Library, Newark, Delaware.

man, woman, and child of the millions who shall visit that vast Temple of Concord, will return to their homes imbued with the spirit of its worship, and become preachers of the new revelation.[12]

Cropsey's painting, with its central Temple of Peace and its evocations of untroubled commerce and industry, also served as a sermon of this new revelation.[13]

A great deal of activity among peace reformers preceded their banner year of 1851. Anti-war sentiment in the United States gained strength in late 1847 in reaction to the war with Mexico, which offered Americans a compelling personal reason to encourage peace principles and denounce a national martial spirit, even after the fighting stopped and victory was assured by February 1848.

 Peace reform was further invigorated in the wake of the 1848 revolutions. As the *Independent* noted in February 1849, "the concurrence of events . . . is now securing for Peace principles a degree of attention which they have not before

enjoyed."[14] While most American peace reformers sympathized with European struggles for liberation (although not necessarily with nationalism), they felt that international arbitration and, more important, Christian brotherhood, were the most effective antidotes to war. From 1848 through 1851 annual peace congresses were held in various European cities to promote the cause of harmony among nations and to instigate the establishment of a Congress of All Nations. Businessmen—and we should remember Hector Tyndale and his understanding of the merchant's millennial contribution—were the largest single group of participants at these congresses.[15]

In an address before the 1850 congress, Elihu Burritt (the leading midcentury American peace reformer, known as "The Learned Blacksmith" because of his former occupation and his wide reading) assessed the preparations already undertaken to write a code of international law. "All the signs of the times that I can distinguish," he proclaimed,

indicate that this preparation is already far advanced. The morning light of the good time coming is everywhere breaking upon the eyes of those who are looking and longing for its appearing. . . . The great necessities and interests of the age unite to make peace the first want and predilection of the nations. The fatherhood of God and the brotherhood of men are coming to be recognized by civilization and science, as well as by Christianity.[16]

Burritt enumerated the technological and social advances that served to break down barriers between nations: canals, railroads, telegraphs, penny postage. "These are the material manifestations of that idea of universal brotherhood which is now permeating the popular mind in different countries, and preparing them for that condition promised to mankind in Divine revelation."

A number of artists besides Cropsey participated in this midcentury examination of war, its effects, and its possible elimination; their work probably helped turn Cropsey's thoughts in a similar direction. His earliest exposure to such contemporary interpretations seems to have occurred in England during his first stay in Europe. On 28 June 1847, Cropsey noted in his journal a visit to "Mr. Vernon's Collection of Pictures" where he had seen "Landseer . . . Peace."[17] Edwin Landseer's *Time of Peace* and *Time of War* were first exhibited at the Royal Academy in 1846 and proved popular in the United States. They were exhibited in New York in 1851, and engravings after the paintings were available to Americans by late 1850, also appearing in giftbooks: *Time of Peace* in *The Odd-Fellows' Offering, for 1852* (fig. 51) and *Time of War* in *The Odd-Fellows' Offering, for 1853*.[18]

Although Landseer's subject must have had some effect on Cropsey's imagination, his visualization of it obviously did not. Landseer's pair of images used contemporary settings and large-scale figures, offering an ostensibly more realis-

FIG. 51. After Sir Edwin Landseer, "Peace," 1851; engraving published in *The Odd-Fellows' Offering, for 1852*. The Library of Congress.

tic interpretation of the theme than Cropsey's Cole-inflected, idealized version. Landseer's *Peace* was a bucolic, domesticated, and feminine world of picnickers in which a lamb nibbled grass and flowers from the mouth of an abandoned cannon. Landseer's *War*, a violent image of masculine carnage, depicted the bodies of dead and dying horses crushing the corpses of fallen soldiers amid the ruins of a farm.

In a letter dated 29 October 1848 from his friend, patron, and fellow artist John Falconer, Cropsey learned that George Inness was at work on a new picture entitled "Peace & War," although Falconer did not think that Inness had conveyed his meaning clearly.[19] In 1849, Inness painted a related allegorical work, now lost, entitled *Religion Bringing Peace to the World*. Influence from and, perhaps, rivalry with Inness must have provided another artistic impetus for Cropsey's choice of *War* and *Peace*, particularly after Cropsey returned to the United States from Europe late in 1849 and had access to Inness's paintings.[20]

Back in New York, Cropsey could have viewed other contemporary American images treating themes of war and peace. American peace advocates often emphasized war's disruptive effect on domestic harmony to counteract appeals to civic pride and national glory by supporters of such campaigns as the war against Mexico. Henry Peters Gray's *Wages of War* (fig. 52), for example, produced in 1848, presented this toll in the abstract language of high art with an emphasis on the idealized human form.[21]

Gray's composition presents in continuous narrative, from right to left, the

FIG. 52. Henry Peters Gray, *The Wages of War*, 1848; oil/canvas, 48¼″ × 76¼″. The Metropolitan Museum of Art, Gift of Several Gentlemen, 1871. (73.5) The Metropolitan Museum of Art.

story of a warrior armed for battle, whose burial is carved in relief on the sarcophagus behind his mortally wounded body. In the painting's left foreground, the soldier's widow mourns over his tomb. She wears the vivid red cloak of her dead husband around her bowed body and limply holds the arm of a sad-eyed child, whose empty hand extends toward the viewer. Twilight bloodies the sky and illuminates a procession of tiny figures on horseback crossing a bridge toward a fortress in the background. Although the foreground figures, costumes, and sculpture are classical, the middleground figures and the background architecture appear medieval, accentuating the universalizing message of despair presented by the image.[22] No Christian symbolism gives sanction or offers comfort, although the bereaved child and useless weapons of war suggest inversions of Isaiah's popular millennial vision.

When paired with depictions of women and children widowed and orphaned by the war with Mexico, the specifically mid-nineteenth-century American associations of Gray's ostensibly timeless meditation become clear. Tompkins H. Matteson's engraving "News from the War," for example, which appeared in the July 1847 issue of the *Union Magazine* (fig. 53) presents a down-to-earth reenactment of a similar tragedy. In it, a woman lies prostrate on the floor of a rustic cottage, collapsed upon the newspaper that brought her news of her husband's death in battle. The soldier's presence is implied by the jaunty military headgear

FIG. 53. Tompkins Harrison Matteson, "News from the War," *The Union Magazine*, July 1847. University of Delaware Library, Newark, Delaware.

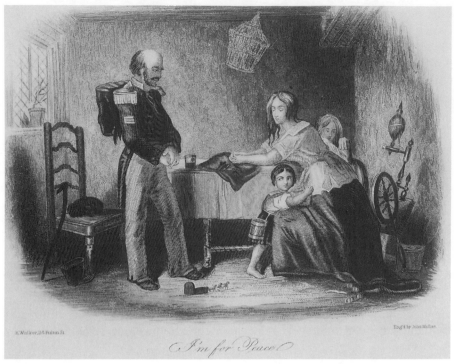

FIG. 54. "I'm for Peace," 1849; engraving published in *the Odd-Fellows' Offering, for 1850*. The Library of Congress.

worn by a now-fatherless and wailing child. The woman herself acts as a surrogate corpse, mortally wounded in spirit if not in body.

Matteson's engraving was produced in 1847, and it might be supposed that by late 1848, when Gray's painting was completed, unhappy war memories would have faded from American consciousness. But, as discussed in chapter 2, Magee took up the same theme in his *Reading of an Official Dispatch (Mexican War News)*, which was exhibited at the American Art Union in 1849, the same time that Gray's *Wages of War* appeared as an engraving in the art union *Bulletin*.

Other contemporary images presented in visual terms the crippled bodies, broken spirits, and lost labor of returning veterans who, like widows and orphans, were counted as casualties of war by peace reformers. "I'm for Peace," cried the ragged veteran in an engraving published in *The Odd-Fellows' Offering, for 1850* (fig. 54) when he returned home to his now-destitute family. Finding his young son at play with a toy drum (recall the infant soldier in Magee's painting), he warned against the insidiously dangerous plaything. "Give him a hoe," the veteran counseled, "a hammer, or a spade—a tiny plow, or a toy rake— and teach him that *they* are the weapons with which God designs man to conquer and 'subdue the earth'—the weapons of peace and righteousness."[23]

This obvious evocation of Isaiah's admonition to "beat swords into plowshares and spears into pruning hooks," and the little child included in each genre and allegorical version of the "wages of war" demonstrate the pervasive hold of Isaiah's millennial vision on the midcentury imagination.[24] As we have seen, the two vignettes were joined in the foreground of Sartain's *Harmony of Christian Love: Representing the Dawn of the Millennium* (fig. 20) as well as in Cropsey's *Spirit of Peace*. Individually, they formed the basis of at least two other midcentury paintings: Junius Brutus Stearns's *The Millennium* (pl. 2), given to the National Academy of Design in June 1849, and Thomas Buchanan Read's *Blacksmith Shop of the Nineteenth Century*, completed by January 1851.

Read's *Blacksmith's Shop of the Nineteenth Century*, a pendant to his reformist *Spirit of the Age* discussed in chapter 5, was based on Isaiah 2:4. In the late summer of 1850, Read traveled to Cologne from Florence to meet the American delegation on its way to the peace congress in Frankfort. The delegation included Elihu Burritt, the "Learned Blacksmith," and the occasion must have guided Read in his choice of allegorical subject.[25] According to the *Bulletin of the American Art-Union*, the painting depicted a "sturdy smith, in the centre with his anvil . . . forging into implements of husbandry the swords and arrows of war which Time . . . bears upon his back. . . . At the left, Peace directs him to lay his weapons before the anvil, while Truth, in the background, blows the bellows."[26]

While Read's allegorical painting with its lofty moral message was typical of the artist, the painting Junius Brutus Stearns presented to the National Academy in June 1849, which was included in the academy's annual exhibition in 1851, was not.[27] An unusual choice of subject for an artist who devoted his career to portraiture and scenes of American history and genre, *The Millennium* was based on Isaiah's familiar lines but did not literally illustrate them. The painting's central group depicts a large reclining lion, a lamb, a leopard, and a cow, but no wolf, fatling, or kid; Stearns also included a lioness, which Isaiah did not. A completely naked male child leans against the lion's side and playfully grasps a tuft of his mane while the animal remains placid and subdued. A delicate wooden cross lies in the immediate foreground and an untroubled vista unfolds in the background.[28]

The small but prominent cross demonstrates that, to Stearns, Isaiah's Messianic Age was possible only through Christ's literal sacrifice, the means by which humanity won redemption and salvation. Stearns's undraped child is quite clearly male, although Isaiah's "little child" was assigned no sex, and his total mastery over the lion conveys more than the reconciliation of might and innocence. The Christlike associations of this figure are strengthened by the fact that his gaze is directed toward the lamb; the two are also visually united by their

light coloration. Among other associations, the lamb was a biblical symbol of meekness, obedience, and the need for protection.[29] Christ's role as shepherd to his flock is suggested by this relationship, with the lamb symbolic of the community of believers protected by their faith.

But the boy and the small cross also evoke a young John the Baptist, as does the lamb, John's chief attribute. To Christians, John served as successor to Isaiah and the bridge from Old Testament to New, heralding the coming of the Messiah as the "Lamb of God, which taketh away the sin of the world" (John 1:29). The diagonally placed cross points directly toward the lamb, underscoring its symbolic connection with Christ's sacrifice. Yet the Lamb of God was also a figure of potential strength; the Book of Revelation uses "Lamb" twenty-eight times to refer to the risen Christ as ruler of the world, victorious over sin and evil.[30] In Stearns's painting, the lamb's delicate head rests close to the lion's potentially dangerous mouth, but the little creature, his eyes open and alert, is the less docile of the two.

A lion could be more than a symbol of man-eating ferocity, however. Like the lamb, it had christological associations; the Lion of Judah was one of the Messiah's titles (see, for example, Revelation 5:5). The alignment of the two animals' heads, the mirrored curves of their bodies, and their placement within the two upper quadrants of the cross suggests that this pairing was more than an emblem of reconciliation between predator and prey. A visualization, perhaps, of Christ's dual nature of meekness and strength, mercy and judgment, Stearns's treatment of his subject placed the millennium within an apocalyptic Christian narrative, evoking both the First Advent and the Second Coming. As that time when evil and sin were at least temporarily vanquished, Stearns's millennium is dominated by the loving spirit of the Lamb and the Christ child while the Lion of Judah sleeps.[31]

Stearns's pairing of cow and leopard in the right of his *Millennium*, however, does serve as a general illustration of two antithetical natures coexisting in harmony. And if a New Yorker and his or her family wished to learn a similar lesson while indulging in a more popular but still respectable public amusement, they could have left the National Academy gallery and taken themselves down Broadway to the curiosities and freaks at P. T. Barnum's American Museum.

In 1850, Barnum brought to his museum an exhibit that had proved popular in Europe. Called the "Happy Family," it featured a large cage of ostensibly live animals—including cats, dogs, rats, monkeys, and squirrels—all living together without violence. The phenomenon, pictured in Barnum's newspaper, the *New York Illustrated News*, in May 1853 (fig. 55), was described as "a collection of perhaps two or three hundred birds, beasts, reptiles, etc., whose nature it is to destroy each other, but who, by some mysterious process, have been so far taught to illustrate the Law of Love."[32]

The author of this article did not presume to explain the miraculous means by which such natural enemies obliterated their original natures and substituted

THE HAPPY FAMILY —AT THE AMERICAN MUSEUM.

FIG. 55. "The Happy Family," published in the *New York Illustrated News*, 18 May 1853. © Collection of The New-York Historical Society.

new and gentle habits, tastes, and feelings. But his unspoken implication was that, if beasts, birds, and reptiles could do it, so could human beings. Barnum was a social reformer as well as a huckster and his "Happy Family" offered an opportunity to unite both predilections. The "Happy Family" was, according to the *Illustrated News*, "the best practical fore-shadowing of the millennium, when, we are told, 'the lion and the lamb shall lie down together,' that ever haunted the imagination of a philosopher." The *Illustrated News* called Barnum's millennial "Happy Family" "the most characteristic exponent of the peace principle extant."

Barnum's mangy assortment of creatures in a sideshow of natural oddities might seem immeasurably distant from Stearns's carefully finished, academic allegory of biblical wisdom. In fact, the common yearning expressed in both examples links them firmly despite differences in medium and milieu. Public amusements no less than "high art" exhibitions often claimed to uplift as well as entertain (sometimes, of course, using moralizing rhetoric as a marketing strategy). Both the showman Barnum and the artist Stearns—each, perhaps, partaking a little of the other's role—were sensitive to the millennial fervor around them, and added their own fuel to its fire.[33]

But what about Japser Cropsey's own interest in such millennial expectations and their expression in the language of peace reform? With *The Spirit of War* and *The Spirit of Peace* was he merely orchestrating his own "Happy Family" for the intellectually ambitious, cashing in on an enthusiasm clearly "in the air" or were they tokens of a deeper sympathy? Examined in light of Cropsey's activities, interests, and, especially, his companions in the years just before 1851, the two paintings do seem imbued with personal conviction.

From May 1847 through the summer of 1849, Cropsey lived and traveled in Europe, often in the company of William Wetmore Story, Thomas Hicks, and Christopher Pearse Cranch, spending most of his time in Italy with trips to England and France. Cropsey's paintings of this period show that he was drawn to the romance of the past embodied in ruins and to the picturesque figures of monks, peasants, and beggars. But, in his letters and sketches, the artist also displayed a keen awareness of the political and social conditions around him. In particular, Cropsey's reaction to the Italian situation in 1848 demonstrates his desire to translate contemporary issues into the enduring language of high art, and gives us insight into the genesis of *The Spirit of War* and *The Spirit of Peace*.

On 16 March 1848 (apparently unaware of his friend's recent death) Cropsey wrote to Cole from Rome about the current Italian situation:

At present it is very quiet in Rome, except in a political way which so far as the Roman people are concerned is all in all. Now the spirit of Democratic government and liberty has so diffused itself into the people's mind, as that almost every man . . . exhibits some badge that openly says he is a member of the Guardia Civica. . . . I am quite inclined to rejoice with them, for let the former glory of Rome be what it may none can say but it is now very low in degradation, and every step her people shall take from such degradation must meet the aspirations of those that love liberal principles — both civil and religious.[34]

Cropsey suggests his love of liberal principles again in an idea for a painting to be entitled "Temple of Liberty upon the Mountain," which he outlined in his 1848 sketchbook. More indicative of the artist's negative assessment of contemporary Italy was his idea for another never-produced allegorical painting depicting "Italy — modern." A drawing in his 1848 sketchbook (fig. 56) shows a composition centered on a tholos temple, like the contemporary idea for the Temple of Liberty and the later *Spirit of Peace*. However, this temple was a ruin and the surrounding landscape, judging from Cropsey's written description, presented a desolate scene very different from the prosperous vision of the later painting:

A ruined temple, no fire to rise from the ruined altar, a Beggar seated upon its platform. Stagnant water in the foreground. Broken ruins, scattered all about, & Cypresses growing up all over from their midst. Ruined aqueducts stretching across an uncultivated place with snow covered mountains in the distance. Over all hangs the gloom of a melancholy sky. — The bas-relivios of the muses & and the graces, of painting & poetry yet

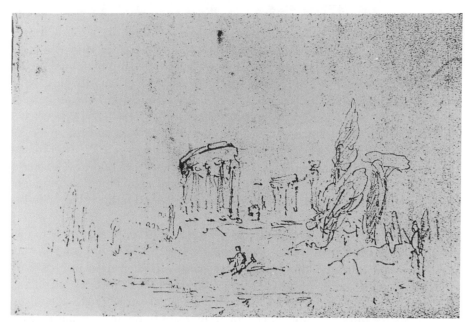

FIG. 56. Jasper Francis Cropsey, *Italy–Modern*, ca. 1848; pencil/paper, 8¼" × 5¼". Courtesy of Brown Reimhardt.

partially legible. Pines which once had spread luxuriantly their green tops over perfect temples now are withering amid the funeral like cypresses. The oak and other foliage change its colour. The olive and palm is dead. The thistle & briar gives place to the rush & lily. Autumn bleak & desolate reigns over all. . . . The viper hisses from amid the ruins—the [subtlety ?] of Priesthood . . . superstitions of the church. The sun as it sinks into the sea throws back ray of splendor but in a melancholy manner. Wrecks of vessels lay along the shore.[35]

Indeed, Cropsey's assessment of the state of Catholic Italy at midcentury was in every way a negation of the millennial—and specifically Protestant—promise that he later expressed in *The Spirit of Peace*. Whatever its past glories, ruin and decay hung over modern Italy like a pall; the Catholic Church mired the country in superstition and a beggar served as its most characteristic symbol. Olive and palm trees—those emblems of peace, prosperity, and redemption so central to the message of *The Spirit of Peace*—found no nourishment in modern Italian soil.

The stagnant water that Cropsey planned to include in the painting's foreground suggests his familiarity with imagery employed by contemporary supporters of progressive reform. "The age in which we live is one of Reform and Progress," claimed the author of an article that appeared in Horace Greeley's *New-York Daily Tribune* on 11 February 1848. "It is only the standing water that engenders miasm and taints the air with its death-bearing vapor. The stream

runs on clear and limpid, until it mingles with the ocean which is constantly agitated. . . . Progress is the law of life."[36] The standing water that Cropsey planned for the foreground of modern Italy would have been understood by sympathetic viewers as the emblem of a moribund society; a similar pool in *The Spirit of Peace* serves as a fitting repository for the detritus of the past.

Although he did produce a number of Italian landscapes, Cropsey never painted this openly critical view of contemporary Italy. Perhaps he never felt strongly enough about the issue to devote considerable time and energy (as he would for *The Spirit of War* and *The Spirit of Peace*) to a large allegory of Italian backwardness. Perhaps he wondered about the possibility of finding a buyer for such a subject. Perhaps his intellectual and emotional sympathies led him more naturally to envision in his allegorical works the perfected future rather than the desolate present.

Nevertheless, Cropsey was not averse to hinting at his critical attitude in picturesque landscapes. In a letter dated 4 September 1848, Falconer wrote to Cropsey about the latter's painting *Italia*, which had recently arrived in New York from Rome. After commenting that the painting reminded him of Cole and that he thought the figure of the monk was well done, Falconer laughed: "Then you wag! To put the torch carrying procession in there, lighting up open day at so expensive a rate. Satirizing monkery by the way—are they searching for that social comfort you say they want?"[37] The monks with their torches uselessly aflame in the light of day were, apparently, Cropsey's subtle indictment of what he perceived as a backward, tradition-bound religious despotism that literally beggared its people. Cropsey managed to include an anti-Catholic dig clearly recognizable to a member of the New York art world in an ostensibly innocent view of Italian scenery, picturesque ruins, and rural life.

Cropsey would have been encouraged in any reformist sympathies by Story, Hicks, and Cranch, his closest artist companions during this European sojourn. Story had written antislavery poetry in the early 1840s and impassioned antiwar poetry in 1846 and 1847 and was a frequent contributor to the Associationist journal the *Harbinger*.[38] Hicks, and Cranch, who also wrote denunciatory poetry against slavery and the Mexican War, had even closer ties to Associationism.[39]

In 1844, Cranch wrote to John S. Dwight of Boston's American Union of Associationists:

I have long been looking to something better than I can arrive at, under our present social organization. . . . It is getting to be more and more the great vital question, the heaviest pressure upon my thoughts, the gloomiest shades around my heart, this matter of Social Reform, and I wish now . . . to study the system of Fourier.[40]

Hicks, too, felt an attraction to the ideals of Associationism. In December 1847, the *Harbinger* identified him as "our friend Thomas Hicks." Hicks also implies his sympathy with Fourierist ideas of passional attraction in a letter of 1842, in

which he wrote that blood ties meant little to him but that "he is my brother whose sympathies, affections, hopes and faith accord with mine. . . . Humanity is, or should be, our family."[41]

American Associationism, based on the principles of Charles Fourier, was critical of the selfish acquisitiveness of modern society and a commercial system that pitted labor against capital, encouraging competition and inequality.[42] These conditions, Associationists believed, violated the God-given laws of universal harmony that Fourier expounded. Associationists planned to attain an harmonious state on earth by uniting capital, labor, and skill under a system of joint-stock proprietorship that respected private property. At the heart of Fourier's system was the phalanx, a self-supporting community of like-minded individuals who, at least theoretically, would gravitate to the work for which they were naturally suited; many Associationist sympathizers, however, never actually joined a phalanx.

American Associationism, far more than its French model, emphasized the specifically Christian and millennial basis of its social critique, as Parke Godwin's address before an Associationist convention amply demonstrates:

An important branch of the divine mission of our Savior Jesus Christ, was to establish the Kingdom of Heaven upon Earth. He announced incessantly the practical reign of Divine wisdom and love among all men; and it was a chief aim of all his struggles and teachings to prepare the minds of men for this glorious consummation. He proclaimed the universal brotherhood of mankind; he insisted upon universal justice, and he predicted the triumphs of universal unity. . . . These Divine truths must be translated into actual life. . . . In Association alone can we find the fulfillment of this duty. . . . It is verily in harmony, in Associative unity, that God will manifest to us the immensity of his providence, and that the Savior will come, according to his word, in "all the glory of his Father": it is the Kingdom of Heaven that comes to us in this terrestrial world; it is the reign of Christ.[43]

A number of midcentury American artists besides Hicks and Cranch were drawn to Associationism (even though most did not join a phalanx), including John Sartain and his son Samuel, Lilly Martin Spencer, John Peter Frankenstein, Edward Augustus Brackett, and William Page.[44] Associationists posited a connection between the reformer's aspirations for a social millennium and those of the true artist. The temperament of the artistic soul, they believed, sensitized its possessor to the selfishness, meanness, and falsity of modern life, drew him toward higher and more perfect plains of harmony, and suited him for the role of social leader. [45]

Art was not merely an aid to aesthetic cultivation and morality, Parke Godwin, a leading Associationist, told an audience at the National Academy of Design in 1851. More important, it gave "free expression to the inherent activity of the soul," and thus had a glorious role to play in the fulfillment of the earthly millennium. Throughout human history, artists had pointed the way with their

poems, their paintings, and their temples; such creations were, according to Godwin, "symbols of the To-Come."

They have been the pillar of fire by day and of cloud by night, which have gone before Humanity in the weary march of wilderness, but when the end of their guidance shall be attained, when every act and method and process of life shall become artistic, then the promised land will break full and fair upon the view, and the fire and cloud fade into the light of perfect day.[46]

American Associationists did not require art painfully to expose the social inequalities and injustices they hoped to eradicate; they encouraged instead an art of beauty, just as the movement itself worked for the attainment of a glorious ideal in social relationships. Above all, the true work of art had to express the spirit of its time, no matter what the subject. It must, the *Harbinger* explained, "prove itself cognate with the ideas and aspirations that are the animating soul of the age."[47]

Associationists perceived that this was not always an easy task. The true artist often struggled to convey a message of redemption to a cold and heartlessly practical world; the Byronic young man struggling up a mountain toward "light, more light still!" in John Sartain's title page to the *Nineteenth Century* illustrates just such a type (fig. 41). According to an article that appeared in the Associationist *Herald of Truth*:

In our own land, the Artist is not appreciated; he is not recognized as a laborer, working in the ranks of Progress, with earnest desires for the world's regeneration. Yet, when true to his calling, he is such, and his influence shall not be lost. There is nothing more chilling, than to be working for the benefit of our fellow men, and see them turn away from us with a look of scorn. It is a brave heart that will not despair under such treatment, and turn his back to the plow. But, thank God, there are such hearts, that, deeply imbued with the gloriousness of their calling, brave the storm without a murmur.[48]

It was the social responsibility of the artist, if he or she had the spark of poetic genius and the requisite Christlike moral and mental strength, to take on the ancient prophetic function of rebuker and guide. The role of reformer-prophet must have appealed to artists like Cranch and Hicks who sought ways to contribute to the progressive movements of their day, and it suggests a topical dimension to the ostensibly apolitical subject matter of such artists.[49]

Indeed, Cranch felt his contribution to humanity's progressive reform could take the form of landscape paintings, images with little apparent reference to the struggles of the modern world. In his letter to Dwight, Cranch expressed his desire to contribute what he could. "I must do more than receive. I must also give and create. . . . I have taken up the intention of succeeding in my limited sphere, as a painter of landscapes."[50]

A project undertaken while he and Cropsey were companions in Italy was clearly an attempt by Cranch to participate in the great struggles of the day. On 4 May 1848, at the end of an article about the European revolutions, the New York *Tribune* published a poem "descriptive of a picture" by Cranch; the painting was *The Castle of the Colonnas.*[51] The poem and painting were, the *Tribune* acknowledged, "not irrelevant to this present communication."

Cranch's poem opened with the description of a feudal castle on top of a rugged gray mountain. Once the scene of ferocious battles, the fortress lay in ruins, smothered by the lush vegetation of a peaceful countryside. (Although the painting is lost, something of its appearance can be gleaned from Cranch's slightly later *Castle Gandolfo, Lake Albano* [1852; fig. 57], although this work lacks the craggy mountain and ruined fortress of the other.) Cranch's edifice can perhaps be imagined as a counterpart to the structure crumbling under the influence of enlightened reason, liberal institutions, and revolutionary enthusiasm in Rothermel's *Laborer's Vision of the Future*, and to the feudal castle on a mountain central to Cropsey's *Spirit of War*.

In fact, Cranch's poem and, we can assume, his related painting, contained a number of images, particularly the medieval castle and its ruins, which prefigured aspects of both *The Spirit of War* and *The Spirit of Peace*. Cranch imagined the fortress in its heyday as a battleground, and then in its current desolate but peaceful condition:

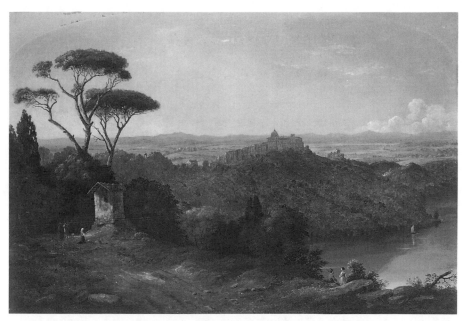

FIG. 57. Christopher Pearse Cranch, *Castle Gandolfo, Lake Albano*, 1852; oil on canvas. In the Collection of the Corcoran Gallery of Art, Washington, DC, Gift of William Wilson Corcoran. 69.23. (36½" × 54½".)

> Here bristling up the steep and narrow path
> Host after host came flaming in fierce wrath.
> .
> Up the gray rocks no more the files advance,
> No more the battle stern, the wild romance.
> Peace hath her victories now, perchance as famed
> As those in olden time the Warrior claimed.

Cranch wrote the poem in February 1848, when Pius IX was still hailed as a champion of liberty. He credited the pope's influence in this triumph of peace and allowed himself to envision a future of perfect reconciliation in words which presage Cropsey's *Spirit of Peace*:

> More mildly seems to bend the summer sky
> Its infinite dome of blue; the morning's eye
> Opens more hopefully, and evening closes
> With tinted clouds like dropping leaves of roses,
> .
> Love, Freedom, Truth may yet extend their wing,
> And all be realized that poets sing.

Cropsey certainly knew of Cranch's painting—Falconer mentioned its sale in a letter to Cropsey dated 3 October 1848—and was most likely witness to its conception and execution in Italy. He likely also read Cranch's poem and participated in conversations about the current European struggles and their ultimate outcome. Experiences of this nature can only have influenced Cropsey's decision to undertake *The Spirit of War* and *The Spirit of Peace*, ambitious allegories of social and religious prophecy.

No evidence proves that Cropsey sympathized with the Associationist-influenced reformism of his artist friends, or that he had any direct relationship with an official Associationist organization. Yet Cropsey's expressed support of political and religious freedom, as well as some indication of an Associationist emphasis on the responsibility and power of art is especially apparent in his *The Spirit of Peace*.

When the hall of the Philadelphia Union of Associationists was dedicated in May 1848, a newspaper account described the setting in words evocative of *The Spirit of Peace*: "[E]verything, in this little home and nursery of Associative aspiration, spoke of Nature, and of Harmony, and of God's love, and typified the idea of a true society, which will be God's kingdom on earth, and in which Art and Nature will preside with use."[52]

Natural beauty, classical architecture, and harmonious human activity are the most significant millennial tokens in *The Spirit of Peace*. Biblical references in the painting are all conveyed through the medium of art—that Associationist vehicle of the "To-Come"—in the form of carved reliefs or sculptures. By contrast, Stearns's slightly earlier treatment of the subject conveyed its specifically Christ-centered message in a more literal manner. It visualized and

reinforced orthodox doctrine through the ostensibly living human form rather than through such abstract symbols as Cropsey's puffs of incense rising from an altar emblematic of the transformed human heart.

Although using the same biblical text and proclaiming a similar Christian message, the two paintings are in fact quite different in their emphases. Cropsey's "sculptural" grouping of the lion, lamb, and child, for example, is more general in its form and message than Stearns's clearly apocalyptic reminder of Christ's sacrifice and power. In Cropsey's version, an enormous lion crouches benevolently over a tiny lamb and looks down upon a standing child. The transformative power of Christian love is all that keeps them safe from the lion's jaws.

Cropsey's European experiences, his close friendship with artists committed to progressive social reform, and the marked increase in American and European interest in peace reform by 1851 all provide a compelling context for his paired allegories. Yet, as Angela Miller has demonstrated, the paintings must also be examined in light of their more specifically national context. According to Miller, the paintings were essentially conservative reactions to the Compromise of 1850. Cropsey's *Spirit of War* "spoke to the growing fears of a fratricidal conflict threatening the Union," while *Peace* "lauded the efforts of compromise through which disunion would be averted."[53]

From January through September 1850, Congress debated a series of resolutions introduced by Henry Clay in an attempt to diffuse mounting sectional antagonism. The five measures, known collectively as the Compromise of 1850, were enacted between 9 and 20 September; the most controversial was the Fugitive Slave Law. This law placed fugitive slave cases under federal jurisdiction, and, among other requirements, empowered special commissioners to demand the aid of bystanders, even in free states, to help return fugitive slaves to their owners.

The Fugitive Slave Law incensed radical abolitionists and disgusted many moderate antislavery sympathizers; Northern states generally enacted legislation that nullified the federal requirements.[54] Still, many moderate and conservative Northerners and Westerners welcomed the compromise with satisfaction and relief, even given the Fugitive Slave Law, believing it would calm the waters and save the Union. It is with this group that Miller placed Cropsey.[55]

Miller's interpretation of *The Spirit of War* and *The Spirit of Peace* implies a level of provincialism and social conservatism on Cropsey's part that he might not have felt in the spring of 1851. His millennial vision is universal rather than national in scope; the palm-studded landscape and the medieval ruins in *Peace* argue against a too-narrow American context in terms of either geography or chronology.[56] Yet the paintings do seem to engage moral issues raised by the Fugitive Slave Law, although in ways more spiritually profound than those suggested by Miller's analysis.

Without question, fear of national disintegration compelled many avowedly liberal Northerners into silence on slavery after the Compromise of 1850. Cropsey's friend William Wetmore Story suffered a typical loss of nerve, muting and disguising his own antislavery sentiments after 1850, although he neither welcomed nor applauded the Fugitive Slave Law. Northerners like Story were caught and immobilized between their hatred of slavery and their fear of national apocalypse.[57]

The law presented Northerners who prided themselves on their piety as well as their patriotism with a nearly impossible dilemma. On the one hand, most Protestant Americans believed their government and its laws to have some element of divine sanction and they accepted obedience to this law as necessary for an orderly society. On the other hand, their Protestant heritage taught that no human authority could stand over them in place of God. Human institutions were by nature imperfect; the individual had the right and responsibility to decide what providence ultimately required of him. Too submissive an attitude toward secular law smacked of Romanism and despotism to many Protestant Americans.[58] Which voice to obey, then: national law or individual conscience?

In a speech delivered on 11 March 1850, New York senator William Seward applied a "higher law" doctrine in his arguments against the compromise. According to Ralph A. Keller,

As used in his speech, the term "higher law" referred to a commonly understood "law of nature" which demanded that territories now free be kept free. . . . But Seward indicated that he thought all proposed laws should pass similar scrutiny under the higher law . . . [that they] "be brought to the standards of the laws of God, and be tried by that standard, and must stand and fall by it."[59]

In 1850, Cropsey's friend C. P. Cranch responded in an angry prophetic voice to the injustice of the Fugitive Slave Law in a sonnet whose imagery evoked the analogous laws of nature and divine justice:

> Man was not made for forms, but forms for man.
> And there are times when law itself must bend
> To that clear spirit always in the van,
> Outspeeding human justice. In the end
> Potentates, not humanity, must fall.
> Water will find its level, fire will burn,
> The winds must blow around the earthly ball,
> The earthly ball by day and night must turn;
> Freedom is typed in every element.
> Man must be free, if not through law, why then
> Above the law, until its force be spent,
> And justice brings a better. But, O, when,
> Father of light, when shall the reckoning come
> To lift the weak and strike the oppressor dumb?[60]

The Spirit of War and *The Spirit of Peace* do not present a similar argument in visual terms. Peace, not freedom, was Cropsey's paramount concern, and his narrative sequence moved toward the millennium rather than a day of reckoning. Yet the public advocacy of peace principles so clearly stated in these paintings contained implicit criticism of slavery and, more particularly, of the coercive authority necessary to enforce the Fugitive Slave Law.

Pacifism and antislavery beliefs had been intimately linked since the 1830s; peace reform found little support in the South where it was closely associated with abolitionism. "Whatever else peace advocates disagreed on," Ronald Walters noted, "they almost uniformly considered slavery an unjust use of force, in the same category as war." Both antislavery and peace advocates

expressed a belief that the world should be ruled by God's law, not force, and that people could act morally and of their own free will. This was both a millennial dream and a response to a basic question in Jacksonian America. How could men and women be made to behave properly in a mobile, heterogeneous society where traditional governing institutions such as church and state had little hold on the country's citizens? The answer, for abolitionists, pacifists, woman's rights advocates, and some other reformers, was to do away with external restraints and to trust moral people with freedom.[61]

Viewed from this perspective, Cropsey's *War* and *Peace* presented an argument for each individual to treat all others in accordance with God's law of universal brotherhood, a higher law than any of man's devising. Were all human behavior ruled by the spirit of Christian peace and brotherhood, not only war but slavery, poverty, ignorance, and unhappiness would naturally disappear (witness the "apocalyptic panorama" in the *Laborer's Vision*).

Much of the heated discussion that followed the passage of the Fugitive Slave Law concerned how best to counteract it. Few antislavery Northerners advocated violent resistance and most hoped for the law's repeal. In the meantime, moral suasion and peaceful resistance were to most the only acceptable means of dissent. One particularly radical example of such suasion was presented in an abolitionist print entitled *No Higher Law* (fig. 58). The allegorical image, described in the *Independent* on 23 January 1851, depicts

the Demon of Slavery . . . sitting on his throne, supported by human skulls, and leaning on the Fugitive Slave bill. Before him is an altar, in the form of an allegorical wild beast of cruel aspect, and a priest on one side is pouring incense on the fire, while a group of hapless men of various complexions, in chains, are waiting on the other side for their turn to be sacrificed. The altar is inscribed "SACRED TO SLAVERY," and rests upon a huge volume, inscribed "LAW."[62]

Although this print is national and topical, and Cropsey's allegory aims at timeless universality, the two images share the same rhetorical device of constructing an altar, a public site of belief and worship, to make concrete the

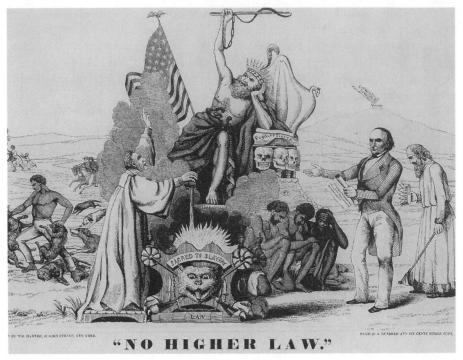

"NO HIGHER LAW."

FIG. 58. William Harned, *No Higher Law*, 1851; wood engraving. © Collection of The New-York Historical Society.

place of the Bible in their moral testimony. The closed Bible in *No Higher Law* is rendered inaccessible beneath the elbow of the Demon of Slavery and the Fugitive Slave Bill, which covers the volume. This antichrist, with whip and chains held high and pistols at his waist, rules by violence and coercion devoid of biblical sanction, grounded in the authority of secular law alone. Civil power and religious orthodoxy unite in the figure of the robed minister in support of such blasphemy.

In Cropsey's *Spirit of War*, a similar despotism holds sway; individuals have no ability to exercise judgment outside the rule of their violent lords. Yet in *Peace*, the spirit of Christ pervades the entire scene, obviating the need for any weapons or tools of intimidation, imprisonment, or coercion. The Bible and its lessons of benevolent Christianity are, literally, open books. No external religious authority is required; the delicate clouds of incense rising from the Temple of Peace are precipitated not by the actions of a berobed "priest" but by the unceasing piety of individual hearts.

If *No Higher Law* depicts a society in which the lessons of the Bible are silenced, then *The Spirit of Peace* imagines that unrealized state of perfection in which the higher law *is* the law of the land. Rather than encouraging its viewers

to accept the coercive law instituted by the Compromise of 1850 as a necessary price to pay to maintain national harmony, *The Spirit of Peace* seems to plead with them to open their hearts to the immanent and intrinsic influence of divine love.

Significantly, the harshest critic of *The Spirit of War* and *The Spirit of Peace* was someone who had every reason to sympathize with their form and content. George William Curtis, from 1850 through 1852 art critic for the *New-York Daily Tribune*, was a close friend of Cranch. He accompanied the artist and his wife to Europe in 1846, where he met Cropsey and Hicks, with whom he sketched in France in 1849.[63] Curtis had been a member of Brook Farm before it became an Associationist community and was a contributor to the *Harbinger*.[64] Imbued with transcendental faith in the individual and with reformist zeal, he was sympathetic to both the prophetic function of art and the appeal of pacifism. According to Curtis, the Old Testament law of an eye for an eye no longer had relevance. "There is a newer, nobler law," he observed in 1852; "The age, the conviction of men, history, and hope, all preach the gospel of peace."[65]

Curtis's reaction to a very different scriptural painting, which he reviewed just about the time Cropsey began *War* and *Peace* makes a telling introduction to his thoughts on that allegorical pair. Frederic Church's *Deluge*, a scene of Old Testament retribution conceived in the English tradition of expressive landscape as popularized by Martin and Cole, was on display at the National Academy exhibition in the spring of 1851.[66] (The painting is lost; a preliminary pencil study outlines the entire composition [fig. 35], while an oil sketch depicts the main figures [pl. 5].) Like *The Spirit of War*, Church's image emphasized the setting's sublimity through its rocky terrain, rising waters, and billowing clouds in a stormy sky. A precariously balanced, flat-topped outcropping supporting a woman, her child, and a menacing tiger formed the center of the composition.[67]

Curtis joined other observers in criticizing what they saw as Church's weak and pedestrian approach to an often-painted theme.[68] Curtis faulted a number of large and small details that he felt diminished the dignity and sublimity of the scene, rendering it too realistic and without any "universal, symbolic effect."[69] In pictures of this type, Curtis argued, "the mind instinctively demands something symbolic." Church's *Deluge* fell short as art because its aspirations were limited and it lacked the requisite dignity to invest one individual's demise with universal significance.

Yet the painting's chief failing was not its pedestrian execution but the "unmitigated horror" of its conception. No image that overwhelmed the viewer with unrelieved destruction and despair, Curtis believed, could succeed. "The eye reels about the canvas disturbed and dismayed," he wrote. "Like a tempest-tossed bird, it seeks but does not find the green bough to which it may cling while the roar of divine wrath rages along the world." The woman, child, and tiger had meaning only if they illustrated "in the extreme of earthly horror what is promised in the fruition of heavenly hope, the lying down of the lion and the lamb."

Curtis, called upon to discuss Cropsey's *War* and *Peace* a year later, did not question the validity or necessity of the lessons that the paintings taught as he had with *The Deluge*. Cropsey's subject matter was, it seems, sufficiently progressive and optimistic, implicitly endorsing the belief in the perfectibility of humanity under the influence of Christian benevolence, a belief that underpinned Curtis's reformism. Curtis noted with approval that through these paintings Cropsey was attempting to "exercise a direct moral influence."[70]

Yet Curtis did not heap praise on *The Spirit of Peace* as one might imagine. In fact, according to the same *New-York Daily Tribune* article, he chastised Cropsey precisely because he believed that the artist had not presented this direct moral influence with sufficient force or clarity. Whereas the *Albion's* critic praised the paintings' breadth of conception, Curtis faulted their lack of focused impact. To him, *The Spirit of Peace* was just another peaceful landscape. By contrast, Landseer's *Time of Peace* presented the viewer with an unmistakable visual emblem for its theme: sheep feeding from a cannon's mouth.[71] Curtis's disappointment was understandable; here was an image whose content *was* in accord with the "newer, nobler law" of the modern age but whose form lacked conviction and sufficient dignity.

Curtis made no mention of slavery or the Fugitive Slave Law in his discussion of Cropsey's paintings. Indeed, Curtis did not speak out publicly against slavery until 1856, although he had given private voice to his feelings years earlier, calling slavery "a monstrous sin" that produced "angel-abhorred guilt."[72] He was particularly troubled by the Compromise of 1850 and its Fugitive Slave Law, yet still did not express this disapproval in a public forum.

In a letter to his father written in the fall of 1851, Curtis was willing to accept that "nobody denies the obligations of the law." Yet, he argued,

laws may be irretrievably bad . . . and by no obligation is a man bound to regard them. In fact this pro-fugitive slave law movement and the doctrine of the law at all hazards is, in politics, the same damnation that the infallibility of the Romish church is in religion, and wherever, as with us, the tendency of the times is to individual and private judgment, the cause of the wrong is just as much lost in politics as it is in Religion.[73]

Cropsey, who manifested his perception of the despotic, stultifying, and antidemocratic effects of the Catholic Church in his design for "Italy–Modern" and in his letter to Thomas Cole, might very well have agreed with such an assessment.

To Curtis at least, Cropsey's *The Spirit of Peace* was a weak attempt to contrast the devastation of war with the perfect tranquility and prosperity that only true peace could bring. As we shall see in chapter 7, Curtis enthusiastically supported those allegorical or religious images that presented an unequivocal progressive message and severely criticized those like Cropsey's *War* and *Peace* that he believed should have done so but did not. Cropsey himself might have grudgingly agreed with Curtis; as we have seen, the artist was concerned that, in

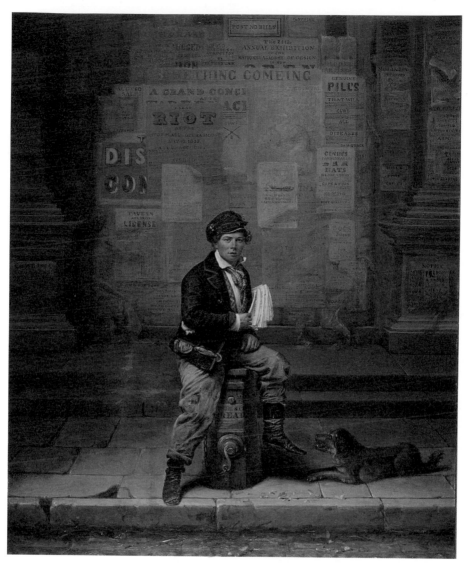

PL. 1. Frederick R. Spencer, *The Newsboy*, 1849; oil/wood, 21″ × 17″. Private collection.

PL. 2. Junius Brutus Stearns, *The Millennium*, 1849; oil/canvas, 51" × 68¼". National Academy of Design, New York City.

PL. 3. 48.471, *Opening of the Wilderness*, ca. 1857–59, Thomas Pritchard Rossiter (U.S., 1818–1871); oil on canvas, 17½" × 32½" (44.5 × 82.6 cm). Museum of Fine Arts, Boston. Bequest of Martha C. Karolik for the Karolik Collection of American Paintings, 1815–1865.

PL. 4. Thomas Pritchard Rossiter, *Muses and Graces*, 1859; oil/canvas, 17" × 28⅛". Private collection.

PL. 5. Frederic Edwin Church, *Study for The Deluge*, ca. 1851; oil/canvas, 14¼" × 20⅜". New York State Office of Parks, Recreation and Historic Preservation, Olana State Historic Site.

PL. 6. James Henry Beard, *North Carolina Emigrants: Poor White Folks*, 1845; oil/canvas, 43" × 60". The Procter & Gamble Co. Collection.

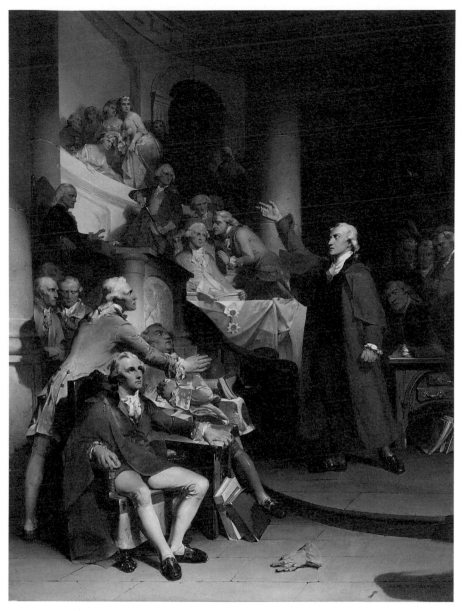

PL. 7. Peter Frederick Rothermel, *Patrick Henry Before the Virginia House of Burgesses*, 1851; oil/canvas, 79" × 61". Red Hill, The Patrick Henry National Memorial, Brookneal, Virginia.

PL. 8. Jasper Francis Cropsey, *Spirit of Peace*, 1851; oil/canvas, 44" × 67". Collection: Woodmere Art Museum, Philadelphia, Penna., Bequest of Charles Knox Smith.

PL. 9. Jasper Francis Cropsey, *The Spirit of War*, 1851; oil/canvas, 43⅜" × 67⅜". Avalon Fund, Photograph © 1999 Board of Trustees, National Gallery of Act, Washington.

PL. 10. Jasper Francis Cropsey, *The Millennial Age*, 1854; oil/canvas, 38" × 54". Courtesy of the Newington-Cropsey Foundation.

PL. 11. Asher Brown Durand, *God's Judgment Upon Gog*, ca. 1851–1852; oil/canvas, 60¾" × 50½". ©
Chrysler Museum of Art, Norfolk, Va. Gift of Walter P. Chrysler, Jr., 71.499. Photography by Scott Wolff, Chrysler Museum of Art.

his desire to paint a picture of marketable size, he had failed to convey his message with sufficient force.

Yet, after years of equivocation, Cropsey *did* choose to produce images dealing with weighty spiritual and moral concerns at precisely that moment when many hitherto vocal critics were falling silent. Cropsey, it is true, never voiced clear antislavery sympathy in any of his paintings or ideas for paintings; like all of the artists discussed in this study, he was keenly aware of the realities of American patronage. An ideal composition, tainted too obviously with the specifics of contemporary life and politics would have breached the etiquette of high-minded art and, like any partisan argument produced without benefit of patronage, would have been a risky venture indeed. (Cranch, for all the antislavery anger he poured into his poetry, never openly broached the subject in his painting.) Yet, in his "epico-allegorical" paintings, Cropsey used the imagery and rhetoric of contemporary social reform. The artist put in concrete terms the means by which pious, liberal-minded Protestant Americans could imagine the apocalyptic restructuring of human nature necessary for the realization of that "good time" they so anxiously awaited.

1851/1852: Asher B. Durand, Jonathan Sturges, and *God's Judgment upon Gog*

When the twenty-seventh annual exhibition of the National Academy of Design opened in April 1852, Asher B. Durand's *God's Judgment upon Gog* (pl. 11) offered viewers a markedly different vision of humanity's relationship with the divine than did *The Spirit of Peace*, Jasper Cropsey's paean to Christian grace also on display. Many observers found Durand's scene of divine retribution highly unusual for the pastoral artist, an aberration they explained by the fact that the subject was not his choice but was "prescribed by, and painted for, Mr. Jonathan Sturges," a New York merchant and art patron.[1]

In fact, the subject was as unusual for the patron as for the artist. Before *God's Judgment*, little in Sturges's personal art collection suggested a proclivity for either imaginary sublime landscapes or Old Testament scenes of divine retribution. Rather, his tastes ran to American and English landscape views by Thomas Cole, humorous genre paintings by William Sidney Mount and Francis W. Edmonds, and, as Lillian Miller described them, "smoothly idealized paintings of American children, engaged in the virtuous activities of prayer, industry, or study . . . [which] demonstrated how art could convey morality and nationality at once."[2] Before asking the artist to execute *God's Judgment*, Sturges had hired Durand to paint *Kindred Spirits* (fig. 59) as a gift to William Cullen Bryant in memory of Thomas Cole, and had acquired a number of other paintings by the artist including English and alpine views and a copy of Titian's *Graces*.

For *God's Judgment*, however, Sturges asked Durand to depict chapter thirty-nine of the Book of Ezekiel, in which God exhorts the prophet to warn Prince Gog of the imminent destruction of his armies by beasts and birds of prey:

prophesy against Gog, and say, Thus says the Lord God Behold I am against you, O Gog. . . . You shall fall upon the mountains of Israel, you and all your hordes . . . ; I will give you to birds of prey of every sort and to the wild beasts to be devoured.[3]

Gog's aggression against the peaceful people of Israel invited God's wrath, his warring and greedy nation destined for destruction in payment for sins committed against the innocent and for disdain of God's law. The subject also served as

a type of the ultimate battle of good and evil—of Gog and Magog—described in Revelation 20:8.

According to the *Albion*, *God's Judgment upon Gog* illustrated that "moment at which the Prophet is carrying out the divine command, by launching on the armed host of the infidel devouring beasts and birds of prey."[4] Lit from the front and with his arms raised in execution of God's command, Ezekiel stands on a precipice overlooking a

valley stretching away into infinite distance and hemmed in between two ranges of precipitous rock. Above his head are sweeping and swooping the "feathered fowl," whilst beneath his feet the "beasts of the field" are swarming forth from their lairs, and rushing onward upon the great feast set before them. A portion of the magnificent array of the victims is already in the clutches of the devourers; man and horse are thrown into wild confusion; some are prostrate, and some are rolled headlong over the sheer precipices of the foreground.

Durand's debt to Thomas Cole and, in particular, to John Martin is manifest in *God's Judgment* in such markers of the sublime as the dead tree, the dark sky rent by lightning, and the insignificance of the human actors against an overwhelming rockbound landscape. In its vertical composition, dominant central

void, and jutting rock platform, however, it echoes Durand's own *Kindred Spirits*. The resemblance is not necessarily fortuitous, since, as we have seen, Sturges was also the patron who a few years earlier had suggested the theme of *Kindred Spirits* to Durand.[5] The two paintings are joined by a common bond of prophetic intent—visions of both the denunciatory jeremiad and universal harmony.

The meticulously observed natural detail in *Kindred Spirits*, which spoke so eloquently of the transcendent presence of the divine in nature, finds no place in the turbulence of *God's Judgment*. Stripped of any softening foliage, here the cliffs loom above the struggling horde like malevolent demons.[6] The writhing human and animal bodies that fill the central middleground are suggested by energetic dabs of paint, with white horses, black figures, and red banners creating the strongest visual accents.[7] A high ledge apparently formed of hand-hewn blocks in the right of the composition acts as a breached dam, unable to contain the men and horses who stream toward it and fall from its heights. This ledge is also the site of more legible incident, in particular the vignette of a supplicant female figure with what seems to be a child behind her. This innocent pair, tiny yet perceptible, adds a poignant note of sentiment while underscoring the stern impartiality of God's judgment, similar in effect to the mother and child in Frederic Church's *Deluge*.

The painting's central chaos of mass annihilation is separated from the foreground by a rushing stream of water that falls from the steep rocks on the left and moves diagonally across the composition. A similar stream in *Kindred Spirits* flows forward from the background, linking the distant, light-softened hills to the viewer's experience. In *God's Judgment*, water acts as a physical marker of domain, imprisoning the guilty human beings on the far side of its banks. There is no escape; men and horses can only fall from the ledge into its current.

Ezekiel is the sole human being to occupy that desolate foreground area demarcated by the stream. Here the wrath of the Almighty and its destructive power, most clearly situated in the lurid clouds and lightning bolts above, also finds horrifying expression in arid color and broken texture. Barely distinguishable from the ground over which they creep, the forms of lions and tigers—living agents of Jehovah's wrath—surround but do not encroach upon the prophet's outcropping. They swarm toward the stream that marks the border between the unapproachable sublimity of the Lord and its effects, moving without distraction or pity toward their human prey.

Yet all is not desolation and destruction in *God's Judgment upon Gog*. Beyond the walls of the rocky valley lies a peaceful landscape bathed in light, its misty blues and greens providing respite from the sulphurous reds and yellows and the inky blackness of the lightning-riven clouds, and reminding the viewer of the ultimate outcome of God's wrath. Ezekiel 39:21–29 describes God's victory over Gog and all of Israel's enemies and the ultimate restoration of the Israelites: "Now I will . . . have mercy upon the whole house of Israel. . . . They shall forget their shame . . . when they dwell securely in their land with none to make them

afraid. . . . I will not hide my face any more from them, when I pour out my Spirit upon the house of Israel, says the Lord GOD."

The critic for the *Literary World* recognized the visual and thematic importance of the background vista in *God's Judgment*:

We are glad to escape over that mighty multitude of death-doomed men to the peaceful sunlight of the broad valley beyond, and simply as regards the feeling of the picture there is something exquisitely touching in that passage of golden light which comes stealing up through the cool gloom of the pass. . . . It gives a point of relief to both the eye and the mind, without which the picture would only be a scene of carnage and terrible agony.[8]

This commentator perceived a forceful inward movement generated by the painting's composition. "The expression of retreating space in the range of cliffs at the left is very fine, you feel every inch of the canvas carries you farther into the distance." Indeed, the painting pulls its viewers into and through a whirling funnel very different from the peacefully enclosing environment of *Kindred Spirits*. With its jutting diagonals and sweeping curves leading toward a pastoral vista, *God's Judgment* is a prophetic vision in which movement back in space correlates to an immeasurable movement forward in time, and which implies the necessity of present judgment to attain future reward.

Jonathan Sturges, the New York merchant responsible for *God's Judgment*, had devout faith in both religion and art and would have recognized the moral lesson such a painting taught. Sturges's Dutch Reformed piety, as we shall see, was a significant factor motivating not only his involvement in the New York art world and his own art collecting, but also his membership in charitable associations and, perhaps, his political affiliation.[9] In 1851, this piety, in response to moral questions raised by such issues of national concern as the Fugitive Slave Law and by the cries of revolution and its suppression still emanating from Europe, must have also awakened his interest in the story of God's judgment upon Gog.

Early in their marriage, Jonathan and Mary Cady Sturges were Presbyterian; sometime in the 1830s they switched to a Dutch Reformed affiliation. From that point on, the Sturges family attended several of the various churches that comprised the Collegiate Reformed Protestant Dutch Church in New York, although when traveling outside of that city they would sometimes attend Presbyterian services.[10] This shuttling between Presbyterianism and the Dutch Reformed Church required little if any adjustment; both denominations were closely related in their adherence to a fundamentally conservative Reformed tradition.[11]

In 1856, the Reverend Thomas De Witt, one of the ministers of New York's Collegiate Church and a friend of the Sturgeses, assessed the position of his

denomination in words that underscore the conservatism of this tradition in the United States:

Our Reformed Dutch Church in America, throughout her history, has been distinguished for her steady adherence to the truth and order she professes, while continually dwelling by the side of other evangelical denominations, in the exercise of mutual respect and kindness. She has remained undisturbed in the midst of the agitating influences which have pressed around and invaded elsewhere.[12]

The doctrines that shaped the Reformed tradition at its inception continued to inform the beliefs of mid-nineteenth-century American denominations. Above all was God's "awful and absolute sovereignty," his "utter transcendence and unknowableness," which together joined with the doctrine of human depravity to emphasize the complete dependence of sinful humanity on the divine.[13] According to a biographer, the Reverend De Witt—for all the honors and respect accorded him in his life—"never forgot that he was a sinner saved by grace."[14]

Yet the power of an unknowable God and the fact of human depravity did not absolve the individual of moral responsibility. Whatever his or her state of grace, each Reformed believer lived under God's law and was obligated "to glorify his Creator by obedience."[15] God's revealed law as manifest in Scripture provided the authoritative direction for the church in all aspects of doctrine, discipline, worship, and personal behavior.

Above all, scriptural law proclaimed God as creator of the universe. The law was also the measure against which individual shortcomings in faith and behavior were judged and the sinner brought to true repentance and humility. Secular law enforced by governments was perceived as an additional brake on humanity's depraved inclinations. Their emphasis on divine law and its profane analogies encouraged Reformed leaders to attempt to shape, regulate, and convert culture according to the will of Christian authority.

Reformed leaders believed that they were "but instruments in God's plan for reordering human society," optimistic in their desire to reconstruct a world in accordance with God's law.[16] This conviction was particularly strong in antebellum America, where, as Fred Hood observes, a "major task of the Reformed was to shape and mold American character through voluntary means" in order to "perpetuate America's 'free institutions' and bring in the millennium." Indeed, members of the Reformed leadership in the United States believed themselves to be "the patriarchs of the millennial age."[17]

As a founding and lifelong member of the New York Association for Improving the Condition of the Poor, Sturges himself might have felt some of that patriarchal responsibility for a millennial dawn. The AICP, led by Presbyterian merchant and temperance reformer Robert M. Hartley, was organized in 1843 by a committee of gentlemen who recognized the failure of private charities to deal

adequately with the effects of the depression of 1837; the AICP's membership comprised primarily Protestant merchants and professionals.[18] According to Roy Lubove, the organization "evolved into a leading spokesman for an urban middle class increasingly bewildered by the rapid spread of poverty."[19]

The AICP's attempts to improve, if not completely eradicate, the conditions of pauperism were based on the Reformed association of poverty with viciousness, the belief that poverty was the result, not of social inequities or economic conditions beyond individual control, but of sin and irreligion.[20] Members of the association, much as they recognized a kinship with the poor as fellow children of God, were not willing to absolve them of responsibility for their pitiful condition. The individual, through such moral failings as indolence, improvidence, and intemperance—failures to control and discipline the mind and body—was deemed to hold both the cause and cure of poverty.

Reformers were duty bound, therefore, to guide the poor in the process of their own redemption, offering mercy tempered with justice (and motivated at least in part by fear of social chaos), a charity of the head, adhering to strict rules and behavioral guidelines, as much as of the heart. Among the fundamental precepts of AICP policy were that no alms ever be given to beggars and that no individual receive direct relief (and never in the form of money) without the approval of an association visitor, who ascertained both the person's need and his or her deservedness. "The AICP was, in fact, less a charitable agency than an instrument of moral uplift," designed to inculcate the virtues of self-reliance, hard work, discipline, and piety in what many in the middle-class perceived as a growing population of foreigners ill-equipped to contribute to national prosperity and morality.[21]

Given Sturges's involvement in the AICP, it makes perfect sense that his name appeared in the *New-York Daily Tribune* on 9 April 1846 as vice-president of the Whig Party for New York's Ward 3.[22] Besides Sturges's status as a wealthy merchant, his Reformed affiliation, with its charge to act for virtue and truth, to respect the law both scripturally and as a stabilizing social force, and to maintain Christian order and influence in society, would have been entirely consistent with Whig advocacy of a strong national government and moral and religious uniformity and harmony. Indeed, evangelical Protestants, like those in the Reformed tradition, were more likely than members of ritualistic denominations to be Whigs.[23]

On 5 April 1851—probably not long before he suggested the subject from Ezekiel to Durand—Sturges gave a short speech at the opening of the twenty-sixth National Academy exhibition, in which he explained his convictions regarding the purpose of art. In his comments, Sturges took issue with sentiments expressed by Parke Godwin in an earlier address to the academy, in which Godwin claimed that "it should be no part of an artist's object to teach either morality or religion," and that the "everlasting struggle between virtue and vice" was "unnatural."

On the contrary, Sturges asserted, the "everlasting struggle between virtue and vice, between truth and error, is not an unnatural state, and it will never cease until the nature of man shall change." Therefore, it was the solemn duty of the artist to

cultivate great thoughts, and study to place them in the most effective way before the people. You must not paint merely for the love of it. You must paint to soften, to refine, and to humanize your fellow-men. I believe this to be the great object of your art, and I believe this should be the great object of your exhibitions.[24]

The softening and refining purposes of art mentioned in Sturges's address seem appropriate to such sentimentally pious images in his collection as Robert W. Weir's *Faith*, a female figure holding a communion cup, and *A Child's Devotion*, a child praying at its mother's knee. But a large, dramatic visualization of the judgment of the Almighty on the sinful Gog and his people takes a far more serious stand in the everlasting struggle between good and evil, thunderously alerting its viewers to the consequences of yielding to the baser aspects of human nature.

His choice of *God's Judgment upon Gog* as the subject of a painting for public exhibition and his private collection was certainly grounded on the rock of Sturges's Reformed faith: God's awful transcendence dominates the scene, while the subject reminds its viewers that Gog and his people individually chose to follow a path in conscious disobedience of God's law. What Sydney E. Ahlstrom identified as the Reformed tradition's "austere Hebraic legacy," rigorous and merciless in its judgment of transgressors, is reanimated here for the spiritual and moral edification of contemporary Americans. Yet, with its funnel of space pulling inward toward a redeemed future—a restored Israel—the painting promises a world subjected and disciplined in accordance with God's law and reordered as the millennium.

The merchant's involvement in an organization of social and moral reform and control and his apparent Whig political affiliation were also related to his Reformed faith and all three are relevant to his understanding of the purpose and responsibility of art. Sturges recognized the innate sinfulness of human nature, while acknowledging the possibility and the obligation of each individual to choose virtue and truth over vice and error. These individual choices could be shaped through art as through other means, thus exerting Christian control and discipline on society and culture in preparation for the arrival of the kingdom of God on earth.

By the second half of 1851, Sturges must have recognized that vice and error were collective as well as individual temptations and that the defiance of divine law was a dangerous path for any nation. As discussed in the preceding chapter, the

passage of the Fugitive Slave Law in September 1850 forced many Northerners to consider the meaning of obedience to either the law of human government or to one of higher origin. Although by the middle of 1851 the issue was no longer on the front pages of secular and religious newspapers, it still festered as a divisive issue in Northern hearts and minds and was reanimated when individual fugitive slave cases grabbed popular attention, as two did in September and October 1851.

The incidents in Christiana, Pennsylvania, and Syracuse, New York, were marked by unusual violence, including what conservative observers saw as treason and mob action by those opposed to the return of fugitive slaves. Such a violent turn concerned even men and women who bitterly opposed the Fugitive Slave Law yet "valued the American system of law and government." According to Ralph Keller, "the 'consequences' argument of the conservatives had begun to bear weight in the minds of the radicals, too," who now saw a real threat to peace, order, and public safety by too-forceful resistance to the law.[25]

Given the denomination's emphasis on law as a guiding and disciplining force against humanity's natural tendency toward sin, the official Dutch Reformed response to the Fugitive Slave Law was conservative. The *Christian Intelligencer*, the denomination's weekly newspaper, was relieved in September 1850 when the compromise measures were safely passed and the unhealthy agitation that had preceded its passage was quieted.

Yet, by January 1852, the *Intelligencer* was greatly concerned "that agitation over the Fugitive Slave Law still threatened the Union. Every time the law was executed it stirred up trouble anew." The *Intelligencer* blamed white agitators and fugitive slaves for creating such disturbances and ignoring the consequences to the Union of their resistance. The *Intelligencer* "was afraid that the year 1852 . . . might see all of the questions of 1850 opened up once again, and that this time they might be solved only by the sword."[26]

Perhaps Sturges, too, blamed and condemned the forces of disobedience and anticipated the violence their actions might precipitate. Yet evidence that he was disturbed by slavery suggests that Sturges might have held that institution and the people who supported it ultimately responsible. According to his *New York Times* obituary, "in politics Mr. Sturges was a stanch [sic] supporter of Republican institutions and was a recognized leader of the anti-slavery movement."[27] Antislavery and abolition, of course, were hardly the same thing in the years before the Civil War. Nothing in Sturges's economic, social, political, or, most important, religious context ties him to an abolitionist stance.[28] Still, even an anti-abolitionist position would not have precluded Sturges from thinking of himself, or having others think of him, as opposed to slavery.

Although her autobiography contains little comment on national affairs, Mary Cady Sturges made a number of pointed references to slavery with which we can assume her husband, who also hailed from Connecticut before spending time in Virginia, had at least some sympathy. She remembered moving as a child from Connecticut to Virginia and witnessing the brutal beating of a slave,

"much to the horror of my mother and us children." In 1826, Mary Cady's father decided to move his family out of Virginia to New York because, she believed, he was in frail health and "did not wish to leave us in a slave country."[29]

On a visit to Virginia in 1832, Mary Sturges noted that "I had everywhere to lament the influence of slavery, and to feel thankful that my lot was cast forever beyond its bounds. I think the good people even then realized it was a curse they would gladly be rid of."[30] Still, the couple felt warmly enough toward that state to name one of their daughters "Virginia," hardly evidence that they held the South in contempt. We should remember that Sturges was reminiscing in 1885, not 1852; perhaps in those earlier years she felt torn between her dislike of slavery and its effects, and her feelings of kinship toward the people she knew and loved in the South.

Both Mary and Jonathan Sturges visited Charleston in April 1850 and saw the recently deceased John C. Calhoun lying in state. In the context of the congressional debates that led to the Compromise of 1850 and, in particular, its divisive Fugitive Slave Law, Mary Sturges noted a sadly ironic aspect of the spectacle: "The slaves passed through by the thousands, all unconscious that they were gazing on the face of the man, who, above all others had been most strenuous in riveting the chains that bound them as slaves."[31]

Jonathan Sturges was then a friend of William Cullen Bryant, editor of the *New York Evening Post* as well as one of America's most respected poets. Bryant's perspective on questions of law, human freedom, and moral responsibility provide additional insight into their shared intellectual environment. In 1874, Sturges was selected to deliver an address in honor of Bryant's eightieth birthday. "For more than fifty years you have been a journalist, and vindicated the duties as well as the rights of men, with all the genuine freedom . . . of our age," the retired merchant observed,

You have been a good citizen and a true patriot . . . steadfast from the first to last in your loyalty to the liberty and order of the nation. You have stood up manfully for the justice and humanity that are the hope of mankind and the commandment of God.[32]

Bryant's reply to this address contained references to a number of issues that had engrossed him and his friends in the preceding decades. Bryant rejoiced that the condition of mankind had improved in his lifetime, that people of "civilized" countries were more enlightened, free, humanitarian, and charitable than they had ever been. He particularly celebrated the extinction of slavery in the United States and the unification of Italy under a secular government, and voiced a millennial desire still in tune with pre–Civil War romanticism: "There is yet a time which good men earnestly hope and pray for—the day when populations of the civilized world shall prepare for universal peace."[33]

Sturges's praise of his friend's devotion to both liberty and order—the struggle to strike a balance between two equally compelling social and spiritual

mandates—was, as we have seen, the crux of the dilemma raised for most moderate or conservative Northerners by the passage and the enforcement of the Fugitive Slave Law twenty years earlier.[34] Bryant's editorial response to the fugitive slave disturbances in Christiana and Syracuse demonstrates a respect for the law of the land as great as that of the Dutch Reformed *Christian Intelligencer*, while lamenting the price such obedience could exact.[35]

Bryant accepted a constitutional and legal right for Southerners to own slaves and conceded that there did have to be some appropriate legal means for slaveowners to reclaim fugitives. His conviction that respect and adherence to the law of the land was paramount for the maintenance of a free and orderly society is evident throughout the editorial. Yet Bryant also expressed his moral repugnance with the Fugitive Slave Law, acknowledged the contribution of free blacks to Northern society, and recognized the innate desire of slaves to be free.

According to Bryant, the people of the United States were not used to obeying a law just because they were supposed to; they were not, in fact, used to thinking about the constraints of the law at all. Rather, he wrote, "they obey the dictates of their consciences, and conform to the standards of right and justice which prevail in their respective communities." The "fearful and bloody riots" that erupted in two peaceful rural settlements were, therefore, the inevitable collision that occurred when its officers were compelled to enforce a law "which violates the moral instincts of the people." The Fugitive Slave Law was "one of these offensive laws" particularly because it forced Northerners to reduce to slavery blacks who had for years lived among them as "industrious and honest citizen[s]," people whom they "met in their daily walks," with whom they might even have broken bread.

The authors of the Fugitive Slave Law overlooked two important considerations when they drafted the measure, Bryant observed. First, that "it is the curse of this law that the people of the free states can never get reconciled to it." They might allow the officers of justice to do their duty, but each time they did so the "fountains of bitterness" were opened and good, peaceful citizens are drawn into "the dangerous habit of questioning the wisdom and justice of our lawgivers." More and more self-restraint was required of even the most "conservative and orderly of our people" to remember that "it is better for one or a dozen men to suffer, than the moral supremacy of our law should be shaken."

In addition, the drafters of the law, not to mention slaveholders, had ignored and continued to ignore a fundamental aspect of human nature: they failed to recognize the slave's

constitutional and inseparable propensity to run away—to be other than it is—property. The slave will as surely seek to be a freeman as he will breathe, and it is [as] much a part of what every man buys when he buys a slave, as it is a part of the seedling to struggle upward from the soil towards the light. . . . The impulse towards freedom is one which no legislature can extinguish or control.

Although Bryant shared the racism of most of his contemporaries, he was at least willing to accept, as many others did not, that free blacks *could* become industrious members of society and that blacks were not by nature subservient, with little desire or capacity for freedom.[36]

The "impulse towards freedom" that, according to Bryant, motivated the fugitive slave in 1851 was also still at work among the oppressed masses of Europe. Members of the Sturges family took an interest in the course of European revolution, as a journal entry written by Virginia, daughter of Mary and John, and dated 2 February 1852, makes clear. "Kossuth [is] now among us pleading the cause of his down trodden fatherland," she observed, "and this year sees France once more in the power of a Napoleon who is advancing towards his throne through throngs of victims to a longing for liberty they have never seen."[37]

By the end of 1849, Louis Napoleon, Napoleon Bonaparte's nephew, had been elected president of the French Republic, a conservative reaction to the bloody counterrevolution of June. Even though he was elected, Louis Napoleon's rule elicited distrust among some Americans, suspicions confirmed when, on 2 December 1851, he staged a coup d'etat marking the end of the Second Republic and the beginning of the Second Empire.

While many Americans lamented the course of events in France, they remained particularly sympathetic to the continuing Hungarian struggle for independence from Austrian imperial domination. As Bryant wrote in August 1849, after the French and German revolutions had failed: "To Hungary clung the hopes, of all who did not despair of the Freedom of Europe."[38] But victory was short-lived; Russia intervened on behalf of Austria forcing Louis Kossuth, the Hungarian revolutionary leader, to flee to Turkey.

The exiled Kossuth came to the United States in December 1851 with the support and encouragement of Congress to plead the cause of Hungarian independence and sell bonds to help finance his struggle. Many Americans, especially libertarians and Free-Soilers, warmly supported Kossuth and his mission.[39] Poems, plays, and panoramas in honor of the Hungarian struggle and its most famous champion appeared even before his arrival in December.[40]

Sturges's friend and fellow art patron Charles Leupp was a member of the executive committee of "Aid to Hungary," and in December 1851 Bryant presided at a banquet in honor of Kossuth given by New York journalists. In his toast, the editor promised that the American press would play a prominent role in "'this great attempt of man' against the mightiest despotisms of the world" to regain his God-given rights.[41]

A number of New York artists were also eager to participate in the official welcome of Kossuth, and offered their services to the mayor. In November 1851 they volunteered to design decorative arches and tableaux because they felt, as Vincent Colyer expressed it, "deep interest in the great effort that has been going on

these last few years, in Europe, for the good of mankind," and because they entertained "the sincerest admiration for the greatest of leaders in that effort, Louis Kossuth."[42]

Exactly what material these artists eventually contributed to the decorations for the many Kossuth processions and banquets held in New York in December 1851 is difficult to determine. But published descriptions of such events indicate the profusion of banners, arches, and decorations—even "emblematic confectionary"—which filled the streets and banquet halls of New York. The *Times*, for example, described Kossuth's procession along a Broadway hung with evergreen wreaths, American and Hungarian flags and colors, and banners with allegorical designs and inscriptions like "Liberty of Thought and Liberty of Speech! Forever in Defiance of Injustice, Oppression, or Proscription" and "Kossuth: The Washington of Hungary."[43]

An illustration for "The Calendar of Liberty 1852" entitled "One of the People's Saints" (fig. 60) suggests the nature of these allegorical tableaux, as well as the intensely nationalistic enthusiasm that fired most American admirers of Kossuth. And the print's use of the language of divine retribution and the imagery of apocalypse in relation to contemporary events, linking the spiritual and the political with unabashed self-righteousness, suggests that similar meaning exists in *God's Judgment upon Gog*.

"One of the People's Saints" focuses on Kossuth while referring to previous and related revolutionary struggles. The Hungarian freedom fighter is depicted as a modern St. Michael armed with the sword of eloquence and the shield of truth. A liberty cap and a burst of stars behind his head form a halo. Like St. Michael in, for example, Benjamin West's painting (1797; fig. 61), Kossuth wields these weapons in a gravity-defying, supernatural battle with the many-headed dragon of the Apocalypse—the antichrist, the embodiment and agent of Satan—in this case, Austria and its allies. Her own sword broken and useless, the distressed female figure of Liberty, analogous to the "woman clothed with sun" of the Apocalypse, lies nearby. The beast's mighty paw bears down on her knee, but her unshod foot rests on the monster's tail, suggesting ultimate victory.

The apocalyptic dragon carries a banner inscribed "Throne and Altar," an expression of the anti-Catholic and antimonarchical sentiment so prevalent in American society at the time. The forces of good and evil are clearly demarcated and the struggle is mighty. On one head, the beast wears a papal tiara. Indeed, the shield of truth, onto which this head of the beast is reflected, reveals what appears to be the face of Pope Pius IX. The middle head of the creature is that of a wolf wearing a crown, symbolic of Austria, while the third head—a bear with an Eastern crown—is emblematic of Russia, Austria's ally.[44]

Outside the arena of combat, revolutionary partisans of other nations shout encouragement and wave their flags, as if attending a rowdy cockfight rather than a cosmic death-struggle. An American sailor on the far left carries the stars and stripes. He jostles an adjacent Englishman whose banner includes a cross of

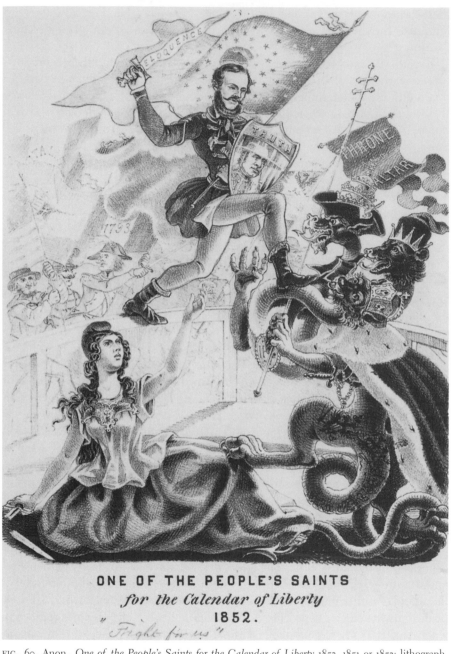

ONE OF THE PEOPLE'S SAINTS
for the Calendar of Liberty
1852.
"*Fight for us*"

FIG. 60. Anon., *One of the People's Saints for the Calendar of Liberty 1852*, 1851 or 1852; lithograph, 10¼" × 7⅗". The Library of Congress. LC-USZ62-89603.

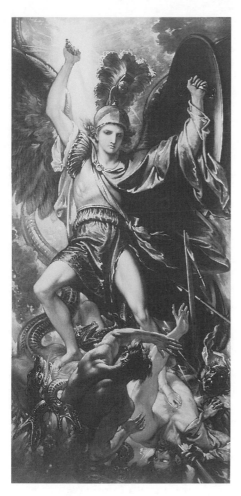

FIG. 61. Benjamin West, *St. Michael and the Dragon*, 1797; oil/canvas, 50½" × 23⅞". Toledo Museum of Art; Museum Purchase.

St. George. An Italian patriot flanks a Frenchman who bears the standard of 1793, and a German and a Turkish flag are visible in the background.[45] However informal the setting, this image of a modern St. Michael imagines a world united in common cause and visualizes the Protestant hope for a millennium of civil and religious liberty free from the evil restraints of pope and king.

The apocalyptic rhetoric so enthusiastically, albeit naïvely, appropriated in "One of the People's Saints," was also adopted in a variety of other responses to Kossuth's visit and the general condition of Europe.[46] The Reverend Samuel H. Cox, a New School Presbyterian minister who had married the Sturgeses in 1828 and in whose church the couple remained for several years, wrote a particularly bloodthirsty poem whose theme and imagery call to mind those of *God's Judgment*:

> Blood must they drink who martyr blood have shed;
> Judgments divine and truthful there are sped,
> Where old corruptions all the scene embroil;
> But prophecy must wholly be fulfilled
> In all, as writ, the killing and the killed;
> And Europe's vanity may cease to smile;
> Her own must flow for blood that she has spill'd;
> As oracles declare, as God in heaven has will'd;
> So persecution, tyranny, and wrong,
> Crushing the weak, and flattering the strong,
> Must meet their day and doom of retribution:
> Earthquakes of terror, wrath, and revolution,
> Shall rock their continent—in mill-stone style
> Old Italy's peninsula shall fall,
> And guilty Rome *be found no more at all!*
> Czar, Sultan, Pope, King, Bishop, Emperor,
> Shall be extinguished to exist no more!
> Usurpers and their trains, in Church and State,
> Vanquished and vanished, neither good nor great!
> Such are the changes destined there to come
> Before can be Christ's own millennium.[47]

By the end of 1851, the lessons of the Fugitive Slave Law joined with those of European revolution to inspire a literary reaction expressed in the language of biblical apocalypse, the most forceful and influential example of which is Harriet Beecher Stowe's *Uncle Tom's Cabin.*[48] Written to protest the Fugitive Slave Law and to present the evils of slavery in horrifying detail, the book was published in its entirety in March 1852; its first installment appeared in the *National Era* in June 1851.

Raised in an environment where terrible warnings of eternal damnation were tempered by promises of Christ's redemptive grace, Stowe was caught in the tension "between progress and apocalypse." As Cushing Strout observes, Stowe's "passionate faith in the Second Coming wavered between the optimistic hopes of the postmillennialists and the apocalyptic fears of the premillennialists, but the eschatological expectation is always present as a reverberating note of the novel's major thematic chords."[49]

Nowhere are these apocalyptic fears more evident than in chapter 45, "Concluding Remarks." After assuring her readers of the truth of the terrible narrative they had just read, Stowe asked them to consider what they could do to counteract the evils of slavery. Feel strong sympathy, she advised, pray and educate the black race in the virtues of republican government and the Christian religion—before sending them off to Liberia. If these steps were not taken and if the United States did not repent its injustice and cruelty, the Union could not be saved and the promised day of grace would never come. Stowe described the unique character of the present age as it struggled for universal liberty, and she prophesied a grave national fate:

A mighty influence is abroad, surging and heaving the worlds, as with an earthquake. And is America safe? Every nation that carries in its bosom great and unredressed injustice has in it the elements of this last convulsion. For what is this mighty influence thus rousing in all nations and languages those groanings that cannot be uttered, for man's freedom and equality? O, Church of Christ, read the signs of the times! . . . Can you forget that prophecy associates . . . the *day of vengeance* with the year of his redeemed. . . . [I]njustice and cruelty shall bring on nations the wrath of Almighty God![50]

This language of doom and promise offers a compelling parallel to the imagery of Durand's *God's Judgment*; the novel and the painting were in production at the same time and both were available to the public by the spring of 1852.

Stowe's novel was clearly motivated by the Fugitive Slave Law, her historical and spiritual vision obviously affected by European events. The same cannot be said unequivocally of Durand's—Sturges's—*God's Judgment upon Gog*. But its scope parallels that of Stowe's "Concluding Remarks"; neither are sermons aimed at the redemption of individual souls. The barely distinguishable figures struggling in the center of *God's Judgment* are too small to foster emotional kinship or serve as individual surrogates for their American viewers. Depicted here is collective sin and its punishment, an entire nation destroyed by its own transgressions. We must believe that Sturges, with his belief in art's social and moral responsibilities, found it a particularly relevant moment to sound such a warning.

To whom, then, was this warning directed? Who, in other words, were Gog and his armies? What providential law had they transgressed or ignored to bring such doom upon their heads? Were they the kings and priests of Europe or the revolutionaries who subverted traditional authority? Were they American slaveholders, or abolitionists? Those who obeyed the Fugitive Slave Law but broke a divine law? Those who broke the law of the land to follow the law of their consciences?

At least by 1874, Sturges, as we have seen, denounced tyranny and oppression and asserted that justice and humanity were the commandments of God. This assertion implies a belief that those—like Prince Gog—who ignored such commandments invited divine retribution. Virginia Sturges's journal entry expressing sympathy for Hungarian and French victims of oppression probably resulted from conversations with family and friends; most likely her father ascribed to such an opinion and denounced king, czar, and priest.

Perhaps Sturges saw the American government, too, as being in defiance of God's commandments, forcing its citizens to question the moral authority of the law of the land and thus the rule of law in general. Yet Sturges might have viewed those who actively, even violently, denounced or defied governmental authority as equally guilty of undermining the law, upon which rested both national harmony and the universal millennium. The fear of chaos and loss of control that motivated so much midcentury reformism is echoed in the turbulence

of *God's Judgment*. The nation that knowingly defied God's law and was now the food of wild beasts could have as citizens both the enemies of individual liberty—European monarchs and American slaveholders—as well as the enemies of righteous restraint and moral rigor—too-ardent abolitionists and radical revolutionaries.

The painting serves as a warning to the United States but also to humanity at large, and its impetus was probably not one specific, discrete event so much as the melding of all contemporary signs of the times. Above all, *God's Judgment upon Gog* is a visual sermon commissioned by a devout Reformed Protestant, who feared for the spiritual future of his country and the world if human nature were not restrained by awareness of God's directives and of the consequences of sin.

Asher Durand was the artist Sturges trusted to conceive and execute the narrative of God's judgment upon Gog in visual form. The patron knew Durand's strength lay in landscape and he must have believed him capable of conveying the power and meaning of the scene as much through natural metaphor as through figural gesture and expression. Yet in 1894, John Durand, the artist's son, claimed that "as usual with subjects chosen for an artist, [*God's Judgment*] was not a success,"[51] implying that his father had little understanding of the subject and invested none of his own spirit into the painting's conception or production.

Durand's apparent conception of God and the religion of nature does not, it is true, seem consonant with the message of unmitigated fear and vengeance that *God's Judgment* appears to convey. According to David Lawall, Durand, although raised in a climate of orthodox Calvinism, was soon drawn to more liberal Unitarian thinking and "tended to interpret the Christian Scriptures in the light of an increasingly non-sectarian point of view."[52]

Durand also expressed an early and consistent faith in the perfectibility of man's earthly condition and, especially after 1848, he espoused a theism heavily influenced by the Unitarian minister William Ellery Channing. In this view, the artist acted as a conduit through which the divine idea "impose[d] itself upon a world as yet partially formed. . . . In assuming the role of prophet Durand . . . aim[ed] . . . to reveal 'truth amid a host of errors' and promote the 'moral perfection of mankind.'"[53] In their general understanding of art's lofty mission, then, Durand and Sturges would have been in complete agreement, however much their respective Unitarian and Reformed beliefs differed on the specifics of humanity's fundamental nature and the character of the divine.

Despite his (and his patrons') predilection for scenes of natural harmony, however, Durand's conception of the "divine idea" as evident in nature and channeled through the artist was not always peacefully transformative. God, according to Channing, was manifest as unqualified benevolence. But it was a benevolence sometimes expressed in the form of justice in order to "chasten and improve" humanity and make it receptive to "the fullness of divine goodness."[54] Aspects of the

natural world revealed the duality of the divine character; the sublime in nature was an emblem of God's justice, the beautiful an emblem of God's mercy.

Justice and mercy were not equal attributes of the divine, Channing argued. The operation of justice was merely one manifestation of benevolence and it always preceded grace. According to Lawall, Durand not only combined emblems of divine justice and divine love, but arranged them in the proper order. Hence, the sublime passages symbolizing divine justice appear in the foreground, the beautiful aspect of divine love and ultimate redemption in the distance.[55] In a painting like *God's Judgment upon Gog*, then, the message of a purgatory justice leading to blissful salvation is contained as much in the landscape as in the figurative elements. It is expanded beyond the limits of an individual soul in nature, to encompass the collective experience of humanity.

Durand had, years before painting *God's Judgment*, expressed hope in the eventual perfection of the human condition through the overthrow of oppression. In a letter dated 31 January 1832, he observed that the truly brave man was one who, "walking alone in his moral energy and having no other weapons than his voice and the press, causes thrones and hierarchies, that had been regarded as unshakable, to fall."[56] Perhaps Durand maintained this vision some twenty years later, and, like his patron, would have perceived contemporary meaning and moral purpose in the story of *God's Judgment upon Gog*.

John Durand's negative assessment notwithstanding, contemporary critical reaction to *God's Judgment upon Gog* was overwhelmingly positive. The *Knickerbocker* called Durand's painting "the best he has exhibited . . . a most thoroughly studied composition, showing a right and just composition of the grand. . . . It has made a most successful picture."[57] The *Albion*'s critic expressed surprise that Durand was "adventuring on a higher grade of subject" than his usual "soft rural scenery," and was pleased to find it "treated with so much power, and invested with so many claims on admiration."[58] The *Literary World* praised the painting as "a great advance on all his former efforts, displaying powers that had not been before credited to him. . . . This is the noblest landscape ever painted in America, both in greatness of conception and thoughtfulness of treatment." And E. Anna Lewis, writing in *Graham's Magazine* in 1854, called *God's Judgment upon Gog* one of Durand's "most remarkable pictures. The conception is bolder, and the handling more free and vigorous than in any of his works."[59]

The critic most displeased with *God's Judgment upon Gog* was, in fact, George William Curtis. Curtis was disappointed with the painting for the same fundamental reason that he faulted Church's *Deluge* and Cropsey's *The Spirit of Peace*: in each case, the artist had failed to exercise a direct and constructive moral influence through his painting.[60] Curtis's interest in and his ultimate dissatisfaction with these three images demonstrates just how seriously he viewed the social role of art, especially ideal, allegorical art. Curtis would hardly have

chastised Durand, Church, and, to a lesser degree, Cropsey so sternly had he judged the artists' subjects irrelevant or their failures merely aesthetic.

Curtis acknowledged the "excellent details" to be found in *God's Judgment*, but, even more than he had with Church's *Deluge*, questioned both the choice of subject and its treatment. True art, Curtis argued, appealed to "the interior eye." It was grand, rich, and universally meaningful—more than straightforward illustration. The purpose of a painting like *God's Judgment* should be "to impress the spectator with the sense of divine justice, more profoundly than he would be impressed by the simple narration." Using this criterion, Curtis again pronounced the painting a failure because it was "an inadequate and obvious representation of the scene. . . . Is the fierce vision of the Hebrew Prophet made more palpable," Curtis asked, "is the wrath of Jehovah impressed more deeply— is the lesson of the event more sternly urged by this picture than it has been before?" No, he answered, and he assessed Durand's painting as talented storytelling rather than inspired poetry.

Curtis was more profoundly disturbed by Durand's violent scene of providential judgment than by what he saw as Cropsey's vague treatment of the subject of peace or by Church's emphasis on horror rather than hope. He wondered whether Jehovah's ferocious wrath was, in fact, a fit subject for such emphasis, and doubted that it should have been painted at all. Curtis rejected what he viewed as the vindictive deity of the Old Testament: such a cruel and willful God provoked pity for his victims rather than respect for his justice. Thus, in the case of *God's Judgment*, "the sympathy of the spectator is on the wrong side." What enlightened viewer could accept the equity of the prophet's situation, armed as he was with all the power of God and nature against a miserably weak human army—a contest of lion against mice.

"The mind recoils from acknowledging fellow-humanity with [Ezekiel] upon the rock imprecating this terrific curse of nature upon the miserable Gog and his host," Curtis argued. "A man who would use such power as an instrument of achieving wrathful vengeance is a monster. . . . What shall be said of a Prophet of God . . . ?" Curtis held God and his prophets to the same rules of fair play that he did human beings, and he was apparently unconcerned with humanity's role in calling down divine vengeance or with Gog's guilt.

"The only justifiable purpose for [the painting's] existence," he explained, "must be to inspire greater reverence for God by revealing the terrors of his vengeance." But this mission was unacceptable because, Curtis maintained, it "revives . . . a low idea, an idea repulsive to the noble and humane mind." *God's Judgment upon Gog*, he lamented, would not lead viewers to a purer, more trusting faith in the progressive "Christian" God of benevolence, mercy, and love. The painting's worst fault was its outdated and dangerous message. To Curtis, the Old Testament law of an eye for an eye was no longer pertinent to the modern world. "There is a newer, nobler law. The age, the conviction of men, history, and hope, all preach the gospel of peace."

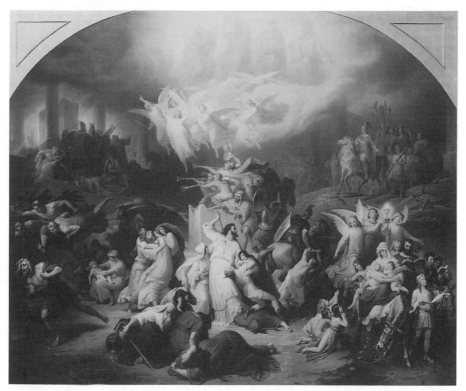

FIG. 62. Wilhelm von Kaulbach, *The Destruction of Jerusalem*, 1842–1854; oil/canvas, 231‰" × 276‰".
Neue Pinakothek München.

Curtis did manage to find a contemporary image that treated the subject of
God's vengeance to his satisfaction. He pronounced *The Destruction of Jerusa-
lem* (1842–1854) by Munich artist Wilhelm von Kaulbach (fig. 62) superior to
Durand's *God's Judgment,* just as he believed Edwin Landseer's *Time of Peace*
transcended Cropsey's conception of that theme.[61] In both instances, the Euro-
pean artists used much larger-scaled and thus more expressive human and ani-
mal figures to convey their meanings; Curtis must have found such an approach
more eloquent for allegorical or religious subjects, which may explain why he
was so often disappointed when artists tried to convey complex ideas primarily
through landscape elements.

Although *The Destruction of Jerusalem* contained such cataclysmic details as
raging fires and crashing columns, to Curtis the painting presented the subject
of Jerusalem's defeat by the Romans not merely as an example of divine anger,
but as a milestone in "the progress of human destiny." The painting succeeded
because it, unlike Durand's, "grasps the theme with a richness, a variety and
splendor of imagination which is exhaustless." It excites sympathy for "the inof-
fensive victims and for the shattered pride of the leaders." Most important, the

spectator does more than grieve for the fall of the old order; "his feeling [is] enlisted for the new."

The viewer simultaneously mourns the victims, understands the justice of their fall and, above all, rejoices in the promise of a new order. In the upper right of the composition, the Roman emperor Titus and his soldiers—agents of divine justice—advance upon the scene as symbols of the "purifying storms" necessary to open the way for modern civilization. The new order is symbolized, Curtis explains, by the "holy peace that leads away the Christian family on the right, [which] leads Hope also, into a happy Future, and leaves the mind content."

Jonathan Sturges, a Whig member of the Reformed Dutch Church, found a compelling moral message in *God's Judgment upon Gog*, where George William Curtis, a transcendental Associationist, could see only the ugly face of primitive vengeance. Not even the distant green fields and open sky in *God's Judgment* seem to have appealed to Curtis, perhaps because he saw no means by which individuals, motivated by Christian benevolence, mercy, and love, could help achieve such a state. Curtis had no patience for *God's Judgment* and its traditional Calvinist emphasis on human depravity and powerlessness in the face of God's awful transcendence—perhaps the very aspects of the subject that so attracted Sturges.

Sturges, as we have seen, disagreed with Parke Godwin (like Curtis, Unitarian and Associationist) about the purpose of art and its relation to human nature and, by extension, the means by which art's apocalyptic function was best fulfilled. As discussed in chapter 6, Godwin granted art a significant role in the realization of God's kingdom on earth precisely because it allowed "free expression to the inherent activity of the soul."[62]

Art, to Godwin, should not coerce, mold, or bend people to its will; it did not have to sternly *teach* its morality and religion. It should not be a chastising sermon that shamed and terrified its perceivers into suppressing their sinful proclivities. Instead, true art encouraged the realization of each soul's inherent goodness, acting as a gentle but inexorable influence that dissolved the bonds of fear and selfishness that inhibited human nature.

To Godwin, transformation occurred quietly and gradually; when all human thought and activity became artistic—in other words, when it allowed for the unhampered self-realization of each soul—only then would "the promised land break full and fair upon the view." But to Sturges, apocalyptic transformation could be effected only within the violent turmoil of the "everlasting struggle" between "virtue and vice" and "truth and error." Individual and national souls had a constant duty to wrestle with their inherent depravity and to weigh their thoughts and actions against the standard of God's law; *God's Judgment upon Gog* was a reminder to do just that.

1853/1854, Epilogue: Rossiter's *Babylonian Captivity* and Cropsey's *Millennial Age*

For several succeeding years, echoes of 1851 continued to reverberate in the work of at least two artists. In March 1853, Thomas Pritchard Rossiter completed *The Babylonian Captivity (Jeremiah)*, a large, multifigured painting he had begun in the summer of 1851. By late 1854, Jasper Cropsey finished *The Millennial Age* (pl. 10), a reworking of his 1851 *Spirit of Peace*. With these two paintings, the post-1848 surge of apocalyptic expression in American art subsided.

At precisely the moment George William Curtis offered Wilhelm von Kaulbach's *Destruction of Jerusalem* as a counterweight to Durand's *God's Judgment upon Gog*, Rossiter was at work on an Old Testament subject in which millennial harbingers clearly mitigated the wrath of Jehovah.[1] We can only guess that Curtis would have approved of the thematic and moral purpose of Rossiter's *Babylonian Captivity (Jeremiah)*, since he was no longer art critic for the *Tribune* when the painting was completed. Still, the message of Rossiter's painting is so similar in didactic purpose to what Curtis advocated, that something of the same reformist, perfectionist vision must have motivated them both.[2]

As he had with *The Return of Dove to the Ark* and *Miriam Rejoicing over the Destruction of Pharaoh's Host*, Rossiter selected a subject whose fundamental message was God's inescapable judgment upon sinful nations and their rulers, and his promise of protection and reward for his chosen people.[3] Rossiter selected as inspiration two biblical texts that expressed the captive Israelites' longing for their ravaged homeland; their suffering from famine, persecution, and the indignities of exile; their remorse for the sins that had called down such punishment; and their plea for God's mercy and forgiveness: "Turn us unto thee, O Lord! And we shall be turned; renew our days as of old."[4]

The Babylonian Captivity depicted Jeremiah, prompted by a presentiment of his approaching death, visiting Babylon and convening the principal Jews on the banks of the Euphrates. Rossiter deliberately conflated disparate characters and narratives, sacrificing scriptural accuracy to the eloquent conveyance of meaning.[5] For all its apparent focus on punishment, lamentation, and remorse,

Rossiter intended the painting, above all, to "represent the leading features con-
nected with the Hebrew exilement, clustered together in such a manner as shall
express the sentiment of hope."[6]

According to Rossiter's description, the painting imagined a lush and exotic
Eastern setting, with the city of Babylon visible in the distance, the smoke of eve-
ning sacrifice curling above it. A temple with a winged Assyrian bull (perhaps
based on recent archaeological information) reminded viewers of the heathen
beliefs of the Israelites' captors, and the famous hanging gardens added pictu-
resque grandeur to the scene.

As twilight faded into gloomy night, Jeremiah intoned his last lamentation
while Baruch, his ever faithful scribe, sat close by to record the words. The
prophets Habakkuk and Ezekiel were placed immediately beneath Jeremiah,
with Ezekiel accorded particular prominence because, Rossiter explained, his
principal care was to console the captives by "promises of future deliverance . . .
and to encourage them by assurances of future blessings."[7] Rossiter also used fe-
male figures to characterize and encapsulate the essence of this optimistic spirit:
a mother watching her children playing with a lotus blossom, "the Oriental sym-
bol of Hope," and a woman dressed in the colors of the Virgin who noticed Dan-
iel on his way to predicting the fall of Babylon.[8]

Although Old Testament Israelites, the captives in Rossiter's painting could
have served as emotional and spiritual surrogates for devout modern Ameri-
cans—the new Israelites—buffeted by the news of international revolution and
the strains of domestic squabbling, particularly relevant when Rossiter chose the
subject in 1851. The longing for release from an imperfect present, the often
mournful realities of earthly existence, and faith in a perfected future found ex-
pression not only in Rossiter's sixteen-foot visualization of hope—that "national
characteristic" of the new chosen people—but in the two other apocalyptic
scenes it joined on tour in March 1853.[9]

Rossiter began *The Babylonian Captivity* shortly before his marriage on 15
October 1851 to Anna Ehrick Parmly, daughter of wealthy dentist and art patron
Eleazar Parmly and his wife Anna Maria Valk Smith.[10] The Parmlys were devout
members of the Disciples of Christ, for whom Dr. Parmly was a lay preacher.[11]
Rossiter's marriage into a family motivated by nonsectarian Christian faith and
repentance and by God's promise of eternal life argues for his own attraction to
and belief in the religious themes he depicted.[12] (The fact that the Parmlys were
vehemently opposed to slavery while Rossiter apparently accepted the biblical
curse of Ham to explain black inferiority and servitude, indicates that there were
areas of possible contention between Rossiter and his new family.)[13]

The Parmlys had other affiliations that indicated a belief in the necessity of
reordering contemporary society. In the 1840s and into the 1850s, both Eleazar
and his brother Levi were nonresident members of the North American Pha-
lanx, the most successful American experiment in Associationism, located about
forty miles south of New York City in Monmouth County, New Jersey.[14]

Soon after Rossiter married into the Parmly circle he, too, showed an interest in the North American Phalanx and demonstrated his acquaintance with some of its residents. In a letter dated only "Saturday 9th" (probably 9 October 1852), fellow artist Paul Peter Duggan expressed his regret that he would not be able to join Rossiter in "the pleasant party you proposed." Duggan requested that Rossiter "give my best respects to our friends Mr. & Mrs. Spring whom I should have more particularly like [sic] to have seen at the *Phalanx.*"[15]

Marcus and Rebecca Spring, friends of the Parmlys,[16] were active and, as it turned out, disruptive members of the North American Phalanx, first as nonresident shareholders and then as residents. Marcus Spring was a New York businessman with antislavery interests and a belief in the reformative powers of art; Rebecca Buffum Spring was the daughter of Quaker abolitionist Arnold Buffum; both were committed to abolitionism as well as women's rights.[17] Marcus Spring, in particular, must have been sympathetic to the ideals and goals of artists of scriptural scenes, such as his friends Rossiter and Duggan; the two artists probably appreciated the respect shown to both art and religion by the reform-minded couple.[18]

We cannot determine whether Rossiter's acquaintance with the Springs came about because he knew the Parmlys (or vice-versa), or whether he met both families through similar social circles. What is clear, however, is that between the time he began *The Babylonian Captivity* in 1851 and the time he finished it in 1853, Rossiter was intimately associated with a group of people committed to social reform and motivated by liberal religious belief. Although Rossiter might not have agreed with all the views of these friends or family members, he shared their faith in the transformative power of Christian philanthropy and its expression in art.[19]

By December 1854, with *The Spirit of War* and *The Spirit of Peace* still in his possession, Jasper Cropsey had completed another painting that visualized the attainment of universal peace, which he sold to Philadelphia merchant Edward P. Mitchell.[20] Like its predecessor, *The Millennial Age* depicts a palm-studded landscape and evokes a classical arcadia. Yet it is compositionally tighter and its message is clearer and more focused, perhaps in response to Curtis's criticism of *The Spirit of Peace.*

The central tholos temple of *The Spirit of Peace* has been replaced by a complex sculpted altar based on the small grouping of lion, lamb, and child, which flanked the original temple of peace. The altar, placed closer to the viewer, dominates the panoramic scene more forcefully than the earlier structure. No medieval ruins or tombs vie with it for attention, and the palm trees are now arranged in isolated groupings, which border but do not encroach upon its space.

The altar is crowned by a slab on which sits a huge lion, a small child with his arm draped over a lamb, and a calf. The slab, outlined in ivy, is supported by a

procession of paired maidens in simple robes. The altar's Christian meaning is emphasized by the cross, held by a putto, which gleams with the same white light as the rising sun. Another putto holds a banner proclaiming "On Earth Peace," and an open Bible sculpted at the base of the altar is inscribed "Isaiah II:4" and "Isaiah XI:6," verses that include the images of swords beaten into plowshares and the child leading wild and domestic animals.[21]

Two wispy columns of incense—Cropsey's metaphor, as we have seen, for pious faith and adoration—rise from the altar and mingle to form gentle clouds in an otherwise perfect sky. The sun hugs the horizon, tangible and perfectly revealed, unlike the brilliant but veiled beacon at the heart of so many midcentury images of aspiration, from Durand's *God's Judgment* to the title page of the *Nineteenth Century*.

A faithful dog and a shepherd's cloak lie at the base of the altar, adding a note of intimate informality. A quiet group of figures—a shepherd, a woman with a distaff, and three young boys—is seated in the central foreground. The seated youth in the middle holds a harp, the instrument of prophecy, rather than a pastoral flute or pipes, and his companions write on sheets of white paper. The arcadian mood of the landscape, with its hint of nostalgia, is projected into the future through these children, whose poetic voices continue the work of prophesying history and recording its fulfillment.

Although the mood is classical, nothing in the landscape, the figures, or the architecture of Cropsey's *Millennial Age* locates the scene unequivocally in the Old World. There is no specifically classical architecture, and there are no medieval ruins and tombs, such as those that marked the passage of time in *The Spirit of Peace* and reminded the viewer of death and decay. The palm trees, suggesting the eternal warmth and fecundity of an earthly paradise, are as evocative of tropical America as they are of southern Europe. The iconic treatment of the three largest palms reinforces the spiritual rather than the earthly meaning of the landscape. *The Millennial Age* is an even more timeless and abstract conception of the spiritual, emotional, and physical experience of absolute peace than *The Spirit of Peace*.[22]

Whatever role in bettering the human condition Cropsey might have envisioned for *The Millennial Age*, he could hardly have directed how the image would be perceived by the members of the family in whose home it was placed. Edward P. Mitchell was business partner and brother-in-law of Hector Tyndale, the man who four years earlier had asked Peter Rothermel to paint *The Laborer's Vision of the Future*. Mitchell, son of a Virginia slaveholder, was married to Elizabeth, sister of his antislavery partner and daughter of an abolitionist Pennsylvania Quaker who espoused Associationism.

This mixture of backgrounds and beliefs in the Mitchell family apparently led to some domestic disagreements, a microcosm, perhaps, of the United States' own familial conflict. In a letter dated 19 June 1854 to the couple's son, James Tyndale Mitchell, a family friend mentions a visit to the Mitchell house

in Philadelphia, where the conversation turned to the recent riots in Boston oc-
casioned by the return of a runaway slave under the Fugitive Slave Law.[23] "You
should have heard the argument your father . . . had with your mother and
grand-mother on the subject," he reported, "it was highly interesting I assure
you."[24] Sarah Tyndale and Elizabeth Tyndale Mitchell's sympathies must cer-
tainly have been against the hated law, while E. P. Mitchell—who contributed
articles to the *Knickerbocker Magazine* under the name "Ralph Roanoke"[25]—
would have taken the side of constitutional authority and the rule of law.

Clearly, an image like Cropsey's *Millennial Age* had different implications
for each member of the Mitchell family, just as its precursor would have had for
each member of its broader American audience. To Edward, the painting prob-
ably reverberated with the progressive spirit of the modern age, a spirit to which
he constantly referred in his *Knickerbocker* articles, published from April 1852 to
March 1854. In them, Mitchell expressed his unbridled enthusiasm for the
United States and his commitment to the myth of its political and spiritual lead-
ership and supremacy.

In an essay published in September 1852, Mitchell recognized the scenic
wonders of the Old World and contrasted them to its social horrors before extol-
ling the virtues of the New World. To Mitchell, the United States was all youth-
ful virility, bursting with prosperity and power, a "new home . . . without the pale
of misrule and despotism, away from the depressing evidences of hopeless,
down-trodden humanity."[26] Mitchell also articulated an attitude toward per-
sonal, evangelical religion that hints at the appeal Cropsey's *Millennial Age*
might have held for him. To Mitchell, the present age was marked by the natu-
ral progress of universal brotherhood, sympathy, and tolerance, guided by God's
wisdom and goodness.[27]

Mitchell seemed oblivious to the contradiction of slavery in a land of liberty
and resolutely blind to the conflicts then tearing apart his own vaunted nation.
Cropsey's visualization of a future Golden Age ruled by the law of universal
brotherhood would have reinforced his professed faith in the unstoppable ad-
vance of civilization to a state of complete harmony.

Yet the inherent ambiguity of the message of *The Millennial Age* becomes
clear if we look at the painting from the perspective Edward's son, James Tyn-
dale Mitchell, might have had. James was most likely indoctrinated against the
evils of slavery and the injustices at work in the United States as well as Europe
by his mother, Elizabeth, his grandmother, Sarah, and, perhaps, his uncle Hec-
tor. In June 1854, six months before E. P. Mitchell purchased Cropsey's *Millen-
nial Age* (also known at the time as the *Golden Age*), a poem by James T. Mitch-
ell entitled "The Golden Age" was published in the *Knickerbocker*.[28]

The poem has a strident and crusading tone completely unlike the gentler ru-
minations of Edward's articles. James used the popular romantic device of an
imagined daydream to present the fate of earlier civilizations and the progress of
liberty, a narrative similar to Horatio Stone's *Eleutheria*. Mitchell emphasized

the importance of union among men and nations when directed against despotism in the cause of liberty. The present age, he wrote, was "a period of struggling thoughts: the whole world is their mighty battlefield."

The poem continued in desperation, as Mitchell tried to balance what could not be balanced and hoped for peace, union, and liberty at a time when international strife, national disunion, and the curse of slavery were harsh realities. (As we have seen, his own family felt the repercussions of this struggle.) Whoever emerged victorious, Mitchell prophesied, would rule the world "through every future age." Present signs and the lessons of history suggested that those who "now strike for liberty and peace" would prevail in this great final battle:

> When all this strife, in centuries to come,
> Is over, and the ever-conquering powers
> of LIBERTY, and UNION, and of PEACE,
> Shall bury in OBLIVION'S dark grave
> The hated names of SLAVERY and WAR,
> And in their place shall HAPPINESS and LOVE
> Direct the march of man for ever on!

To James Tyndale Mitchell, Cropsey's *Millennial Age* might have held a poignancy that his father could not recognize. Although historical precedent and contemporary signs led James to believe that the forces of good would eventually prevail in the coming apocalyptic struggle, their victory is not absolutely assured. James's conception of the future has no room for complacency; the message of faith and hope inherent in *The Millennial Age* is not a sentimental cliché but a necessary encouragement along a dangerous path. To father and son, to all of the Mitchells and Tyndales and others like them, Cropsey's peaceful, glowing visualization of future perfection must have spoken, in varying tones of urgency, of present realities contrasted with future possibilities.

By 1856, for reasons unknown, E. P. Mitchell sold *The Millennial Age* to Joseph Harrison, Jr., a collector who had acquired Crospey's *The Spirit of War* and *The Spirit of Peace* earlier that year.[29] Harrison, a mechanical engineer and inventor, lived in Russia from 1843 until his return in 1852 to Philadelphia where he built an imposing mansion and began to amass a large and important art collection.[30]

Harrison planned this collection to be public, an eventual gift to the city of Philadelphia. Above all, he wished to provide moral exemplars to the people, especially through portraits of great men and pictures of their deeds. Peter Rothermel's *Patrick Henry*, for example, was in Harrison's collection by 1855.[31] Allegorical works, such as the three by Cropsey, as well as scenes from biblical history were also included in Harrison's selection of edifying high art.

Harrison was in Russia during the revolutionary years of 1848 and 1849. His letters from this period demonstrate a concern with the moral character of the present and the future, which helps explain his later motivation to collect im-

ages of past American greatness and timeless Christian spirituality.[32] "The United States has an important mission to fulfill in the world's progress," Harrison observed, "and well it will be for her and the world if nothing occurs to stop her on her onward course."[33]

This "if" underscores Harrison's fundamental uneasiness about the world's prognosis. "Republics have never lasted long and it remains to be seen whether our own country will be able to steer clear of the shoals that have wrecked all former attempts at self-government." Although a supporter of republican government, Harrison was no democrat and he believed that American slaves and European peasants alike were not yet ready to be free. He deplored slavery, however, and called it "the curse of our country," a curse that, he predicted, "will be our ruin sooner or later I very much fear."[34]

The absolute rule of the Russian monarchy was better, Harrison believed in 1849, than current European anarchy; too much order was preferable to too much freedom.[35] Blending the secular and the spiritual in the language of revivalism, Harrison observed that "Liberty is like the Christian Religion and man must be regenerated before he can understand its spirit or feel its value."[36]

What better way to effect such regeneration than by exposing unregenerated—or partially regenerated—hearts and minds to the immediate emotional impact of visual exemplars? Harrison emphasized subjects of American history and portraits of American heroes in his art collection, all visualizations and models of America's mission and of the as-yet successful but incomplete fulfillment of her promise.

And, given Harrison's belief in the necessity of spiritual regeneration—a complete moral reformation and personal consecration—as a prerequisite for successful republican government, paintings like Cropsey's *The Spirit of Peace* and *The Millennial Age* would have served as exemplars and catalysts of this social and religious experience. In Harrison's didactic art collection, the sacred and the secular united in a grand but not yet complete scheme of historical progress, Cropsey's allegories of Christian millennial fulfillment complementing and reinforcing Rothermel's equally apocalyptic *Patrick Henry*.

Conclusion

In the five years from 1848 through 1852, American artists undertook at least ten ambitious paintings of apocalypse and millennium. By 1854, when Jasper Cropsey completed his *Millennial Age*, whatever forces had joined to motivate him and Thomas Rossiter, Frederic Church, James Beard, Peter Rothermel, and Junius Brutus Stearns to produce these prophetic scenes of divine retribution and ultimate redemption had apparently abated. None of these artists dealt with such specifically apocalyptic subjects again during their long and varied careers. Church, Durand, and Cropsey subsequently couched their explorations of American destiny in the language of pure landscape; Rothermel undertook literary, historical, and religious subjects; Rossiter produced portraits, genre paintings, historical scenes, and Christian allegories; Stearns also devoted himself to genre, portraiture, and history; and Beard—"the American Landseer"—specialized in anthropomorphic paintings of animals. This loss of interest must have been due, in part, to artistic maturation, as individual artists abandoned youthful experimentation and found the subjects and the visual vocabulary that most satisfied themselves and their patrons.

And by 1854, many of the issues that intersected in 1848 and stirred popular imagination had either disappeared, become less pressing, or, conversely, taken on an even more fearsome aspect. Cholera, famine, and gold fever had all run their course, the failure of the European revolutions was by now unequivocal, and hopes for universal peace were dashed in the face of the Crimean War, while increased sectional violence in America was fueled by the 1854 Kansas-Nebraska Act.

Prophetic Old Testament subjects did not, of course, disappear from American art after 1854, nor did the production and exhibition of religious images. As we have seen, Rossiter's three scriptural pictures continued on view into the 1860s, and in 1857 William Page produced *Moses, Aaron, and Hur on Mount Horeb*, a large painting (now in ruined condition) whose theme prophesied the coming national crisis.[1] And in 1858, Jesse Talbot undertook a series of paintings depicting *The Division of the Earth among the Sons of Noah*, which, although not specifically apocalyptic, calls to mind questions of racial origin as well as the

fate of nations.[2] Apocalyptic expectation, language, and symbol also continued through the late 1850s and into the Civil War years, as Julia Ward Howe's "Battle Hymn of the Republic" or Frederic Church's landscape vision of *Twilight in the Wilderness* demonstrate.[3] By this time, however, the horizon was more lowering than in the "ominous-hopeful" years around 1848.

Thus, the millennial beacon that seemed to shine steadily through even the darkest clouds around 1848 was flickering just a few years later. In a radio commentary broadcast late in 1991, Daniel Schor contrasted the general mood of those waning months with its counterpart in 1990. In late 1991, he observed, people no longer talk about the end of history and the cessation of struggle and they do not allow themselves to imagine, as they had just one year before, that the lion was finally lying down with the lamb and that swords were, at last, being beaten into plowshares. Although such barometers of national opinion, whether in the mid-nineteenth or late-twentieth centuries, are by nature imprecise, they do illustrate the changeability of the popular mood (as understood by educated observers and commentators) buffeted by unexpected political storms.

The images treated in this study are barometers of such national weather. More important, they are evidence of the desire of some American artists to influence the future of their country, to contribute to its spiritual and thus its social and political destiny. Clearly, these images were understood and advertised first and foremost as models of and lessons in the Christian faith, as aids to the individual believer undergoing his or her "everyday Apocalypse."[4] But inseparable from their spiritual purpose, these paintings, like contemporary "political sermons" and "pulpit politics," spoke to the most crucial secular issues of the day.

The fascination with allegorical and religious art manifest by the artists in this study was not an escape from the harsh materialism of American "real" life into an ideal world of aestheticized spirituality, but rather an avenue into this reality. It was a means to explore, in appropriate artistic language, the complex social and political issues that animated the American present and defined American destiny, which were too complex to be expressed in safer and more marketable "home scenes."

What precisely constituted appropriate artistic language and appropriate artistic territory was open to interpretation in midcentury America, and each artist had to reconcile the economic realities of patronage with the promptings of his own conscience in his choice and treatment of subjects. To the general American public—or, more important, to the arbiters of taste who directed the nation's academies and art unions—an artist could offer moral lessons and encourage piety and patriotism, could imagine happy rural idylls or exotic scenes for the pleasure of tired urban gentlemen, could provide portraits of loved ones or public figures.[5] Rarely was he asked or encouraged to comment directly in his art on the controversial and unsettling affairs of the day. "But enough of Politicks," Cincinnati patron Nicholas Longworth felt compelled to write to Hiram Powers—whose letters and art are filled with references to contemporary politics

and international affairs—"for you, as an artist have nothing to do with them."[6] And Jasper Cropsey, at the end of a particularly news-oriented paragraph in a letter to Thomas Cole, avowed his devotion to painting, almost as if to apologize for an unseemly interest in politics.[7]

If by politics we mean the day-to-day machinations of vote-getting, then it is true that the images in this study were not politically motivated. But Cropsey and the other artists discussed here *were* interested in the larger moral issues on which political activity and national government were based, and they were not content to be perceived merely as polite purveyors of refined entertainment. These artists must have believed that, as an observer noted in 1849, art "can alone be productive of the highest good to a nation when it is true to its mission upon earth . . . : to concentrate and roar, whirlwind-like, against all the strongholds of oppression; to rise with the exhaled prayers of earth, and to descend laden with the blessings and peace of heaven."[8]

Yet artists had every reason to sublimate strongly held opinions about contemporary conditions or events, even ones that obviously intersected with the realm of morality and religious education that many felt to be the proper province of art.[9] (Rothermel's *Laborer's Vision of the Future*, the painting most clearly contemporary in theme and symbol, was a commissioned work.) Indeed, this strategy of sublimation must have been internalized by the artists themselves as well as by sympathetic patrons, all agreeing that artists best fulfilled their prophetic function by using the symbolic language of high art, not party propaganda.

The artists' desire to appeal to an audience and a clientele of diverse opinions joined with their belief that the transformative power of art was best harnessed through metaphorical and poetic means to produce apparently timeless images loaded with topical associations. That these associations must be read between the lines does not render them invisible, and the range of possible interpretations they invite does not render them meaningless. Like all images, the apocalyptic paintings treated here are by nature ambiguous, their message dependent on the individual consciousness receiving it. They appeared at a moment itself fraught with possible meanings, a time when such ambiguity allowed them to appear on public view wearing a sedate mask of universal abstraction through which they preached sermons on contemporary life.

Whatever range of meanings these paintings might have held for the members of their general audience, however, there are patterns to be discerned in the political and religious orientation of their artists and patrons. Artists Frederic Church and James Beard (and probably Frederick Spencer), patrons Jonathan Sturges and Joseph Harrison, Jr., were all Whigs, to whom appealed the complexity and perhaps elitism of the symbols and narratives, and the lessons of discipline and communal harmony in these images. No parallel Democratic interest is apparent.

More specifically, all of the apocalyptic images that focused on divine vengeance were either painted or commissioned by Whigs: Church, Beard, and Sturges.[10] Of these, Church and Sturges were essentially conservative Calvinists; Beard's religious affiliation is less clear. On the other hand, all of the artists and patrons associated with images focusing on millennial hope and promise sympathized with more liberal social and religious ideas. Artists Thomas Rossiter and Jasper Cropsey had Unitarian, Quaker, or Associationist friends and relatives, as did the patron Hector Tyndale, who belonged to no particular religious denomination. Peter Rothermel, although Presbyterian, produced a visual argument for nonsectarianism, and Rossiter married into a deeply religious but nonsectarian family.

Regional background seems to have played a role as well. Beard, whose experiences in border states like Ohio and Kentucky must have taught him that American union was tenuous and that violence pushed against the veneer of American national piety, offered the most pessimistic vision of national destiny. He, among all the artists and patrons discussed in this study, seems the least swayed by postmillennial dreams and the most fearful of the wages of American sin. On the other hand, Philadelphia, a city with an active tradition of pacifism, liberalism, and reformism, was particularly receptive to hopeful millennial allegories. By 1856, Rothermel's *The Laborer's Vision of the Future*, copies of Thomas Buchanan Read's *The Spirit of the Age* and *The Blacksmith Shop of the Nineteenth Century*, and Cropsey's *The Spirit of Peace* and *The Millennial Age* had all found a home in that city.

Uniting them all, however—from James Beard to Hector Tyndale—was a belief in the sacred significance of the secular world and a kinship with those antebellum Americans seeking to ameliorate the world's woes. "For even as some of today's scholars glean mostly 'secular' significance from religion," Robert H. Abzug explains, "the antebellum reformers saw mainly transcendent meanings in politics, society, and the economy. We must concentrate on the religious imagination of reformers in order to grasp the essential nature of reform."[11]

A similar focus is required in order to understand the language and world view of those who produced and appreciated the apocalyptic images discussed in this book. Like enthusiasts for such causes as peace, temperance, abolition, Odd-Fellowship, or Sabbatarianism, they shared a "reform cosmology" shaped in response to economic and social change. According to Abzug, most antebellum American reformers were uncomfortable with the values they saw manifest in a fast-paced world increasingly motivated and dominated by the marketplace, where rampant individualism and self-interest outweighed consideration of the common good. This discomfort was framed "within a literally cosmic setting of divine judgment."[12]

The collage of torn and overlaid posters in Frederick Spencer's *The Newsboy* encapsulates these shifting foundations of antebellum American society, posing a question with which Americans wrestled in both their religious and secular lives:

how much rule of law—the "post no bills" authority of edicts, licenses, and tradition—could society enforce, and how much unfettered individual feeling, preference, and moral conscious could society allow before exploding into "RIOT"?

With its poster announcing "SOMETHING COMEING," *The Newsboy* hawks the cosmic dramas enacted in the religious paintings discussed in succeeding chapters. These images provided the dramatic narrative, actors, scenery, and lighting necessary to animate in vivid and emotionally engaging terms precisely the cosmic implications of the question posed above. Each one encapsulated a vision of what was at stake at that moment for the individual, national, even universal, soul.

Some, like Church's *Plague of Darkness*, Beard's *Last Victim*, Durand's *God's Judgment upon Gog*, even Rossiter's *Babylonian Captivity*, presented their viewers with the psychic as well as the physical consequences of human behavior undisciplined by adherence to divine authority and, by analogy, any human moral equivalent. Mental confusion, hopelessness, panic, and an aching sense of loss and homelessness are the truly apocalyptic horrors promised by these images.

On the other hand, Rossiter's *Return of the Dove* and his *Miriam*, Rothermel's *Laborer's Vision*, Cropsey's *Spirit of Peace* and *Millennial Age*, provide their audiences with alternatives, with gentler exhortations to be strong in faith, to offer providence proper gratitude, to model oneself after Christ, to transform one's own nature, to effect an interior apocalypse. Although each set of images, dependent on a variety of personal and professional considerations, stressed a different aspect of the apocalyptic process, together they demonstrated just how necessary both external exhortation and internalization were in the reformist, religious imagination of the time.

How well—or even whether—these paintings actually helped initiate such a process in their viewers is nearly impossible to tell. A hint of their reformist impact is evident, however, in the emotional responses provoked by Rossiter's *The Return of the Dove to the Ark* and Rothermel's *The Laborer's Vision of the Future* and reported in several abolitionist and antislavery newspapers. Even the disappointment evident in George William Curtis's reviews of Church's *The Deluge*, Cropsey's *The Spirit of Peace*, and Durand's *God's Judgment upon Gog* testifies to a firm belief in the affective potential of the visual. At the least, those Americans concerned with contemporary social relationships and predisposed to interpret biblicial imagery as emblematic of such relationships, credited the apocalyptic paintings discussed here with an active role in shaping the culture.

None of the paintings we have examined was meant to reinforce the status quo, to praise its viewers for lives well lived and responsibilities fulfilled.[13] None of these paintings encouraged the complacent acceptance of an existing world view. Their purpose was transformative: they were apocalyptic in function as well as subject, designed to unsettle their viewers with a vision of human inadequacy, while offering hope for a total obliteration of the old self and the emergence of a regenerated being into a regenerated world.

Notes

Introduction

1. David N. Lord, "Millennial State of the Church," *Theological and Literary Journal* 2 (April 1850): 656–657. David Nevins Lord (1792–1880), a graduate of Yale, was a New York dry goods merchant with a consuming interest in the interpretation of biblical prophecy. He edited the *Theological and Literary Journal* from July 1848 through April 1861; in 1847 Harper and Brothers published Lord's *An Exposition of the Apocalypse*. Most of the journal articles were written by Lord or by his brother Eleazar (1788–1871), one of the first presidents of the Erie Railroad. Both brothers were premillennialists, believers in the imminent Second Advent of Christ before the millennium. (*Dictionary of American Biography*, vol. 6, 405–406; and Jean Hoornstra and Trudy Heath, eds., *American Periodicals 1741–1900: An Index to the Microfilm Collections* [Ann Arbor: University Microfilms, International, 1979], 208). According to Robert Kieran Whalen, David Lord was "the most important American [premillennialist] of the antebellum period, and more than any other man he gave the doctrine form and direction" ("Millenarianism and Millennialism in America, 1790–1880" [Ph.D. diss., State University of New York, 1971], 40–42, 64–69).

2. "The Book of Revelation," *Literary World*, 22 May 1852, 356–357.

3. This approximate number is based on a search of the published exhibition records of the National Academy of Design, the American Art-Union, the Pennsylvania Academy of the Fine Arts, the Boston Atheneum, and the National Museum of American Art's compilation of exhibition catalogues through 1876. From 1840 through 1844, approximately two paintings of such themes were produced and exhibited; from 1845 through 1849, approximately 10; from 1850 through 1854, approximately 11; from 1855 through 1859, approximately 5. Key words used in the search were: Apocalypse, Millennium, Prophet, Prophecy, Revelation, as well as the names of individual prophets (i.e., Daniel, Ezekiel, Isaiah, Jeremiah, Miriam) and events (i.e., Deluge, Plagues of Egypt, Belshazzar's Feast, Destruction of Sodom and Gomorrah). Moses was considered in his prophetic role (i.e., in relation to the plagues of Egypt and the Parting of the Red Sea) but not in biographical (i.e., Finding of Moses), law-giving (i.e., Moses on the Mount), or miracle-working (i.e., Moses Striking the Rock) roles. This information does not, of course, prove an inordinate prophetic interest in the years from 1848 through 1854, since it is approximate and it does not take into account the total number of paintings of all themes produced and exhibited during these years. It does, however (especially when coupled with the giftbook information outlined in note 4), support the assessment of contemporary observers that interest in prophecy was strong in the years immediately after 1848.

4. Of such items published between 1840 and 1860, approximately three appeared in the years from 1840 through 1844, compared to thirty in the years from 1845 through 1849. Nine were published in 1850 through 1854, and fewer in the years 1855 through 1860. The estimate of items that appeared in giftbooks between 1840 and 1860 (for that I do not claim absolute accuracy) is based on a study of E. Bruce Kirkham and John W. Fink, comps., *Indices to American Literary Annuals and Gift Books, 1825–1865* (New Haven: Research Publications, Inc., 1975); the same key words were used as in the search for paintings (see note 3). The dates mentioned in my text reflect the year of copyright, not the year indicated in the title of the

giftbook. In other words, a book entitled *The Opal for 1846* would usually be copyrighted and ready for distribution by late 1845, and thus would be counted for 1845, not 1846. Approximately 71 giftbooks were published from 1840 through 1844, compared to approximately 121 from 1845 through 1849, 118 from 1850 through 1854, and 18 from 1855 through 1859. Thus the total number of giftbooks published in the period 1845–1849 (121) almost doubled the number printed in the five previous years (1840–1844, 71). Yet the number of prophetic items increased ten times in the later period (going from approximately three to approximately thirty) indicating an unusual surge of interest which did more than mechanically reflect the larger number of publications.

5. This is not to imply that those groups considered to be more radical interpreters of prophecy like the Shakers or the followers of William Miller who anticipated Christ's Second Coming in 1843 and 1844 had no visual expression. Millerites used illustrated charts, timetables, and maps; Shakers produced spiritual "gift drawings." For a recent discussions of Millerite charts, see David Morgan, *Visual Piety: A History and Theory of Popular Religious Images* (Berkeley, Los Angeles, and London: University of California Press, 1998), 189–194; for Shaker "gift drawings," see Sally M. Promey, *Spiritual Spectacles: Vision and Image in Mid-Nineteenth-Century Shakerism* (Bloomington and Indianapolis: Indiana University Press, 1993).

6. The words of Reverend Albert Barnes, an evangelical New School Presbyterian who served as pastor of Philadelphia's First Presbyterian Church for forty years, appear frequently in these pages. Although no one person can serve as *the* exemplar of such a pervasive and multivalent ideology as antebellum postmillennialism, Barnes's faith in progress, his evangelical missionary zeal, his acknowledgment of divine retribution, his concern with the spiritual implications of social and political conditions, and his anti-Catholicism do qualify him as a likely candidate for, at least, the northern and actively reformist version. But more significant from my perspective was Barnes's role as foremost antebellum postmillennial explicator of prophetic scripture. His volumes on the books of Isaiah, Revelation, and Daniel offered an appealing and palatable alternative to premillennial literalism in the interpretation of biblical prophecy and were, according to Whalen, "enormously popular," selling over a million copies in the United States. (Whalen, "Millenarianism and Millennialism," 231.) The books are: *Notes: Critical, Explanatory, and Practical on the Book of the Prophet Isaiah; with a New Translation*, 3 vols. (Boston, 1840); *Notes: Explanatory, and Practical on the Book of Revelation* (New York, 1852); and *Notes: Critical, Illustrative, and Practical on the Book of Daniel, with an Introductory Dissertation* (New York, 1853). Barnes was less concerned with literal timetables, esoteric calculations, and an imminent apocalypse than he was with the general correspondence between the language of biblical prophecy, the events of the present, and the upward trajectory of divine history. Barnes manifested in his apocalyptic exegesis an engagement with social problems and historical events and, in his sermons, he used the imagery of biblical prophecy to express his involvement with contemporary society. An article in the *Knickerbocker* in September 1849 noted Barnes's prolific output and his united interest in prophecy and social change: "Of all his brethren in the pulpit, and by the press, no one of this age perhaps, exceeds him in professional industry and practical usefulness. He has published more volumes than many divines have written sermons. . . . Dr. Barnes is not only a judicious annotator on divine revelation, but he is an eloquent writer on human freedom" ("Living Pulpit Orators. The Reverend Albert Barnes, D.D." *Knickerbocker Magazine* 34 [September 1849]: 189–204). Indeed, Barnes was an ardent antislavery spokesman. Timothy L. Smith calls Barnes "foremost among the distinguished group of revival men who dominated the New School synods," who was, by 1856, "Philadelphia's most famous citizen" (Smith, *Revivalism and Social Reform: American Protestantism on the Eve of the Civil War* [Baltimore: Johns Hopkins University Press, 1980], 53; 214). See also Barnes's autobiographical sermon, *Life at Threescore and Ten* (New York, 1859).

7. Stephen D. O'Leary, *Arguing the Apocalype: A Theory of Millennial Rhetoric* (New York and Oxford: Oxford University Press, 1994), 61.

8. Rev. H. Hastings Weld, "Religion and Art," in Weld, ed., *The Sacred Annual, A Gift for All Seasons* (Philadelphia, 1850), 122.

9. Barry Brummett, *Contemporary Apocalyptic Rhetoric* (New York: Praeger, 1991), 10; O'Leary, *Arguing the Apocalypse*, 4.

10. Ernest R. Sandeen, "Millennialism," in Edwin S. Gaustad, ed., *The Rise of Adventism: Religion and Society in Mid-Nineteenth-Century America* (New York: Harper & Row, 1974), 116.

11. Landscape painting is, of course, an essential component of antebellum visual expression. However, I have severely limited my discussion of the apocalyptic implications of American landscape imagery because it has received recent scholarly attention, particularly by Angela Miller in *The Empire of the Eye: Landscape Representation and American Cultural Politics, 1825–1875* (Ithaca and London: Cornell University Press, 1993). Miller discusses the social and political content of mid-nineteenth-century landscape painting, emphasizing the process by which meaning is constructed in landscape imagery and how the "politics of representation" are used in a "struggle between contenders" (4). Miller's chapter entitled "Millennium/Apocalypse: The Ambiguous Mode" examines the importance of millennial thinking to the construction of antebellum landscape painting, especially as it "turned on an unanswered question central to national identity: Where was the country headed, and where was it situated in the millennial timetable?" (109). American painters, she continues, used landscape as "the arena within which collective destiny would be tested." Because the outcome of prophetic history was unknown and ultimately unknowable, these landscapes had implicit in their compositional or narrative structures uncertainty and ambiguity in relation to national destiny—intimations of millennial fulfillment or failure.

I hope the present study complements Miller's, by asking many of these same questions in relation to other types of imagery (although with a slightly different perception of the nature of the artists' apocalyptic faith), and by illustrating that landscapes were only part of a larger field of interconnected visual strategies.

12. William Gerdts, "Belshazzar's Feast II: 'That is his Shroud,'" *Art in America* 61 (May/June 1973): 62.

13. Premillennialists, not surprisingly, were apparently drawn to such dramatic apocalyptic images—whether or not the artist was himself a believer. In 1846, for example, the *Advent Herald*—a Boston-based Millerite newspaper—devoted a long and admiring descriptive article to Rembrandt Peale's *Court of Death*, and published several highly favorable notices about Anelli's *End of the World*. I am grateful to Barbara Franco for bringing these articles to my attention.

14. J. Gray Sweeney, "The Advantages of Genius and Virtue: Thomas Cole's Influence, 1848–1858," in William H. Truettner and Alan Wallach, eds., *Thomas Cole: Landscape into History* (New Haven: Yale University Press, 1994), discusses Cole's influence on the religious and allegorical work of Church, Durand, and Cropsey (114–127). According to Franklin Kelly, Church's *Deluge*, Durand's *God's Judgment upon Gog*, and Cropsey's *Spirit of Peace* "contributed to this short-lived Cole revival of the early 1850s" ("Frederic Edwin Church and the North American Landscape, 1845–1860" [Ph.D. diss., University of Delaware, 1985], 119, 150 n. 87). And, according to Ella Foshay, Cropsey's millennial allegories of the early 1850s are explained in part by his "long-standing admiration for Thomas Cole" ("Jasper F. Cropsey, Painter," in *Jasper F. Cropsey: Artist and Architect* [New York: New-York Historical Society, 1987], 26–27).

15. See Kirsten Hoving Keen, "John Martin's Apocalyptic Imagery and Its Contemporary Context" (Master's thesis, University of Delaware, 1977), 84–92.

16. On 11 October 1848, for example, the *New-York Daily Tribune* carried a large advertisement announcing the opening of an exhibition of "Sacred Scenery." In addition to "Hannington's Sacred Dioramas of the Creation of the World, and the grand Spectacle of the Deluge," nineteen "Bible Subjects" painted by Francis Baker, "from Designs by John Martin of London" were on view as well. See also the engravings after paintings by Martin illustrated in this book, which appeared in such annuals as *The Odd-Fellows' Offering*.

17. An important exception is Wendy Greenhouse, "Daniel Huntington and the Ideal of Christian Art," *Winterthur Portfolio* 31 (Summer/Autumn 1996): 103–140.

18. John W. Dixon, Jr., "The Bible in American Painting," in Giles Gunn, ed., *The Bible and American Arts and Letters* (Philadelphia: Fortress Press, 1983), 157–185.

19. See, for example, William H. Gerdts's negative assessment of Peter Rothermel's *The Laborer's Vision of the Future* and J. Gray Sweeney's comments on Asher B. Durand's *God's Judgment upon Gog*. Gerdts, "On Elevated Heights: American Historical Painting and Its Critics," in William H. Gerdts and Mark Thistlethwaite, *Grand Illusions: History Painting in America* (Fort Worth: Amon Carter Museum, 1988), 103, and Sweeney, "The Advantages of Genius and Virtue," 121.

20. John Davis discusses the importance of childhood familiarity with the Bible for the cultivation of an emotional relationship with its characters and landscape. *The Landscape of Belief: Encountering the Holy Land in Nineteenth-Century American Art and Culture* (Princeton: Princeton University Press, 1996), 17–18.

21. George P. Landow, *Images of Crisis. Literary Iconology, 1750 to the Present* (London and Henley: Routledge & Kegan Paul, 1982), 15.

22. According to Brummett, true apocalyptic eschatology holds that human beings cannot change or alter the plan of history: God alone has set its predetermined course. To many observers, this determinism suggests that apocalyptic belief fosters ahistoricism and apoliticism; all human beings can do is wait for the end. Prophetic eschatology, on the other hand, is seen as less concerned with the ultimate fulfillment of history than on the righteousness of the present. History, to the prophet, is not predetermined, although God has set its course. Human beings create the conditions required for the realization of God's plan. Prophecy has a strong historical context and an important social and political function. The prophet as forthteller (as opposed to mere prognosticator) admonishes his listeners, in the form of the jeremiad, to repent and change their ways (92–93). Brummett offers another type of discourse: "apocalyptic rhetoric," which "uses ancient apocalyptic visions to make historically grounded, personally and politically relevant pronouncements to an audience in the present. Yet unlike prophecy, these pronouncements are exhortations to change not history, but rather oneself, so as to take advantage of the unchangeable, impending culmination of history" (12). This approach, based on an apocalyptic vision of history and an understanding of the prophet's social function, is, I believe, the general one shared by the artists and patrons in this study.

23. Sandeen, "Millennialism," 112–117.

24. Paul Boyer, *When Time Shall Be No More: Prophecy Belief in Modern American Culture* (Cambridge, Mass., and London: Harvard University Press, Belknap Press, 1992), 3.

25. Boyer, Brummett, and O'Leary, and Garry Wills, *Under God: Religion and American Politics* (New York: Simon and Schuster, 1990), especially 146–151, for example, all focus on contemporary American apocalypticism.

26. Boyer, *When Time Shall Be No More*, ix.

27. O'Leary, *Arguing the Apocalypse*, 3.

28. Peter Steinfels, "Gulf War Proving Bountiful for Some Prophets of Doom," *New York Times*, 2 February 1991, 1. See also Bill Lawren, "Are You Ready for Millennial Fever?" *Utne Reader* 38 (March/April 1990): 90–97; and Robert Jay Lifton and Charles B. Stozier, "Waiting for Armageddon," *New York Times Book Review*, 12 August 1990.

29. A connection between 1848 and 1989 was made, for example, in a *New York Times* editorial on 4 December 1989, "European Marxism, 1848–1989. History Completes a Cycle in Central Europe."

30. Francis Fukuyama, "The End of History?" *National Interest* 16 (Summer 1989): 34, n. 39, and Fukuyama, "A Reply to My Critics," *National Interest* 18 (Winter 1989/1990): 21–28. Brummett discusses Fukuyama's arguments as disguised and secularized postmillennial discourse in *Contemporary Apocalyptic Rhetoric*, 147–161.

1. *The Apocalyptic Context and the Signs of the Times*

1. O'Leary, *Arguing the Apocalypse*, 5–6.
2. O'Leary, *Arguing the Apocalypse*, 34–35, 61.
3. Boyer, *When Time Shall Be No More*, xi.
4. Brummett, *Contemporary Apocalyptic Rhetoric*, 48.
5. Brummett, *Contemporary Apocalyptic Rhetoric*, 49.
6. O'Leary, *Arguing the Apocalypse*, 10.
7. In most English versions of the Bible, there are five books of the prophets: the four Major Prophets (Isaiah, Jeremiah, Ezekiel, and Daniel) and the book of the twelve Minor Prophets (Hosea to Malachi). In Christian tradition, these five books are located at the end of the Old Testament and "manifestly point forward to future fulfillment," leading the Old Testament into the New. John F. A. Sawyer, *Prophecy and the Prophets of the Old Testament* (Oxford: Oxford University Press, 1987), 1–2. George P. Landow describes such typology as "a Christian form of scriptural interpretation that claims to discover divinely intended anticipations of Christ and His dispensations in the laws, events, and people of the Old Testament. . . . Typology connects two times, the second of which is said to 'complete' or 'fulfill' the first, and therefore it provides a meaningful structure to human history" (*Victorian Types and Victorian Shadows: Biblical Typology in Victorian Literature, Art, and Thought* [London and Henley: Routledge & Kegan Paul, 1980], 3, 5).
8. Boyer, *When Time Shall Be No More*, 62–63, 68, 70–72.
9. Nathan O. Hatch, *The Democratization of American Christianity* (New Haven: Yale University Press, 1989), 184–189.
10. Boyer, *When Time Shall Be No More*, 226, 228.
11. Garry Wills, *Under God*, 23–24. Ernest R. Sandeen notes, for example, that the years 1828–1832 and 1867–1870 were unusually apocalyptic in both Britain and the United States. See Sandeen, "Millennialism," 177 n. 10. Ruth H. Bloch identifies the period of the French and Indian War as especially apocalyptic. (*The Visionary Republic: Millennial Themes in American Thought, 1756–1800* [Cambridge: Cambridge University Press, 1985], 22).
12. Brummett, *Contemporary Apocalyptic Rhetoric*, 10–11.
13. Brummett, *Contemporary Apocalyptic Rhetoric*, 23. Scholars continue to debate the reasons for the appeal of apocalyptic belief and its greater or lesser strength in different cultures at different times. For a summary of such debates, see O'Leary, *Arguing the Apocalypse*, 8–11, and Boyer, *When Time Shall Be No More*, 55. O'Leary cautions against relying exclusively on those explanations for the appeal of apocalypticism that are based "in conditions of social and economic class, in experience of calamity, or in psychological anomie." He emphasizes apocalypticism as a rhetorical strategy, a discourse that has persuasive appeal to its audiences. "I do not . . . argue that no predispositions exist among converts to apocalypticism, or that concepts such as calamity, anomie, deprivation, or oppression (whether economic or psychological) are utterly useless in the analysis of apocalyptic rhetoric; rather, I . . . argue that previous analyses have ignored the specifically rhetorical nature of these concepts" (11). O'Leary emphasizes how apocalyptic rhetoric also serves to create and support feelings and perceptions of oppression and dissatisfaction. I view the images in the present study as both reactions to a moment of disorder and as evidence of a preexisting rhetorical tradition.
14. Hatch, *Democratization of American Christianity*, 184, 6. Hatch writes specifically of the period 1780–1830.
15. Sandeen, "Millennialism," 116–117.
16. See, for example, David Bjelajac, *Millennial Desire and the Apocalyptic Vision of Washington Allston* (Washington, D.C.: Smithsonian Institution Press, 1988), in which the author examines the religious and political contexts of Allston's prophetic imagery.
17. Angela Miller, *Empire of the Eye*, 35–36.

18. The painting is described by the artist and an outline drawing provided in the pamphlet *The End of the World an Original Painting, of a Very Large Size, with Colossal Figures Painted in New York and Lately Finished by F. Anelli* (New York, 1844). The painting measured 19' × 23'. The painting was exhibited by the Apollo Association in New York in 1844; was on exhibition at Horticultural Hall in Boston in June 1845 (information from Kevin Avery, based on a hand-dated handbill in the Harvard Theater Collection); was also in Boston in July 1846 from where it went to Portland (article in the *Advent Herald*, 15 July 1846 provided to me by Barbara Franco); and was on exhibition in a Dutch Reformed Church in Brooklyn in May and June 1848 George C. D. Odell, *Annals of the New York Stage*, vol. 5 (New York: Columbia University Press, 1927–1949). By early May 1850, the painting, now called *The Dream, or End of the World* was offered "for sale cheap for cash" along with the artist's depiction of the Deluge. The two paintings were on display at the Apollo Rooms in New York in hope of a purchaser. (*New-York Daily Tribune*, 6 May 1850, 5.)

19. Ruth Alden Doan, "Millerism and Evangelical Culture," in Ronald L. Numbers and Jonathan M. Butler, eds., *The Disappointed: Millerism and Millenarianism in the Nineteenth Century* (Knoxville: University of Tennessee Press, 1993), 122, 125–127. After the Disappointment in 1844, when the Second Coming did not occur, date-setting fell increasingly out of favor.

20. Doan, "Millerism and Evangelical Culture," 130.

21. "The Coming Age," *Independent*, 16 January 1851, 10. The *Independent* was among the leading religious newspapers of its day, founded in New York in December 1848 by Joseph Thompson, R. S. Storrs, Henry Ward Beecher, and George B. Cheever as a Congregationalist organ. The paper supported middle-of-the-road revivalism, advocated moral reform through political action, and was antislavery although not radically abolitionist. See Smith, *Revivalism and Social Reform*, 43, 52, 208–210, and Louis Filler, "Liberalism, Anti-Slavery, and the Founders of 'The Independent,'" *New England Quarterly* 27 (September 1954): 291–306.

22. Rev. Dr. Coxe, "Millennium," *Episcopal Recorder*, 22 December 1849, 161.

23. For a discussion of this relationship, see Timothy L. Smith, *Revivalism and Social Reform*.

24. "The Coming Age," *Independent*, 16 January 1851, 10.

25. See, for example, the sarcastic "prize medal" awarded by the humor magazine the *John-Donkey* to the antislavery reformer Horace Greeley in the 22 January 1848 issue. The medal was given to honor Greeley "who has done more than any man living towards the dissemination of saw-dust pudding and the proper appreciation of strapless pantaloons." The design for the medal, presented in two illustrations, shows the profile of a pointy-nosed and scraggly-haired Greeley bordered by the words "Horatius Greeley. Amic. Nigra" on one side, and a pair of legs in boots and unfashionable strapless trousers surrounded by the words "There's a Good Time Coming, Boys. 1848" on the other.

26. Lewis O. Saum, *The Popular Mood of Pre–Civil War America* (Westport, Conn.: Greenwood Press, 1980), 55, 74.

27. Jonathan M. Butler and Ronald L. Numbers, introduction to *The Disappointed*, xviii.

28. See, for example, Ronald D. Graybill, "The Abolitionist-Millerite Connection," in Butler and Numbers, *The Disappointed*, 139–152; and O'Leary, *Arguing the Apocalypse*, 111–133.

29. David L. Rowe, "Millerites: A Shadow Portrait," in Numbers and Butler, eds., *The Disappointed*, 9–10.

30. Whalen, "Millenarianism and Millennialism."

31. Doan, " Millerism and Evangelical Culture," 119.

32. Doan, "Millerism and evangelical Culture," 119.

33. Whalen discusses, for example, those believers who maintained strong aspects of orthodox Calvinism *and* accepted the chronology of postmillennialism. How did they manage to reconcile a belief in innate human depravity with conceptions of human instrumentality in ushering in the earthly millennium? Whalen describes cataclysmic millennialism: a belief

that evil would progressively triumph in the world until, at the last moment, the Divine would intervene to destroy it and usher in the millennium. "Generally, the more theologically conservative the writers the darker the days before the millennium and the more articulated his eschatology" (Whalen, "Millenarianism and Millennialism," 134–137).

34. James H. Moorhead, "Between Progress and Apocalypse: A Reassessment of Millennialism in American Religious Thought, 1800–1880," *Journal of American History* 71 (December 1984): 534.

35. Carl J. Guarneri, "The Associationists: Forging a Christian Socialism in Antebellum America," *Church History* 52 (March 1983): 36–49. For a discussion of the role of artists in American Fourierism (Associationism), see Ann Katharine Martinez," The Life and Career of John Sartain (1808–1897): A Nineteenth Century Philadelphia Printmaker" (Ph.D. diss., George Washington University, 1986), 85–87. American Associationism, although based on the principles of Charles Fourier, took pains to distinguish itself from French Fourierism. Americans were more concerned with Fourier's practical writings on industrial association than with his unorthodox views on marriage, his esoteric philosophical, religious, and scientific speculations. Associationists wanted to do away with the system of commerce that pitted labor against capital and encouraged competition and inequality. These conditions, they believed, violated the God-given laws of universal harmony, which Fourier expounded. See Sterling F. Delano, *"The Harbinger" and New England Transcendentalism: A Portrait of Associationism in America* (Rutherford, N.J.: Fairleigh Dickinson University Press, 1983), 25–50; Ronald G. Walters, *American Reformers, 1815–1860* (New York: Hill and Wang, 1978), 67–70.

36. H. H. van Amringe, "God's Methods in Reforms," *Nineteenth Century* 2 (July 1848): 601, 603, 606, 614–616. Van Amringe was, according to Guarneri, "a Pittsburgh lawyer and amateur theologian [who] claimed to have divined the 'inner sense' of the Book of Revelation: a history of Christianity's doctrinal and spiritual degeneration after the apostolic age, and a glorious prophecy of universal salvation through Christ's second coming into human hearts. [H]e saw in Fourier's plan the millennial kingdom prefigured by his biblical studies" (Carl J. Guarneri, *The Utopian Alternative: Fourierism in Nineteenth-Century America* [Ithaca: Cornell University Press, 1991], 71).

37. "From 1843 to 1848 prophetic calculation and civil unrest coincided to bring [apocalyptic] expectation to a boil" (Ernest R. Sandeen, *The Roots of Fundamentalism: British and American Millenarianism, 1800–1930* [Chicago: University of Chicago Press, 1970], 59).

38. D.C.E., "The Approach of the Millennium Argued from the Signs of the Times," *Christian Review* 13 (June 1848): 250.

39. "The Voyage of Life," *Philadelphia Public Ledger and Transcript*, 1 January 1848.

40. "The Past Year," *Christian Watchman and Reflector*, 4 January 1849, 2. A Baptist organ, this periodical was strongly evangelical and antislavery. See Timothy L. Smith, *Revivalism and Social Reform*, 152–153.

41. "Editor's Department," *Nineteenth Century* 2 (1848): 171. The *Nineteenth Century* was published in Philadelphia by members of the American Union of Associationists, followers of the French utopian socialist Charles Fourier.

42. "Religion and Politics," *Christian Watchman and Reflector*, 21 September 1848, 150. For a concise discussion of the relationship of religion and politics in the United States, see R. Laurence Moore, "The End of Religious Establishment and the Beginning of Religious Politics: Church and State in the United States," in Thomas Kselman, ed., *Belief in History: Innovative Approaches to European and American Religion* (Notre Dame and London: University of Notre Dame Press, 1991), 237–264.

43. Rev. T. R. Birks, "The Political Worth of Daniel's Visions," *Episcopal Recorder* (Philadelphia), 22 January 1848, 175; 29 January 1848, 181; 5 February 1848, 185.

44. The speech was delivered at Union College's commencement by Rev. Tayler Lewis. Rev. E. L. Magoon (a noted art patron) also delivered an address. The event was reported in *Literary World* on 11 August 1849, 113.

45. Cecil Blanch Woodham-Smith, *The Great Hunger: Ireland 1845–1849* (London: H. Hamilton, 1962), 40–42.

46. The description is from an article written by playwright and actor John Howard Payne, "The Beggar Ship," which appeared in *Union Magazine* 3 (September 1848): 98.

47. Mrs. Asenath Nicholson, *Lights and Shades of Ireland: Annals of the Famine of 1847, 1848, and 1849*, 2nd ed. (New York, 1851), 14. Other commentators also interpreted the famine as a divine lesson to an errant nation; see, for example, "Ireland and Its Potato," *Home Journal*, 1 September 1849, 2.

48. "National Retribution," *National Era*, 5 August 1847, 1.

49. For a discussion of millennialism and Manifest Destiny, see Ernest Lee Tuveson, *Redeemer Nation: The Idea of America's Millennial Role* (Chicago: University of Chicago Press, 1966), chapter 4, "When Destiny Became Manifest," 91–136.

50. New York *Herald*, 13 May 1846, as cited in Robert W. Johannsen, *To the Halls of the Montezumas: The Mexican War in the American Imagination* (New York: Oxford University Press, 1985), 8.

51. For anti–Mexican War attitudes and arguments, see John H. Schroeder, *Mr. Polk's War: American Opposition and Dissent, 1846–1848* (Madison: University of Wisconsin Press, 1973), especially chapter 6, "Nonpolitical Dissent: Pacifist and Abolitionist," and chapter 7, "Nonpolitical Dissent: Religious and Literary." See also Johannsen, *To the Halls of Montezumas*, chapter 10, "The War and the Republic," and Frederick Merck, "Dissent in the Mexican War," *Massachusetts Historical Society Proceedings* 81 (1969): 120–136.

52. The Wilmot Proviso, introduced into the House by Democrat David Wilmot in response to the prospect of acquiring new territory through the Mexican War, resulted in heated and far-reaching debate. The proviso was included as an amendment to an appropriations bill designed to smooth negotiations with Mexico, and stated that slavery would not be permitted in any territory acquired from Mexico by treaty. The proviso was adopted in the House on 8 August 1846 but lost in the Senate on 10 August. An attempt to reintroduce such a slavery exclusion clause was ultimately defeated in early March 1847. The controversy over the Wilmot Proviso in late 1846 and early 1847 confirmed that the issues of war, expansion, and slavery were inseparable. The issue came to a head during the presidential campaign of 1848, when antislavery Democrats (Barnburners), dissident New England Whigs (Conscience Whigs), and Liberty Party supporters held the national convention of the newly formed Free Soil Party on 8 August 1848. The Free Soil Party, other than opposing the extension of slavery (while not necessarily calling for its immediate abolition), favored river and harbor improvements, and free homesteads for settlers. The Free Soil Party did not carry any state in the election held on 7 November 1848, but it did enable the Whig candidate Zachary Taylor to defeat the Democrat Lewis Cass by splitting New York's electoral votes. See Richard Morris, ed., *Encyclopedia of American History*, 6th ed. (Harper and Row, 1982), 240–241, 248–249; and Anne Marie Serlio, *Political Cartoons in the 1848 Election Campaign* (Washington, D.C.: Smithsonian Institution Press, 1972).

53. "War and Its Conclusion," *Home Journal*, 22 July 1848, 2.

54. "The Evil to Come," *Christian Watchman and Reflector*, 10 September 1847, 45.

55. "Common Sense," Philadelphia *Public Ledger*, 25 January 1848, 2.

56. D. H. Barlow, "Mission of America," *Graham's Magazine* 38 (January 1851): 48.

57. Johannsen, *To the Halls of Montezumas*, 302–303. For a contemporary assessment of these political conditions in Europe, see, for example, Joseph R. Chandler, "Reflections on Some of the Events of the Year 1848, Annus Mirabilis," *Graham's Magazine* 33 (December 1848): 318–324. Chandler discusses the situation in France, Poland, Austria, Hungary, Prussia, Russia, Italy, Portugal, England, and Ireland, as well as the effects of the Mexican War on the United States.

58. Tuveson, *Redeemer Nation*, 77, 90.

59. Barbara Franco, letter to the author, 12 June 1989.

60. Albert Barnes, *The Casting Down of Thrones: A Discourse on the Present State of*

Europe, delivered at the First Presbyterian Church in Philadelphia on 14 May 1848 and published in New York that year.

61. Barnes, *Casting Down of Thrones*, 107.

62. Ibid.

63. L. C. Lord, "Kings and Thrones Are Falling," *Home Journal*, 21 September 1848, 4.

64. "The Onward March of Revolutions," *Christian Watchman and Reflector*, 14 September 1848, 146.

65. "The Present Condition of Pope Pius IX, with References to the Prophecies," New York *Herald*, 18 February 1849, 2. The sermon was presented by Rev. Dr. Dowling.

66. Ruth H. Bloch, *The Visionary Republic*, 161–163, 170, Clarke Garrett, *Respectable Folly: Millenarians and the French Revolution in French and England* (Baltimore: Johns Hopkins University Press, 1975), 169.

67. *Presbyterian*, 6 May 1848; "Protestant Judgment and Prophecy," *United States Catholic Magazine and Monthly Review* 7 (June 1848): 316; "The Past Year," 2; *National Anti-Slavery Standard*, 8 February 1849, 148. European revolutions attracted self-avowedly rational and skeptical minds to nonbiblical prophetic speculation as well. The author of an article published in December 1848 explained, in painfully tortured prose, the reason for such interest. Given the "uncertainty as to the issue of the convulsions under the throes of which Europe is at present writhing, the troubled mind may surely attach itself to the obscure revelations of such strange announcements . . . without too much deserving the stigma usually attached to superstitious credulity" ("Prophecies for the Present," *Blackwood's Edinburgh Magazine* 64 [December 1848]: 713). Napoleon's prophecy was of particular interest. As recounted by Count Las Cases in his *Memorial de Sainte-Helene* (1823), the exiled conqueror stood on a rock overlooking the sea (a typical prophetic vantage point) and pronounced on the future of Europe. According to a translation of Napoleon's reported words published in the *Home Journal* in May 1848, he announced that "before the sun shall have revolved fifty periods round its orbit the whole European system will be changed. Revolution will succeed revolution, until every nation becomes acquainted with its individual rights. . . . Once again France will be a republic, and other countries will follow her example." An editorial published in the *New York Herald* on 9 April 1849 also commented on Napoleon's prophecy, remarking that "it would appear that the hour for the fulfillment of that remarkable prediction is close at hand. . . . All the signs of the times are indicative of convulsion and change." Perhaps the most famous nonbiblical prophecy to interest Americans in 1848/1849 was the prophecy of Orval, purportedly written in the Belgian abbey of Orval in the sixteenth century and discovered there in 1789. In fact, the document was written and published in 1839 as legitimist propaganda against the July Monarchy. (Thomas A. Kselman, *Miracles and Prophecies in Nineteenth-Century France* [New Brunswick: Rutgers University Press, 1983], 78–79. It reappeared in 1848 when its amazingly precise and detailed predictions were interpreted to coincide with events leading to the overthrow of Louis Philippe. For evidence of American interest, see, for example, "The Orval Prophecy," *United States Catholic Magazine and Monthly Review* 7 (August 1848): 429–432; and an article in the Louisville *Journal*, 24 January 1849, 2.

68. D.C.E., "The Approach of the Millennium," 253.

69. D.C.E., "Approach of the Millennium," 255.

70. "The Approaching Crisis," *Christian Watchman and Reflector*, 27 July 1848, 118.

71. Donald Dale Jackson, *Gold Dust* (New York: Alfred A. Knopf, 1980), 66.

72. "Sermon on California," delivered by Dr. Cheever of the Puritan Church on 31 December 1848, reported in the *Home Journal*, 20 January 1849, 2. This duality is visualized, for example in Hiram Powers's sculpture of *California*, begun in 1850 and completed in 1858, in which a female personification holds a divining rod in her left hand and, behind her back, a bunch of thorns in her right.

73. For a discussion of the anxiety produced by American prosperity, see Fred Somkin, "Prosperity the Riddle" in *Unquiet Eagle: Memory and Desire in the Idea of American Freedom* (Ithaca: Cornell University Press, 1967), 11–54.

74. "A Man Who Is Not Going to California," *New York Herald*, 19 February, 1.

75. J. S. Holliday, *The World Rushed In: The California Gold Rush Experience* (New York: Simon and Schuster, 1981), 25. See also "The Moral Aspects of California: A Thanksgiving Sermon of 1850, with an Introduction by Clifford Merrill Drury," *California Historical Society Quarterly* 19 (December 1940): 299–307.

76. "California," *American Review* 3 (April 1849): 331–338.

77. Charles E. Rosenberg, *The Cholera Years: The United States in 1832, 1849, and 1866* (Chicago: University of Chicago Press, 1987), 101, 105.

78. "The Cry of the Cholera," *Harbinger*, 8 January 1848, 75.

79. "Topics of the Month: The Cholera," *Holden's Dollar Magazine* 1 (February 1848): 125.

80. "The Cholera a Visitation from God," *Independent*, 28 June 1849, 118. The religious implications of the disease will be treated in more detail in chapter 2 and especially in chapter 4. For a discussion of scientific theories about the disease's causes and treatments, see Rosenberg, *The Cholera Years*.

81. *United States Catholic Magazine and Monthly Review* 7 (December 1848): 631.

82. Rosenberg, *The Cholera Years*, 121. The national day of fasting and prayer will be discussed in more detail in chapter 4 in relation to Beard's *Last Victim of the Deluge*.

83. W. "The Duties of Christians in Times Like These," *Independent*, 15 February 1849, 41. To reiterate a point made earlier, the *Independent* was among the leading religious newspapers of the day, founded in New York in December 1848 by Joseph Thompson, R. S. Storrs, Henry Ward Beecher, and George B. Cheever as a Congregational organ. The paper supported middle-of-the-road revivalism, advocated moral reform through political action, and was antislavery although not radically abolitionist. See Louis Filler, "The Founders of 'The Independent.'" According to Charles Rosenberg, the *Independent* was "the most widely read" of the influential religious newspapers of the antebellum period. (*The Cholera Years*, 247).

84. C. N. "On 1848–An Epitaph," *Littell's Living Age*, 24 March 1849, 574. Reprinted from the *Spectator*, where it was published on 28 December 1848.

85. The "Day of Midian" refers to a great battle between the Midianites, the aggressors, and Israel, their distant blood relatives. The Midianites were defeated. See Exodus 2:15 and 3:3.

2. *Something Coming: Frederick R. Spencer's* Newsboy

1. The painting is signed by Spencer and dated 1849 on the reverse. Judging from a reference to Father Mathew, an Irish priest crusading for temperance who began a visit to the United States on 29 June 1849 (see the poster in the upper right of the painting), it was probably not begun until at least July of that year. *The Newsboy* was exhibited at the National Academy of Design's 25th Annual Exhibition, which opened in early April 1850, and at the American Art-Union in 1851. The painting received brief mentions in the *Albion*, 27 April 1850, and the *New York Tribune*, 22 June 1850. It was sold to John Simonson in 1851 for $170.

2. Spencer was elected a member of the American Academy of Fine Arts in 1832; he served as a director for that organization from 1833 through 1835 and as secretary in 1834 and 1839. He was elected an associate member of the National Academy of Design in 1838 and became an "academician" in 1847. He was recording secretary for the National Academy in 1849 and 1850, and member of the exhibition committee in 1846, 1849, and 1850. He was also a member of the academy's council in 1849 and 1850. For biographical information, see Laurence B. Goodrich, "A Little-Noted Aspect of Spencer's Art," *Antiques* 90 (September 1966): 361–363, and Munson-Williams-Proctor Institute, *A Retrospective Exhibition of the Work of Frederick R. Spencer, 1806–1875* (Utica, N.Y.: Munson-Williams-Proctor Institute, 1969).

3. "Newspapers in the United States," *United States Democratic Review* 24 (March 1849): 222.

4. For discussion of the rise of the penny press, see Michael Schudson, *Discovering the News: A Social History of American Newspapers* (New York: Basic Books, 1978), and Alexander Saxton, "Problems of Class and Race in the Origins of the Mass Circulation Press," *American Quarterly* 36 (1984): 211–234.

5. For a discussion of power and its recipients in relation to the development of newspapers and other forms of literacy, see Richard D. Brown, *Knowledge Is Power: The Diffusion of Information in Early America, 1700–1865* (New York: Oxford University Press, 1989). With their implications of democratic social and intellectual leveling, their promise (if not delivery) of equal access to vital information, their indications of a nation intimately linked yet ideologically divided, the public and communal aspects of antebellum newspaper reading infinitely interested antebellum Americans. A significant number of genre paintings produced in the 1840s and 1850s had the newspaper itself, as opposed to the newsboy, as the central figure and protagonist in narratives of American heterogeneity and social conflict. Christian Mayr, James G. Clonney, Richard C. Woodville, and William S. Mount were just some of the artists who dealt with the subject. For recent discussions of the subject of newspaper reading in nineteenth-century American art see Patricia Hills, "Images of Rural America in the Work of Eastman Johnson, Winslow Homer, and Their Contemporaries: A Survey and Critique," in Hollister Sturges, ed., *The Rural Vision: France and America in the Late Nineteenth Century* (Omaha: University of Nebraska Press, 1987), 65–67. Barbara Groseclose also treated the subject of the newspaper and its topical associations in "Politics and American Genre Painting in the Nineteenth Century," *Antiques* 120 (November 1981): 1214. And Bryan Wolf, in "All the World's a Code: Art and Ideology in Nineteenth-Century American Painting," *Art Journal* 44 (Winter 1984): 330–334, discussed the penny press revolution of the 1830s and 1840s and its shaping of social perceptions as manifest in mid-nineteenth-century art.

6. Alexis de Tocqueville, *Democracy in America*, vol. 2, Phillips Bradley, ed. (New York: Alfred A. Knopf, 1963), 111.

7. The image was published on 15 April 1846, and was signed "D. F. Read, del & J. A. Read, sc." D. F. Read provided the drawing, and J. A. Read produced the plate for the wood engraving.

8. For a discussion of sensationalism in penny papers, see David S. Reynolds, *Beneath the American Renaissance: The Subversive Imagination in the Age of Emerson and Melville* (New York: Alfred A. Knopf, 1988), 171–175.

9. "The Answer of the American Press," *Foreign Quarterly Review* 31 (April 1843): 251, 265.

10. Laurence Goodrich noted the conflict between beauty and ugliness presented by these classical pilasters defaced with bills. ("A Little-Noted Aspect," 363.)

11. Nathan O. Hatch, *Democratization of American Christianity*, 222. We should also recognize the humor in Spencer's strategy. Like popular literary urban humorists of the time, he seems to have used humor to, as Reynolds describes the process, "manipulate and recombine potentially disturbing aspects of contemporary popular culture" and to "distance himself from threatening social realities" (Reynolds, *Beneath the American Renaissance*, 468, 479).

12. See, for example, Henry Inman, *The News Boy*, 1841 (reproduced in Elizabeth Johns, *American Genre Painting: The Politics of Everyday Life*, [New Haven: Yale University Press, 1991], pl. 24), and James H. Cafferty, *Newsboy Selling New York Herald*, 1857 (reproduced in Lee M. Edwards, *Domestic Bliss: Family Life in American Painting, 1840–1910* [Yonkers, N.Y.: Hudson River Museum, 1986], fig. 65).

13. *New-York Daily Tribune*, 22 June 1850.

14. *Albion*, 27 April 1850.

15. 26 February 1849, "The Diaries of Sidney George Fisher 1844–1849," *Pennsylvania Magazine of History and Biography* 86 (January 1962): 83–84.

16. "Newspapers," *Arcturus* 1 (January 1841): 69–70.

17. "The Newspaper Literature of America," *Foreign Quarterly Review* 30 (October 1842): 201–202.

18. Reynolds bases his discussion on Mikhail M. Bakhtin's conception of the carnival as a

linguistic situation in which, he explains, "inequality or distance between people is suspended." To Bakhtin, democratic America was a "carnival culture," which encouraged undifferentiated social relativity. (Reynolds, *Beneath the American Renaissance*, 444).

19. Reynolds, *Beneath the American Renaissance*, 444–445.

20. B., "A Picture," *Episcopal Recorder*, 21 April 1849, 22.

21. 26 February 1849, "The Diaries of Sidney George Fisher," 83–84.

22. "The Spirit of the Age," *United States Catholic Magazine and Monthly Review* 4 (December 1845): 750.

23. "T DIS CON" most likely refers to "The Distins Grand Concert" reported, for example, in the *Herald* on 24 April 1849. The Distins, a family of tuba and saxophone players, were the musical sensation of 1849.

24. Felix O. C. Darley and Joseph C. Neal, *In and about Town; or, Pencillings and Pennings* (Philadelphia, 1843), 105.

25. For a discussion of the print, see Carl Bode, *Midcentury America: Life in the 1850s* (Carbondale: Southern Illinois University Press, 1972), 20–21.

26. See Bryan Wolf, "All the World's a Code," especially 330–331, for a discussion of the commercialization of knowledge and its social implications.

27. Beginning in the 1840s, the young boys who roamed the streets selling cheap, accessible, and intellectually homogenizing newspapers were the subject of a number of genre images like Spencer's *The Newsboy*. The earliest appears to have been Henry Inman's 1841 *The News Boy*. For discussions of the visual type of the newsboy, see Johns, *American Genre Painting*, 184–187, 190–192. Other discussions of newsboy imagery include Joshua C. Taylor, *William Page: The American Titian* (Chicago: University of Chicago Press, 1957), 36–40; William H. Gerdts, "Henry Inman: Genre Painter," *American Art Journal* 9 (May 1977): 39–41; Hedy Monteforte da Costa Nunes, "Iconography of Labor in American Art, 1750–1850" (Ph.D. diss., Rutgers University, 1983): 304–325.

28. "The Newsboy," *The Ruby for 1850* (New York, 1849), 254.

29. For this assessment of the newsboy's costume, I am indebted to David Rickman and to Deborah Kraak, formerly Textile Curator at the Henry Francis du Pont Winterthur Museum.

30. "The Newsboy," 254–255. An item reported in the *Tribune* on 20 April 1848 indicates that this reputation had a basis in fact: "[A] Disgraceful Fight . . . occurred in Spruce-st., near the office of *The Tribune* yesterday afternoon, in which a large number of news-boys were participants . . . ," 2.

31. Willis Lloyd Turner, "City Low-Life on the American Stage to 1900" (Ph.D. diss., University of Illinois, 1956), 28–29. For Turner's full discussion of b'hoys, see 28–35. According to Christine Stansell, "the Bowery [was] the broad avenue running up and down the east side of the island. Lined with workshops, manufactories and workers' and small masters' dwellings, the Bowery was the plebeian counterpart of elegant Broadway to the west. In the two decades before the Civil War, it became a byword for working-class culture" (*City of Women: Sex and Class in New York 1789–1860* [Urbana and Chicago: University of Illinois Press, 1987], 89). For Stansell's full discussion of Bowery culture, see 89–100. For a developed discussion of b'hoys, see also Peter George Buckley, "To the Opera House: Culture and Society in New York City, 1820–1860" (Ph.D. diss., State University of New York at Stony Brook, 1984), 294–409.

32. Nicolino Calyo (1799–1884) was born in Naples and studied art at the National Academy in that city. He arrived in Baltimore in 1834 and by the end of 1835 was in New York City. He produced a number of city views and a series of urban character types entitled *Cries of New York*. He also produced dioramas and panoramas. Biographical information from Richard J. Koke, comp., *A Catalog of the Collection, Including Historical, Narrative, and Marine Art*, vol. 1 (New York: New-York Historical Society, 1982): 129. Although there is no external evidence to prove that Spencer used Calyo's watercolor as an inspiration or model for his *Newsboy*, there is also nothing to preclude the possibility. Yet, as much as Spencer's painting resembles Calyo's *Soap-Locks*, there are important differences in terms of the content of their posters and, therefore, in the seriousness of their social comment. Calyo's posters refer almost

entirely to public entertainments; the exceptions are two posters that advertise steamboats and one that announces the availability of the humor magazine *Brother Jonathan*. Certainly a number of Calyo's posters recall topical issues (i.e., the war with Mexico), but they do not match the breadth of Spencer's concerns, which, as we shall see, range beyond the sites of public entertainment. In visual terms, Spencer emphasized surface flatness far more than Calyo, again recalling newspaper space, and he paid far more attention to the illusionistic lettering of his posters and to complex layering.

33. The trousers and boots are described in Charles Haynes Haswell, *Reminiscences of an Octogenarian*, quoted in Stansell, *City of Women*, 255 n. 42.

34. Hydrants were often the cause of fights as rival companies raced to claim and use them during fires. See George W. Sheldon, *The Story of the Volunteer Fire Department of the City of New York* (New York, 1882), 170–171. For b'hoys and fire companies, see Turner, "City Low-Life," 35–38.

35. Quoted in Buckley, "To the Opera House," 296.

36. Entitled "Who Says Gas? Or The Democratic B'Hoy," published by [Peter E.] Abel & Durang, Philadelphia. Probably drawn by E. F. Durang. Information from Bernard F. Reilly, Jr., *American Political Prints, 1766–1876: A Catalog of the Collections in the Library of Congress* (Boston: G. K. Hall & Co, 1991), 310–311.

37. "The Newsboy," *Literary World*, 2 December 1848, 879. The article was reprinted in the *Literary World* from the *Tribune*. The pit was the orchestra level of the theater, as distinct from the more expensive boxes and the cheaper gallery.

38. Turner, "City Low-Life," 58; Buckley, "To The Opera House," 391. Buckley discusses the vogue for the theatrical and novelistic "sketch," which explored a full range of city occupations and characters, in relation to the development of the penny press ("To the Opera House," 353). Sarony's *One of the News B'hoys* was, in fact, part of a series entitled *Sketches of New York* (no. 18). Such visual "sketches," including Spencer's *Newsboy* and Calyo's *Soap-Locks*, should also be recognized as an element in this discourse.

39. Lawrence W. Levine, *Highbrow/Lowbrow: The Emergence of Cultural Hierarchy in America* (Cambridge: Harvard University Press, 1988), 56.

40. Buckley, "To the Opera House," 160. The bifurcation of theatrical audiences and spaces is clear, for example, in *The Soap-Locks*: a seat in the pit of the still upper-end Park Theatre cost fifty cents while one at the lower-class Bowery Theatre could be had for only twelve and a half cents.

41. Buckley, "To the Opera House," 334.

42. Levine, *Highbrow/Lowbrow*, 68.

43. Forrest was not involved in the violence, although advance planning to foment mob violence was evident in the actions of nativist politicians and journalists. (Bruce A. McConachie, "'The Theater of the Mob': Apocalyptic Melodrama and Preindustrial Riots in Antebellum New York," in McConachie and Daniel Friedman, eds., *Theatre for Working-Class Audiences in the United States, 1830–1980* [Westport, Conn.: Greenwood Press, 1985], 39.)

44. "Opinions of the Press on the Late Occurrences in Astor Place," *New York Herald*, 16 May 1849, 1.

45. McConachie, "Theater of the Mob," 35.

46. Levine, *Highbrow/Lowbrow*, 63.

47. George Foster, *New York by Gas-Light* (New York, 1850), 103, quoted in Turner, "City Low-Life," 33.

48. Robert W. Johannsen, *To the Halls of the Montezumas*, 302.

49. Odell, *Annals of the New York Stage*, 5:376. The performance included actors portraying Louis Phillipe of France, Nicholas of Russia, William of Bavaria, and Frederick of Prussia, as well as young ladies in the allegorical guises of Revolution, Progress, Rumor, and Truth.

50. Odell, *Annals of the New York Stage*, 5:448.

51. New York *Herald*, 16 May 1849, 2.

52. The graffiti and notices that cover the wall behind the two newsboys reflect, according

to the Toledo Museum of Art, *American Paintings* (Toledo, Ohio: Toledo Museum of Art, 1979), 59–60, "strident opposition to the Pope, caricatured in profile at lower right; a cardinal who supported the papacy is depicted as a stick figure." The large slogan "Gioberti ai Romani," printed on one of the central posters, refers to Vincenzo Gioberti, "an influential priest and philosopher who actively opposed the Pope's government." See also Theodore Stebbins, Jr., *The Life and Works of Martin Johnson Heade* (New Haven: Yale University Press, 1975), 9–11, 13, 212.

53. The gallery was located on the upper floor of the New York Society Library Building at the corner of Broadway and Leonard Street. The twenty-five-cent admission fee, which was waived for city schoolchildren, must have been a hardship to many people at a time when the customary wage of a day laborer was a dollar a day (see Stansell, *City of Women*, 111), but it was not particularly expensive in comparison to other performances and exhibitions. For an idea of the range of admission prices to a group of basically reputable theaters, concert halls, and exhibitions, see Calyo's *The Soap-Locks*. There were cheaper forms of entertainment (minstrelsy, pantomime, and vaudeville could cost as little as five cents), which even members of a poor working-class family could occasionally have enjoyed. For admission prices, see Buckley, "To the Opera House," 145–146.

54. Thomas S. Cummings, *Historic Annals of the National Academy of Design . . . from 1825 to the Present Time* (Philadelphia, 1865), 356. Approximately 11,012 paying customers visited during the three months the exhibition was open.

55. Ingham to Durand, 7 September 1849, Charles H. Hart Autograph Collection, Archives of American Art. Approximately 250,000 people—approximately 21,000 per month—visited the American Art-Union exhibition, which was open most of the year. See Charles E. Baker, "The American Art-Union," in Mary Bartlett Cowdrey and Theodor Sizer, eds., *American Academy of Fine Arts and American Art-Union 1862–1852* (New York: New-York Historical Society, 1953), 216. We should recognize that many artists and patrons did support both the National Academy and the American Art-Union.

56. For a discussion of the goals and organization of the American Art-Union and the role it played in midcentury American cultural politics, see Rachel N. Klein, "Art and Authority in Antebellum New York City: The Rise and Fall of the American Art-Union." *Journal of American History* 81 (March 1995): 1534–1561.

57. Baker, "The American Art-Union;" and Maybelle Mann, *The American Art-Union* (Otisville, N.Y.: ALM Associates, 1977).

58. "The American Art-Union," *Harbinger* 6, 18 December 1847, 53. Despite such criticism, *Harbinger* was generally supportive of the American Art-Union and the assistance it offered artists in their search for customers.

59. *Literary World* 1848, quoted in Baker, "The American Art-Union," 212.

60. Quoted in Baker, "The American Art-Union," 209.

61. "The American Art-Union," *Knickerbocker Magazine* 32 (November 1848): 446.

62. 1847 report of the American Art-Union Committee, quoted in Baker, "The American Art-Union," 209.

63. Quoted in Cummings, *Historic Annals*, 215. For a discussion of the relations of the National Academy and the American Art-Union in 1850 and 1851, with particular emphasis on the perceived need for unity and harmony at a time of national tension, see Miller, *Empire of the Eye*, 228–229.

64. *Holden's Dollar Magazine* 1 (April 1848): 250. The first of these troupes, imported from Europe and promoted by Dr. Collyer, opened in New York on 23 December 1847. See Odell, *Annals of the New York Stage*, 5:378–381. The *Herald* carried an advertisement for the Model Artists, 30 January 1849, 3.

65. Reynolds discusses model artists as examples of "social voyeurism," evidence of a growing recognition in the 1840s of the powerful and irrepressible sexual drive. Reynolds argues that such exhibitions provided release for male fantasies and also reflected an increased interest in the sexuality of women. (*Beneath the American Renaissance*, 214, 217.)

66. "Model Artists Again," *Herald*, 5 February 1849, 2.

67. March 1848, quoted in Odell, *Annals of the New York Stage*, 5:380.

68. *Albion*, 27 April 1850. David M. Lubin, *Picturing America: Art and Social Change in Nineteenth-Century America* (New Haven: Yale University Press, 1994), 276–277. Lubin notes that trompe l'oeil artists often favored flat surfaces covered with layers of other flat items (i.e., letter racks) because they were better able to successfully sustain illusion with such two-dimensional planes; Spencer seems to have employed this strategy.

69. As we have seen in note 23, "T DIS CON" most likely indicates "The Distins Grand Concert." The partially hidden poster announcing "A Grand Concert at the Tabernacle" probably also refers to the Distins, who were honored by a "grand miscellaneous concert" at the Broadway Tabernacle, a respectable venue. The Tabernacle—home of Charles Finney and seat of American evangelism—was a place of entertainment and education suitable for the most genteel New Yorkers. And the large yellow poster that partially obscures the Tabernacle announcement has on it the faint outlines of one of P. T. Barnum's Mammoth Ladies, on display at his American Museum on Broadway. By the 1840s, Barnum had established what contemporaries and historians agree was "the most important site for entertainment in New York." The museum's audience was as mixed as its collection of questionable curiosities, its living human freaks, assorted vaudeville and musical acts, and uplifting moral dramas. Through hyperbolic advertisement, careful siting, and innovative techniques of promotion and production, Barnum managed to bridge the widening gap between high and low, bringing together in one place varieties of amusement that catered to different tastes. (Buckley, "To the Opera House," 481, 495.)

70. "City Intelligence. Beware of Mock Auctions," *New York Herald*, 12 March 1849, 4.

71. [Sidney George Fisher], "The Diaries of Sidney George Fisher, 1844–1849," *Pennsylvania Magazine of History and Biography* 86 (January 1962): 84.

72. The painting was commissioned by Robert McElrath, copublisher with Horace Greeley of the *New-York Daily Tribune*, the newspaper held and examined by the left central figure. Mount included himself; he is the figure seated in the right foreground with a sketchbook in his pocket. For a description and discussion of painting, see J. Gray Sweeney, *Themes in American Painting* (Grand Rapids: Grand Rapids Museum of Art, 1977), 113; and David Cassedy and Gail Shrott, *William Sidney Mount: Works in the Collection of the Museums at Stony Brook* (Stony Brook, N.Y.: The Museums at Stony Brook, 1983), 61.

73. Quoted in Alfred Frankenstein, *William Sidney Mount* (New York: Harry N. Abrams, 1975), 45. The dual nature of El Dorado is visualized, for example, in Hiram Powers's allegorical sculpture of California, begun in 1850. California beckons with a divining rod in her left hand; with her right she hides a bunch of thorns behind her back.

74. The lithograph is signed "Perkins" and was published by [Henry] Serrell & [S. Lee] Perkins of New York. For information about the print, See Bernard F. Reilly, Jr., *American Political Prints, 1766–1876: A Catalog of the Collections in the Library of Congress* (Boston: G. K. Hall, 1991), 327.

75. Johannsen, *To the Halls of the Montezumas*, 284.

76. Marcus Cunliffe, *Soldiers and Civilians: The Martial Spirit in America 1775–1865* (Boston: Little, Brown and Company, 1968), 116.

77. The painting was exhibited at the American Art-Union after it had already been purchased by George Austen, the art union treasurer. Alfred Jones published two engravings after the painting for the art-union in 1851, one a large folio, the other a small print, which appeared in the *American Art-Union Bulletin* in April 1851 and in the giftbook *Ornaments of Memory* (New York, 1854). See Francis S. Grubar, "Richard Caton Woodville: An American Artist, 1825 to 1855" (Ph.D. diss., Johns Hopkins University, 1966), 232–239.

78. The Mexican War was the first conflict in which the telegraph was used as a major means of communication and to relay news. See Richard A. Schwarzlose, *The Nation's Newsbrokers*, vol. 1, *The Formative Years, from Pretelegraph to 1865*, 65–66. (Evanston: Northwestern University Press, 1989). According to one contemporary observer, Woodville's image depicts

the moment "when nation raises up sword against nation, when war creates the most thrilling interest in every mind . . . when . . . dread . . . is succeeded by cheering news from the field of battle." Richard Vaux, "The Mexican News," *Ornaments of Memory* (New York, 1854), 155.

79. Bryan Wolf claims that the painting offers a "paradigm for American society as an extended family unit" which was white, patriarchal, and stratified by power and status: "All the World's A Code," 332. For a description of the range of types, see also Johns, *American Genre Painting*, 1. The location of the painting was identified as a southern tavern in a review in the *Literary World*, 13 December 1851, 471, perhaps on the basis of the two African American figures who appear in the right foreground. There appears to be no strong internal evidence, however, limiting the painting to a southern setting.

80. Johannsen, *To the Halls of the Montezumas*, 279–280. Two contemporary books about revolutionary war veterans that had an antiwar message, for example, tied this message obliquely but obviously to the Mexican War, emphasizing the negative aspects of war and a soldier's life and preaching against the prevalent "my country right or wrong" slogan: Joseph Alden, *The Old Revolutioner* (New York, 1847) and Alden, *The Old Revolutionary Soldier* (New York, 1848).

81. See Albert Boime, *The Art of Exclusion: Representing Blacks in the Nineteenth Century* (Washington, D.C.: Smithsonian Institution Press, 1990), 16–17, 102–103.

82. Magee's painting is reproduced in Hermann Warner Williams, *Mirror to the American Past: A Survey of American Genre Painting, 1750–1900* (Greenwich, Conn.: New York Graphic Society, 1973), 81, fig. 63. Magee's was not the only nor the earliest version of this subject. In July 1847, for example, an engraving designed by Tompkins H. Matteson and entitled *News from the War* was published in the *Union Magazine*. In it, a woman lies prostrate on the floor of a rustic cottage, collapsed like a surrogate corpse upon the newspaper that informed her of her husband's death in battle. A month earlier, the staunchly antiwar *Harbinger* (organ of the American Union of Associationists) had published an article entitled "The Wages of War," which offers a striking verbal counterpart to Matteson's and Magee's visual evocations of the suffering of women and children in time of war. (*Harbinger*, 26 June 1847, 42–43).

83. Magee's painting provided the model for an engraving that appeared in *The Odd-Fellows' Offering, for 1852* (New York, 1851). An accompanying poem entitled "The Mexican Express" by E. Anna Lewis reminded its readers of this bitter truth (257).

84. For a discussion of Father Mathew, see Elizabeth Malcolm, *"Ireland Sober, Ireland Free": Drink and Temperance in Nineteenth-Century Ireland* (Dublin: Gill and Macmillan, 1986), c. 3. For advertisements of Father Mathew's likeness, see, for example, *New York Herald*, 3 July 1849, 5.

85. "Father Mathew and His Friends," *New York Herald*, 11 July 1849, 2.

86. See, for example, Lebbeus Armstrong, *The Temperance Reformation: Its History from the Organization of the First Temperance Society to the Adoption of the Liquor Law of Maine, 1851* (New York, 1853). "In the struggle of years past, the *license law* has been the bone of contention between the advocates of temperance or principles of total abstinence, and advocates of the *human right* to make, vend, and consume intoxicating liquors, under the sanction of the *license law of the land*." According to Armstrong, a "no License" law was passed in New York State on 19 May 1846, only to be repealed at the next legislative session (47–49).

87. Malcolm, *"Ireland Sober, Ireland Free,"* 150.

88. There was, indeed, a serious problem with drink among the Irish; see Ian R. Tyrrell, *Sobering Up: From Temperance to Prohibition in Antebellum America* (Westport, Conn.: Greenwood Press, 1979), 299. Another immigrant-related issue is raised in Spencer's notice calling for an honest servant, located in the extreme upper left of the composition. The status of servants declined in the 1830s as immigration increased; American antiforeign attitudes contributed to the prejudice and contempt apparent in numerous articles that complained about the dishonesty and unruliness of contemporary servants. For a discussion of this situation, see Da Costa Nunes, "Iconography of Labor," 328–329.

89. "The Emigrant's Dream," *Yankee Doodle*, 19 December 1846, 259. The short-lived periodical began publishing in 1846 and ended the next year. A self-styled American *Punch*, it was edited by young American humorist Cornelius Mathews. See Frank Luther Mott, A *History of American Magazines*, vol. 1 (Cambridge: Harvard University Press), 425.

90. See, for example, *The Emigrant's Dream*, a "fairy sketch" that appeared at the Broadway Theatre from 28 December 1847 through 6 January 1848, which included not only "Jemmy," "Molly," and Peggy," but such characters as "American-Eagle," "Genius of America," and "Hibernia." Joseph N. Ireland, *Records of the New York Stage from 1750 to 1860*, vol. 2 (New York, 1866; reprints New York: Benjamin Bloom, 1966), 496–497. For a discussion of dream images in antebellum American art, see William H. Gerdts, "Daniel Huntington's *Mercy's Dream*: A Pilgrimage through Bunyanesque Imagery," *Winterthur Portfolio* 14 (Summer 1979): 177–178, and Randall C. Griffin, "The Untrammeled Vision: Thomas Cole and the Architect's Dream," *Art Journal* 52 (Summer 1993): 66–73.

91. Woodham-Smith, *The Great Hunger*, 73–74.

92. Few American artists treated the plight of famine victims in a straightforward manner, although one genre painting of the time does touch on the subject and, indirectly, on the role of the newspaper in American public's discussion of it. *The Orphan's Funeral* by Francis William Edmonds was exhibited at the National Academy in 1847 (the painting is unlocated and now known through an engraving). In it, a ragged young mother, child in tow, clutches a small coffin beneath one arm. To the left of this pathetic and lonely pair lies an unkempt graveyard, the last resting place of the child in the coffin. That at least one viewer by 1848 directly associated Edmonds's painting with the Irish situation is evident in a poem entitled "The Irish Mother's Lament. Suggested by Seeing 'The Pauper's Funeral' by F. W. Edmonds," by Mrs. Elizabeth T. Herbert, published in the *Union Magazine* 2 (June 1848): 273. The woman was also identified as Irish in an article by Mrs. C. M. Kirkland in *The Odd-Fellows' Offering, for 1850* (New York, 1849): 123–135. Edmonds's image of a mother carrying the coffin of her own child to burial was not a sentimental figment of the artist's imagination. The New-York *Daily Tribune*, for example, reported on 17 June 1847 that "yesterday . . . three women, poorly dressed . . . and . . . three little children with them passed up Fiftieth Street to the burial ground. . . . One of them held with her hand a plain pine coffin . . . and the unhappy creature wept as though her heart would break. It was the coffin of her own infant." As reprinted in the *Harbinger*, 31 July 1847.

93. Hone wrote that cholera had been brought to the city aboard the packet ship *New York* bound from the Hague. (*The Diary of Philip Hone* [New York: Kraus Reprint Company, 1969], 16 December 1848, 2:858; 30 June 1849, 2:871.) Charles Rosenberg affirms that the ship *New York* arrived in New York on 1 December 1848 with cholera victims aboard. But the cold winter weather delayed the onset of the epidemic in the North until the spring. (*Cholera Years*, 101). Cholera was, not surprisingly, much more widespread and virulent among poor immigrants who lived in wretched and overcrowded urban conditions with no sanitary facilities. Over forty percent of those who died of the disease in New York had been born in Ireland. (Rosenberg, *Cholera Years*, 135.)

94. See note 1 to support this dating of the painting.

95. *New York Herald*, 10 June 1849, 2; *Herald*, 17 July 1849, 2; *Diary of Philip Hone*, 2:872; *Herald*, 3 August 1849, 3.

96. Da Costa Nunes, "Iconography of Labor," 192.

97. Levine, *Highbrow/Lowbrow*, 176. Levine sees this pervasive mood as catalyst for the bifurcation of culture, especially by the turn of the twentieth century: those who were most threatened and worried by change either escaped into aesthetic culture or tried to change lower-class cultural behavior to match elite ideals. I suggest that when this process first gained momentum in the early and mid-nineteenth century, religion provided the refuge of structure and order.

98. There is no ready explanation for Spencer's misspelling of the word "coming" as "comeing." According to an edition of Noah Webster's *An American Dictionary of the En-*

glish Language, published in New Haven in 1841, the correct spelling of the word does not include an "e" and there is no mention in the dictionary's introductory section on orthography of such an alternate approach to adding "ing" to words that end in "e." Spencer's version of the word, then, is clearly wrong by the rules of his time. It is possible that the artist actually saw such a spelling of the word—perhaps even the entire phrase "something comeing"—and incorporated such a sign of nonstandard (or substandard) language into his vision of a changing America as more evidence of the weakening of established authority and tradition.

99. "Duties of Christians," 41.

100. A. M. P., "Stanzas: Progress," *Knickerbocker Magazine* 31 (May 1848): 397–398.

101. As published in Mackay, *Ballads and Lyrics* (London, 1859): 103. The song originally appeared as a poem in the *London Daily News*, was included in Mackay's book of poems entitled *Voices from the Crowd*, and was subsequently set to music, first by Henry Russell and then, in 1846, by Stephen Foster.

102. Charles Mackay, *Through the Long Day; or, Memorials of a Literary Life during Half a Century*, vol. 1 (London, 1887), 134–135. Letter from Whittier to William Ticknor and James T. Fields, 18 May 1858, published in John B. Pickard, ed., *Letters of John Greenleaf Whittier*, vol. 3 (Cambridge: Harvard University Press, Belknap Press, 1975): 367. The song was as popular among reformist circles in the United States as in England, and was regularly included, for example, in concerts by the Hutchinson Family. See William W. Austin, *"Susanna," "Jeanie," and "The Old Folks at Home": The Songs of Stephen C. Foster from His Time to Ours* (Urbana: University of Illinois Press, 1987), 17–19; 35.

103. For the interpretation of technological improvements as millennial harbingers, see, for example, Ernest Lee Tuveson, *Millennialism and Utopia: A Study in the Background of the Idea of Progress* (Berkley: University of California Press, 1949), 137; Moorhead, "Between Progress and Apocalypse," 533–534; and James W. Carey, "Technology and Ideology: The Case of the Telegraph," *Prospects* 8 (1983): 304, 307.

104. "The Newspaper Press," *Independent*, 7 December 1848, 2.

105. D.C.E., "The Approach of the Millennium," 252. The *Christian Review*, in which it appeared, was a Baptist periodical.

106. Philip Harwood, "The Hebrew Prophets and the Christian Gospel," *The Nineteenth Century* 3 (1840): 295.

107. This relationship is implied in Oertel's engraving *Things as They Were, and Things as They Are*; as we shall see, emblems of liberty frame the modern age of newspapers while emblems of war flank an outdated world of Catholic pieties.

108. "Popular Institutions," *Graham's Magazine* 38 (March 1851): 189.

109. For a discussion of the important role of evangelical Christianity in the development of a mass reading audience in the United States, see David Paul Nord, "The Evangelical Origins of Mass Media in America, 1815–1835," *Journalism Monographs* no. 85 (May 1984); and Hatch, *The Democratization of American Christianity*, 141–146.

110. The American Home Missionary Society was a nonsectarian Protestant organization founded in 1826 to promote the evangelization of the American West and the conversion and religious instruction of recent immigrants. It was run by Congregationalists and New School Presbyterians but intended to be a glorious experiment in interdenominational cooperation—hence the emphasis on the millennial aspects of Christian Union—although it ultimately failed. (Clifford S. Griffin, "Cooperation and Conflict: The Schism in the American Home Missionary Society, 1837–1861," *Journal of the Presbyterian Historical Society* 38 [December 1960]: 213–233.)

111. Sartain's print is clearly indebted to Thomas Sinclair's lithograph *Christian Union*, which was published in 1845. Sartain's version differs, however, in its inclusion of a foreign group—the Islamic—within the realm of the converted, in the central importance given to the black figure and its suggestion of ultimate liberation, and in its emphasis, through the engraved title, on the millennial meaning of the subject.

112. W. C., "The Boys of the Bowery Pit," copy in Harvard Theatre Collection, Cam-

bridge, Mass. The broadside on which the song is printed is not dated. John R. Scott, the actor mentioned in this verse, came to prominence in the mid-1830s and died in 1856. He and the type of play for which he was best known began to lose popularity after 1850. The song, then, probably appeared in the late 1830s or sometime in the 1840s. "Gallus" was b'hoy slang for something pleasing; see Turner, "City Low-Life," p. 32. "Wide-Awake," besides it obvious meaning of alertness, was usually associated with American eagerness for the main chance, the shrewdness of its citizens for economic advantage. Johns, *American Genre Painting*, 9, 29.

113. This affinity raises the intriguing possibility that Spencer had this particular song and these particular lines in mind when he lettered his sign, especially since the chorus of the song identifies the majority of the "boys of the Bowery Pit" as newsboys: "The Newsboys they're a gallus crowd, as I will let you know, / They go to the Bowery Pit for to see the show." Since I have no hard evidence to support a direct relationship between Spencer and this song, and since I do not know its precise date, I hesitate to build an argument on it. I am likewise not asserting that Spencer was specifically referring to "The Good Time Coming." I am more concerned with the hopes and fears these two songs expressed and with the general resonance of their language to Spencer's "SOMETHING COMEING."

114. "Opinions of the Press."

115. McConachie, "'Theater of the Mob,'" 24. See also MConachie, *Melodramatic Formations: American Theatre and Society, 1820–1870* (Iowa City: University of Iowa Press, 1992).

116. McConachie, "'Theater of the Mob,'" 21–23. *The Last Days of Pompeii* and *Nick of the Woods* were adapted from novels by Louisa Medina, a prolific author of the 1830s. See chapter 5, "'The Earthquake! The Earthquake'" in McConachie, *Melodramatic Formations.*

117. McConachie, "'Theater of the Mob,'" 24, 35.

118. McConachie, *Melodramatic Formations*, 135.

119. Benson Lossing (1813–1891) was a prolific wood engraver, author of popular illustrated historical books, and editor. (His *Outline History of Art* was published in New York in 1840.) A Democrat until he changed allegiance to the Republican Party sometime before 1859, Benson was against slavery, a devout but liberal Episcopalian, and a prominent supporter of Odd-Fellowship. David D. van Tassel, "Benson J. Lossing: Pen and Pencil Historian," *American Quarterly* 4 (Spring 1954): 32–44, discusses Lossing's importance as a popularizer rather than serious historian.

120. Odd-Fellowship encouraged acts of individual charity and benevolence (not, like Associationism, the total restructuring of society) as the means to counteract national vice, greed, belligerence and pride, and to promote world peace and universal brotherhood. Odd-Fellowship had, like the Masonic Order, a complex system of degrees and rites and, particularly important for the purposes of this study, a language of visual emblems and symbolic biblical imagery. Like Associationism, Odd-Fellowship seems to have attracted a number of antebellum American artists and critics; in addition to Lossing, John C. Hagen, a New York artist and member of the Sketch Club, the genre painter Tompkins H. Matteson, the art critic Henry Tuckerman, and C. Edward Lester, author of *The Artists of America: A Series of Biographical Sketches of American Artists* (New York, 1846) were active Odd-Fellow Brothers. On 5 June 1849, the *Tribune* reported that "The Order of has become so extensive and important in this country that their halls, their decorations, their celebrations, their congresses, to say nothing of their everyday influence throughout the length and breadth of the continent, are matters of no ordinary public importance. The rapid growth of the fraternity is one of the wonders of the age." The order, among other enterprises, published its annual from 1842 through 1853 *(The Odd-Fellows' Offering, for 1843–The Odd-Fellows' Offering, for 1854).* According to the *Knickerbocker*, this annual was "recommended not only to all members of the Order, but to the public at large. It has heretofore enjoyed . . . as it deserves to, an extended popularity" (*Knickerbocker* 34 [December 1849]: 549). The use of biblical imagery for social as well as individual and spiritual ends was an important aspect of the Odd-Fellowship's didactic strategy. For a discussion of the order's goals, see Thomas Austin, "The Genius and Benevolence of Odd-Fellowship," *The Odd-Fellows' Offering, for 1854* (New York, 1853), 9–58.

121. The lecture was delivered again by Thompson on 20 May at a church in Washington Square; the entire text of the lecture was published on the front page of the *Tribune* on 25 May 1849.

122. Gordon Waterfield, *Layard of Nineveh* (London: John Murray, 1963): 190; London *Times*, 9 February 1849, 5. Davis, *The Landscape of Belief*, 111–113.

123. Waterfield, *Layard*, 178–179.

124. For a discussion of Thompson, especially his antislavery, "free soil" stance, see Filler, "Liberalism, Anti-Slavery, and the Founders of 'The Independent,'" 291–306.

125. The apocalyptic melodrama *The Last Days of Pompeii* had, in fact, recently finished a run at the Bowery Theatre (it was performed 20–26 February [Odell, *Annals of the New York Stage* 5:451]) although members of its working-class audience were probably not among the select and respectable few who visited the academy exhibition a few months later. Still, it is clear that "low" and "high" culture shared a common language in which to express their fears as well as their fantasies of vengeance, however different these fears and fantasies might be.

126. *Knickerbocker* 33 (May 1849): 470. Deas was committed to a mental institution in the summer of 1848, and the ultimate source of this monstrous fantasy must have been the artist's own tortured mind. He continued to paint similar visions while in the asylum. But this horrific scene of human beings crushed in the embrace of serpents must also be placed in the broader context of other catastrophic, despairing, and suffering images on view at the academy and elsewhere in 1849. Especially intriguing in this regard is a description of the sufferings of cholera victims offered by a New York physician recalling the 1849 epidemic: "One often thought of the Laocoon, but looked in vain for the serpent" (Edward H. Dixon, *Scenes in the Practice of a New York Surgeon* [New York, 1855], 15, quoted in Rosenberg, *The Cholera Years*, 3).

127. *Paradise Lost* 11. 475–493. See also the carefully lettered inscription from *King Lear* in the painting's foreground: TAKE PHYSIC POMP. The speech from which these words come is delivered by Lear at that point when his fortunes are at their worst and when madness and a growing sense of his own guilt affect his mind (3.4.28–36). Dieter Mehl, "King Lear and the 'Poor Naked Wretches, *Deutsche*,'" in Hermann Heuer, ed., *Deutsche Shakespeare-Geselschaft West Jarhbuch* 1975 (Heidelberg: Quelle and Meyer, 1975), 154. Pomp—the arrogant display of majesty, power, and wealth—must take a purgative dose of medicine to cure itself of superfluity, greed, and selfishness. And this physic takes the form of an empathetic dose of suffering. Duggan, as Henry Tuckerman reported, "was an Irishman" (Henry T. Tuckerman, *Book of the Artists: American Artist Life* [New York, 1867], 431); perhaps he was recalling the sufferings of his countrymen as he painted this *Lazar House*.

3. *1848/1849: Thomas P. Rossiter,* Miriam Rejoicing *and* The Return of the Dove to the Ark

1. "Brief Mention—Rossiter," *Home Journal*, 13 January 1849, 2.

2. Neither painting has been currently located. *Miriam*'s dimensions are reported in Ilene Susan Fort, "High Art and the American Experience: The Career of Thomas Pritchard Rossiter" (master's thesis, Queens College, City University of New York, 1975, 187 n. 62. Rossiter describes the two works in a pamphlet: *A Description of Rossiter's Scriptural Paintings: The Return of the Dove to the Ark; or, The Triumph of Faith; and Miriam the Prophetess Exulting over the Destruction of Pharaoh's Host. Together with a Sketch of the Life of the Artist, Notices of the Press, etc. etc.* (New York, [1851–1852]). (My dating of this pamphlet is based on several internal clues, most important the information on page 6 that Rossiter was at work on his *Babylonian Captivity* [here entitled "The Children of Israel beside the Waters of Babylon"]. He began that painting around July 1851 and finished by March 1853.) According to this pamphlet, *The Return of the Dove* was begun in April 1848, *Miriam* was painted in November and

December 1848 (11). Rossiter also outlined in this pamphlet his plans to have the two paint-
ings "engraved in mezzotint by the best engravers in Paris" (7); nothing seems to have come of
this project. For mentions of *The Return of the Dove to the Ark*, see the *Literary World*, 14 Oc-
tober 1848, 735; the *Home Journal*, 21 October 1848, 2; the *Christian Observer* (Philadelphia),
23 December 1848, 209; the *Philadelphia Freeman*, 1 February 1849, 2; and a broadside pub-
lished by the Pennsylvania Academy of the Fine Arts, probably in November or December
1848. A number of excerpts from the New York press are included in this broadside; Nathaniel
Parker Willis is identified as the author of the *Home Journal* review (Willis was one of the
magazine's two editors. The PAFA broadside mistakenly noted the date of this review as 2 Oc-
tober instead of 21 October.) Judging from these newspaper notices, *The Return of the Dove to
the Ark* was in New York in October and November 1848 and in Philadelphia from December
1848 through February 1849. According to the published pamphlet, *Miriam* joined *The Return
of the Dove to the Ark* on view at the Pennsylvania Academy of the Fine Arts in January and
February 1849 (12). Rossiter added a third large painting to this pair in early 1853, *The Babylo-
nian Captivity (Jeremiah)*, begun in 1851, and all three works (now lost) were exhibited to-
gether in the 1850s and 1860s in cities from New Orleans to Buffalo. Fort discusses these three
paintings in her thesis (59–63). See also Tuckerman, *Book of the Artists*, 435. All three paint-
ings were described and discussed by the artist in a pamphlet entitled *A Description of Three
Scriptural Pictures*, published in New York in 1860 to coincide with the first public exhibition
of any of the three paintings in that city.

 For Rossiter, in addition to the Fort thesis, see reprint of Henry W. French, *Art and Artists
in Connecticut* (Boston and New York, 1879), 102–103; *Dictionary of American Biography*,
3:182; and Margaret Broaddus, "Thomas P. Rossiter: In Pursit of Diversity," *American Art &
Antiques* (May/June 1979): 106–113.

 3. The book was published in Philadelphia. An advertisement for *The Women of the
Scriptures* dated 9 November and announcing that the book was "now ready" appeared in the
Christian Observer on 18 November 1848, 188. Rossiter, therefore, must have undertaken his
painted version of the subject immediately after this giftbook project; as noted above, he pro-
duced that work in November and December 1848. Horatio Hastings Weld (1811–1888) was a
printer and newspaper editor in Lowell, Boston, New York, and Philadelphia before taking or-
ders in the Protestant Episcopal Church in 1845. Weld then served as rector of various
churches in Pennsylvania and New Jersey, and edited numerous religious books and annuals
in the late 1840s and 1850s. The fact that Rossiter sent *Miriam* to Philadelphia for exhibition as
soon as it was finished (instead of showing it in New York), suggests that Reverend Weld or
some other Philadelphia connection encouraged Rossiter in this project.

 4. "Brief Mention—Rossiter," *Home Journal*, 13 January 1849, 2.

 5. Rossiter, *Description* [1851–1852], 8.

 6. This small painting appears to be a later, redesigned, and, judging from the cursory
handling of Terpsichore and the Three Graces to her right, probably unfinished version of a
six-by-nine-foot treatment of the subject, which Rossiter produced, according to Fort,
between 1846 and 1853. Fort, "Rossiter," 67. When Fort wrote her thesis in 1975, the painting
was owned by an art gallery, which has since lost track of the work. Based on a photograph of
the painting included in Fort's thesis, the figures of the Three Graces and of Terpsichore were
all much more highly finished in the artist's large version.

 7. "The Hebrew Commonwealth," *Christian Reflector and Watchman*, 8 June 1848, 85.
The privileged relationship that many in the United States felt they enjoyed with Moses and
the ancient Israelites is also exemplified by the popular nineteenth-century conception of
Washington as the American Moses. See Robert P. Hay, "George Washington: American
Moses," *American Quarterly* 21 (Winter 1969): 780–791, and Patricia Anderson, *Promoted to
Glory: The Apotheosis of George Washington* (Northampton, Mass.: Smith College Museum
of Art, 1980), 4–6.

 8. The painting was accompanied in the exhibition catalogue by lines from Exodus 10:
21–22:

And the Lord said unto Moses, stretch out thine hand toward heaven, that there may be darkness over the land of Egypt, even darkness which may be felt. And Moses stretched forth his hand toward heaven; and there was a thick darkness in all the land of Egypt three days.

9. *Bulletin of the American Art-Union* 2 (April 1849): 14. The American Art-Union purchased Church's four-by-five-foot painting. The following is the description from the *Bulletin*:

Here, as in several other of Church's work, the sky is the scene of his triumph. The horizon is low, and the long lines of massive architecture are shown dimly under reflected lights. A lofty crag in the foreground, and the white robed figure of the Great Law-giver, who stands upon it—the solitary living being in this scene of desolation—alone catch the sunshine, all beneath eneveloped wholly in supernatural darkness. Far above appears a remnant of blue sky from which these few lingering rays fall upon the earth. The eye, to reach it, traverses an almost illimitable vista of clouds, black and frowning, excepting where their fleecy sides are touched by those passing sunbeams. This piece has much of that grandeur which characterized Martin's celebrated pictures.

For a more detailed description of the painting, see "Church's 'Plague of Darkness,'" New Haven *Daily Palladium*, 8 July 1858, 2. I would like to thank Gerald Carr for bringing this reference to my attention.

10. "National Academy of Design," *Albion*, 14 April 1849, 177.

11. Ernest Helfenstein, "The Plague of Darkness," John Keese, ed., *The Opal* (New York, 1846): 181–188.

12. "The Common People of Europe," *Christian Watchman and Reflector*, 9 November 1848, 178. "Communism, which is now spreading so rapidly among the masses of [Europe]," this observer explained, "has a retributive mission—it is allowed by the Almighty to go forth on an errand of judgment against the monopolies and aristocracies of the old world."

13. Angela Miller suggests that Church's *Plague of Darkness* may convey the Whig artist's displeasure with the Mexican War and the Democratic Party whose expansionist ambition encouraged it. The painting "may register the artist's protest against Polk and his party, the 'Egyptians,' whose actions placed them at cross-purposes with national destiny" (*The Empire of the Eye*, 118). Added to this continued questioning of the United States' role in the war with Mexico, I believe, should be American awareness of contemporary European struggles against tyranny and despotism.

14. Benson J. Lossing, "The Two Feasts," *The Odd-Fellows' Offering, for 1849* (New York, 1848), 282–286. The essay was accompanied by an illustration depicting the Egyptian banquet in an exotic setting of pylons and papyrus columns; Lossing, with experience in archaeological illustration, was probably its designer.

15. Rossiter, *Description* [1851–1852]: 8.

16. Exodus 15:19–21.

17. The same theme is treated in Rossiter's earlier *Return of the Dove to the Ark*. An engraving after John Martin's *Pharaoh's Host Drowned in the Red Sea* (one of three illustrations after Martin included in *The Odd-Fellows Offering, for 1850* [New York, 1849; fig. 28]), clearly balanced punishment and redemption, although it stressed the awful sublimity of the cosmic drama.

18. Edward Beecher, "Pharaoh and His Host Drowned in the Red Sea," in Thomas Wyatt, ed., *The Sacred Tableaux: or, Remarkable Incidents in the Old and New Testament* (Boston, 1847), 105. Beecher was the son of Lyman Beecher and the brother of Henry Ward Beecher and Harriet Beecher Stowe. For a discussion of Beecher's social millennialism, see Timothy L. Smith, *Revivalism and Social Reform*, 159, 161, 225.

19. Rossiter, *Description* [1851–1852], 9. See James C. Moore, "The Storm and the Harvest: The Image of Nature in Mid-Nineteenth-Century American Landscape Painting" (Ph.D. diss., Indiana University, 1974). According to Moore, "it seems that no disaster or struggle could be described without an attendant account of the improvement following in its wake" (228).

20. Allston's paintings of Old Testament prophecy produced in the 1820s are the clearest precedent for Rossiter's preoccupation with similar themes in the 1840s and 1850s. For a discussion of Allston's *Miriam* as "a representation of Jewish liberation and, therefore, an emblem or type for America's millennial promise or desire," see David Bjelajac, *Millennial Desire*, 145.

21. David Bjelajac, "Washington Allston's Prophetic Voice in Worshipful Song with Antebellum American," *American Art* 5 (Summer 1991): 68–87.

22. Bjelajac, "Allston's Prophetic Voice," 82.

23. "Homeless," *Union Magazine* 2 (January 1848): 34. This commentary accompanied an engraving by T. H. Matteson, which depicted a destitute mother and child.

24. Notice from the *Baltimore Patriot*, quoted in Rossiter, *Description* [1851–1852], 9.

25. Bjelajac, "Allston's Prophetic Voice," 79.

26. For a discussion of this phenomenon related specifically to landscape painting, see Miller, *Empire of the Eye*, chapter 7, "Domesticating the Sublime."

27. H[oratio] Hastings Weld, "Women's Mission," in Weld, ed., *The Women of the Scriptures* (Philadelphia, 1848), 37.

28. Mrs. Clara Lucas Balfour, "Miriam," in Weld, ed., *The Women of the Scriptures*, 99–100.

29. Rossiter, *Three Scriptural Pictures*, 7. In addition, in the center of the composition, a mother "under the momentary influence of hope expresses a gleam of gladness which contrasts strongly with the overwhelming grief of her companions." According to Sarah J. Hale, editor of *Godey's Ladies Book* and author of a history of distinguished women published in 1853, "WOMAN is God's appointed agent of *morality*, the teacher and inspirer of those feelings and sentiments which are termed the virtues of humanity . . . the progress of these virtues and the permanent improvement of our race, depend on the manner in which her mission is treated by man." Nina Baym argues that Hale's moral and religious conception of the progress of world history had femininity and Christianity as its two inextricable agents. Women, superior spiritual beings, were drawn to Christianity and were responsible for the world's conversion. In Hale's plan, when every woman was a Christian and when every Christian man had learned to recognize women's superiority, Baym explains, "the goal of history itself will have been achieved and history will presumably come to an end." Quoted in Nina Baym, "Onward Christian Women: Sarah J. Hale's History of the World," *New England Quarterly* 63 (June 1990): 255.

30. *Eleutheria* was subsequently presented at the Broadway Tabernacle on 20 April 1849, at Reverend Henry Ward Beecher's Plymouth Church on 21 February 1850, and in the Apollo Rooms on 21 April 1851 (New York *Evening Post*, 7 April 1849, 2; 11 April 1849). See also Odell, *Annals of the New York Stage*, 5:504, 505, 594; 6:95. Horatio Stone's words to the cantata were published in 1864 in a book of the artist's poems entitled *Freedom*. Stone (1808–1875) was born on a farm in upstate New York and practiced medicine in New York City from 1841 to 1847. He turned increasingly to sculpture, particularly after a move to Washington, D.C., in 1848. Stone was an active organizer of the Washington Art Association and in 1857 became its president. Exhibitions of his work were held at the National Academy in 1849 and 1869. (*Dictionary of American Biography*, vol. 9; *New York Times* obituary, 24 September 1875; Wayne Craven, *Sculpture in America*, rev. ed. [Newark, Del.: University of Delaware Press, 1984], 207–208). For a discussion of the interest in Handel's oratorios, especially the *Messiah* and *Israel in Egypt* in England and the United States, see Bjelajac, 79–80.

31. Horatio Stone, *Eleutheria*, in *Freedom* (Washington, D.C., 1864): 57–71.

32. One stanza reads:

> Let them prate of the lands that have for their creeds
> The days that have gone and their ancestors' deeds
> While titles oft cover a centuries [?] Error
> While mercy [?] lies starving—and Truth hides from terror
> But give me the air where mind is a thing
> That raises the humble as high as a king.

Thomas P. Rossiter, "The Old and the New," to Thomas Cole, 4 March 1842, Thomas Cole Papers, New York State Library, Albany. Microfilm in Archives of American Art.

33. *Literary World* 2 (1847): 583.

34. Francis Alexander, letter to Kensett, 18 September 1848, Kensett papers, Archives of American Art. Alexander specifically asked Kensett about news of "his old crony Rossiter"; Rossiter and Kensett remained close lifelong friends from their early days together in New Haven.

35. Letter from Vincent Collyer, *New York Times*, 18 November 1851, 4. Rossiter's studiomates John Kensett and Louis Lang were also among this group. Frederic Church's possible interest in the course of freedom and its relation to the old and new worlds in 1848 and 1849 is suggested by another of his paintings which, like *The Plague of Darkness*, was included in the National Academy of Design exhibition of 1849. Franklin Kelly and Christopher Kent Wilson relate Church's *West Rock, New Haven* (1849) to issues of American democracy as manifest in the landscape and history of Connecticut. Kelly, *Frederic Edwin Church and the National Landscape* (Washington, D.C.: Smithsonian Institution Press, 1988), 22–24; Christopher Kent Wilson, "The Landscape of Democracy: Frederic Church's 'West Rock, New Haven,'" *American Art Journal* 18 (1986): 20–39. (Angela Miller disputes such a national reading of Church's painting, arguing that the association of West Rock with regicide judges was not made publicly until 1852, after Church's painting. Miller argues that, to some conservative New Yorkers, the associations of West Rock might have been very different and very negative. *Empire of the Eye*, 103–105.) The painting, developed from sketches produced in the summer of 1848, depicts an apparently peaceful and prosperous American scene. A church steeple and a harvest scene inject religious meaning in this hymn to American destiny, while West Rock, which dominates the background, evokes equally important historical associations. Two judges who had ordered the execution of Charles I fled to America in 1661 and were hidden in a cave near the top of West Rock. A large stone monument commemorating the bicentennial of their judgment against the king was erected in New Haven and dedicated in 1849. According to Wilson, "Church's painting . . . stands as a pictorial tribute to the courage of the judges and the people of New Haven who sheltered them. When viewed from this historical perspective, Church's juxtaposition of the single spire silhouetted against the great rock reaffirms in emphatic, visual terms that opposition to tyrants is indeed obedience to God." If opposition to tyranny encourages God's benevolence, the practice of tyranny—as manifest, for example, in the rule of European monarchs and despots—invites his retribution. *The Plague of Darkness* and *West Rock, New Haven* complement each other thematically and chronologically, the prophetic and biblical merging with the historical and national. Church explored the same pervasive issues of spiritual righteousness, national destiny, and universal liberty in his idyllic view of pastoral New England as in his image of the ninth Egyptian plague. According to David Huntington, Church took the role of artist-prophet seriously. He was a devout Christian of Calvinist bent, with Whig background and sympathies. Huntington described Church's paintings as jeremiads, symbols of national consensus and prophecy. (David C. Huntington, "Frederic Church's *Niagara*, Nature and the Nation's Type," *Texas Studies in Language and Literature* 25 [Spring 1983]: 111). Together, *The Plague of Darkness* and *West Rock, New Haven* convey the parameters and strategies of the American jeremiad.

36. The volume also included the words to the earlier *Eleutheria*. In the book's salutation, Stone urged his countrymen—especially soldiers, statesmen, preachers, and artists—to persevere in the glorious struggle for freedom. The war then underway was, he believed, the "grandest conflict of the ages for the rights of humanity" (*Freedom*, 6). Stone's commitment to this struggle and his vision of it in progressive and millennial terms are evident in the religious tone of his address, which also emphasized his belief in the prophetic function of art. Even so, he does not mention American slavery by name nor does he refer to the Emancipation Proclamation, effective 1 January 1863, which established the abolition of slavery as a Union war aim.

37. According to David Howard-Pitney, "the biblical motif of the Exodus of the chosen people from Egyptian slavery to a Promised Land of freedom was central to the black socio-

religious imagination" (David Howard-Pitney, *The Afro-American Jeremiad: Appeals for Justice in America* [Philadelphia: Temple University Press, 1990], 12).

38. Lawrence Levine, "Slave Songs and Slave Consciousness: An Exploration in Neglected Sources," in Tamara K. Hareven, ed., *Anonymous American: Explorations in Nineteenth Century Social History* (Englewood Cliffs, N.J.: Prentice-Hall, Inc. 1971): 121.

39. See, for example, Richard Allen and Absolom Jones, "Address to those who keep Slaves, and approve the Practice" (1794), quoted in Wilson Jeremiah Moses, *Black Messiahs and Uncle Toms: Social and Literary Manipulations of a Religious Myth* (University Park, Pa.: Pennsylvania State University Press, 1993), 34; David Walker, *An Address to the Slaves of the United States*, published in Boston in three printings between 1829 and 1830 and again in 1848. For a discussion of Frederick Douglass, see Howard-Pitney, *Afro-American Jeremiad*, 19.

40. *Home Journal*, 13 January 1849, 2. As discussed in note 2 above, Willis was identified as the reviewer of Rossiter's earlier *Return of the Dove to the Ark*. According to Peter George Buckley, Willis was a dandyish Whig concerned with maintaining the voice and power of the cultural elite, spokesman for the "layer of [New York] gentility" just below the top ranks, people "for whom the culture of luxury promised a means of ascendancy and a recognition of effort" ("To the Opera House," 243, 238).

41. According to Paul Goodman, *Of One Blood: Abolitionism and the Origins of Racial Equality* (Berkeley and Los Angeles: University of California Press, 1998), 126:

> The attack on abolitionists as "amalgamationists," advocates of intermarriage, was one of the most explosive and effective means of closing minds to abolitionist argument. It could arouse intense, sometimes violent public hostility. . . . Nor was the attack readily countered. Some abolitionists believed as a matter of principle that no law should prohibit intermarriage and advocated the repeal of miscegenation statutes; all insisted that they did not encourage racial mixture, but they could not deny that interracial mingling on a plane of equality might lead to the dreaded blood taint. . . . Whatever their views on intermarriage, immediatists regarded the charge of promoting amalgamation as an inflammatory red herring, a diversion from the moral imperatives of freeing the slaves.

42. Josiah Priest, *Bible Defense of Slavery; or The Origin, History, and Fortunes of the Negro Race* (Kentucky, 1853), 258. The book was copyrighted February 1851.

43. Priest, *Bible Defense of Slavery*, 266, 270.

44. From Richard Hildreth, *The Slave; or, Memoirs of Archy Moore* (1836), quoted in James Kinney, *Amalgamation! Race, Sex, and Rhetoric in the Nineteenth-Century American Novel* (Westport, Conn., and London: Greenwood Press, 1985), 49.

45. George M. Frederickson, *The Black Image in the White Mind: The Debate on Afro-American Character and Destiny, 1817–1914* (New York: Harper & Row, 1971), 120–121.

46. For contemporary references to the painting, see note 2 above. Miller suggests that Rossiter's painting, produced after the conclusion of the Mexican War, was related to hopes of peace after conflict. (*Empire of the Eye*, 118 n. 21.)

47. Pennsylvania Academy of the Fine Arts broadside [November/December 1848].

48. "Thanksgiving Day," *Episcopal Recorder*, 18 November 1848, 143. This paper was edited by Weld. Thanksgiving Day was celebrated by seven states, including New York, on 24 Nov 1848.

49. "The Return of the Dove to the Ark," *Pennsylvania Freeman*, 1 February 1849, 2.

50. Rossiter, *Description* [1851–1852], 6. In the earlier PAFA broadside, the phrase "more resembling the Coptic or Egyptian" was not included.

51. "The Return of the Dove," *London Illustrated News*, 1 December 1849, 360. All of the members of this family appear to be of the same race, although hair coloring is obviously differentiated and some figures' faces are cast in shadow. In a discussion of the Irish artist Daniel Maclise's *Noah's Sacrifice* (1847–1853) in *Putnam's Monthly*, the reviewer does recognize differences in skin coloring and temperament among the three sons, from the fairest-skinned Shem to dark-brown-haired Ham, implying but not illustrating the racial variety they will propagate. ("Editorial Notes—The Fine Arts," *Putnam's Monthly* 5 [May 1855]: 556–557.)

John Everett Millais's *Return of the Dove to the Ark,* exhibited at the Royal Academy in 1851, concentrated solely on two light-skinned girls kissing a dove.

52. This is not to imply that Rossiter was alone in such interests. See, for example, a poem by John Roberts entitled "The Deluge," which appeared in another giftbook edited by H. H. Weld, *Scenes in the Lives of the Patriarchs and Prophets* (Philadelphia, 1847); 39–40. The poet described Noah's three sons and their future domains: Shem and his wife went to Asia; Ham to Africa, while "great Japhet" populated Europe. Yet the poet did not describe the racial features of Noah's sons and daughters-in-law.

53. Frederickson, *Black Image,* 28–29.

54. D. W. Clark, "National Righteousness. A Sermon Preached in the Sullivan M. E. Church Thanksgiving Day, Nov. 23, '48," *New York Tribune,* 24 November 1848, 2.

55. Audrey Smedley, *Race in North America: Origin and Evolution of a Worldview* (Boulder, San Francisco, Oxford: Westview Press, 1993), chapter 10, "A Different Order of Being: Nineteenth-Century Science and the Ideology of Race," 231–254.

56. According to Reginald Horsman, Van Amringe attempted in this book to "harmonize religion and science by arguing that while all men sprang from Adam and Eve [and then from Noah and his wife] there were four distinct species," white, yellow, black, and red. ("Scientific Racism and the American Indian in the Mid-Nineteenth Century," *American Quarterly* 27 [May 1975]: 161.)

57. William Frederick Van Amringe, *An Investigation of the Theories of the Natural History of Man* (New York: Baker & Scribner, 1848), 63, 65. The *United States Magazine and Democratic Review,* published in New York, took up the issue and supported Van Amringe's perspective on it with considerable vigor in a series of articles by T. P. Kettell, which appeared in 1850 and 1851.

58. [T. P. Kettell], "Natural History of Man," *United States Magazine and Democratic Review* 26 (April 1850): 336. Kettell's identity is established in an article by Van Amringe published in the same magazine, "Natural History of Man," vol. 29 (October 1851): 320.

59. Van Amringe, *Investigation,* 63.

60. Van Amringe, *Investigation,* 331, 337.

61. Van Amringe, *Investigation,* 666.

62. [T. P. Kettell?], "The Variety in the Human Species," *United States Magazine and Democratic Review* 27 (September 1850): 216.

63. [W. F. Van Amringe], "Natural History of Man," *United States Magazine and Democratic Review* 29 (October 1851): 321.

64. Van Amringe, "Natural History" 323. The clergyman whom Van Amringe disputes was Rev. T. V. Moore, "Unity of the Human Race," *Methodist Quarterly Review* 33 (July 1851): 345–377. The quotation to which van Amringe refers is on page 351 of this article. The *Methodist Quarterly Review* was as staunch a supporter of the unity of the human race as the *Democratic Review* was its opponent.

65. [Van Amringe], "Natural History," 331.

66. When, in 1857, the polygenist ethnologist George Gliddon reviewed the list of men who had made important contributions to the argument for human unity, he suggested that "the whole of these authors, great or small, merge into PRICHARD." Cited in George W. Stocking, Jr., *Researches into the Physical History of Man, James Cowles Prichard* (Chicago and London: University of Chicago Press, 1973), x.

67. James Cowles Prichard, *The Natural History of Man; Comprising Inquiries into the Modifying Influence of Physical and Moral Agencies on the Different Tribes of the Human Family,* 2nd ed. (London, 1845), 5–7.

68. In a pamphlet published in 1859 describing his painting of *Washington and Lafayette at Mount Vernon,* Rossiter demonstrated his interest in and familiarity with the kind of cranial measurements and comparisons performed by ethnologists and anthropologists of the time, as in his comment that "the height of [Washington's] skull from the centre of the eye to the summit is greater than in most heads" (A *Description of the Picture of the Home of*

Washington After the War. Painted by T. P. Rossiter and L. R. Mignot with Historical Sketches of the Personages Introduced [New York 1859], 30). In a letter to Rossiter dated 28 April 1863, Mrs. Eliza W. Farnham wrote: "I find nothing so copious in illustration as Pritchard [*sic*]. The late French books I could hear nothing of at the Astor Library[.] If I should find them through the help of the Ethnological Society shortly and they sh'd seem likely to prove helpful I will advise you." Letter in Leffingwell Collection, New Haven Colony Historical Society. By the 1860s and in the wake of Darwin, Prichard's monogenist ethnology was superseded by a polygenist or evolutionary approach mure fully based on physical anthropology and his work "soon lost all current anthropological significance, save as an encyclopedic compendium of ethnological data" (Stocking, *Prichard*, cviii). So, by the time Prichard is mentioned in a letter to Rossiter, his work was old-fashioned compared to the "late French books," one of which was most likely by French anthropologist Paul Broca, "one of the major racial determinists of the nineteenth century." See Audrey Smedley, *Race in North America*, 160–161. Perhaps Rossiter wanted to use Prichard's illustrations of skulls and racial types to help in his painting, like the series illustrating *Paradise Lost* exhibited in New York in 1865.

69. Prichard, *The Natural History of Man*, 5, 489, 545.
Religion, as manifest in the parallelism of beliefs and practices among peoples of the world, distinguished human beings from animals and joined each human being to the others, making it possible, as Prichard wrote, "to draw confidently the conclusion that all human races are of one species and one family." From *The Natural History of Man*, 1st ed., London, 1843), 546, quoted in Stocking, *Prichard*, xc.

70. Stocking, *Pritchard*, lxxxix.

71. Prichard, *Natural History of Man*, 546. Prichard was "not trying to provide an alternative explanatory framework to that contained in the Bible. He was rather trying to fill in the gaps in the biblical account. . . . The task of Prichard's ethnology . . . followed directly from these essentials. It was to show how all modern tribes and nations of men might have derived from one family, and so far as possible to trace them back historically to a single source" (Stocking, *Pritchard*, xciv).

72. Another hint that Rossiter might have been familiar with Prichard's book is in the artist's description of Ham as less swarthy than the "Ethiopian" race while having hair and facial features, "more closely resembling the Coptic or Egyptian." Prichard claimed that Egyptians were "swarthy" with "crisp or curly hair," "flat noses and thick lips, who had something of the African, though probably not the truc Negro physiognomy" (*Natural History of Man*, 137). He argued for "a gradual transition from the characters of the Egyptian to those of the Negro, without any broadly marked line of abrupt separation" (269).

73. Discussed in chapter 2, pp. 71–72.

74. John Bachman, *The Doctrine of the Unity of the Human Race Examined on the Principles of Science* (Charleston, 1850), 211. Nott, along with Dr. Samuel Morton of Philadelphia and George R. Gliddon, an Egyptologist, formed what Frederickson called "the scientific triumvirate which attempted to convince educated Americans that the Negro was not a blood brother to the whites" (Frederickson, *Black Image*, 75).

75. Between 1836 and 1838 (a period of intense abolitionist activity), Rossiter studied in his native New Haven with portraitist Nathaniel Jocelyn, brother to the abolitionist Simeon Jocelyn and an abolitionist himself. Jocelyn painted portraits of a number of abolitionists and, in 1840, produced the most celebrated depiction of Cinqué, leader of the Amistad revolt, a portrait commissioned by a black patron, Robert Purvis. See Richard J. Powell, "Cinqué: Antislavery Portraiture and Patronage in Jacksonian America," *American Art* 11 (Fall 1997): 48–73. Jocelyn's enlightened and humane attitude toward race is apparent in his conduct during an ugly argument with the Artists' Fund Society of Philadelphia. In 1841, Purvis tried to exhibit the portrait of Cinqué. The society refused to display the work on the grounds that it would be unseemly for its black patron to visit the exhibition among other gentlemen. Jocelyn's reply to the society suggests the type of moral lesson that Rossiter might have picked up, or at least been exposed to, in his teacher's studio. Jocelyn reminded the society of "that just and liberal

sense of the rights of man which it is the tendency of the liberal arts to promote. I need not say that artists, as individuals, have in all ages been among the first to assert these rights and to sustain the cause of liberty and justice" (Nathaniel Jocelyn, letter to the Artist's Fund Society, 10 May 1841, Harriet Sartain Papers, Historical Society of Pennsylvania, microfilm in Archives of American Art). For a discussion of Rossiter's in-laws, see the epilogue.

76. In 1865, Rossiter exhibited a painting entitled *America Triumphant* at the Philadelphia Sketch Club; this must have been the painting listed for sale in Rossiter's 1868 auction as *America Triumphant: Feeding the Emigrant and Freeing the Slave* and may have been the painting entitled *America* on view at the Northwestern Fair in Chicago in 1863. After the Civil War, then, the artist was willing to celebrate emancipation as one of two great national accomplishments. See James L. Yarnell and William H. Gerdts, comps., *The National Museum of American Art's Index to American Art Exhibition Catalogues from the Beginning through the 1876 Centennial Year*, vol. 4 of 6 (Boston: G. K. Hall and Co., 1986), 3046–3047; and the typescript of *Mr. Rossiter's Paintings: Catalogue of the Entire Collection of Paintings, Studies and Sketches of Mr. T. P. Rossiter, Cold Spring on Hudson. To be Sold by Auction without Reserve, at the Clinton Hall Art Galleries, Astor Place, on Friday Evening April 24, at 7 1/2 o'clock* (New York, 1868).

77. PAFA broadside [November/December 1848].

78. Rossiter, *Description* [1851–1852]: 6.

79. See Thomas Smyth, *The Unity of the Human Races, proved to be the Doctrine of Scripture, Reason, and Science, with a Review of the Present Position and Theory of Professor Agassiz* (New York, 1850). I am not arguing that Rossiter depended on Smyth for his arguments; Smyth's book was not published until 1850. However, I suggest that they used common sources (Prichard among them) and came to similar, but not necessarily identical, conclusions. For example, both Smyth and Rossiter identified Shem as progenitor of the Caucasian race and Japheth father of the Oriental; many Americans considered Japheth ancestor of the Caucasian. See Rossiter, *Description* (1848), 6, and Smyth, *Unity of Human Races*, 29. In his defense of monogenesis, Smyth was joined by the Lutheran minister John Bachman, also of Charleston. By 1850, Bachman had also written a book on the subject: *Doctrine of the Unity of the Human Race*.

80. Thomas Virgil Peterson, *Ham and Japheth: The Mythic World of Whites in the Antebellum South* (Metuchen, N.J.: Scarecrow Press, 1978), 75. Bachman, too, believed that "the African is an inferior variety of species," yet "his inferiority . . . in intellect does not prove that he is not a man" (Bachman, *Doctrine*, 212). One of Smyth's sources was Baron von Humboldt's *Cosmos*, from which he quotes: "There are families of nations more readily susceptible of culture, more highly civilized, more ennobled by mental cultivation than others; but not in themselves more noble. . . . Deeply rooted in man's most inmost nature, as well as commanded by his highest tendencies [is] the full recognition of the bond of humanity, of the community of the whole human race" (Smyth, *Unity of Human Races*, 141). Von Humboldt could have been one of the sources from which Rossiter also took some of his ideas.

81. Smyth, *Unity of Human Races*, 82.

82. Peterson, *Ham and Japheth*, 109–110.

83. Smyth, *Unity of Human Races*, 18; 45.

84. "Rossiter's New Picture," *New-York Daily Tribune*, 22 November 1848, 2. As we have seen, Rossiter sent the picture first to Philadelphia rather than to the South.

85. By the time this pamphlet appeared, *The Return of the Dove to the Ark* and *Miriam* had already been exhibited together not only in Philadelphia, but also in, at least, Providence, Rhode Island; Richmond and Norfolk, Virginia; New London, Connecticut; and St. John's, New Brunswick. Notices from the newspapers of these cities appear in this pamphlet.

86. Rossiter, *Description of the Home of Washington*, 21, 24.

87. *Charleston Daily Courier*, 27 April 1855, 2. The three paintings were on view in Charleston from 2 to 27 April 1855, at the Apprentices' Library Hall. According to notices in the *Courier*, they were going next to "Interior towns" in South Carolina.

88. Even notices of the painting in the New York and Philadelphia press did not mention Ham. The "Oriental" beauty of the women was praised, the manliness of Japheth and Noah commended, the sublimity of the setting, the domestic truth of the scene, the strong emotions it engendered in the viewer were all appreciatively noted. Even the *Pennsylvania Freeman* did not comment on the painting's racial variety. Reviews appeared in *Literary World*, 14 October 1848; *Home Journal*, 21 October 1848; *New-York Daily Tribune*, 22 November 1848; *Christian Observer* (Philadelphia), 23 December 1848; *Pennsylvania Freeman* (Philadelphia), 1 February 1849. In a description of the painting in the *Milwaukee Sentinel and Gazette*, 24 July 1851, the darker figure was noted: "Ham stands in the background near Noah, the attention of both being turned to the same object."

89. Elizabeth Johns, *American Genre Painting*, 36–37.

90. When the three scriptural paintings were finally exhibited together in New York, the *Tribune* lamented Rossiter's wasted talent: "the true friend of art cannot but regret that it had not been employed upon subjects more consonant to the present popular taste" (*New-York Daily Tribune*, 18 February 1860, 4). Yet in the 1860s Rossiter painted a series illustrating *Paradise Lost* and continued to produce other religious works.

91. Thomas P. Rossiter, "Notes on the Universal Exposition of Fine Arts in Paris," *Crayon* 2 (19 December 1855): 390–391. The essay was written in Paris and dated 20 November 1855.

92. Rossiter, "Universal Exposition," 391.

93. Matthew Paul Lalumia, *Realism and Politics in Victorian Art of the Crimean War* (Ann Arbor: UMI Research Press, 1984), 106.

4. *1849: James H. Beard and* The Last Victim of the Deluge

1. The *Cincinnati Gazette*, 5 June 1849, announced the artist's return from a visit to the South.

2. James T. Barrett, "Cholera in Missouri," *Missouri Historical Review* 55 (July 1961): 346; *Louisville* (Kentucky) *Journal*, 1 January 1849; 24 January 1849; 28 March 1849; 3 April 1849.

3. From the *St. Louis Union*, reprinted in the *Louisville Journal*, 16 July 1849.

4. On 28 August 1849, the *Cincinnati Gazette* mentioned that Beard was then at work in his Cincinnati studio on an eight-by-seven-foot canvas entitled *The Last Victim of the Deluge*.

5. On 19 September 1849, the *Cincinnati Gazette* reported that Beard's painting was close to completion. Beard exhibited the painting, for a fee, in Cincinnati in October and December 1849, in Louisville in November 1849, in St. Louis and in New Orleans in January 1850, and in New York City in May 1850. By March 1851 it was back in Cincinnati and on display in a store. It was subsequently purchased by A. B. Coleman and hung in the Burnet House in Cincinnati. (*Cincinnati Gazette*, 12 October 1849; 31 October 1849; 8 December 1849; 5 January 1850. *Louisville Journal*, 2 November 1849; 8 November 1849. *New Orleans Weekly Delta*, 4 February 1850; *New Orleans Daily Crescent*, 15 March 1851; *New York Herald*, April 1908, clipping in Daniel Carter Beard Papers, Library of Congress.)

6. For a more complete discussion of Beard, see Husch, "Poor White Folks and Western Squatters: James Henry Beard's Images of Emigration," *American Art* 7 (Summer 1993): 15–39.

7. For a discussion of the ark as a type of Christ and his church, see George Landow, *Images of Crisis*, especially 135, 138.

8. The subject of the Deluge and related non-biblical shipwreck scenes were enormously popular in France and, especially, England in the late eighteenth and early nineteenth centuries. Poems and paintings of these watery subjects in a Miltonic, apocalyptic manner reached their height of popularity in the 1820s and 1830s. Lynn Robert Matteson argues that after 1840, scenes of the evening before the Deluge, which appealed to Victorian taste for domestic tragedy and melodrama, became more popular. (Matteson, "Apocalyptic Themes in British

Romantic Landscape Painting," 120–121; and Matteson, "John Martin's *The Deluge*: A Study in Romantic Catastrophe," *Pantheon* 39 [July/August/September 1981]: 220–228.)

9. Ellwood C. Parry III, *The Art of Thomas Cole: Ambition and Imagination* (Newark, Del.: University of Delaware Press, 1990): 87–89.

10. The official magazine of the International Order of Odd-Fellows was called *The Covenant*; *The Rainbow* was another of its publications.

11. Odell, *Annals of the New York Stage*, 5:402, 499.

12. John Keese, ed., *The Opal: A Pure Gift for the Holy Days, 1847* (New York, 1847); Weld, *Scenes from the Lives of the Patriarchs*; Sarah J. Hale, ed., *The Opal: A Pure Gift for the Holy Days, 1848* (New York, 1848); Edward Walker, pub., *The Odd-Fellows' Offering, for 1850* (New York, 1849).

13. Like Vanderlyn, Beard followed a more typically French tradition of figure painting in his ambitious scriptural pictures rather than the English and Netherlandish models he favored for his more modest genre images. Gericault's dark, melancholy father brooding over the body of his son in the well-known *The Raft of the Medusa* — or the iconography of Ugolino on which Gericault's image is based — seem more likely precedents for Beard's *Last Victim* than figures by Martin or Cole. That *The Raft of the Medusa* was familiar to Americans at midcentury is evident, for example, in a reference to "Gericault's famous painting" made by George W. Curtis in the *New-York Daily Tribune*, 10 May 1851. Beard recalled that in Cincinnati in the 1830s "there was a picture by David—'Napoleon's favorite artist'—of 'Cain meditating on the death of Abel' placed on exhibition. . . . It seemed to me that the figures must be alive" (J. H. Beard, unpublished autobiography, folder 5, p. 280. Daniel Carter Beard Papers, Library of Congress). Whether this was an authentic painting by David, a copy, or a work by some other French artist, its colorism and sculptural form impressed the young Beard. Perhaps his *Last Victim* is, in part, an homage to or remembrance of Davidian inspiration. *The Last Victim* and Cain with the dead Abel share thematic links in terms of sin and its desserts, human defiance, and divine vengeance, and suggest a visual relationship: a lone figure meditating over a corpse.

Church's *Deluge* is discussed in chapter 6.

14. See accompanying essay by Benson J. Lossing, "The Covenant," *The Odd-Fellows' Offering, for 1850* (New York, 1849), 102.

15. *Cincinnati Gazette*, 19 September 1849.

16. *Cincinnati Gazette*, 13 October 1849.

17. Beard's *Last Victim* can be viewed as an example of what George Landow termed an "image of primal isolation" in which, like a castaway on a desert island, the person is alienated from God and humanity, deprived of freedom, spiritual and physical nourishment, even a sense of the passage of time. (*Images of Crisis*, 22.)

18. "Visit to a Gallery of Art," *Western Journal and Civilian* 6 (April 1851): 64. I would like to thank Angela Miller for bringing this review to my attention.

19. Sacvan Bercovitch, *The American Jeremiad* (Madison: University of Wisconsin Press, 1978), 156. For a discussion of Thomas Cole's *Prometheus Bound* (1846–1847) and its relationship to the idea of will, ambition, and pride as a critique of American culture, see Angela Miller, *The Empire of the Eye: Landscape Representation and American Cultural Politics, 1825–1875* (Ithaca and London: Cornell University Press, 1993): 179–189.

20. Charles Ellis Dickson, "Jeremiads in the New American Republic: The Case of National Fasts in the John Adams Administration," *New England Quarterly* 60, no. 2 (June 1987): 207.

21. An editorial by Horatio Hastings Weld made such connections clear. On that particular Thanksgiving Day, Americans should be grateful for "the restoration of peace [the Mexican War officially ended in July 1848], an abundant ingathering of the fruits of the earth, freedom from the ravages of pestilence, a continued possession of political, civil, and religious liberty, with hopeful prospects for the future" ("Thanksgiving Day").

22. Rosenberg, *The Cholera Years*, 122. This is not to say that every American observed the

day—see Rosenberg, 121–132, for a discussion of the fast day controversies—but it was noted with solemnity in daily papers. Indeed, many local civic leaders had already called for their own fast days; Cincinnati, for example, had held its on 4 July 1849.

23. Rosenberg, *The Cholera Years*, 123–124.

24. "The President's Recommendation—This Day," *Louisville Journal*, 3 August 1849.

25. "Mortality on Steamboats, *Louisville Journal*, 21 May 1849.

26. W. W., "Western Emigrants—A Picture by Beard," *Cincinnati Gazette*, 29 August 1845.

27. "Emigration from North Carolina," letter signed "A North Carolinian" and published in the *National Intelligencer*, reprinted in the *North Carolina Standard*, 8 April 1846; W. W., "Western Emigrants—A Picture by Beard."

28. *Anglo-American*, 2 May 1846, 45.

29. [Charles F. Briggs], "Poor White Folks," *National Anti-Slavery Standard*, 21 May 1846, 203.

30. See, for example, "Effect [of Slavery] on the Poor White Population," *National Era*, 25 November 1847.

31. According to Bette S. Weidman, Briggs "expressed the belief that slavery was doomed to extinction through progressive industrialization of the South. He deplored the anger of abolitionists, reminding them of the tacit consent of Northern business interests in Southern slavery" (Weidman, "Charles Frederick Briggs," *Dictionary of Literary Biography*, vol. 3 [Detroit: Gale Research, Inc., 1979], 22–25).

32. Stephen E. Maizlish, *The Triumph of Sectionalism: The Transformation of Ohio Politics, 1844–1856* (Kent, Ohio: Kent State University Press, 1983), 16.

33. "The Lexington Disturbance," *Louisville Journal*, 21 August 1845; "Policy of Removing Slaves from Kentucky—Our Position," *Louisville Journal*, 6 October 1845.

34. "From the National Intelligencer," *Louisville Journal*, 7 February 1845; "The New York Abolitionists," *Louisville Journal*, 4 February 1845.

35. "A Treatise on the Theory and Practice of Landscape Gardening," *Louisville Journal*, 15 January 1845.

36. Ibid.

37. Julie Schimmel, "Inventing 'the Indian,'" in William H. Truettner, ed., *The West as America: Reinterpreting Images of the Frontier, 1820–1920.* (Washington, D.C.: National Museum of American Art, 1991), 168–169.

38. *Louisville Journal*, reprinted in the *Cincinnati Gazette*, 21 September 1850.

39. See Schimmel, *Inventing the Indian*, 169.

40. Beard autobiography, folder 9, 46.

41. *Anglo-American*, 8 May 1847, 69; *Literary World*, 27 May 1847, 371.

42. The tenth verse of William Cullen Bryant's poem "An Indian at the Burial Place of His Fathers" (1824) accompanied *Last of the Red Man* in the exhibition catalogue, but the poem's last verse should also be considered:

> But I behold a fearful sign,
> To which the white man's eyes are blind;
> Their race may vanish hence, like mine,
> And leave no trace behind,
> Save ruins o'er the region spread,
> And the white stones above the dead.

The golden promise of America—built on usurped land and Indian graves—might yet, it seems, prove hollow.

43. "Choctaw Indians," *Louisville Journal*, 22 September 1845.

44. Maizlish, *Triumph of Sectionalism*, 65.

45. "Dissolution of the Union: From the Address of Dr. George W. Bethune, Lately Delivered at Cambridge, Massachusetts," *Louisville Journal*, 31 August 1849, 2.

46. "Slavery and Emancipation," *Louisville Journal*, 21 August 1849.

47. *Louisville Journal*, 3 September 1849.

48. It was common practice for newspapers and journals to admonish their readers to view religious panoramas, as a Christian duty akin, in some ways, to a pilgrimage. For panoramas and their promotion, see Davis, *The Landscape of Belief*, especially 70.

5. *1850: Peter F. Rothermel, Hector Tyndale, and* The Laborer's Vision of the Future

1. Henry S. Patterson, "Address Before the Art Union of Philadelphia, December 31, 1850," *Philadelphia Art Union Reporter* 1 (January 1851): 16–19.

2. "Editor's Department." As an Odd-Fellow, Patterson was the Grand Master of the Grand Lodge of the state of Pennsylvania and he contributed essays to the Odd-Fellow *Offerings*. For a biography of Patterson, see *The Lives of Eminent Philadelphians, Now Deceased. Collected from original and authentic sources by Henry Simpson, member of the Historical Society of Pennsylvania* (Philadelphia, 1859), 762–768. Patterson was born in Philadelphia in 1815 and died in 1854 at the age of thirty-nine. The *Nineteenth Century*, with Charles Chauncy Burr as editor, was a short-lived Philadelphia journal espousing the tenets of Associationism, the American manifestation of Fourierism. Its first issue appeared in 1848. According to Ann Katharine Martinez, John Sartain designed and engraved the title page; the caption "Light, more light still" was attributed to Goethe on his deathbed. (Martinez, "The Life and Career of John Sartain," 107–108.) For Sartain's own reformist involvements, see Martinez, chapter 3, "Sartain's Involvement with Fourierism." Sartain, in addition to serving as a treasurer of Philadelphia's Union of Associationists, was a member of antislavery minister William Henry Furness's First Unitarian Church. In his autobiography, *Reminiscences of a Very Old Man, 1809–1897* (New York, 1899), Sartain recalled that he had been an abolitionist since 1835 (229).

3. According to Ellwood Parry, an upward, outstretched arm reaching toward a distant goal symbolized hope in Protestant emblem books and by the 1840s, Parry writes, it "still signifies a desperate, hopeful longing" (Ellwood C. Parry III, *The Art of Thomas Cole: Ambition and Imagination* [Newark, Del.: University of Delaware Press, 1990], 237–239).

4. For a literary expression of prophetic reform see, for example, the poem "The Reformer's Vision," *Knickerbocker Magazine* 27 (April 1846): 303–306.

5. Joseph Sill diary, 26 November 1850, AM 1525, vol. 9, 254–255, Historical Society of Pennsylvania, Philadelphia. The painting is discussed in William H. Gerdts, "On Elevated Heights: American History Paintings and Its Critics," in Gerdts and Thistlethwaite, *Grand Illusions*, 103; and in Mark Thistlethwaite, *Painting in the Grand Manner: The Art of Peter Frederick Rothermel (1812–1895)* (Chadds Ford, Pa.: Brandywine River Museum, 1995), 15–16.

6. In addition to Sill's discussion, descriptions of the painting include "Rothermel's Last Picture," *Philadelphia Art Union Reporter* 1 (January 1851): 19; "Senior," "A Poem, A Painting, A Prophecy," *National Era*, 27 February 1851, 1 (reprinted in the *Pennsylvania Freeman* (Philadelphia), 13 March 1851, 4); William F. Small, "Rothermel's Apotheosis of Labour. Or, 'The Labourer's Vision of Human Progress,'" *Sartain's Union Magazine*, April 1851, 277–279 (the description of the painting included in this article was credited to the *Philadelphia Public Ledger*, 5 February 1851); Thomas Dunn English, "Peter Rothermel," *Sartain's Union Magazine* 10 (January 1852): 16. A shorter discussion appeared in "The American School of Art," *American Whig Review* (August 1852): 144–145. All of these descriptions generally agree, although each offers a few details not included in the others, and some differ in specifics. For example, the painting was described as being five by four feet by "Senior" and by the *Philadelphia Public Ledger* as being six by four feet.

7. *Philadelphia Art Union Reporter*; "Senior," "A Poem."

8. This tool was identified by the *Philadelphia Art Union Reporter* as a pickaxe, by "Senior"

as a sledge, and by Thomas Dunn English as a spade. It was identified by Small as a mattock or pickaxe. These discrepancies are a lesson in the unreliability of "eyewitnesses" and the dangers of relying on others' descriptions of visual material.

9. For a discussion of the image of the farmer and American agrarian idealism, see Elizabeth Johns, "The Farmer in the Works of William Sidney Mount," in Robert I. Rotberg and Theodore K. Rabb, eds., *Art and History: Images and Their Meaning* (Cambridge: Cambridge University Press, 1988), 257–282.

10. Gerdts notes this relationship with European stonebreaker images. By 1850, when Rothermel was at work on the painting, the subject of labor had taken on new importance in European art, particularly in the wake of the 1848 revolutions. (Linda Nochlin, *Realism* [Harmondsworth, England: Penguin Books, 1971], 111–112.)

11. *Philadelphia Public Ledger*, 5 February 1851, as cited in Small, "Rothermel's Apotheosis of Labour," 277.

12. According to "Senior," this group included a healthy child with a book and a female teacher; according to the *Philadelphia Public Ledger*, it depicted a beautiful girl and a handsome youth "happily poring over a large folio, held before him by the genius of art and science," indicating "a more intellectual order of labourers."

13. *Art Union of Philadelphia Transactions of 1849* (Philadelphia, 1849), 66. For a discussion of the painting, see Michael Paul Driskel, "Painting, Piety, and Politics in 1848: Hippolyte Flandrin's Emblem of Equality at Nimes," *Art Bulletin* 66 (June 1984): 280–281.

14. When the image was used as a frontispiece for a prayerbook published in the South in the early 1850s, the black figure was eliminated; John Greenleaf Whittier wrote a poem denouncing this hypocrisy.

15. The *National Era* and the *Pennsylvania Freeman*. The masthead of William Lloyd Garrison's abolitionist weekly the *Liberator* included a full-length image of Christ carrying a cross, with a praying slave and a cringing slavedriver at his feet, a grouping generally suggestive of Rothermel's allegory, although, as befitted its context, far less equivocal in its specific condemnation of American slavery.

16. Horace Greeley, "The Age We Live In," *Nineteenth Century* 1 (1848): 52.

17. Thomas Cole, for example, introduced the motif in such paintings as *The Present* (1838) and *Landscape Tower with Ruin* (1839). Bruce Chambers outlined the social implications of the subject in "Thomas Cole and the Ruined Tower," *Currier Gallery of Art Bulletin* (1983): 15–16.

18. *New-York Daily Tribune*, 1 May 1848, 2.

19. Reproduced in Thistlethwaite, *Painting in the Grand Manner*, cat. no. 49. Thistlethwaite suggests its kinship with the painting because of the drawing's treatment of the poor and its inclusion of Lucifer, and dates it around 1850 because of this relationship. The inscription appears to be in Rothermel's handwriting.

20. "The American School of Art," 144–145.

21. Karen Halttunen discusses the use of gothic haunted castle and haunted house imagery in the rhetoric of moral and social reform, in which architectural symbols are used to visualize the human decay caused by vices like intemperance and social evils like slavery. Halttunen, "Gothic Imagination and Social Reform: The Haunted Houses of Lyman Beecher, Henry Ward Beecher, and Harriet Beecher Stowe," in Eric J. Sundquist, ed., *New Essays on* Uncle Tom's Cabin (Cambridge: Cambridge University Press, 1986), 107–134.

22. For discussion of the role of religion in the antebellum labor movement, see Jama Lazerow, "A Good Time Coming: Religion and the Emergence of Labor Activism in Antebellum New England" (Ph.D. diss., Brandeis University, 1983). The author argues that most labor historians have accepted the "religion as opiate of the people" thesis and have not fully recognized the significance of a Christian model for those dissatisfied with, rather than invested in, the status quo.

23. D. H. Barlow, "The Present as It Is, and the Future to Be," *Graham's Magazine* 39 (November 1851), 260. This periodical was published in Philadelphia.

24. "Rothermel's Last Picture," *Philadelphia Art Union Reporter* 1 (January 1851): 19; "Senior," "A Poem, A Painting, A Prophecy," *National Era*, 27 February 1851, 1.

25. William H. Gerdts, *Painting and Sculpture in New Jersey* (Princeton: D. Van Nostrand, 1964), 93–100. The artist's sketches and plans were discussed in the *Philadelphia Art Union Reporter* in September 1851. ("Lockwood's 'Last Judgment,'" *Philadelphia Art Union Reporter* 6 [September 1851]: 99.) This writer apparently used an earlier sketch for the painting as the basis of his description; there are discrepancies between this description and the sketch reproduced here, which matches a key to the figures that accompanied an engraving of the finished painting. The reproduced sketch, then, corresponds with the final work while the *Reporter's* description does not.

26. Slavery appears in figure 45 as a seated nude female figure immediately on Washington's right rather than as one of a pair directly above Despotism. Other figures in the composition include the Holy Family, St. Michael, angels, personifications of virtues and vices, and historical figures representing the arts and sciences. For a more detailed description, see Gerdts, *Painting and Sculpture in New Jersey*, 98–99.

27. Read, a frequent contributor to the *Nineteenth Century*, was originally from Chester, Pennsylvania, and lived in Philadelphia from 1846 until he sailed for Europe early in 1850 (he settled again in that city briefly in 1852). Read and Rothermel probably met in Philadelphia; by 1857 they and their families were good friends. Read notes in a letter to his brother-in-law Cyrus Garrett dated 28 May 1857 that Mrs. Read will spend the summer with the Rothermels, "friends of ours from Philadelphia" (T. B. Read Letters, Archives of American Art, reel 1478, no. 586).The *Spirit of the Age* was painted in Florence, begun in the fall of 1850 and finished by February 1851. Read discussed the painting in a letter written in Florence on 20 January 1851 and published in the *Bulletin of the American Art-Union* in April 1851. Read also mentions the painting (as well as its companion picture, *The Blacksmith's Shop of the Nineteenth Century*) in a letter to Garrett, written from Florence on 13 February 1851. Another American artist at midcentury undertook an allegory that attempted to encapsulate the "spirit of the age," the guiding force and particular mission of the day. Completed by 1853, William Allan Wall's *Nativity of Truth, or The Spirit of the Age* (on deposit at the New Bedford Whaling Museum) was, according to Angela Miller, "a neo-Baroque 'summa' of expansionist themes" ("The Imperial Republic," 227–239). Wall's painting explored the popular theme of the westward course of empire and added the new dimension of an advance from Northern to Southern America in the providential plan of redemption. This allegory, it seems, differed from Read's in its more explicit nationalism and its noncritical acceptance of imperial myths. Read's context is more international, his stance more activist, and his message critical as well as hopeful. He openly acknowledges the militarism and slaveholding of the United States, and his reformist optimism that justice, freedom, and peace would eventually obliterate these evils.

28. *Bulletin of the American Art-Union* 4 (April 1851): 13.

29. Read writes enthusiastically about the revolutions in a letter to Garrett, 20 August 1850, Read Papers. For a sample of these critical poems see *Lays and Ballads* (Philadelphia, 1849). For a discussion of Read's early radicalism and his change of heart around 1854 when he, like many others who despised slavery but feared disunion more, tempered his rhetoric, see Aaron Kramer, *The Prophetic Tradition in American Poetry, 1835–1900* (Rutherford, N.J.: Fairleigh Dickinson University Press, 1968), 85–86, 104, 340.

For a discussion of racial unity and its millennial implications, see chapter 3.

30. Read discusses the two replicas in a letter to Claghorn, written from Cincinnati, 20 December 1851 (Claghorn Letters, Archives of American Art, reel 3580).

31. J. McL (probably John McLaughlin, a close friend of Tyndale's and executor of his will), *Memoir of General Hector Tyndale* (Philadelphia, 1882); *Dictionary of American Biography* 10:100. Tyndale was born 24 March 1821 and died 19 March 1880. In 1851, Tyndale visited Europe in order to improve his knowledge of and taste in china, pottery, and glass. Upon the death of Tyndale's wife in 1897, their collection of decorative art went to the Philadelphia

Museum of Art. Tyndale also collected paintings, mostly by French artists, and a few by local Philadelphians like Rothermel.

32. Information from family papers sent to author by Mrs. Judy Van Skike of Santa Ana, California. Mrs. Van Skike's great-grandmother was Hector Tyndale's sister. Included in these papers is the typescript of a letter from Sarah Tyndale to her son Hector, written from Brooklyn to Philadelphia and dated 25 November 1856. The letter provides ample evidence of Mrs. Tyndale's transcendental understanding of spiritual matters, as well as her antislavery sympathy—she calls the abolitionist Wendell Phillips "great." Mrs. Tyndale was a friend of Marcus and Rebecca Spring (see Epilogue), whom she visited and assisted with the North American Phalanx and the Raritan Bay Union.

33. McL[aughlin], *Memoir of General Hector Tyndale*, 7. In the 1840s and 1850s, the antislavery stance of most Free-Soilers and Republicans was not the same as that of radical abolitionists. Most of the former were much less interested in the condition of the enslaved blacks, more likely to believe in the innate and irremedial inferiority of the black race, and more concerned that new territories be kept all white than that Southern slaves be freed. Abolitionists were more likely to believe in the unity of the human race and to advocate immediate emancipation. See James D. Bilotta, *Race and the Rise of the Republican Party, 1848–1865* (New York: Peter Lang, 1992). While we cannot measure precisely Tyndale's degree of antislavery belief, his involvement in the John Brown affair, his eulogy by William Henry Furness, and the abolitionism of his mother all suggest that his opposition to slavery and his Free-Soilism were based on something other than—or at least, more than—racism and a desire to keep slavery contained in the South.

34. Marcus and Rebecca Spring and Rev. William Henry Furness (who had married the Springs) were involved in the John Brown drama as well. Tyndale's mother's connection with the Springs and both Spring's and Tyndale's friendship with Furness probably led to Hector Tyndale's involvement in the retrieval of Brown's body.

35. Thistlethwaite notes in a general way the possible connection of the painting to debates about the Fugitive Slave Law of 1850. (*Painting in the Grand Manner*, 15.)

36. Clifford E. Clark, Jr., *Henry Ward Beecher: Spokesman for a Middle-Class America* (Urbana: University of Illinois Press), 130.

37. Quoted in McL[aughlin], *Memoir of General Tyndale*, 22.

38. Ibid., 19.

39. *Tenth Annual Report of the Mercantile Beneficial Association of Philadelphia, November 1852. Annual Reports of the MBAP* (Philadelphia: Historical Society of Pennsylvania1923), 55.

40. Tyndale's address is published in McL[aughlin], *Memoir of General Tyndale*, 87–96.

41. Given the didactic nature of Rothermel's allegory, we must wonder why it was not more widely exhibited. *The Laborer's Vision* was never exhibited in the annual exhibitions at the Pennsylvania Academy of the Fine Arts, the National Academy of Design, or the Boston Atheneum. It was, however, on display at the Philadelphia Art Union Gallery in January and February 1851, and was exhibited in Boston in 1853 at the Massachusetts Academy of the Fine Arts. Perhaps the painting did not receive more public exposure because, as previously noted, it was on display in the meeting room of the Mercantile Beneficial Association.

42. Carl J. Guarneri, *The Utopian Alternative*, 100, 101.

43. Guarneri, *Utopian Alternative*, 102.

44. Jama Lazerow, *Religion and the Working Class in Antebellum America* (Washington, D.C.: Smithsonian Institution Press, 1995), 201–203.

45. See Lazerow, *Religion and the Working Class*, 203.

46. Rothermel was born 18 July 1812 and died 15 August 1895; he settled permanently in Philadelphia in 1820. For biographical information, see Thomas Dunn English, "Peter Rothermel"; Joseph G. Rosengarten, "Memoir of P. F. Rothermel, Read before the American Philosophical Society, November 1, 1895," *Proceedings of the American Philosophical Society* 34 (1895): 393–396; Mark Thistlethwaite, "Peter F. Rothermel: A Forgotten History Painter,"

Antiques 125 (November 1983): 1016–1022; and Thistlethwaite, *Painting in the Grand Manner*, 1995. Rothermel began his artistic career as a portrait painter but turned to history painting in the 1840s, producing scenes from American and British history as well as religious, mythological, and literary subjects. Rothermel's leading rival in history painting in Philadelphia, Emmanuel Leutze, was in Dusseldorf by this time. As John Sartain explained in 1849, "Rothermel belongs to the very foremost rank of living historical painters in this country, and in the opinion of many of those best able to form a correct judgment, takes the lead of all." John Sartain, "Editorial. Notices of Arts and Artists," *Sartain's Union Magazine* 4 (June 1849): 414. Rothermel was elected vice-president of the Artist's Fund Society of Philadelphia in 1844, and served as a director of the Pennsylvania Academy from 1847 to 1855.

47. Rothermel painted portraits of Hector Tyndale, Tyndale's sister, Elizabeth, and his brother, Sharon, and was the most extensively represented American artist in Tyndale's collection of paintings. Of the twenty-seven works owned by Tyndale and exhibited at the Pennsylvania Academy of Fine Arts before 1870, nineteen were exhibited in 1855 and were by artists living in Paris, mostly French, which Tyndale probably acquired during one of his trips to Europe. Of the remaining eight paintings, all were by Philadelphia artists: three were by Rothermel; two were by James Hamilton; two were by Isaac L. Williams; and one was by William T. Russell Smith. Apparently, Tyndale patronized artists from his home city, and Rothermel seems to have been his favorite. For a discussion of Tyndale's collection, see "Private Art-Collections of Philadelphia. X. Additional Galleries," *Lippincott's* 10 (December 1872): 708–709.

48. The incident was described in Sir Walter Scott's *History of Scotland*. Rothermel's painting measured 5' × 7' and was exhibited at the Pennsylvania Academy in 1850 and the National Academy in 1851, purchased by the Philadelphia Art Union by March 1851, and soon after sold to the American Art-Union. The painting was engraved by Alfred Jones and published in the *Bulletin of the American Art-Union* in September 1851; it was also reproduced in the giftbook *Ornaments of Memory* (New York, 1856). Information generously provided by Wendy Greenhouse. The painting is an indication of the widespread popularity in the mid-century of themes from English history. See Wendy Greenhouse, "Reformation to Restoration: Daniel Huntington and His Contemporaries as Portrayers of British History, 1830–1860" (Ph.D. diss., Yale University, 1990).

49. "Exhibition of the Academy of Design," *Albion*, 17 May 1851, 237. See Thistlethwaite, *Painting in the Grand Manner*, 14–125, for a discussion of painting in connection with anti-Catholicism.

50. "The American School of Art," 144.

51. According to author's conversation with Mark Thistlethwaite, there is no evidence to explain why Rothermel produced this small study.

52. The painting is signed and dated 1851. For a discussion of the painting, see Thistlethwaite, *Painting in the Grand Manner*, 16; cat. no. 8, 52–57.

53. "A New Feature in Our Plan," *Philadelphia Art Union Reporter* 1 (March/April 1851): 39.

54. It is not clear whether Rothermel or the art union chose the specific subject for this painting, although the general category of American history must have been of particular interest to both the managers and Rothermel. What better way to encourage national spirit and display the talents of living American artists than through dramatic and educational episodes drawn from the nation's history? I would suggest that the general subject area of American history was agreed upon, but that Rothermel selected the specific episode and was responsible for its interpretation.

55. "What the Press Say of Us," *Philadelphia Art Union Reporter* I (January 1852): 154.

56. "Key to Rothermel's Picture of Patrick Henry, Delivering his Celebrated Speech in the House of Burgesses of Virginia, in the Year 1765" (Philadelphia Art Union, 1 June 1852).

57. This quotation is from the art union pamphlet, but is itself credited to and paraphrased from William Wirt, *Sketches of the Life and Character of Patrick Henry*, 9th ed. (Philadelphia, 1845), 83.

58. Two preliminary drawings in the collection of Red Hill, the Patrick Henry National Memorial in Brokkneal, Virginia, illustrate the development of Rothermel's composition. One drawing, apparently the earlier of the two, uses a horizontal format, which presents a more accurate picture of the Virginia House of Burgesses in Williamsburg than the final painting. The drawing is perhaps related to an illustration of the same subject that appeared in Benson J. Lossing's popular book, *Seventeen Hundred and Seventy-Six; or, The War of Independence* (New York: Edward Walker, 1847). An obviously later and more complete drawing shows Rothermel's shift to a vertical format. See also Thistlethwaite, *Painting in the Grand Manner*, 54–55.

59. In notes he made for the painting, Rothermel marveled at Henry's height—"nearly 6 feet"—and observed that "the text [probably William Wirts's standard account] does not justify putting upon him a cloak," a distinguished aricle of clothing for lawyers and statesmen. See notes in collection of Red Hill, Patrick Henry National memorial. In fact, Henry did not own a bright red cloak like the one he wears in Rothermel's painting until he became the American governor of Virginia in 1776. Information concerning Henry's dress comes from Mark Couvillon at Red Hill.

60. Albert Barnes, *The Casting Down of Thrones*, 4–5, 24, 21, 10–11.

61. Marriage certificate, 27 May 1844, signed John W. Dowell, Pastor Central [?] Presbyterian Church, Philadelphia. Rothermel Papers, Archives of American Art.

62. Thistlethwaite, "A Forgotten History Painter," 1019. Thistlethwaite also cites Ruben's *Mystical Marriage of St. Catherine* and Washington Allston's *Belshazzar's Feast* as possible influences.

63. "The Academy of Fine Arts," *Graham's Magazine* 38 (March 1851), 269.

64. Ibid. Indeed, in the spring of 1848, Americans jubilantly sang the Marseillaise in the streets after hearing news of the latest French revolution. (Johannsen, *To the Halls of the Montezumas*, 302.) There were other contemporary visual responses to the 1848 revolutions in Philadelphia. James L. Claghorn, for example, bought "The Proclamation of the Republic of '48" from a now unidentified French artist. See "Private Art-Collections of Philadelphia, I.: Mr. James L. Claghorn's Gallery," *Lippincott's* 9 (April 1872): 438.

65. Other midcentury American artists expressed similar interest in European revolution and used images from the American Revolutionary history to comment on contemporary European struggles. See, for example, Emmanuel Leutze's *Washington Crossing the Delaware* in Barbara Groseclose, "Washington Crossing the Delaware: The Political Context," *American Art Journal* 7 (November 1975): 70–78; and William W. Walcutt, *Pulling Down the Statue of George III at Bowling Green*, discussed in Arthur S. Marks, "The Statue of King George III in New York and the Iconology of Regicide," *The American Art Journal* 13 (Summer 1981): 78–81.

66. "The Philadelphia Art-Union," *Graham's Magazine* 40 (March 1852), 326.

67. Barnes, *The Casting Down of Thrones*, 10–11.

68. "The Philadelphia Art-Union," 326.

69. Barnes, *The Casting Down of Thrones*, 21–22.

70. Quoted in Oliver Perry Chitwood, *Richard Henry Lee: Statesman of the Revolution* (Morgantown: West Virginia University Foundation, 1967): 18–19. The text of this speech was published in Richard H. Lee, *Memoir of the Life of Richard Henry Lee and His Correspondence*, 2 vols. (1825), and would have been available to anyone interested in his life and accomplishments. According to James Grant Wilson and John Fiske, eds., *Appleton's Cyclopedia of American Biography*, Lee's powerful speech contained "the germs of the principal arguments used in later days by northern Abolitionists" (vol. 3 [1887], 664).

71. William Wirt also described Lee in terms thath suggest a poet or artist, suggesting why Rothermel might have chosen this particular historic figure to play the role of seer. "His taste had that delicate touch," Wirt wrote, "which seized with intuitive certainty every beauty of an author. . . . He had a quick sensibility and a fervid imagination" (Wirt, *Patrick Henry*, 67–68).

72. Rosengarten, "Memoir of P. F. Rothermel," 395.

6. 1851: *Jasper F. Cropsey and* The Spirit of Peace

1. Letter describing *The Spirit of War* and *The Spirit of Peace* from Cropsey to "Mr. M.," dated 12 May 1852. Cropsey correspondence, diaries, sketchbooks, collection of Mrs. Arthur Ellsworth and Mrs. John Newington, microfilm in Archives of American Art. Talbot identifies "Mr. M" as either E. P. Mitchell or George Magrath, both patrons of Cropsey. William Silas Talbot, "Jasper F. Cropsey, 1823–1900" (Ph.D. diss., New York University, 1972), 108. All subsequent quotations by Cropsey in reference to these paintings are from this letter unless otherwise noted. According to an entry in Cropsey's journal dated 2 August 1851, he had "begun this Spring here [in West Milford, New Jersey, where the artist was staying with his wife's family] my Peace & War" (Cropsey correspondence). The term "epico-allegorical" is used in a review of the paintings, *Bulletin of the American Art-Union* 4 (December 1851): 149. The paintings were also discussed in the *Literary World*, 31 December 1851, 471–472; the *New York Herald*, 7 February 1852; the *Albion*, 24 April 1852, 201; and the *New-York Daily Tribune*, 24 April 1852, 6.

2. *The Spirit of War* and *The Spirit of Peace* were not the first intellectual expressions that Cropsey had considered for his debut into art of a "higher order" as sketches and descriptions in his notebooks and letters attest. In 1848, for example, he considered but did not execute subjects like "The Palace of the Beautiful," "Italy—Modern," "Temple of Liberty Upon the Mountain," and a series of paintings treating an "art pilgrim" in memory of Thomas Cole.

3. The medieval setting of *The Spirit of War* indicated a "period when constant strife existed." Cropsey's use of the Middle Ages to encapsulate the pomp and folly of incessant combat was common at the time and appeared, for example, in an essay decrying war published in *The Odd-Fellows' Offering, for* 1853. In that era, the author claimed, "the slightest pretext was oftentimes made the cause for plunging into war . . . until the whole world seemed but a vast theatre, lit up by the lurid flames of the battlefield" (T. Austin, "War," *The Odd-Fellows' Offering, for* 1853 [New York, 1852], 251).

4. Cropsey's fundamental debt to Cole has been a major topic of discussion with these two paintings. See Miller, "The Imperial Republic," 241; J. Gray Sweeney, "The Advantages of Genius and Virtue: Thomas Cole's Influence, 1848–1857," in Truettner and Wallach, *Thomas Cole: Landscape into History*, 122–127; and Foshay, *Jasper F. Cropsey*.

5. According to Cropsey, "Red in art in a good sense expressed love, faith but in a bad sense it expressed blood, carnage" (letter to "Mr. M.").

6. "Never again," historian Alexander Tyrrell observed, "was the mid-century peace movement to know a moment of exultation such as it experienced in 1851" (Alexander Tyrrell, "Making the Millennium: The Mid-Century Reform Movement," *Historical Journal* 20 [1978]: 94). I do not want to reduce Cropsey's decision to undertake such ambitious ideal works in 1851 solely to the influence of Anglo-American peace reform; obviously other factors were at work. Talbot emphasized the artist's contact with Old Masters and Nazarenes while in Europe from 1847 to 1849, his involvement in 1850 with a project to illustrate *Pilgrim's Progress*, and his "deeply rooted American idealism," which found "closely reasoned expression in Washington Allston's *Lectures on Art*, published in 1850," as the factors that turned Cropsey to allegory. (Talbot, "Jasper F. Cropsey," 105–106.) Foshay underscored Cropsey's long-standing admiration for Thomas Cole and his own personal religious convictions, which influenced his appreciation of moral and religious themes. (Foshay, *Jasper F. Cropsey*, 26–27.)

7. Eric W. Sager, "The Social Origins of Victorian Pacifism," *Victorian Studies* 23 (Winter 1980): 217. The world's first international peace congress was held in London in 1843; the second was planned early in 1848 to be held in Paris, but the Revolution drove it to Brussels. In 1849 the congress was held in Paris; Frankfort was the site in 1850, and in 1851 it was held again in London. Peace reform lost momentum in Great Britian around 1852 because of tensions that led to the Crimean War, and fizzled around 1854 in the United States because of bitter sectional conflicts, which erupted into violence. Charles DeBenedetti, *The Peace Reform in American History* (Bloomington and London: Indiana University Press, 1980), 54. Peace

congresses were held in Manchester in 1852 and in Edinburgh in 1853, but attendance and enthusiasm were greatly diminished because of such events as the coup d'etat in France.

8. Horace Greeley, "The Crystal Palace and Its Lessons," *Graham's Magazine* 40 (May 1852): 473.

9. "'Peace. Painted by Mr. Armitage," *Illustrated London News,* 31 May 1851, 477.

10. *Independent,* 26 June 1851, 1.

11. Benson J. Lossing, "Peace," *The Odd-Fellows' Offering, for 1852* (New York, 1851), 9–22.

12. Lossing, "Peace," 22.

13. As did Rothermel's *Laborer's Vision,* on view in Philadelphia in January and February 1851, when anticipation of the Crystal Palace was already in the air (see chapter 5).

14. *Independent,* 8 February 1849, 37. According to Sager, "The peace movement [in Great Britain] won its greatest following in the wake of the brief revival of Chartism in 1848 and in the wake of the continental revolutions. . . . Pacifist leaders knew that the revolutions and their aftermath were responsible for the revival of their movement" ("Social Origins of Victorian Pacifism," 232–233).

15. Alexander Tyrell, "Making the Millennium," 89.

16. Elihu Burritt, "Address at the International Peace Congress at Frankfort," 1850. Published in *Old South Leaflets* (Boston: Directors of the Old South Work, 1904), 21–22.

17. Cropsey correspondence.

18. Both paintings were destroyed in 1928. For a discussion, see Richard Ormond, *Sir Edwin Landseer* (London: The Tate Gallery, 1981), 181, 188, and catalogue numbers 137 and 138. On 14 December 1850, the *Literary World* reported that "among the new prints to be seen at Messrs. William & Stevens in Broadway, are proofs of the new engravings from Landseer of 'Peace and War'" ("Fine Art Gossip," *Literary World,* 14 December 1850, 485).

19. John Falconer, letter to Cropsey, New York, 29 October 1848 (Cropsey correspondence). Falconer's description evokes a painting by Inness now in the collection of the Nelson-Atkins Museum entitled *Peace and War, Afternoon,* signed and dated 1848. Falconer, however, seems to have been discussing two separate images. The Nelson-Atkins painting fits the description of "War" with its middleground bridge and foreground rustics. It does not, however, include a young boy and reluctant calf mentioned in Falconer's description of "Peace."

20. Cropsey and Inness were well aware of each other's work; Falconer reported in a letter to Cropsey dated 3 October 1848 that Cropsey's new paintings had recently arrived in New York City and that Inness had come to see them. (Cropsey correspondence.) For a discussion of *Religion Bringing Peace to the World,* see Nicolai Cikovsky, Jr., "The Life and Work of George Inness" (Ph.D. diss., Harvard University, 1965), 13.

21. According to a report in the *Home Journal,* 20 May 1848, 3, Gray was working on his *Wages of War* by May 1848. In October of that year the "Editor's Table" in the *Knickerbocker* reported that Gray had "just completed a large picture. . . . It is an *Allegorical Representation of War*" (383–384). In an unpublished paper, Bruce Weber suggests that "contemporary events [the Mexican War and the European revolutions] seem to have inspired Gray to create a neo-classical allegory of war" ("Henry Peters Gray: The Ideal Painter" [unpublished paper, Graduate Center, City University of New York, Fall 1975], 18). I would like to thank Kevin Avery of the Metropolitan Museum of Art for providing me with a copy of this paper.

22. Weber, "Henry Peters Gray," 18. Weber credits Doreen Bolger with the identification of the building in the left background as medieval. For contemporary descriptions of the painting, see the *Harbinger,* 30 September 1848, 22; the *Knickerbocker* 32 (October 1848): 383–384; *Bulletin of the American Art-Union* 2 (April 1849), 25. The painting was purchased by the art union, and an engraving after it appeared in the October 1849 issue of the *Bulletin.*

23. Felix Quintin, "Peace; or, The Soldier's Return," *The Odd-Fellows' Offering, for 1850* (New York, 1849), 117.

24. These still-evocative images ascribed to the Old Testament prophet Isaiah shaped most mid-nineteenth-century Protestant American conceptions of the millennium, as Albert

Barnes explained in 1840: "[Isaiah], more than any other prophet, has unfolded the future glories and predicted the triumphs of the church on earth. . . . The views of most Christians respecting the Millennium are probably derived from this prophet. . . . If we wish to obtain full and clear conceptions of what the world is yet to be under the reign of the Prince of Peace, we instinctively turn to the glowing visions of [Isaiah]." Albert Barnes, *Notes . . . on the Book of the Prophet Isaiah,* v, vi.

25. On 16 April 1850, John Sartain's son Samuel was appointed a delegate by the Philadelphia Union of Associationists to the Frankfort Peace Congress; he was probably among that American delegation met by Read. Minutes, Philadelphia Union of Associationists, Sartain Family Papers, Historical Society of Pennsylvania, microfilm in Archives of American Art.

26. *Bulletin of the American Art-Union* 4 (April 1851): 13.

27. Stearns was elected an Associate in 1848, and an Academician on 9 May 1849; he presented the painting as a requirement for election as an Academician and it was accepted by the academy in June 1849. Information from letter, Abigail Booth Gerdts of the National Academy of Design to author, 2 March 1988. See also Mark E. Thistlethwaite, "Picturing the Past. Junius Brutus Stearns's Paintings of George Washington," *Arts in Virginia* 25 (1985): 14 n. 10. For a discussion of Stearns's history paintings, see Thistlethwaite, *The Image of George Washington: Studies in Mid-Nineteenth-Century American History Painting* (New York: Garland Publishing Co., 1979). See also Millard F. Rogers, "Fishing Subjects by Junius Brutus Stearns," *Antiques* 102 (August 1970): 246–250.

28. When exhibited at the National Academy in 1851, *The Millennium* was accompanied by the familiar lines from Isaiah 11:6. Stearns's depiction of a child surrounded by placid animals naturally calls to mind Edward Hicks's numerous versions of the Peaceable Kingdom theme, also based on Isaiah. But there is little evidence to suggest any direct connection between the two artists. Hicks's exploration of the subject was a highly personal, twenty-nine-year odyssey, closely tied to the artist's Quaker beliefs and culture, and well out of the mainstream of the nineteenth-century American art world. Stearns, on the other hand, undertook the subject only once and then in an interpretation that emphasized orthodox Christian beliefs and in a sophisticated academic style as a presentation piece for the National Academy. See David Tatham, "Edward Hicks, Elias Hicks and John Comly: Perspectives on the Peaceable Kingdom Theme," *American Art Journal* 13 (Spring 1981): 36–50.

29. Bruce M. Metzger and Michael D. Coogan, eds., *The Oxford Companion to the Bible* (New York and Oxford: Oxford University Press, 1993): 418.

30. Ibid.

31. Christ's infancy and his crucifixion are explicitly evoked in the painting. More subtle, however, is Stearns's possible allusion to his resurrection. The lioness, the artist's addition to Isaiah's menagerie, and her male companion form an almost parental pair behind the lamb. She in particular looks out at the viewer with a dignified alertness suggestive of maternal vigilance. Lions had a traditional symbolic association with Christ's resurrection, based in a belief that lion cubs were always stillborn, and that three days passed between their birth and when they were brought to life by the roar or breath of their sire.

32. "Amusements in New York. The 'Happy Family,'" *New York Illustrated News,* 28 May 1853.

33. In its composition and figural treatment, Stearns's idyllic scene, for all its biblical pedigree, is also strangely evocative of Edwin Landseer's portrait of the famous Dutch-American animal tamer Isaac van Amburgh, painted in 1839 for Queen Victoria. In it, a supremely confident van Amburgh reclines against a massive lion, one arm embracing a placid lamb and the other tugging at the fur of a snarling tiger. Van Amburgh revolutionized wild animal training, claiming to tame the beasts under his control by the rule of love and force of his humanity. Van Amburgh and his promoters evoked biblical associations, including the story of Daniel in the lion's den, in order to add a gloss of spiritual importance to his act. (Joanne Carol Joys, *The Wild Animal Trainer in America* [Boulder: Pruett Publishing, 1983]: 6.) Perhaps Stearns, who had settled in New York by 1838 and whose 1847–1848 trip to Europe included a visit to

England, had some familiarity with the animal trainer and his portrait. Even if Stearns had no awareness of van Amburgh, his portraits, or his publicity, the similarities in subject and composition between Stearns's biblical scene and Landseer's celebrity portrait again highlight the intersection of high art pretensions with the strategies of mass entertainment.

34. Thomas Cole Papers, Archives of American Art.

35. Cropsey correspondence.

36. "Land Reform," *New-York Daily Tribune*, 11 February 1848.

37. John Falconer, letter to Jasper Cropsey, New York , 4 September 1848, Cropsey correspondence. It is not clear to which of Cropsey's Italian paintings Falconer referred. According to Talbot, a painting called *Landscape with Figures near Rome* (1847) now in the collection of the Pennsylvania Academy of the Fine Arts, was the one entitled *Italia* sent from America to Rome in February of 1848. (Talbot, "Jasper F. Cropsey," 339–340.) This painting includes a monk in the foreground, but does not seem to depict a procession of monks with lit candles. More evocative of Falconer's description is a five-by-eight-inch oil sketch in the collection of Newington-Cropsey Foundation, *Procession to a Ruin—Night Scene*. It does depict a monk seated in foreground with a torchlight procession nearby. Despite its title, it might depict a daytime scene. Perhaps a larger, more finished version of this painting was the one to which Falconer referred.

38. Kramer, *The Prophetic Tradition in American Poetry*, 63, 71, 69–70, 112–113.

39. For example, Cranch wrote a "Sonnet on the Mexican War," in which he denounced American tyranny and the spread of slavery and prophesied divine judgment in the form of disunion. The poem appeared in the *Harbinger* on 18 July 1846, 89.

Hicks and Cranch were friends with the Associationist, abolitionist couple Marcus and Rebecca Spring (who were also friends with John Sartain); in a letter from Marcus Spring to Margaret Fuller dated 17 April 1850, he writes that "[Hicks] is doing pretty well painting portraits which, of course, is not to his taste—but poor Cranch is not doing even as well as that— His pictures don't sell" (Raritan Bay and Eagleswood Military Academy Collection, New Jersey Historical Society, Newark). For a discussion of the Springs, see the epilogue, 489–490.

40. Christopher Pearse Cranch, letter to John S. Dwight, New York, 8 April 1844. Published in Leonora Cranch Scott, *The Life and Letters of Christopher Pearse Cranch* (1917; reprint, New York: AMS Press, 1969), 88–89.

41. *Harbinger*, 18 December 1847, 54. Letter quoted in Alice Ford, *Edward Hicks: His Life and Art* (New York: Abbeville Press, 1985), 154. Around 1844 or 1845, Thomas Hicks, second cousin and one-time apprentice to the Quaker artist Edward Hicks, was commissioned by Albert Brisbane, the leading American Fourierist, to paint a portrait of French novelist, reformer, and Fourierist Eugene Sue, suggesting that Hicks had a special relationship to Associationism. (The portrait was never completed, as Sue apparently refused to sit for such a novice. A minor newspaper controversy over Sue's actions followed. See, for example, *Holden's Dollar Magazine*, February 1848, 127.) For biographical information, see references to Thomas Hicks in Ford, *Edward Hicks*; David Tatham, "Thomas Hicks at Trenton Falls," *American Art Journal* 15 (Autumn 1983): 5–20; and George A. Hicks, "Thomas Hicks, Artist, a Native of Newtown," in *A Collection of Papers Read before the Bucks County Historical Society* (n.p.: Bucks County Historical Society, 1917), 89–92. Hicks's sympathy with European revolutionaries is suggested in Tuckerman, *Book of the Artists*: "He was in Paris during the Revolution of 1848, and sheltered two fugitive insurgents in his room, enabling them to finally escape" (465).

42. Albert Brisbane was the first and most important American expositor of Fourier's ideas, and studied with the Frenchman between 1828 and 1832. In 1840 his influential book *Social Destiny of Man* appeared. Human nature, Fourier taught, was made up of twelve different categories—"passions"—which all people had in varying degrees. Different personality types had "passional attractions" to different forms of labor. In modern society, people were usually forced into employment that thwarted these passions. See Delano, *"The Harbinger" and New England Transcendentalism*, 25–50; Ronald G. Walters, *American Reformers, 1815–1860*, 67–73.

43. John Humphrey Noyes, *History of American Socialisms* (1870; reprint New York: Hillary House, 1961): 218–219. The convention was held in New York in 1844.

44. As already noted, John Sartain and his son Samuel were involved with Associationism. The sculptor Edward Augustus Brackett appears as a member of the Philadelphia Union of Associationists in 1849; see Harriet Sartain Papers, microfilm in Archives of American Art. Both John Peter Frankenstein and Lilly Martin Spencer were Cincinnati artists and favorites of the *Herald of Truth,* an Associationist newspaper published in that city. This relationship suggests sympathy and familiarity with the organization, although not necessarily membership. For an article on Frankenstein, see "Art and Artists," *Herald of Truth* 2 (July 1847): 49–56. Spencer's parents were French emigrés who helped establish a Fourierist phalanx in Ohio; there are frequent references to Fourierism in family letters. Spencer and her husband were members of the Sons and Daughters of Temperance. (Benjamin R. Spencer [husband], letter to Spencer's parents, 11 February 1848. Lilly Martin Spencer Papers, microfilm in Archives of American Art.) See Joshua C. Taylor, Robin Bolton-Smith, and William H. Truettner, *Lilly Martin Spencer 1822–1902: The Joys of Sentiment* (Washington, D.C.: National Collection of Fine Arts, 1973); and Whitney Chadwick, *Women, Art, and Society* (London: Thames and Hudson, 1990), 195–197. William Page had close ties with reformer and abolitionist Lydia Maria Child; she was influential in persuading Page to leave his daughters at Brook Farm. See Lydia Maria Child to Francis George Shaw, New York, 15 February 1842: "I have advised [Page] to place [his daughters] with Mrs. George Ripley. I think they would be happy there and that all parts of their character would have a chance to develop in a natural and healthy manner" (Library of Congress, Manuscript Collection, Lydia Maria Child Correspondence). Child was enthusiastic about Fourier's doctrines and was considered a friend by American Associationists. See Delano, "The Harbinger" 66, 74. Shaw was a friend and neighbor of the Brook Farm community. For an example of Associationist art criticism, see an analysis of William Page's *Ruth and Naomi* (present whereabouts unknown) published in the *Harbinger,* 25 December 1847, 58. The painting (Page's second version of the subject) depicted Orpah's departure from Ruth and Naomi and, according to this viewer, was "perhaps the most exquisite narrative of filial devotion on record. . . . The action by which [Ruth] clasps Naomi has more powerful passional force than anything I ever remember to have seen in painting. . . . [It is] the first meeting of an ardent soul with God!"

45. "Editorial Correspondence. Paris, September 7th, 1848," *Harbinger,* 30 September 1848, 173. According to Donald Drew Egbert, French utopian socialists like Charles Fourier and, especially, Henri de Saint-Simon, encouraged this conception of the artist as social guide. (*Social Radicalism and the Arts: Western Europe* [New York: Alfred A. Knopf, 1970], 121–122.) See also Nochlin, "The Invention of the Avant-Garde, France 1830–1880" in *The Politics of Vision: Essays on Nineteenth-Century Art and Society* (New York: Harper & Row, 1989), 2. For a discussion of the role of artists in Associationism, see Ann Katherine Martinez, "The Life and Career of John Sartain," 85–87.

46. Parke Godwin, "Lecture on Art," delivered at the National Academy of Design in New York and reported in the *Philadelphia Art Union Reporter* 1 (February 1851): 26–28.

47. "The American Art-Union," *Harbinger,* 54. This was a major criterion in Patterson's positive assessment of Rothermel's *Laborer's Vision;* see chapter 5. Associationism was, of course, highly sympathetic to goals of peace reform. As we have seen, Samuel Sartain was sent as a delegate to the peace convention in 1850. The union announced its sympathy with the aims and ideals of the 1850 peace convention:

"Whereas an effort is now in progress to introduce the glorious principles of peace in the settlement of differences among the nations of the world in lieu of the scourge and curse of war: and whereas we the Philadelphia Union of Associationists, professing faith in the solidarity of the human race in its oneness of interest of being and destiny and know and feel the necessity of peace as an indispensable element of progress and as a paramount condition of social and political redemption. [Minutes, Philadelphia Union of Associationists,

Sartain Family Papers, Historical Society of Pennsylvania, microfilm in Archives of American Art]

48. Arlington, "Art and Artists," *Herald of Truth* 2 (July 1847): 54.

49. The author of "Art and Artists" in the *Herald of Truth* discussed a painting by Frankenstein in terms that suggest the reformist possibilities inherent in ostensibly traditional religious subjects. Frankenstein's *Christ in the Praetorium (Christ Crowned with Thorns)* (unlocated) was exhibited at the New York Gallery of Art in May 1847. According to Arlington, "never has the idea of a pure, philanthropic soul, suffering under the scorn of those who cannot comprehend it from its very majesty, been so ably depicted to our minds." Christ—the "Great Reformer" as he was called by some—served for Frankenstein's sympathetic critic, and probably for the artist himself, as the exalted model and type of humility, perseverance, and forbearance; the artist as reformer and prophet is figuratively crowned with thorns by an indifferent or hostile public. Such personal identification with Christ and his redemptive mission, and such an attempt to emulate him in his mission and manner was perfectly in keeping with the age's spirit of romantic Christianity. Rather than merely an orthodox expression of conservative piety, preaching patient forbearance and promising a heavenly reward, Frankenstein's painting could embody a very contemporary message, speaking urgently and directly to those Americans actively involved in what they perceived as the great progressive, prophetic, and millennial work of the age.

50. Christopher Pearse Cranch, letter to John S. Dwight, New York, 8 April 1844. Published in Scott, *Life and Letters of Cranch*, 88–89.

51. *New-York Daily Tribune*, 4 May 1848, 1. In a letter to Cropsey dated 3 October 1848, Falconer mentions that the painting (which he called *The Fortress of the Colonna*) had arrived in New York and had been sold by Odgen Haggerty to the American Art-Union. (Cropsey correspondence.) A painting by Cranch entitled *Ruins of the Palace of the Colonna* was exhibited at the Art Loan Exhibition in Detroit's Firemen's Hall in February of 1852; its owner was listed as C. S. Adams.

52. "Dedicatory Festival of the Philadelphia Union of Associationists," unidentified newspaper clipping, 15 May 1848. (It is not from the *Harbinger* or the *National Era*.) Harriet Sartain Papers, Historical Society of Pennsylvania, microfilm in the Archives of American Art.

53. Miller, *Empire of the Eye*, 125–126.

54. The four other elements of the compromise were: the admission of California as a free state; the Texas and New Mexico Act, which included a "popular sovereignty" provision leaving the choice of slavery to the territories; the Utah Act; the abolition of the slave trade in the District of Columbia.

55. Miller gives as evidence the responses of such conservative, patrician observers as Philip Hone and George Templeton Strong. (*Empire of the Eye*, 125.)

56. Particularly since the palm tree had been long identified with the biblical Tree of Life in the Garden of Eden. For a discussion of the palm tree as a biblical symbol in American painting, see Katherine Emma Manthorne, *Tropical Renaissance: North American Artists Exploring Latin America, 1839–1879* (Washington, D.C.: Smithsonian Institution Press, 1989), 11–20. Perhaps Cropsey's *American Harvesting*, painted in 1850 or 1851 and engraved in 1851, is a more appropriate example of a model of national peace and prosperity executed during a time of domestic conflict than his pair of allegories. In *American Harvesting* a plentiful harvest, a church spire, sailboats, steamboats, and a train are illuminated by a sun that beams through a bank of dark storm clouds. Moore, "The Storm and the Harvest," 233.

57. Kramer, *The Prophetic Tradition*, 118–119.

58. Ralph Alan Keller, "Northern Protestant Churches and the Fugitive Slave Law of 1850" (Ph.D. diss., University of Wisconsin, Madison, 1969), 259–260.

59. Keller, "The Fugitive Slave Law," 96–97.

60. Christopher Pearse Cranch, *The Bird and the Bell, with Other Poems* (Boston, 1875).

61. Walters, *American Reformers*, 123, 124.

62. In the left of the composition, a troop of slavehunters on horseback chase a fleeing

family. The father fights off bloodhounds while a woman at the door of a humble cottage welcomes the mother and child. On the right, the figure of Daniel Webster, in the attitude of speech-making, cries "I propose to support the bill, to the fullest extent—to the fullest extent." Behind him, the *Independent* observed, "is the decrepit [*sic*] minister of Liberty, bowed in sorrow, with the crown of Freedom in his hand, and the Liberty cap trailing in the dust. In the background, the statute of Liberty is seen tumbling from its pedestal." The caricature, while not specifically apocalyptic, has a biblical tenor to its symbols of altar and incense, reminiscent of Old Testament infidelity and idol worship. The bone-crowned demon of slavery engulfed in smoke and flames has a hellish quality akin to the image of Apollyon discussed earlier. And the aged "minister of Liberty" recalls an Old Testament patriarch more than the typical classical female personification of the virtue, a type seen in the toppling statue in the rear.

63. Talbot, "Jasper F. Cropsey," 67.

64. By 1856, Curtis was an active supporter of the Republican Party and had gained recognition for his lectures on women's rights, abolitionism, and civil service reform. For a discussion of Curtis, see Franklin Kelly, "Frederic Edwin Church and the North American Landscape," 115–118; and a short biography in Pickard, *The Letters of John Greenleaf Whittier*, 2:306.

65. Curtis wrote this in a discussion of Asher B. Durand's *God's Judgment upon Gog*; see chapter 7.

66. The painting was also exhibited at the American Art-Union in the fall. Curtis's review appeared in "The Fine Arts. The National Academy of Design III," *New-York Daily Tribune*, 10 May 1851, 5. In 1851, Church was, according to Huntington, still "groping for a subject which, both as Genesis and as jeremiad, was peculiarly meaningful to Americans. Envisaged in a single image are purguration by divine wrath and redemption by divine mercy, the prerequisites for a second beginning." Huntington, "Church's *Niagara*," 118.

67. A description of the completed painting appeared in the art union catalogue: "In the foreground, upon a crag which is just about to be torn off by the rushing water from the side of the mountain, are a woman and child and a tiger, who have sought refuge there from the torrents. The rain falls in overwhelming sheets, while the lightning and a lurid sunset add to the terrors of the scene." Quoted in Kelly, *Church and the National Landscape*, 38. Church's treatment of the Deluge theme differed significantly from James H. Beard's (see the discussion in chapter 4), and was more orthodox in its exploration of domestic sentiment and awestruck piety, although it is probably no coincidence in terms of subject matter that both artists were Whigs.

As Franklin Kelly convincingly argues, Church's depiction of *Beacon, off Mount Desert Island*, also on display at the National Academy in 1851, acted as an implicit pendant to his biblical *Deluge*. Both works were organized around a similar central motif: a prominent rock surrounded by water. "In *The Deluge* . . . Church portrayed the world on the brink of being purged of evil and corruption by the all-consuming waters of the Flood. . . . The rock in *Beacon* is an emblem of solidity and permanence, but that in *The Deluge* is marked by its instability." This pairing offered the solace of Christian salvation in a world of sin and it also conveyed a more specifically national meaning. *Beacon* was, on one level, "a symbolic image of America as a postdiluvian new world," promising the safe harbor European emigrants dreamed of encountering in the New World. (Kelly, *Church and the National Landscape*, 41–42.) *The Deluge*, then, evokes the decaying and sinful Old World rocked by divine judgment, a particularly potent image in light of contemporary European revolutions. But in the context of the events of 1850, the pairing of the biblical Deluge and an American beacon of safety would have had a number of other shifting associations. Although the nationalistic myth of a reborn world offering hope to all humanity is implicit in Church's *Beacon*, the inclusion of an eagle in *The Deluge* (mentioned in the *Literary World*, 19 April 1851, 320) indicates that the artist might have been thinking of modern America as well as the revolution-torn Old World when he painted the biblical apocalypse. Kelly discussed the artist's awareness of contempo-

rary politics and the "tension and ambiguity" generated by the events of the day. (Kelly, *Church and the North American Landscape*, 119.) Given his religious and political background, Church would probably have been more concerned with the danger of ignoring or superseding the Constitution of the United States as some abolitionists advocated than with the injustice of the Fugitive Slave Law. But the awareness of an imminent providential trial and judgment upon the American people—guilty and innocent alike—is implicit in *The Deluge*.

68. The *Albion* reviewer found the general conception of the painting "undoubtedly bold and striking," but thought the grouping of mother, child, and tiger not particularly well executed "nor altogether an original idea" ("Fine Arts. The National Academy of Design," *Albion*, 19 April 1851, 189). The *Literary World* did not condemn the choice of subject, but rather the "feebleness of [its] accessories," which compromised the painting's sublimity. (The *Literary World*, 19 April 1851, 320.)

69. The tiger, he complained, seemed to snarl at the mother and child. "Should not the brute nature have been subdued . . . into a terrified stillness?" he asked. And the woman—a symbol, Curtis believed, of the entire human race—was "neither beautiful nor graceful nor commanding." The sublimity of effect, the "supremacy of the chaotic elements in that awful moment" would have been intensified had the victim been correspondingly grand and dignified.

70. "The Fine Arts. Exhibition of the National Academy II, *New-York Daily Tribune*, 24 April 1852, 6.

71. The *Albion* compared them favorably to Landseer's famous images, calling the latter "trashy common place compositions" totally wanting in mind and elevated conception. Cropsey's allegories, on the other hand, were poetically suggestive and grandly conceived. (*Albion*, 24 April 1852, 201.)

72. In a letter to his father written in 1844, for example, Curtis demonstrated his moral repugnance toward slavery and his disapproval of the South's "perpetual attempt . . . to extend its limits and thereby prolong the institution. . . . [W]e can no longer be accomplices in this angel-abhorred guilt . . . we cannot, we will not, aid you in so monstrous a sin." At this point, Curtis did not call for immediate emancipation of all slaves and was willing, however grudgingly, to grant the South a legal right to maintain slaves within its borders. In another letter to his father of that same year, he agreed that slavery would finally be abolished "by the force of public opinion." But, he observed, "The North begins to groan already. While it recognizes the comity of nations and the solemn bond, it begins to speak of the separation with plain words." Much as Curtis did not welcome disunion, he was not willing to advocate for its maintenance at any price. Although the North might give up some commercial prosperity and political advantage, "there would be no real loss, but an eternal gain . . . as unto an individual who sacrifices to Justice." Nor would such a separation "tighten the bonds" of slavery as some people predicted. "It is not credible that a stroke for freedom ever served to perpetuate slavery, because it is an indication of that spirit, alive and in action, to which alone slavery will yield." These two letters written by Curtis in 1844 to his father are excerpted in Edward Cary, *American Men of Letters: George William Curtis* (Boston and New York: Houghton, Mifflin and Co., 1894), 32–35.

73. Ibid., 76–77. With these words, Curtis demonstrates his awareness and acceptance of the "higher law" arguments espoused by most Northerners, especially leaders of more liberal Protestant denominations, who actively opposed the Fugitive Slave Law, and their recognition of the central place of the individual conscience in identifying which human laws broke the higher law. Ralph Keller explains that they understood the dangers of such an approach, but were unwilling to submit to its alternative: "Concerns for the divinely-given authority of government and for commitment to scriptural truth were necessary to temper individualism. But the alternative to it, wherein the individual would be denied the right to decide when the government had gone too far, was immeasurably worse to Protestant leaders. To give over the right of individual judgment to another person or institution would be to submit to the essence of 'Romanism'" (Keller, "The Fugitive Slave Law," 180).

7. *1851/1852: Asher B. Durand, Jonathan Sturges, and* God's Judgment upon Gog

1. John Durand, *The Life and Times of Asher B. Durand* (New York, 1894): 174. The painting measures five by four feet. Sturges was born in Southport, Connecticut, in 1802, the son of a dry goods merchant. He began his career in the employ of his future father-in-law in Fredericksburg, Virginia, where he remained for a short time before returning to Plainfield, Connecticut. He soon moved to New York City and entered the firm of R. & L. Reed, grocers. In 1828 he became partners with Luman Reed, his former employer, who retired from the business in 1832 and died unexpectedly in 1836. For biographical information concerning Jonathan Sturges (1807–1874), see Mrs. Jonathan Sturges [Mary Pemberton Cady], *Reminiscences of a Long Life* (New York, 1894); obituary, *New York Times*, 30 November 1874, 5; Osborn Papers, Notebooks of Virginia Reed Osborn; New-York Historical Society; *Cyclopedia of American Biography*, 3:350. Luman Reed was important to Sturges and others as a model of the self-made, successful man of business aspiring to cultural refinement and devoting himself to the generous social and financial encouragement of American artists. Following his partner's example, Sturges too became one of a number of antebellum New York merchants who rose from humble beginnings to a place of influence in the world of polite culture. Upon Reed's untimely death, Sturges was a prime mover in the establishment of the New York Gallery of Fine Arts, a public gallery comprised of Reed's collection. For a discussion of Reed's patronage and its influence, see Wayne Craven, "Luman Reed, Patron: His Collection and Gallery," *American Art Journal* 12 (Spring 1980): 40–59; Ella M. Foshay, *Mr. Luman Reed's Picture Gallery: A Pioneer Collection of American Art* (New York: New-York Historical Society, 1990); Alan Wallach, "Thomas Cole: Landscape and the Course of American Empire," in Truettner and Wallach, *Thomas Cole: Landscape into History*, 38–39. For the New-York Gallery of Fine Arts, see Foshay, *Reed's Picture Gallery*, 19–22; Maybelle Mann, "The New York Gallery of Fine Arts: 'A Source of Refinement,'" *American Art Journal* 11 (January 1979): 76–86. Sturges was also closely associated with fellow patron Charles M. Leupp in the art life of the city. In 1841, for example, Sturges, Leupp, and William Cullen Bryant—all three of whom were also members of the Sketch Club—were elected to the executive committee of the Apollo Association (soon to become the American Art-Union). And when the National Academy moved to a new building in 1849, the cost of the building was largely underwritten by Sturges and Leupp. (James T. Callow, "American Art in the Collection of Charles M. Leupp," *Antiques* 122 [November 1980]: 998–1009; William Cullen Bryant II and Thomas G. Voss, *The Letters of William Cullen Bryant: Volume 2, 1836–1849* [New York: Fordham University Press, 1981]: 169 n. 1; *Volume 3, 1849–1857*, 124.)

2. "Our Private Collections. No. II," *Crayon* 3 (February 1856): 57–58. According to this article, there was "a long interval" in which Sturges did not acquire any more works by Durand, which was broken by the commission for *God's Judgment*. (*Kindred Spirits* did come just prior to God's Judgment, but was not meant for Sturges's own collection.) Lillian B. Miller, *Patrons and Patriotism: The Encouragement of the Fine Arts in the United States* (Chicago: University of Chicago Press, 1966), 157. Sturges had shown some interest in Old Testament subjects before *God's Judgment*; in 1844 a painting by J. G. Chapman, owned by Sturges, entitled *Hebrew Women Borrowing the Jewels of the Egyptians* was exhibited at the National Academy.

3. The following quotation from Ezekiel 29:17 was included in the National Academy exhibition catalogue:

> And Thou son of man, Thus saith the Lord God; speak unto every feathered fowl, and to every beast of the field, Assemble yourselves, and come; gather yourselves on every side to my sacrifice, that I do sacrifice for you, *even* a great sacrifice upon the mountains of Israel, that ye may eat flesh, and drink blood.

4. "The Fine Arts. The National Academy of Design, No. III," *Albion*, 8 May 1852, 225.

5. For a discussion of their similarities, see Sweeney, "The Advantages of Genius and Virtue," in Truettner and Wallach, *Thomas Cole: Landscape Into History*, 121. *God's Judgment* is not dated and the only indication of its chronology is its exhibition by April 1852 at the National Academy. Some sense of the possible length of its production can be gleaned by using the history of *Kindred Spirits* as a guide. According to Sturges, he commissioned the work from Durand for Bryant "soon after" the poet's funeral oration for Thomas Cole, which was delivered on 4 May 1848. The finished painting was given to Bryant shortly before 26 February 1849 (See David B. Lawall, *Asher Brown Durand, His Art and Theory in Relation to His Times* [New York: Garland Publishing Co., 1977], 517; and Lawall, *Asher B. Durand: A Documentary Catalogue of the Narrative and Landscape Paintings* [New York: Garland Publishing Co., 1978], cat. no. 316.) Thus, the project—from patron's idea to finished product—took approximately nine months to complete. If we assume that *God's Judgment upon Gog* took no longer to conceive and produce and was ready for the academy opening in April 1852, Durand would have begun it no earlier than July 1851.

6. See J. Gray Sweeney, "The Nude of Landscape Painting: Emblematic Personification in the Art of the Hudson River School," *Smithsonian Studies in American Art* 3 (Fall 1989), 43–65.

7. This area of the painting is now much abraded.

8. "The Fine Arts. Exhibition of the National Academy of Design, No. III," *Literary World*, 8 May 1852, 331.

9. According to the *National Cyclopaedia of American Biography*, Sturges was "a Christian, full of zeal and of benevolence." His *New York Times* obituary reported that "in religion Mr. Sturges was a member of the Reformed church, and was one of the most energetic workers in the Church extension Society of that denomination." This is not to ignore or discount other motivations, such as the desire of a newly rich and socially prominent man to acquire the tastes and cultural authority of an aristocracy of birth. For a discussion of such motivations, see Alan Wallach, "Thomas Cole: Landscape and the Course of American Empire," in Truettner and Wallach, *Thomas Cole: Landscape into History*, 38. Indeed, religious devotion—especially one, as we shall see, as fundamentally conservative as Sturges's Reformed tradition—is completely compatible with the desire to educate, refine, and raise one's own social level, to take on trappings of tradition, birth, and authority. Both advocate the continuity of tradition and the notion that, since authority and knowledge ultimately rest in some educated body outside of oneself, individual transformation can be effected only through effort and education.

10. In her memoirs, *Reminiscences of a Long Life*, Mary Cady Sturges listed the Collegiate Dutch Reformed churches that she attended during her years in New York: The Old South Church, Middle Dutch Church, The Old North Church, Lafayette Place Church, Marble Collegiate Church, and Collegiate Reformed Church. Based on the addresses of their residences and the locations of these churches, during the 1840s and 1850s the Sturgeses most likely attended the Old North Church and the Lafayette Place Church. Five pastors worked for this network of collegiate churches in the 1840s and 1850s: John Knox, William C. Brownlee, Thomas De Witt, Thomas E. Vermilye, and Talbot W. Chambers. See Thomas De Witt, *A Discourse Delivered in the North Reformed Dutch Church, in the City of New York, on the Last Sabbath in August, 1856* (New York, 1856), 68. The Sturges family also had ties to Presbyterianism: Mary Cady Sturges wrote, "my mother, sister and myself were all Presbyterians by profession," *Reminiscences*, 95. When the couple's daughter, Virginia Reed Sturges, visited Chicago in 1850, she made a point of attending a Presbyterian church; see Notebooks of Virginia Reed Osborn, New-York Historical Society. See also Sturges, *Reminiscences*, 219, in which she mentions attending a Presbyterian service in Amboy, Illinois, in 1857.

11. According to Fred Hood, the terms "Reformed" and "Reformed tradition" refer to people and groups in the theological tradition of John Calvin with the Presbyterians and the Reformed Dutch retaining the strongest legacy. Both denominations shared a presbyterian form of government, "with presbyterial control over ministerial education, ordination, and

appointment, [which] was designed to promote uniformity" (Fred J. Hood, *Reformed America: The Middle and Southern States, 1783–1837* [University: University of Alabama Press, 1980]: 3–5). According to William B. Sprague's *Annals of the American Pulpit* (New York 1869), "the Reformed Dutch Church is the oldest body of Presbyterians in America" (v).

12. Thomas De Witt, *A Discourse*, 58. In her memoirs, Mary Cady Sturges notes that "Dr. De Witt . . . had the morning service in our church" that day in January 1853 when two of the Sturges children left for Europe. Her wording makes it clear that De Witt was a personal friend of the family. (Sturges, *Reminiscences*, 207.)

13. Sydney E. Ahlstrom discusses the five fundamental themes of the Reformed tradition in *A Religious History of the American People* (New Haven: Yale University Press, 1972), "The Reformed Tradition," 77–81.

14. Edward Tanjore Corwin, *A Manual of the Reformed Church in America (Formerly Ref. Prot. Dutch Church.) 1628–1878* (New York, 1879), 240. Ahlstrom explains that the related doctrine of "double predestination" (that some were elected to eternal salvation and others not) was outdated by the middle of the nineteenth century.

15. Ahlstrom, *Religious History*, 152.

16. Ahlstrom, *Religious History*, 80–81.

17. Hood, *Reformed America*, 141, 151, 144. For a Reformed conception of the millennium, see Hood, *Reformed America*, chapter 4, "The Millennium: Scenario for an American Theocracy," 68–87.

18. The organization was founded in 1843 and incorporated in 1848. Until 1849, Sturges was a member of the Council for the Third District as well as an elected member of the Supervisory Council. From 1850 through 1864, he was no longer a member of the Council for the Third District but was still an elected member of the Supervisory Council. From 1865 until his death in 1874, Sturges was one of four elected members of the Board of Managers of the association. See published annual reports of the association. A memorial tribute to Sturges was included in *The Thirty-First Annual Report* (1875), 93. For information about the organization, see Joel H. Ross, *What I Saw in New-York; or, A Bird's Eye View of City Life* (Auburn, N.Y., 1851), 105–110; and Roy Lubove, "The New York Association for Improving the Condition of the Poor: The Formative Years," *New-York Historical Society Quarterly* 43 (July 1959): 307–327.

19. Lubove, "The New York Association," 314, 308.

20. Hood, *Reformed America*, 143, 146.

21. Lubove, "The New York Association," 316.

22. Only one Jonathan Sturges was listed in the city directory for that year; his address and occupation coincide with the individual discussed here.

23. Those who attended ritualized services (Lutheran, Catholic, Episcopalian) or who did not attend church were more likely to be Democrats. See Robert A. Divine, T. H. Breen, George M. Frederickson, and R. Hal Williams, *America Past and Present, Volume I: to 1877* (Glenville, Ill.: Scott, Foresman and Company, 1984), 294.

24. "Chronicle: Art and Artists in America," *Bulletin of the American Art-Union* 4 (May 1851): 30–31.

25. Keller, "The Fugitive Slave Law," 305–306. Keller discusses the incidents on pages 299–306.

26. Ibid., 154, 307–308. Keller quotes from the *Christian Intelligencer*, 12 January 1852, 102.

27. The *National Cyclopaedia* observed that "Mr. Sturges was noted for his outspoken and liberal support of the national government during the civil war." Both descriptions suggest but do not prove that Sturges had an affiliation with the Republican Party.

28. The Dutch Reformed Church, in its desire to maintain order and harmony within its own body and the nation, did not take any stand on slavery other than supporting colonization. Although individual members of the Dutch Reformed Church could and did adopt abolitionist principles in the 1840s and 1850s, the denomination never officially condemned slavery or advocated abolition. (John R. McKivigan, *The War against Proslavery Religion: Abolitionism and the Northern Churches, 1830–1865* [Ithaca: Cornell University Press, 1984], 165.)

Elizabeth Johns has argued convincingly for a specifically antiabolitionist message in one of the paintings William Sidney Mount produced for Sturges, *Farmers Nooning* (1836). Johns does not claim that Sturges necessarily had personal input into the subject and its treatment, although she leaves that possibility open. But she does suggest that a merchant like Sturges would have been frightened by the economic and political catastrophe that some insisted would result from immediate emancipation and she implies that Sturges understood the point of Mount's "antiabolitionist 'twist'" (Elizabeth Johns, *American Genre Painting*, 33–36). In addition, Johns argues that *Ringing the Pig* (1842), also painted for Sturges, was a "transparent reference to the Whig victories over the Democrats in New York beginning with the elections of 1837" (57), a message the apparently Whig patron might have found appealing.

29. Sturges, *Reminiscences*, 28. 30, 90.

30. Sturges, *Reminiscences*, 149.

31. Sturges, *Reminiscences*, 196.

32. The dinner was held on 3 November 1874. Published in Parke Godwin, *A Biography of William Cullen Bryant, with Extracts from his Private Correspondence* (New York, 1883), 2:348. In a letter to his wife, Frances F. Bryant, dated New York, 12 June 1850, Bryant mentioned that "Mr. Sturges" had called and discussed the health of a mutual acquaintance, a visit suggesting the social interaction of the two men at the time. (*Letters of William Cullen Bryant*, letter 725, 3:130.) As we have seen, Sturges and Bryant were involved in many of same cultural groups and organizations. In January 1867 Bryant attended a dinner in New York in honor of Sturges's retirement, and he gave a response to one of the toasts. See Charles H. Brown, *William Cullen Bryant* (New York: Charles Scribner's Sons, 1971), 482–483.

33. Godwin, *Bryant*, 349.

34. Although Bryant, editor of the *New York Evening Post*, was a Democrat, he had been a critic of the war with Mexico and was vehemently opposed to the spread of slavery into the territories. An early adherent to the Free Soil cause and then to the Republican Party, his concern was the maintainence of "free soil for free labor," not the elimination of slavery in the South. According to George Frederickson, "the political free-soil movement, which developed out of Northern anxieties about Southern expansionism and the extension of slavery, combined principled opposition to slavery with a considerable amount of antipathy to the presence of Negroes on any basis whatever" (Frederickson, *Black Image*, 140). Bryant was, according to James Bilotta, a conservative antislavery Free-Soiler motivated in part by his fear of black contamination of white society. He advocated colonization and the containment of slavery rather than its immediate abolition, and was "anxious to disassociate free soilism from radical abolitionism" James D. Bilotta, *Race and the Rise of the Republican Party*, 101–104, 112). Bilotta argues that Bryant considered blacks mentally and morally inferior to whites and that his antislavery tendencies were motivated by racial fear rather than concern for slaves or free blacks.

35. "The Fugitive Slaves Riots," *New York Evening Post*, 4 October 1851; reprinted in William Cullen Bryant II, comp. and annotator, *Power for Sanity: Selected Editorials of William Cullen Bryant, 1829–1861* (New York: Fordham University Press, 1994): 265 267.

36. See, for example, Frederickson, *Black Image*, especially chapter 2, "Slavery and Race: The Southern Dilemma," 43–70. Proslavery polemicists characterized free Negroes of the North "as [a population] demonstrating its natural unfitness for freedom" (50). Not only was the slave unfit for freedom, but the Negro could find happiness only with a white master (52).

37. For the years 1849 through 1852, Virginia also recorded the details of numerous private gatherings and parties where artists like Durand, Henry Peters Gray, Daniel Huntington, and C. P. Cranch mingled with merchants, poets, and politicians. Osborn Family Papers, Manuscript collection, New-York Historical Society.

38. Quoted in Edward Stone, "Kossuth's Hat: Foreign Militants and the American Muse," *Emerson Society Quarterly* 23 (First Quarter 1977): 37. At the dedication of the American Art-Union's new gallery on 17 October 1849, the introduction of the French representative was met with stony silence. The *United States Magazine & Democratic Review* reported that

"there were murmurs of Rome and Hungary" during the introduction and, it added, "we were glad to hear them" ("The American Art-Union," *United States Magazine and Democratic Review* 25 [October 1849]: 382). France had lost favor in the United States because of its intervention in the Italian uprising, just as Russia had helped defeat the Hungarian partisans. Bryant made clear that he sympathized with European revolutionaries and realized the lessons they had to teach his own country in an editorial in the *Post* on 24 April 1848, The "irresistible purposes of Providence will never stop in their course until justice is done to the oppressed millions. . . . Let Conservatism and Privilege, wherever to be found in this country, take reasonable warning from its fate in Europe." (Quoted in Bryant, *Letters*, 2:522 n. 1, letter 703.) Bryant went to Europe in June 1849 with Charles Leupp, where they witnessed first hand "Europe under the Bayonet." They were back in the United States by late October of that year.

39. But others did not; some Americans were worried that Kossuth sought to embroil the United States in European affairs. Abolitionists grew increasingly disappointed when Kossuth did not speak out against American slavery, while some Southerners were worried about his eloquent defense of liberty.

40. In January 1850, for example, a play entitled "The Siege of Comorn; or, The Hungarian Patriots" was produced at the Bowery Theater. In November and December 1851, New York theatergoers could attend performances of "Kossuth's Kum" or the more dignified sounding "The Hungarians and their Struggle for Liberty." (Odell, *Annals of the New York Stage*, 5:536.) In March 1851, a panorama depicting "the wars for Liberty in Rome, Upper Italy and Hungary" was displayed in New York. Panorama notices in *New-York Daily Tribune*, 29 March 1851, 1. The panorama, credited to Leo Elliot and E. Beyer, was described as containing "thousands of figures . . . this splendid panorama . . . relates to the most important events which have occurred . . . within the past three years." By March 1851, it had already been seen in Philadelphia; Wilmington, Delaware, and Newark, New Jersey. (Odell, *Annals*, 6:142.)

41. Bryant, *Letters*, 3:118–119. For Leupp's name, see *New York Times*, 20 December 1851, 3.

42. Letter from Vincent Colyer, published in the *New York Times*, 18 November 1851, 4; and in the *Bulletin of the American Art-Union* 4 (December 1851): 149. The artists listed: J. F. Kensett; Louis Lang; E. Leutze; T. Addison Richards; William Walcutt; Joseph Kyle; Charles Blauvelt; Thomas Hicks; T. P. Rossitor [*sic*]; C. P. Cranch; S. R. Gifford; R. W. Hubbard; James H. Cafferty; Robert T. Raynor. Although not on this list, Henry Kirke Brown was also involved; see letter from his wife, Lydia Brown, to her brother, 28 December 1851. (Brown Letters, Brown-Bush Papers, Manuscript Collection, Library of Congress).

43. For descriptions, see "The Welcome to Kossuth," *New York Times*, 8 December 1851, 1; and *Times*, 12 December 1851, 1.

44. Bernard F. Reilly, Jr., *American Political Prints, 1776–1876: A Catalog of the Collections in the Library of Congress* (Boston: G. K. Hall & Co., 1991): 346, no. 1852–1.

45. The significance of the Turkish flag, as well as the identification of the bear's head with Russia and the wolf's with Austria in this print come from comparing them to a description of the largest and most elaborate banner that greeted Kossuth as he made his way along Broadway in December 1851. This banner was described in the *Times* (The Welcome to Kossuth") as "an immense allegorical painting," designed by Delamano,

> representing a tableau of Turkey defending KOSSUTH, and Russia and Austria vainly endeavoring to seize him. Kossuth stands in the background, a wreath of laurel above his head; a Turk with uplifted scimitar [*sic*], kneeling on one knee before him; Russia, personified by a human figure wearing the head of a bear, assumes a hostile attitude, holding in one hand a Cossack spear, and flourishing a knout with the other; Austria, a similar figure with the head of a wolf, thrown backward from the ineffectual grasp for the person of the great Magyar, and holding a rod, upon the end of which is perched the double-headed Eagle. Meanwhile the Lion of England stands in an attitude of quiet power by the side of the Turk, as if ready to offer his assistance. Over this expressive tableau, soars the American Eagle, holding in its talons the flags of America and Hungary.

46. Whittier's poem "Kossuth," for example, appeared in the *National Era* on 4 December 1851, the day the Hungarian patriot arrived in New York; Mrs. H. M. Perley's "Lines: To Kossuth" was published in the *Knickerbocker Magazine* in February 1852. To Perley, Kossuth was the "man of the age" and a prophet whose vow to avenge the blood of Hungarian martyrs sealed him to his "holy cause."

47. The poem was published in Samuel Hanson Cox's *Interviews Memorable and Useful: from Diary and Memory Reproduced* (New York, 1853). The book was reviewed, and the poem printed in the *New-York Daily Times* on 29 March 1853. In the 1820s Mary Cady attended Cox's church and the minister married Mary and Jonathan Sturges in December 1828. According to Mrs. Sturges, Cox was a "man of great power and originality of thought. . . . His early life in Boston had given him a strong bias in Unitarianism" (Sturges, *Reminiscences*, 96, 119). Cox was an outspoken leader of the New School faction in the Presbyterian Church controversy of the 1830s, in which the issue of slavery had an important role; by the late 1840s he no longer took a vocal antislavery stance.

48. Also significant is the effect of the law on Melville and *Moby-Dick*, which was published in 1851. According to Carolyn Karcher, Father Mapple's sermon on Jonah "resounds with the abolitionist rhetoric of the momentous years 1850–1851" in its appeal to a higher law and its warning to compromisers who sought to "pour oil upon the waters when God has brewed them into a gale." Karcher argues that Melville's Ishmael, like Jonah in Mapple's sermon, escapes a near-fatal encounter with a whale in order to "prophesy of the doom that awaits an unrepentant people." Melville took considerable notice, Karcher observes, of the warnings of impending judgment pronounced by fanatical millenarians. Although the author of *Moby-Dick* stigmatized these doom-sayers as zealots, he did recognize the foundation of truth in their belief that, as Karcher puts it, "the nation was rushing headlong towards an apocalyptic holocaust." Melville envisioned this holocaust as "an interracial and fratricidal conflict over slavery." (Carolyn L. Karcher, *Shadow over the Promised Land: Slavery, Race and Violence in Melville's America* [Baton Rouge: Louisiana State University Press, 1980]: 78–80).

49. Cushing Strout, "Uncle Tom's Cabin and the Portent of Millennium," *Yale Review* 57 (Spring 1968): 379.

50. Harriet Beecher Stowe, *Uncle Tom's Cabin; or, Life among the Lowly* (New York, 1852); Franklin Center, Pa.: The Franklin Library, 1984), 477–478. A sermon entitled "A Discourse for the Time," delivered in Philadelphia by the Unitarian minister William Henry Furness on 4 January 1852 also illustrates how, by the end of 1851, European political struggles intersected with national concern over slavery. (Furness, *A Discourse for the Time* [Philadelphia, 1852].) Furness began by decrying "that most brutal and ruthless military revolution" in France, which "made every heart, that cherishes any regard for Freedom and Humanity, burn with indignation." "I think there can hardly be found in modern history," he thundered, "any parallel to this outrage upon truth, freedom and humanity." Furness then turned to Kossuth and Hungary. He hoped that the influence of this revolutionary leader would "penetrate the rock of our selfishness . . . and call forth . . . the mighty stream of our sympathy that shall sweep away from our land and from the earth, every vestige of oppression." But Furness lamented that Kossuth's appeal on behalf of liberty was destined to fail because American slavery, that "tremendous obstacle," blocked America's complete sympathy with Hungary's woes and neutralized any moral aid that the United States might wish to offer. (Furness, *A Discourse*, 15, 16, 19.) Similar sentiments were expressed in a poem by Whittier entitled "The Peace of Europe," originally published in the *National Era*, which also appeared in *Littel's Living Age* on 13 March 1852, 522. The poem scorned the idea that—as her kings and priests claimed—peace and order reigned in Europe. Not, Whittier scoffed, while patriots and fighters for liberty were locked in foul dungeons and princes, kaisers, priests, and czars once more held carnival. The "White Angel of the Lord"—symbol of a "better day"—would never, Whittier warned, grace any land, European or American, where slavery ruled. The way had to be prepared by Liberty, symbolized as a prophet, John the Baptist:

> The Baptist Shade of Liberty,
> Gray, scarred, and hairy-robed, must press
> With bleeding feet the wilderness!
> Oh! that its voice might pierce the ear
> Of princes, trembling while they hear
> A cry as of the Hebrew seer;
> REPENT! GOD'S KINGDOM DRAWETH NEAR!

In May 1852, in a letter to William Lloyd Garrison, Whittier envisioned a great clash of opposing forces, "the conflicts and skirmishes which are preparing the way for the great battle of Armageddon, the world-wide, final struggle between freedom and slavery." Whittier had no doubt of "the certain victory of the right" (Whittier to Garrison, published in Pickard, *Letters of Whittier*, 2:191).

51. J. Durand, *Life and Times*, 175.

52. Lawall, *Durand: Art and Theory*, 83–85.

53. David B. Lawall, *A. B. Durand 1796–1886* (Montclair, N.J.: Montclair Art Museum, 1971), 22.

54. Lawall, *Durand: Art and Theory*, 507–508, 510.

55. Lawall, *Durand: Art and Theory*, 513. Lawall cites a composite painting like *Dover Plains* of 1848 as an example of this arrangement.

56. Written in French at West Point as an exercise in French composition, quoted and translated in Lawall, *A. B. Durand*, 60.

57. "Editor's Table," *Knickerbocker Magazine* 39 (June 1852): 566.

58. The *Albion* suggested that Durand had been stimulated in his *God's Judgment upon Gog* to "take a higher place than usual" by the example of "a younger class of Artists to whom attention has latterly been much called," referring certainly to Cropsey and Church. For discussion of a Durand/Church rivalry, see Sweeney, "Cole's Influence," 121–122.

59. E. Anna Lewis, "Art and Artists of America: A. B. Durand," *Graham's Magazine* 45 (October 1854): 318–322.

60. "The Fine Arts. Exhibition of the National Academy. V," *New-York Daily Tribune*, 20 May 1852, 5–6.

61. The translation of a German article describing Kaulbach's monumental paintings for the hall of the Berlin Museum appeared in the *Tribune* on 10 May 1851, 5. According to the introduction to this translation (probably by Curtis), the original of "The Destruction of Jerusalem," painted in oil, "now stands in the new Pinakothek in Munich."

62. Parke Godwin, "Lecture on Art."

8. *1853/1854, Epilogue: Rossiter's* Babylonian Captivity *and Cropsey's* Millennial Age

1. Since 1848, Rossiter had planned to produce a series illustrating the three cardinal virtues, faith, hope, and charity; *The Return of the Dove to the Ark*, as we have seen, represented Faith. (Pennsylvania Academy of the Fine Arts broadside [November/December 1848].) It is not clear whether Rossiter, from the inception of the project, had intended the subject of *The Babylonian Captivity* to illustrate hope. On 5 July 1851, the *Home Journal* noted that "Mr. Rossiter is engaged on his great picture of the 'Hebrews in Captivity by the Waters of Babylon'" (*Home Journal*, 5 July 1851, 3). In March 1853, *Putnam's Monthly* reported that the project was finished: "Mr. Rossiter has painted a very large picture representing the Prophet Jeremiah 'rehearsing a lamentation,' in which he has grouped together all the personages who might be imagined present by the river of Babylon, when the children of Israel sat down and wept over their captivity" ("Editorial Notes—Fine Arts," *Putnam's Monthly* [March 1853]: 352). The

project was Rossiter's most ambitious to date, with a canvas measuring 9'8" × 16' 8" (measurements in Fort, "Rossiter," 187 n. 64. According to Fort, the painting was in ruined condition at Northfield–Mt. Hermon school in Massachusetts; the school now has no record or knowledge of the painting). *The Babylonian Captivity* was planned as an exhibition picture. As *Putnam's Monthly* observed, "The painting is on too large a scale for exhibition in an ordinary room, and the artist has sent it to the southwest, to be shown to those who have but few opportunities of seeing a work of any artistic pretension." Rossiter began the painting in the Broadway studio he shared with John Kensett and Louis Lang; shortly after completing it in March 1853 and sending it on tour with the two other scriptural paintings, he left for Europe with his family.

2. John F. Kensett, Rossiter's closest lifelong friend, was also a "warm friend" of Curtis; see Edward Cary, *George William Curtis*; Rossiter and Curtis must have had social contact as well.

3. Jeremiah as a prophet of doom and judgment with a message for modern times is described, for example, in the giftbook *Leaflets of Memory for 1847* (Philadelphia, 1846). An engraving of the prophet sitting dejectedly on a pile of ruins with a scroll in his hand was accompanied by a poem by Reynell Coates, editor of the annual. The poem imagined Jeremiah's anger and urgency as he admonished Jerusalem to turn from its wickedness—"Repent, or die!"—and his sadness as he pronounced the dire judgment of God upon his beloved city. The poem ended with a chilling reminder that the prophet's eternal lamentation still resounds: "Still calls the seer—the nations will not heed" (Reynell Coates, "Jeremiah," 209). Despair over the destruction of Jerusalem, central to Rossiter's painting, is also visualized in a contemporary giftbook illustration: "Jews Weeping over the Fall of Jerusalem," which appeared in *The Odd-Fellows' Offering, for 1852* (New York, 1851). The engraving, which depicts men and women of varying ages in an assortment of mournful poses (see fig. 63), accompanied two essays. "The Fall of Jerusalem," by "Evangel," took a Christian typological perspective and described the wealth and glory of the city and its temple. "Evangel" left it to Manuel M. Noah to describe fully the meaning of the scene depicted in the engraving, with particular reference to the fate of modern Judaism. (Evangel, "The Fall of Jerusalem," 288–293; Noah, "The Day of Vengeance," 295) For another view of the fall of Jerusalem under the Romans, see a poem by the Reverend H. H. Milman, "The Fall of Jerusalem," published in *The Gem of the Season for 1851*, 200–202, and accompanied by an engraving of Martin's *Fall of Jerusalem*. In this poem, Jerusalem's fate is interpreted as just vengeance upon the Jews for their crucifixion of Christ.

4. Rossiter chose the first two verses Psalm 137 and Lamentations 5:1–22 as his guiding texts. (Rossiter, *Three Scriptural Pictures*, introduction.) The pamphlet includes a historical

FIG. 63. Anon., "Jews Weeping over the Fall of Jerusalem," 1851; engraving published in *The Odd-Fellows' Offering, for 1852.* The Library of Congress.

FIG. 64. Washington Allston,
*Jeremiah Dictating His Prophecy of
the Destruction of Jerusalem to
Baruch the Scribe*, 1820; oil/canvas,
84" × 98½". Yale University Art Gallery.
Gift of Samuel F. B. Morse, B. A., 1810.

note, a description of the city of Babylon, and assorted biographical essays, all of which indi-
cate the artist's scholarly interest in the subject of prophets and prophecy. (Rossiter, *Three
Scriptural Pictures*, 5.)

5. The subject was, the artist admitted, entirely of his own conjecture; he took the liberty
of imagining that Jeremiah journeyed to Babylon "for the purpose of consoling the captives"
(Rossiter, *Three Scriptural Pictures*, 12). The three major narrative subjects were Jeremiah
prophesying, either alone or with his scribe Baruch; the Jews lamenting over the fall of Jerusa-
lem; and Belshazzar's feast. As with *Miriam*, Washington Allston's *Belshazzar's Feast* (1817–
1843; fig. 1) and *Jeremiah Dictating His Prophecy of the Destruction of Jerusalem to Baruch the
Scribe* (1820; fig. 64) could very well have served Rossiter as inspiration if not specific models.
(Fort suggests M. Murat's *Jeremiah and the Daughters of Sinn* [sic] *Lamenting over the Ruins
of Jerusalem*, which Rossiter saw at the French Academy in Rome, as a model; he admired
that painting in a letter to Thomas Cole, 23 April 1843. [Fort "Rossiter," 187 n. 64.]) Allston's
Jeremiah depicts the earlier of the two related subjects in which the prophet foretells the de-
struction of Jerusalem and the beginning of the Babylonian captivity. In *Belshazzar's Feast*,
Daniel "pronounces sentence against the Babylonian empire, liberating the Jews from their
captivity." Taken together, Bjelajac observes, Allston's two paintings "conveyed the conviction
that God punishes as well as protects his chosen people" (Bjelajac, *Millennial Desire*, 135, 138).

6. Rossiter, *Three Scriptural Pictures*, introduction.

7. Rossiter, *Three Scriptural Pictures*, 6.

8. See chapter 3, pp. 89–90, for a brief discussion of these female figures and their millen-
nial implications. The subject of Belshazzar's feast, indicated in Rossiter's painting through
the figures of Daniel and Belshazzar's soldier, held double significance for Christians. See
Bjelajac, *Millennial Desire*, 21–22. On the one hand it served as a type for the Last Judgment
and a warning about the wages of sin. Such a message is evident, for example, in Frederick
Greene Carnes's "Belschazzar [sic]: A Poem," published in the *Knickerbocker Magazine* 33
(June 1849): 516–517, and in an essay by Timothy Bigelow, "The Fall of Babylon," which ap-

peared in *The Beauties of Sacred Literature* (Boston, 1848). But Belshazzar's feast, marking Babylon's imminent demise, also announced the beginning of the end of the Jews' seventy years of captivity. The Jews, once restored to Jerusalem, built a new temple. To many Christians, the restoration of the Jews and the rebuilding of the temple were types of the millennium; with Babylon's destruction, a "new heaven and a new earth" was possible. An essay that underscored this redemptive message appeared, for example, in *The Odd-Fellows' Offering, for 1850* (New York, 1849), accompanied by an engraving after John Martin's famous version of the subject.

9. The paintings were, for example, in Lexington, Kentucky, in October 1853 (*Kentucky Statesman*, 4 October 1843) and in Charleston, South Carolina, in April 1855 (see notices, *Charleston Daily Courier*, 2 April 1855–27 April 1855). In 1860 the three paintings were exhibited together in New York for the first time (see *New-York Daily Tribune*, 1 February 1860; *Home Journal*, 4 February 1860), and by 1863 they were in Buffalo where they were exhibited at the Buffalo Fine Arts Academy. *Jeremiah* and *Miriam* apparently remained in Buffalo through 1868; *The Return of the Dove to the Ark* stayed through 1872. See Yarnell and Gerdts, *The National Museum of American Art's Index*.

10. "Rossiter," *Dictionary of American Biography*, 3:182; "Eleazar Parmly," *National Cyclopaedia of American Biography*, 28:210; and *Dictionary of American Biography*, 7:251–252; Lawrence Parmly Brown, *The Greatest Dental Family* (reprinted from *The Dental Cosmos* for March, April, and May 1923).

11. Brown, *Dental Family*, 2, 14, 22. The Disciples, a Christian restorationist denomination established by Alexander Campbell, sought to recreate the simplicity of primitive Christianity, with no hierarchical clergy or complex liturgy and with direct faith in the New Testament as its fundamental guide.(Ahlstrom, *A Religious History*, 449–452. Eleazar Parmly's own anti-sectarian feelings were manifest, for example, in verses from a poem he wrote in 1854 after attending a Methodist service in England (Parmly, *Thoughts in Rhyme* [New York, 1867], 150):

> Then let sectarian titles die,
> Supplanted by one Christian name;
> Acknowledging the Lord Most High,
> And glowing in his Spirit's flame.

That the Parmlys instructed their children to respect and emulate such piety was evident in their daughter's actions on her deathbed. After calling for the Scriptures, reading from the Psalms, and kissing the book, Rossiter noted in his diary, "she pressed it to her bosom, saying: 'Oh, precious Word! how I was taught to love it!'" (Rossiter, "Last Hours," printed in Parmly, *Thoughts in Rhyme* [New York, 1867], 49).

12. After Anna's death in April 1856, Rossiter was heartbroken. "Oh! what a blessed life I have to look back upon with her! Gentle, blessed Anna! we go linked heart to heart, although a grave is between us!" (Rossiter, "Last Hours," 50). When he returned to New York from Paris in 1856, Rossiter and his three children lived in a house owned by his father-in-law, leaving New York and the Parmly milieu only when he remarried in 1860. Margaret Broaddus, "Thomas P. Rossiter," 112–113.

13. Rossiter's use of the curse of Ham is discussed in chapter 3, pp. 101–102. In 1856, while on board a steamer en route to their daughter in Paris, the Parmlys joined a heated argument that pitted North against South. Parmly described this encounter in a poem (*Thoughts in Rhyme*, 28):

> One would consign a human soul—
> Free from all guilty stains;
> If covered by a dusky skin,
> To servitude and chains.
> The other [Mrs. Parmly], with as keen an eye,
> Such morals could not see;

> But, with broad benevolence,
> Would make all nations free.
> .
> No matter where oppression first
> Had origin, thought I,
> The slavery of my native land
> Is doom'd ere long to die.
> Its skeleton shall hang in air,
> A terror to mankind;
> While all its execrable bones
> Shall rattle in the wind.
> The sordid race which long has liv'd
> By sweat of others' toil;
> Must finally resign their lands
> To those who work the soil.
> Our eagle then shall plume his wings,
> And o'er the nation soar,
> Proclaiming to the joyous world
> That slavery is no more!

Parmly explicitly identified each black slave as possessing a "human soul," thus establishing his position on the question of racial unity or diversity. And his radical proposal that freed slaves be given their erstwhile masters' land clearly disavows conservative colonization schemes designed to rid the United States of the black race.

14. The North American Phalanx existed from 1843 to 1855. For additional discussion of Associationism, see chapter 1, p. 21 and chapter 6, pp. 168–170. As we have seen, many Americans who were interested in an Associationist regeneration and reformation of modern society never actually moved to a phalanx, providing monetary and moral support instead. Eleazar was a member from 1845–1850 (Brown, *Dental Family*, 14); Levi is recorded in the stockledgers of the North American Phalanx as a shareholder from 1852 to 1854. (North American Phalanx Collection, Monmouth Historical Society, Freehold, N.J.) Solyman Brown, Eleazar's closest lifelong friend, a fellow dentist and Swedenborgian minister, was a resident member of the Le Raysville (Pennsylvania) Phalanx in 1844–45. (Brown, 14). For discussion of the North American Phalanx, see Noyes, *History of American Socialisms*, 449–511; Herman J. Belz, "The North American Phalanx: Experiment in Socialism," *Proceedings of the New Jersey Historical Society* 81 (October 1963): 215–247; George Kirchmann, "Unsettled Utopias: The North American Phalanx and the Raritan Bay Union," *New Jersey History* 97 (Spring 1979): 23–36.

15. P[aul] P. Duggan, letter to Thomas P. Rossiter, Collection, New Haven Colony Historical Society. (Duggan's *Lazar House in the Tropics* [1849] is discussed in chapter 3.) From all evidence, this visit was probably planned in November or December 1851, all of 1852, or January–May 1853. The only day in 1851 on which Saturday fell on the ninth (see Duggan's letter) was in August, before the Rossiter's wedding. In 1852, Saturday fell on the ninth in October; in 1853 this occurred in April and July (after the Rossiters' departure for Europe). Thus, the only two possible months that this visit could have been planned were October 1852 or April 1853. But, since by November 1852 the Springs had left the North American Phalanx and since the building for Raritan Bay Union, which they helped establish, was not completed until October 1853, the date of this planned visit was most likely in October 1852.

16. Eleazar Parmly was enlisted by Marcus Spring in support of more religious observance at the North American Phalanx (see note below), and a letter from Mrs. Spring to her husband describes a visit to the Parmlys. (Rebecca Spring, letter, to Marcus Spring, 29 April 1853, Collection of the New Jersey Historical Society, Newark.)

17. The Springs' involvement with Associationism began in 1848 when Marcus joined the

Phalansterian Realization Fund Society; by 1851 the Springs were spending more time at the phalanx in their own private cottage. For history of North American Phalanx, Raritan Bay Union, and the role of the Springs in both communities, see sources cited in note 14 and Maud Honeyman Greene, "Raritan Bay Union, Eagleswood, New Jersey," *Proceedings of the New Jersey Historical Society* 68 (January 1950): 1–20. The couple was at the heart of the discord that split the phalanx in 1852; the primary issue was their desire to have more structured religious observance at the phalanx. (Belz, "North American Phalanx," 237.) In November 1852 they bought land to establish a somewhat modified phalanx, which was incorporated as the Raritan Bay Union in 1853. Eleazar Parmly was asked by Marcus Spring to support his effort to promote a stronger and clearer expression of Protestant Christianity, as evident in a letter Parmly wrote before November 1853: "I would advise all persons who have any respect or regard for the religion of the Bible, and who do not wish to have their feelings outraged by a total want of common courtesy, to keep entirely away . . . from the North American." Parmly's letter was included in a rebuttal of charges of irreligion at the phalanx written by Charles Sears. This rebuttal was dated November 1853 and first published in the *New-York Daily Tribune* on 7 January 1854, 1. In 1854, the Springs established a coeducational boarding school open to black and white children. (Kirchmann, "Unsettled Utopias," 34.)

18. Rebecca Spring visited Rossiter's studio at least once, sometime before April 1853. She mentions the visit in passing, in the context of another discussion, and in a way that suggests it had taken place some weeks earlier. (Rebecca Spring, letter to Marcus Spring, Eagleswood, N.J., 29 April 1853, New Jersey Historical Society, Newark.) Spring was commited to aesthetic education; in the 1830s he had hoped to establish a cooperative colony for New York slum dwellers to foster an appreciation of art, music, and the classics, and in 1864 he and Rebecca established an artistic center at what was now called Eagleswood. (Belz, "North American Phalanx," 241; Greene, "Raritan Bay Union," 13; Kirchmann, "Unsettled Utopias," 28–29.) The Springs' son, Edward A. Spring, studied with Henry Kirke Brown and William Rimmer, taught art at Eagleswood, and established the Perth Amboy Terra Cotta Company and Eagleswood Art Pottery. (Clement and Hutton, *Artists of the Nineteenth Century*, 266–267).

19. Apparently, Rossiter continued to establish relationships with people whose views went against the grain of polite American society. By 1863, for example, Rossiter was corresponding with Eliza W. Farnham in a manner that suggests that the two had common interests and were helping each other with their projects. See letter cited on p. 239, note 68. Both Rossiter and Farnham were concerned with craniometry, the study of skulls, as an indication of mental characteristics. Earlier in her career, Farnham had been a prison matron whose reformist theories were based in part on phrenology; she was also an abolitionist. By the time Rossiter corresponded with her, she was divorced and at work on a book, *Women and Her Era* (published 1864), designed to prove the biological and intellectual superiority of women. (John Hallwas, introduction to *Life in Prairie Land*, by Eliza W. Farnham [Urbana and Chicago: University of Illinois Press, 1988], xv–xxxi; Helen B. Woodward, *The Bold Women* [New York: Farrar, Straus and Young, 1953], 337–356; Edward T. James, ed., *Notable Women 1607–1950: A Biographical Dictionary* [Cambridge, Mass., and London: The Belknap Press of Harvard University Press, 1971], 1: 598–600; *Dictionary of American Biography*, 3:282; John D. Davies, *Phrenology Fad and Science: A 19th-Century American Crusade* [New Haven: Yale University Press, 1955]: 102–103).

20. *The Spirit of War* and *The Spirit of Peace* were not sold until 1856. It is not known whether E. P. Mitchell commissioned *The Millennial Age* or bought it after completion. (Talbot, "Jasper F. Cropsey," cat. no. 75, 375–376.)

21. For a discussion of the painting, see Foshay, *Jasper F. Cropsey*, 20–28, cat. no. 17, 64–65.

22. It is possible, however, to consider the meaning of *The Millennial Age* in relation to a painting by Cropsey that was very specific in its time and location. Cropsey painted *Niagara*, one of several versions he produced of the subject, in 1853, from sketches made on the spot in the summer of 1852. Foshay contrasts the two paintings as images that illustrate the dichotomy of the real and the ideal, a dilemma facing mid-nineteenth-century American artists. (Foshay,

Jasper F. Cropsey, 60–61, 18–19.) Cropsey's *Niagara* depicted the falls, that most American of natural and divine wonders, at the dramatic moment when dark weather is succeeded by sunlight and graced with a rainbow. This rainbow, spanning turbulent water and jagged rocks, carries much of the same symbolic weight as the biblical bow of promise after the Deluge. Cropsey's *Niagara* and his *Millennial Age* seem to work as complements. *Niagara* envisions the United States as a land of promise, perhaps even more specifically as a nation experiencing calm after storm. (The sectional crisis eased somewhat after the 1852 presidential election, only to heat up again with the introduction of the Kansas-Nebraska Act in May 1854.) The rainbow in *Niagara* and all that it implies points the mind ahead to the future envisioned in Cropsey's *The Millennial Age*, entirely reborn beyond the Old World and the New. For a discussion of Cropsey's Niagara paintings, see Jeremy E. Adamson, "Frederic Church's 'Niagara': The Sublime as Transcendence" (Ph.D. diss., University of Michigan, 1981): 227–236, and Elizabeth McKinsey, *Niagara Falls: Icon of the American Sublime* (Cambridge: Cambridge University Press, 1985), 239–240. For a discussion of Niagara Falls and its use as a natural emblem of American providential destiny, merging of the sacred and the secular, see Huntington, "Frederic Church's 'Niagara.'"

23. This must refer to the rendition of Anthony Burns in Boston, a daring but unsuccessful rescue undertaken by the Unitarian Thomas Higginson, who was willing to risk violence for the cause. Ralph Keller calls this incident, which brought the city of Boston near rebellion, "the most sensational of all fugitive slave cases" (The Fugitive Slave Law," 313–315). The Burns case clearly illustrated just how much power slavery had over the nation, a lesson underscored by the simultaneous passage of the Nebraska Bill in late May 1854. According to Keller, by this time, even those conservatives who objected to the use of violence and resistance "were much more prone to criticize the Fugitive Slave Law than to defend law and Union" than they had been in 1850–1851. "Church conferences and associations, as well as the weekly religious papers, lashed out at both the Nebraska Act and the Fugitive Slave Law in 1854" (315, 320).

24. George Inman Riche, letter to James Tyndale Mitchell, 19 June 1854. J. T. Mitchell was away from home attending Harvard University. (Riche Correspondence, Historical Society of Pennsylvania.)

25. E. P. Mitchell's pseudonym is identified in Hampton L. Carson, "Hon. James T. Mitchell, LL.D.," *Pennsylvania Magazine of History and Biography* 40 (1916): 3.

26. Ralph Roanoke [Edward P. Mitchell], "Random Leaf from the Life of Ralph Roanoke," *Knickerbocker Magazine* 40 (September 1852): 196. These words suggest that E. P. Mitchell was the "Mr. M." to whom Cropsey described his idea for a series of paintings entitled *The Genius of the Republic* in a letter dated 12 May 1854, probably in the hope of capturing the merchant's enthusiasm and thus a commission. (Perhaps, then, Mitchell was also the "M" to whom Cropsey described *The Spirit of War* and *The Spirit of Peace* in his letter of 12 May 1852; see chapter 6, n. 1.) *The Genius of the Republic*, which Cropsey never executed, was intended to illustrate "the movement from the Old World to the New in millennial terms" (Miller, *The Empire of the Eye*, 145–146).

27. Roanoke [Mitchell], "Random Leaf," 198.

28. James T. Mitchell, "The Golden Age," *Knickerbocker Magazine* 43 (June 1854): 599–601. It had been written in Philadelphia on 30 September 1852.

29. Cropsey sold the pair of allegories in an April 1856 sale held to finance a trip to Europe. They were first bought by John Rutherford, who soon after sold them to Joseph Harrison. Harrison then purchased *The Millennial Age* from E. P. Mitchell. See Carolyn Sue Himelick Nutty, "Joseph Harrison, Jr. (1810–1874): Philadelphia Art Collector" (Ph.D. diss., University of Delaware, 1993), 247. Thus, Harrison never dealt directly with Cropsey, although he acquired all three allegorical paintings.

30. See Nutty, "Joseph Harrison, Jr."; Nicholas B. Wainwright, "Joseph Harrison, Jr., a Forgotten Art Collector," *Antiques* 102 (October 1972): 660; and Frederick Baekeland, "Collectors of American Painting, 1813–1913," *American Art Review* 3 (November/December 1976): 128–132.

31. Nutty, "Joseph Harrison, Jr.," 256.

32. Unfortunately, there are no letters from 1855 or 1856, the years he purchased Cropsey's paintings, among the numerous Harrison letters at the Historical Society of Pennsylvania.

33. Joseph Harrison, Jr., letter to Henry Harrison, brother, 30 January 1849, Harrison Letter Books, Historical Society of Pennsylvania.

34. Joseph Harrison, Jr., letter to Stephen Poulterer, father-in-law, 17 October 1848, Harrison Letter Books, Historical Society of Pennsylvania.

35. The fact that he and his wife named one of their sons William Henry Harrison (b. 1837) is strong evidence that he was a Whig, which would make sense given the conservatism of his social observations. (William Henry Harrison ran as a Whig candidate for President in 1836, losing to Van Buren.)

36. Joseph Harrison, Jr., letter to Henry Harrison, brother, 30 January 1849, Harrison Letter Books, Historical Society of Pennsylvania.

Conclusion

1. For a discussion of this painting, see Taylor, *William Page*, 153–155.

2. See Miller, *Empire of the Eye*, 145–146 n. 26; *Cosmopolitan Art Journal* 2 (March and June 1858): 148. According to the *Cosmopolitan Art Journal*, "The tenth chapter of Genesis supplies the artist with his subject, or rather his starting point; for, although the division of the earth among the sons of Noah . . . suggests the subject, the period illustrated extends from a time anterior to the death of the patriarch, until after the coming of Christ; and presents to our view the progress of human civilization up to that epoch."

3. See James Moorhead, *American Apocalypse: Yankee Protestants and the Civil War 1860–1869* (New Haven: Yale University Press, 1978). For discussions of the apocalyptic connotations of *Twilight in the Wilderness* and its relation to national crisis, see Kelly, *Frederic Edwin Church and the National Landscape*, 117–122; and Miller, *Empire of the Eye*, 128–129.

4. N. M. S., "The Everyday Apocalypse," *Christian Observer*, 3 February 1849, 1.

5. For a reformist lament over the perversion of artistic genius to such lowly aims as "pointing a moral and adorning a tale," see Barlow, "The Present as It Is, and the Future to Be," 259.

6. Nicholas Longworth, letter to Hiram Powers, spring 1836, Longworth Papers, Cincinnati Historical Society.

7. J. F. Cropsey, letter to Thomas Cole, 16 March 1848, Cole Papers, New York State Library, Albany, microfilm in the Archives of American Art.

8. "The Fine Arts," *Home Journal*, 10 November 1849, 4. Although this article is unsigned, it was most likely written by Augustine Duganne. With some minor changes, its text is very similar to Duganne's pamphlet, *Art's True Mission in America*, published in 1853 by George S. Appleton, New York.

9. Even John Sartain, the mid-nineteenth-century American artist most obviously and publicly involved in reformist activities, including Associationism and abolitionism, did not produce images that unequivocally advocated abolition or Fourierist social principles. According to Katherine Ann Martinez, this was primarily a question of patronage: "By avoiding confrontation Sartain did not further the abolitionist cause, but also did not alienate potential patrons. Opinions could be expressed freely in a family letter, but the kinds of private and institutional means of support for abolitionist artworks were not widely available during the period, and so Sartain's abolitionist artwork is relatively limited" (Martinez, "The Life and Career of John Sartain," 75.

10. Angela Miller suggests that in the late 1840s the Plague of Darkness might have "formed part of a covert language of Whig dissent from the Mexican-American War" (*Empire of the Eye*, 119 n. 24).

11. Robert H. Abzug, *Cosmos Crumbling: American Reforms and the Religious Imagination* (New York and Oxford: Oxford University Press, 1994): 7, viii.

12. Abzug, *Cosmos Crumbling*, 8.

13. Without question, the wages of sin and the rewards of righteousness manifest in these paintings were lessons that the white, middle-class Protestants who made up their main audience (be they Reformed or Unitarian, Whig or Associationist) would want the "unenlightened" masses to absorb for the maintenance of a well-ordered society; in that sense they are fundamentally conservative. But, just as we must hesitate to judge these images based on late twentieth century aesthetic standards, we should also resist labeling and dismissing the people who produced them and those who commissioned, bought, or responded to them as witting or unwitting advocates of social control. For a discussion of the aesthetics of popular religious art, in contrast to modernist aesthetics, see Morgan, *Visual Piety*, 29–34. For a discussion of religion as an agent of social change in antebellum American, see Lazerow, *Religion and the Working Class*.

Bibliography

Books, Articles, and Unpublished Works

Abzug, Robert H. *Cosmos Crumbling: American Reforms and the Religious Imagination.* New York and Oxford: Oxford University Press, 1994.

"Academy of Fine Arts, The." *Graham's Magazine* (March 1851): 269.

Adamson, Jeremy E. "Frederic Edwin Church's 'Niagara': The Sublime as Transcendence." Ph.D. diss., University of Michigan, 1981.

Adelson, Fred B. "Art Under Cover: American Gift-Book Illustrations." *Antiques* 126 (March 1984): 646–653.

Ahlstrom, Sydney E. *A Religious History of the American People.* New Haven: Yale University Press, 1972.

"American Art-Union, The." *Harbinger* 6 (18 December 1847), 53.

"American Art-Union, The." *Knickerbocker Magazine* 32 (November 1848): 442–447.

"American School of Art, The." *American Whig Review* (August 1852): 138–148.

A. M. P. "Stanzas: Progress." *Knickerbocker Magazine* 31 (May 1848): 397–398.

"Amusements in New York. The 'Happy Family.'" *New York Illustrated News,* 28 May 1853.

Anderson, Patricia A. *Promoted to Glory: The Apotheosis of George Washington.* Northampton, Mass.: Smith College Museum of Art, 1980.

"Answer of the American Press, The." *Foreign Quarterly Review* 31 (April 1843): 250–281.

"Approaching Crisis, The." *Christian Watchman and Reflector,* 27 July 1848, 118.

Arlington, "Art and Artists." *Herald of Truth* 2 (July 1847): 49–56.

Armstrong, Lebbeus. *The Temperance Reformation: Its History from the Organization of the First Temperance Society to the Adoption of the Liquor Law of Maine, 1851.* New York, 1853.

Austin, Thomas. "The Genius and Benevolence of Odd-Fellowship." In Edward Walker, ed., *The Odd-Fellows' Offering, for 1854,* 9–58.New York, 1853.

———. "War." In Edward Walker, ed., *The Odd-Fellows' Offering, for 1853,* 247–258. New York, 1852.

Austin, William W. *"Susanna," "Jeanie," and "The Old Folks at Home": The Songs of Stephen C. Foster from His Time to Ours.* Urbana: University of Illinois Press, 1987.

B. "Picture, A." *Episcopal Recorder,* 21 April 1849, 22.

Bachman, John. *The Doctrine of the Unity of the Human Race Examined on the Principles of Science.* Charleston, 1850.

Baekeland, Frederick. "Collectors of American Painting, 1813–1913." *American Art Review* 3 (November/December. 1976): 40–59.

Baker, Charles E. "The American Art-Union." In Mary Bartlett Cowdrey, Mary Bartlett, and Theodore Sizer, eds., *American Academy of the Fine Arts and American Art Union, 1816–1852.* 2 vols. New York: New-York Historical Society, 1953.

Barlow, D. H. "Mission of America." *Graham's Magazine* 38 (January 1851): 43–48.

———. "The Present as It Is, and the Future to Be." *Graham's Magazine* 39 (November 1851): 257–260.

Barnes, Albert. *The Casting Down of Thrones: A Discourse on the Present State of Europe.* New York, 1848.

————. *Home Missions. A Sermon in Behalf of the American Home Missionary Society: Preached in the Cities of New York and Philadelphia, May 1849.* New York, 1849.

————. *Life at Threescore and Ten.* New York, 1859.

————. *Notes: Critical, Explanatory, and Practical on the Book of the Prophet Isaiah;* with a new translation. 3 vols. Boston, 1840.

————. *Notes, Explanatory, and Practical, on the Book of Revelation.* New York, 1852.

Barrett, James T. "Cholera in Missouri." *Missouri Historical Review* 55 (July 1961): 344–354.

Baym, Nina. "Onward Christian Women: Sarah J. Hale's History of the World." *New England Quarterly* 63 (June 1990): 249–270.

Beam, Christopher M. "Millennialism and American Nationalism, 1740–1800." *Journal of Presbyterian History* 54 (Spring 1976): 182–199.

Beard, Daniel Carter. *Hardly a Man Is Now Alive: The Autobiography of Dan Beard.* New York, 1939.

Beecher, E[dward]. "Pharaoh and His Host Drowned in the Red Sea." In Thomas Wyatt, ed., *The Sacred Tableaux: or, Remarkable Incidents in the Old and New Testament,* 104–118. Boston, 1847.

Belz, Herman J. "The North American Phalanx: Experiment in Socialism." *Proceedings of the New Jersey Historical Society* 81 (October 1963): 215–247.

Bercovich, Sacvan. *The American Jeremiad.* Madison: University of Wisconsin Press, 1978.

Bergoffen, Debra. "The Apocalyptic Meaning of History." In Lois Parkinson Zamora, ed., *The Apocalyptic Vision in America: Interdisciplinary Essays in Myth and Culture.* Bowling Green, Ohio: Bowling Green University Popular Press, 1982.

Bermingham, Peter. *Jasper F. Cropsey, 1823–1900: A Retrospective View of America's Painter of Autumn.* College Park: University of Maryland, 1968.

Bilotta, James D. *Race and the Rise of the Republican Party, 1848–1865.* New York: Peter Lang, 1992.

Birks, Rev. T. R., "The Political Worth of Daniel's Vision," *Episcopal Recorder,* 22 January 1848; 29 January 1848; 5 February 1848.

Bjelajac, David. *Millennial Desire and the Apocalyptic Vision of Washington Allston.* Washington, D.C.: Smithsonian Institution Press, 1988.

————. "Washington Allston's Prophetic Voice in Worshipful Song with Antebellum America." *American Art* 5 (Summer 1991): 68–87.

Bloch, Ruth H. *The Visionary Republic: Millennial Themes in American Thought, 1756–1800.* Cambridge: Cambridge University Press, 1985.

Bode, Carl. *Midcentury America: Life in the 1850s.* Carbondale: Southern Illinois University Press, 1972.

Boime, Albert. *The Art of Exclusion: Representing Blacks in the Nineteenth Century.* Washington, D.C.: Smithsonian Institution Press, 1990.

"Book of Revelation, The," *Literary World,* 22 May 1852, 356–357.

Boyer, Paul. *When Time Shall Be No More: Prophecy Belief in Modern American Culture.* Cambridge, Mass., and London: Harvard University Press, Belknap Press, 1992.

"Brief Mention—Rossiter." *Home Journal,* 13 January 1849, 2.

[Briggs, Charles F.]. "Poor White Folks." *National Anti-Slavery Standard,* 21 May 1846, 203.

Broaddus, Margaret. "Thomas P. Rossiter: In Pursuit of Diversity." *American Art & Antiques* 2 (May/June 1979): 106–113.

Brown, Charles H. *William Cullen Bryant.* New York: Charles Scribner's Sons, 1971.

Brown, Lawrence Parmly. *The Greatest Dental Family.* Reprinted from *The Dental Cosmos* (n.p., n.d.) for March/April/May 1923.

Brown, Richard D. *Knowledge Is Power: The Diffusion of Information in Early America, 1700–1865.* New York: Oxford University Press, 1989.

Brummett, Barry. *Contemporary Apocalyptic Rhetoric.* New York: Prager, 1991.

Bryant, William Cullen. *The Letters of William Cullen Bryant.* Edited by William Cullen Bryant II and Thomas G. Voss. New York: Fordham University Press, 1981.

Bryant, William Cullen II, comp. and annotator. *Power for Sanity: Selected Editorials of William Cullen Bryant, 1829–1861*. New York: Fordham University Press, 1994.

Buckley, Peter George. "To the Opera House: Culture and Society in New York City, 1820–1860." Ph.D. diss., State University of New York at Stony Brook, 1984.

Burnham, Patricia Mullan. "Trumbull's Religious Paintings: Themes and Variations." In Helen A. Cooper, ed., *John Trumbull, The Hand and Spirit of a Painter*. New Haven: Yale University Art Museum, 1982.

[Burr, C. Chauncey.] "Editor's Department. Henry Stuart Patterson, M.D." *The Nineteenth Century* 2 (1848): 171–173.

Burritt, Elihu. "Address at the International Peace Congress at Frankfort, 1850." In *Old South Leaflets*. Boston: Directors of the Old South Work, 1904.

"California." *American Review* 3 (April 1849): 331–338.

Callow, James T. "American Art in the Collection of Charles M. Leupp." *Antiques* 122 (November 1980): 998–1009.

Carey, James W. "Technology and Ideology: The Case of the Telegraph." *Prospects* 8 (1983): 303–325.

Carson, Hampton L. "Hon. James T. Mitchell, LL.D." *Pennsylvania Magazine of History and Biography* 40 (1916): 1–45.

Cary, Edward. *American Men of Letters: George William Curtis*. Boston and New York: Houghton, Mifflin and Co., 1894.

Cassedy, David, and Gail Shrott. *William Sidney Mount: Works in the Collection of the Museums at Stony Brook*. Stony Brook, N. Y.: The Museums at Stony Brook, 1983.

Chadwick, Whitney. *Women, Art, and Society*. London: Thames and Hudson, 1990.

Chambers, Bruce. "Thomas Cole and the Ruined Tower." *Currier Gallery of Art Bulletin* (1983): 2–32.

Chandler, Joseph R. "Reflections on Some of the Events of the Year 1848, Annus Mirabilis." *Graham's Magazine* 33 (December 1848): 318–324.

Chielens, Edward E., ed. *American Literary Magazines: The Eighteenth and Nineteenth Centuries: Historical Guides to the World's Periodicals and Newspapers*. New York: Greenwood Press, 1986.

Chitwood, Oliver Perry. *Richard Henry Lee: Statesman of the Revolution*. Morgantown: West Virginia University Foundation, 1967.

"Choctaw Indians." *Louisville Journal*, 22 September 1845.

"Cholera a Visitation from God, The." *Independent*, 28 June 1849, 118.

"Chronicle: Art and Artists in America." *Bulletin of the American Art-Union* 4 (May 1851): 30–31.

"Church's 'Plague of Darkness.'" *New Haven Daily Palladium*, 8 July 1858, 2.

"City Intelligence. Beware of Mock Auctions." *New York Herald*, 12 March 1849, 4.

Cikovsky, Nicolai, Jr. "The Life and Work of George Inness." Ph.D. diss., Harvard University, 1965.

Clark, Carol. "Charles Deas." In *American Frontier Life: Early Western Paintings and Prints*. Forth Worth: Amon Carter Museum, 1987.

Clark, Clifford E., Jr. *Henry Ward Beecher: Spokesman for a Middle-Class America*. Urbana: University of Illinois Press, 1978.

Clark, D. W. "National Righteousness. A Sermon Preached in the Sullivan M. E. Church Thanksgiving Day, Nov. 23 '48." *New-York Daily Tribune*, 24 November 1848, 2.

Clark, H. Nichols B. *Francis W. Edmonds: American Master in the Dutch Tradition*. Washington, D.C.: Smithsonian Institution Press, 1988.

Clement, Clara Erskine, and Laurence Hutton. *Artists of the Nineteenth Century and Their Works*. 2 vols. Boston and New York: Houghton, Mifflin and Company, 1884.

C. N. "On 1848–An Epitaph." *Littel's Living Age*, 24 March 1849, 574.

Coates, Reynell. "Jeremiah." In Reynell Coates, ed., *Leaflets of Memory for 1847*, 209–211. Philadelphia, 1846.

"Coming Age, The." *Independent*, 16 January 1851.

"Common People of Europe, The." *Christian Watchman and Reflector*, 9 November 1848, 178.

"Common Sense." *Philadelphia Public Ledger*, 25 January 1848, 2.

Congleton, Betty Carolyn. "George D. Prentice: Nineteenth Century Southern Editor." *Register of the Kentucky Historical Society* 65 (April 1967): 94–119.

Corwin, Edward Tanjore. *A Manual of the Reformed Church in America (Formerly Ref. Prot. Dutch Church.) 1628–1878.* New York, 1879.

Cowdrey, Mary Bartlett, comp. *National Academy of Design Exhibition Record, 1826–1860.* 2 vols. New York: New-York Historical Society, 1941–1942.

Cowdrey, Mary Bartlett, and Theodore Sizer. *American Academy of the Fine Arts and American Art-Union, 1816–1852.* 2 vols. New York: New-York Historical Society, 1953.

Cox, Samuel Hanson. *Interviews Memorable and Useful, from Diary and Memory Reproduced.* New York, 1853.

Coxe, Rev. Dr. "Millennium." *Episcopal Recorder*, 22 December 1849, 161.

Cranch, Christopher Pearse. *The Bird and the Bell, with Other Poems.* Boston, 1875.

———. "Sonnet on the Mexican War." *Harbinger*, 18 July 1846, 89.

Crandall, John C. "Patriotism and Humanitarian Reform in Children's Literature, 1825–1860." *American Quarterly* 21 (Spring 1969): 3–22.

Craven, Wayne. "Asher B. Durand's Imaginary Landscapes." *Antiques* 111 (November 1979): 1120–1127.

———. "Luman Reed, Patron: His Collection and Gallery." *American Art Journal* 12 (Spring 1980): 40–59.

———. *Sculpture in America.* Newark: University of Delaware Press, 1984.

"Cry of the Cholera, The." *Harbinger*, 8 January 1848, 75.

Cummings, Thomas S. *Historic Annals of the National Academy of Design . . . from 1825 to the Present Time.* Philadelphia, 1865.

Cunliffe, Marcus. *Soldiers and Civilians: The Martial Spirit in America 1775–1865.* Boston: Little, Brown and Company, 1968.

Da Costa Nunes, Hedy Monteforte. "Iconography of Labor in American Art, 1750–1850." Ph.D. diss., Rutgers University, 1983.

Darley, Felix O. C., and Joseph C. Neal. *In and About Town: or, Pencillings and Pennings.* Philadelphia, 1843.

Davies, John D. *Phrenology Fad and Science: A 19th-Century American Crusade.* New Haven: Yale University Press, 1955.

Davis, David Brion, ed. *Ante-Bellum Reform.* New York: Harper and Row, 1967.

Davis, John. *The Landscape of Belief: Encountering the Holy Land in Nineteenth-Century American Art and Culture.* Princeton: Princeton University Press, 1996.

D.C.E. "The Approach of the Millennium as Argued from the Signs of the Times." *Christian Review* 13 (June 1848): 249–258.

DeBenedetti, Charles. *The Peace Reform in American History.* Bloomington: Indiana University Press, 1980.

Delano, Sterling F. *"The Harbinger" and New England Transcendentalism: A Portrait of Associationism in America.* Rutherford, N.J.: Fairleigh Dickinson University Press, 1983.

Den Hollander, A. N. J. "The Tradition of 'Poor Whites.'" In W. T. Couch, ed., *Culture in the South.* Chapel Hill: University of North Carolina Press, 1935.

De Witt, Thomas. *A Discourse Delivered in the North Reformed Dutch Church in the City of New York, on the Last Sabbath in August, 1856.* New York, 1856.

Dickson, Charles Ellis. "Jeremiads in the New American Republic: The Case of National Fasts in the John Adams Administration." *New England Quarterly* 60, no. 2 (June 1987): 187–207.

"Dissolution of the Union: From the Address of Dr. George W. Bethune, Lately Delivered at Cambridge, Massachusetts." *Louisville Journal*, 31 August 1849, 2.

Divine, Robert A., T. H. Breen, George M. Frederickson, and R. Hal Williams. *America Past and Present. Volume 1: to 1877*. Glenville, Ill.: Scott, Foresman and Co., 1984.

Dixon, John W., Jr. "The Bible in American Painting." In Giles Gunn, ed., *The Bible and American Arts and Letters*. Philadelphia: Fortress Press, 1983.

Doan, Ruth Alden. *The Miller Heresy, Millennialism, and American Culture*. Philadelphia: Temple University Press, 1987.

Driskel, Michael Paul. "Painting, Piety, and Politics in 1848: Hippolyte Flandrin's Emblem of Equality at Nimes." *Art Bulletin* 66 (June 1984): 270–285.

[Duganne, Augustine]. "The Fine Arts." *Home Journal*, 10 November 1849, 4.

Durand, John. *The Life and Times of Asher B. Durand*. New York, 1894.

"Duties of Christians in Times Like These, The." *Independent*, 15 Februry 1849, 41.

Edwards, Lee M. *Domestic Bliss: Family Life in American Painting, 1840–1910*. Yonkers: The Hudson River Museum, 1986.

Egbert, Donald Drew. *Social Radicalism and the Arts: Western Europe*. New York: Alfred A. Knopf, 1970.

English, Thomas Dunn. "Peter Rothermel." *Sartain's Union Magazine* 10 (January 1852): 13–16.

"European Marxism, 1848–1989: History Completes a Cycle in Central Europe," *New York Times*, 4 December 1989, A22.

Evangel [pseud.]. "The Fall of Jerusalem." In Edward Walker, ed., *The Odd-Fellows' Offering, for 1852*, 288–294. New York, 1851.

"Evil to Come, The." *Christian Watchman and Reflector*, 10 September 1847, 45.

"Exhibition of the Academy of Design." *Albion*, 17 May 1851, 237.

"Father Mathew and His Friends." *New York Herald*, 11 July 1849, 2.

Feaver, William. *The Art of John Martin*. Oxford: Clarendon Press, 1975.

Filler, Louis. "Liberalism, Anti-Slavery, and the Founders of 'The Independent.'" *New England Quarterly* 27 (September 1954): 291–306.

"The Fine Arts. The National Academy of Design." *Albion*, 19 April 1851, 189.

"The Fine Arts. The National Academy of Design, No. III." *Albion*, 8 May 1852, 225.

"The Fine Arts. Exhibition of the National Academy of Design, No. III." *Literary World*, 8 May 1852, 331.

"The Fine Arts. The National Academy of Design. II." *New-York Daily Tribune*, 24 April 1852, 6.

"The Fine Arts. The National Academy of Design. III." *New-York Daily Tribune*, 10 May 1851, 5.

"The Fine Arts. Exhibition of the National Academy of Design, V." *New-York Daily Tribune*, 20 Mayl 1852, 5–6.

Fink, Lois, and Joshua Taylor. *Academy: The Academic Tradition in American Painting*. Washington, D.C.: The National Collection of Fine Arts, 1975.

[Fisher, Sidney George]. "The Diaries of Sidney George Fisher 1844–1849." *Pennsylvania Magazine of History and Biography* 86 (January 1962): 49–90.

Ford, Alice. *Edward Hicks: His Life and Art*. New York: Abbeville Press, 1985.

Fort, Susan Ilene. "High Art and the American Experience: The Career of Thomas Pritchard Rossiter." Master's thesis, Queens College, City University of New York, 1975.

Foshay, Ella M. *Jasper F. Cropsey: Artist and Architect*. New York: New-York Historical Society, 1987.

———. *Mr. Luman Reed's Picture Gallery: A Pioneer Collection of American Art*. New York: New-York Historical Society, 1990.

Frankenstein, Alfred. *William Sidney Mount*. New York: Harry N. Abrams, 1975.

Frederickson, George M. *The Black Image in the White Mind: The Debate on Afro-American Character and Destiny 1817–1914*. New York: Harper & Row, 1971.

French, Henry W. *Art and Artists in Connecticut*. Boston and New York, 1879. Reprint, New York: Kennedy Graphics and Da Capo Press, 1970.

Froom, LeRoy Edwin. *The Prophetic Faith of Our Fathers: The Historical Development of Prophetic Interpretation.* 4 vols. Washington, D.C.: Review and Herald, 1954.

"Fugitive Slave Riots, The." *New York Evening Post*, 4 October 1851. Reprinted in William Cullen Bryant II, comp. and annotator. *Power for Sanity: Selected Editorials of William Cullen Bryant, 1829–1861.* New York: Fordham University Press, 1994.

Fukuyama, Francis. "The End of History?" *National Interest* 16 (Summer 1989): 3–18.

——. "A Reply to My Critics." *National Interest* 18 (Winter 1989/1990): 21–28.

Furness, William Henry. *A Discourse for the Times.* Philadelphia, 1852.

Garrett, Clarke. *Respectable Folly: Millenarians and the French Revolution in France and England.* Baltimore: Johns Hopkins University Press, 1975.

Gerdts, William H. "Belshazzar's Feast II. 'That is his Shroud.'" *Art in America* 61 (May/June 1973): 58–65.

——. "Daniel Huntington's *Mercy's Dream*: A Pilgrimage through Bunyanesque Imagery." *Winterthur Portfolio* 14 (Summer 1979): 171–194.

——. "Henry Inman: Genre Painter." *American Art Journal* 9 (May 1977): 26–48.

——. "On Elevated Heights: American Historical Painting and Its Critics." In William H. Gerdts and Mark Thistlethwaite, *Grand Illusions: History Painting in America.* Fort Worth: Amon Carter Museum, 1988.

——. *Painting and Sculpture in New Jersey.* Princeton: D. Van Nostrand, 1964.

Gerdts, William H., and Theodore E. Stebbins, Jr. *"A Man of Genius": The Art of Washington Allston (1779–1843).* Boston: Museum of Fine Arts, 1979.

Gerdts, William H., and Mark Thistlethwaite. *Grand Illusions: History Painting in America.* Fort Worth: Amon Carter Museum, 1988.

Gilmore, Michael T. "Melville's Apocalypse: American Millennialism and Moby-Dick." *Emerson Society Quarterly* 21 (1975): 154–161.

Glanz, Dawn. *How the West Was Drawn.*, Ann Arbor: UMI Research Press, 1982.

Godwin, Parke. *A Biography of William Cullen Bryant, with Extracts from His Private Correspondence.* 2 vols. New York, 1883.

——. "Lecture on Art." *Philadelphia Art Union Reporter* 1 (February 1851): 26–28.

Goodman, Paul. *Of One Blood: Abolitionism and the Origins of Racial Equality.* Berkeley and Los Angeles: University of California Press, 1998.

Goodrich, Laurence B. "A Little-Noted Aspect of Spencer's Art." *Antiques* 90 (September 1966): 361–363.

Greeley, Horace. "The Age We Live In." *Nineteenth Century* 1 (1848): 50–54.

——. "The Crystal Palace and Its Lessons." *Graham's Magazine* 40 (May 1852): 473–483.

Greene, Maud Honeyman. "Raritan Bay Union, Eagleswood, New Jersey." *Proceedings of the New Jersey Historical Society* 68 (January 1950): 1–20.

Greenhouse, Wendy. "Daniel Huntington and the Ideal of Christian Art." *Winterthur Portfolio* 31 (Summer/Autumn 1996): 103–140.

——. "Reformation to Restoration: Daniel Huntington and His Contemporaries as Portrayers of British History." Ph.D. diss., Yale University, 1990.

Griffin, Clifford S. "Cooperation and Conflict: The Schism in the American Home Missionary Society, 1837–1861." *Journal of the Presbyterian Historical Society* 38 (December 1960): 213–233.

Griffin, Randall C. "The Untrammeled Vision: Thomas Cole and the Architect's Dream." *Art Journal* 52 (Summer 1993): 66–73.

Groeschel, Harriet Hoctor. "A Study of the Life and Work of the Nineteenth-Century Genre Artist Tompkins Harrison Matteson (1813–1884)." Master's thesis, Barnard College, 1985.

Groseclose, Barbara. *Emmanuel Leutze, 1816–1868: Freedom is the Only King.* Washington, D.C.: National Collection of Fine Arts, 1975.

——. "Politics and American genre painting of the nineteenth century," *The Magazine Antiques* 102 (November 1981): 1210–1217.

———. "'Washington Crossing the Delaware': The Political Context." *American Art Journal* 7 (November 1975): 70–78.

Grubar, Francis S. "Richard Caton Woodville: An American Artist, 1825 to 1855." Ph.D. diss., Johns Hopkins University, 1966.

———. *Richard Caton Woodville: An Early American Genre Painter*. Washington, D.C.: The Corcoran Gallery of Art, 1967.

Guarneri, Carl J., "The Associationists: Forging a Christian Socialism in Antebellum America." *Church History* 52 (March 1983: 36–49.

———. *The Utopian Alternative: Fourierism in Nineteenth-Century America*. Ithaca: Cornell University Press, 1991.

Hale, Sarah J., ed. *The Opal: A Pure Gift for the Holy Days, 1848*. New York, 1848.

Hallwas, John. Introduction. Eliza W. Farnham, *Life in Prairie Land*. Urbana and Chicago: University of Chicago Press, 1988.

Halttunen, Karen. "Gothic Imagination and Social Reform: The Haunted Houses of Lyman Beecher, Henry Ward Beecher, and Harriet Beecher Stowe." In Eric J. Sundquist, ed., *New Essays on* Uncle Tom's Cabin. Cambridge: Cambridge University Press, 1986.

Harris, Neil. *The Artist in American Society: The Formative Years, 1790–1860*. New York: George Braziller, 1966.

Harrison, J. F. C. *The Second Coming: Popular Millenarianism, 1780–1850*. New Brunswick, N.J.: Rutgers University Press, 1979.

Hatch, Nathan O. *The Democratization of American Christianity*. New Haven: Yale University Press, 1989.

Harwood, Philip. "The Hebrew Prophets and the Christian Gospel." *Nineteenth Century* 3 (1849): 291–304.

Hay, Robert P. "George Washington: American Moses." *American Quarterly* 21 (Winter 1969): 780–791.

"Hebrew Commonwealth, The." *Christian Reflector and Watchman*, 8 June 1848, 85.

Helfenstein, Ernest. "The Plague of Darkness." In John Keese, ed., *The Opal: A Pure Gift for the Holy Days, 1846*, 181–188. New York, 1846.

Herbert, Elizabeth T. "The Irish Mother's Lament, Suggested by Seeing 'The Pauper's Funeral,' by F. W. Edmonds." *Union Magazine of Literature and Art* 2 (June 1848): 273.

Hicks, George A. "Thomas Hicks, Artists, a Native of Newtown." In *A Collection of Papers Read Before the Bucks County Historical Society*. N.p.: Bucks County Historical Society, 1917.

Hicks, Thomas. *Eulogy Delivered on Thomas Crawford*. New York, 1865.

Highley, George Norman, ed. *T. Buchanan Read: Artist, Poet, Sculptor*. West Chester, Pa.: Chester County Historical Society, 1972.

Hills, Patricia. "Images of Rural America in the Work of Eastman Johnson, Winslow Homer, and Their Contemporaries: A Survey and Critique." In Hollister Sturges, ed., *The Rural Vision: France and America in the Late Nineteenth Century*. Omaha: University of Nebraska Press, 1987.

———. *The Painters' America: Rural and Urban Life, 1810–1910*. New York: Whitney Museum of American Art, 1974.

Hilton, Timothy. *The Pre-Raphaelites*. London: Thames and Hudson, 1970.

"History of Opinions Respecting the Millennium." *American Theological Review* 1 (November 1859): 642–655.

Hitchcock, Elizabeth G. "James H. Beard." *Historical Society Quarterly* 13 (May 1971): 1–3.

Holliday, J. S. *The World Rushed In: The California Gold Rush Experience*. New York: Simon and Schuster, 1981.

"Homeless." *Union Magazine* 2 (January 1848): 34.

Hone, Philip. *The Diary of Philip Hone, 1828–1851*. 2 vols. Edited by Allen Nevins. New York, 1927. Reprint, New York: Kraus Reprint Co., 1969.

Hood, Fred. J. *Reformed America: The Middle and Southern States, 1783–1837*. University: University of Alabama Press, 1980.

Hoornstra, Jean, and Trudy Heath, eds. *American Periodicals 1741–1900: An Index to the Microfilm Collections*. Ann Arbor: University Microfilms International, 1979.

Horsman, Reginald. "Scientific Racism and the American Indian in the Mid-Nineteenth Century." *American Quarterly* 27 (May 1975): 152–168.

Howard-Pitney, David. *The Afro-American Jeremiad: Appeals for Justice in America*. Philadelphia: Temple University Press, 1990.

Huntington, David C. *Frederic Edwin Church*. Washington, D.C.: National Collection of Fine Arts, 1966.

——. "Frederic Edwin Church, 1826–1900: Painter of the Adamic New World Myth." Ph.D. diss., Yale University, 1960.

——. "Frederic Church's *Niagara*: Nature and the Nation's Type." *Texas Studies in Language and Literature* 25 (Spring 1983): 100–138.

——. *The Landscapes of Frederic Edwin Church: Visions of an American Era*. New York: George Braziller, 1966.

Husch, Gail E. "*Poor White Folks* and *Western Squatters*: James Henry Beard's Images of Emigration." *American Art* 7 (Summer 1993): 15–39.

——. "Something Coming: Prophecy and American Painting, 1848–1854." Ph.D. diss., University of Delaware, 1992.

"Ireland and Its Potato." *Home Journal*, 1 September 1849, 2.

Ireland, Joseph N. *Records of the New York Stage from 1750–1860*. New York, 1866. Reprint, New York: Benjamin Bloom, 1966.

Jackson, Donald Dale. *Gold Dust*. New York: Alfred A. Knopf, 1980.

James, Edward T., ed. *Notable Women 1607–1950: A Biographical Dictionary*. Cambridge, Mass., and London: Harvard University Press, Belknap Press, 1971.

Johannsen, Robert W. *To the Halls of the Montezumas: The Mexican War in the American Imagination*. New York: Oxford University Press, 1985.

Johannsen, S. K. "Christianity, Millennialism and Civic Life: The Origins of the American Republic." In Jospeh Bettis and S. K. Johannsen, eds., *The Return of the Millennium*. Barrytown, N.Y.: New ERA Books, 1984.

Johns, Elizabeth. *American Genre Painting: The Politics of Everyday Life*. New Haven: Yale University Press, 1991.

——. "The Farmer in the Works of William Sidney Mount." In Robert E. Rotbur, and Theodore K. Rabb, eds., *Art and History: Images and Their Meaning* Cambridge: Cambridge University Press, 1988.

Johnson, Allen, ed. *Dictionary of American Biography*. 11 vols. New York: Charles Scribner's Sons, 1958.

Johnstone, Christopher. *John Martin*. London: Academy Editions, 1974.

Joys, Joanne Carol. *The Wild Animal Trainer in America*. Boulder: Pruett Publishing, 1983.

Karcher, Carolyn L. *Shadow over the Promised Land: Slavery, Race and Violence in Melville's America*. Baton Rouge: Louisiana State University Press, 1980.

Keen, Kirsten Hoving. "John Martin's Apocalyptic Imagery and Its Contemporary Context." Master's thesis, University of Delaware, 1977.

Keese, John, ed. *The Opal: A Pure Gift for the Holy Days, 1846*. New York, 1846.

——. *The Opal: A Pure Gift for the Holy Days, 1847*. New York, 1847.

Keller, Ralph Alan. "Northern Protestant Churches and the Fugitive Slave Law of 1850." Ph.D. diss., University of Wisconsin, Madison, 1969.

Kelly, Franklin. "Frederic Edwin Church and the North American Landscape, 1845–1860." Ph.D. diss., University of Delaware, 1985.

——. *Frederic Edwin Church and the National Landscape*. Washington, D.C.: Smithsonian Institution Press, 1988.

——. *Jasper Cropsey: The Spirit of War and The Spirit of Peace*. Washington, D.C.: National Gallery of Art, 1994.

[Kettell, T. P.]. "Natural History of Man." *United States Magazine and Democratic Review* 26 (April 1850): 327–345.

[Kettell, T. P.?]. "The Variety in the Human Species." *United States Magazine and Democratic Review* 27 (September 1850): 209–220.

Kinney, James. *Amalgamation! Race, Sex, and Rhetoric in the Nineteenth-Century American Novel.* Westport, Conn., and London: Greenwood Press, 1985.

Kirchmann, George. "Unsettled Utopias: The North American Phalanx and the Raritan Bay Union." *New Jersey History* 97 (Spring 1979): 23–36.

Kirkham, E. Bruce, and John W. Fink, comps. *Indices to American Literary Annuals and Gift Books, 1825–1865.* New Haven: Research Publications, Inc., 1975.

Kirkland, C[aroline] M. "The Orphan's Funeral." In Edward Walker, ed., *The Odd-Fellows' Offering, for 1850,* 123–135. New York, 1849.

Klein, Rachel N. "Art and Authority in Antebellum New York: The Rise and Fall of the American Art-Union." *Journal of American History* 81 (March 1995): 1534–1561.

Koke, Richard J., comp. *A Catalog of the Collection, Including Historical, Narrative, and Marine Art.* Vol. 1. New York: New-York Historical Society, 1982.

Kramer, Aaron. *The Prophetic Tradition in American Poetry, 1835–1900.* Rutherford, N.J.: Fairleigh Dickinson University Press, 1968.

Kripps, Jayne K., comp. and ed. *An Annotated Bibliography of American Literary Periodicals, 1741–1850.* Boston: G. K. Hall and Co., 1977.

Kselman, Thomas A. *Miracles and Prophecies in Nineteenth-Century France.* New Brunswick: Rutgers University Press, 1983.

Lalumia, Matthew. *Realism and Politics in Victorian Art of the Crimean War.* Ann Arbor: UMI Research Press, 1984.

"Land Reform." *New-York Daily Tribune,* 11 February 1848.

Landow, George P. *Images of Crisis: Literary Iconology, 1750 to the Present.* London and Henley: Routledge & Kegan Paul, 1982.

———. *Victorian Types and Victorian Shadows: Biblical Typology in Victorian Literature, Art, and Thought.* London and Henley: Routledge & Kegan Paul, 1980.

Lawall, David B. *A. B. Durand, 1796–1886.* Montclair, N.J.: Montclair Art Museum, 1971.

———. *Asher Brown Durand: His Art and Theory in Relation to His Times.* New York: Garland Publishing, 1977.

———. *Asher B. Durand: A Documentary Catalogue of the Narrative and Landscape Paintings.* New York: Garland Publishing, 1978.

Lawren, Bill. "Are You Ready for Millennial Fever?" *Utne Reader* 38 (March/April 1990): 90–97.

Lazerow, Jama. "A Good Time Coming: Religion and the Emergence of Labor Activism in Antebellum New England." Ph.D. diss., Brandeis University, 1983.

———. *Religion and the Working Class in Antebellum America.* Washington, D.C.: Smithsonian Institution Press, 1995.

Lee, Richard H. *Memoir of the Life of Richard Henry Lee and His Correspondence.* 2 vols. 1825.

Levine, Lawrence W. *Highbrow/Lowbrow: The Emergence of Cultural Hierarchy in America.* Cambridge. Harvard University Press, 1988.

———. "Slave Songs and Slave Consciousness." In Tamara K. Hareven, ed., *Anonymous Americans: Explorations in Nineteenth Century Social History.* Englewood Cliffs, N.J.: Prentice-Hall, Inc., 1971.

Lewis, E. Anna. "Art and Artists of America: A. B. Durand." *Graham's Magazine* 45 (October 1854): 318–322.

———. "The Mexican Express." In *The Odd-Fellows' Offering, for 1852,* 256–257. New York, 1851.

"Lexington Disturbance, The." *Louisville Journal,* 21 August 1845.

Lifton, Robert J., and Charles B. Strozier. "Waiting for Armageddon." *New York Times Book Review* 12 (August 1990).

Linen, James. "Apollyon; or, The Destroyer." In *The Odd-Fellows' Offering, for 1849,* 89–97. New York, 1848.

"Living Pulpit Orators. The Reverend Albert Barnes, D.D." *Knickerbocker Magazine* 34 (September 1849): 189–204.

"Lockwood's 'Last Judgment.'" *Philadelphia Art Union Reporter* 6 (September 1851): 99.

Lord, David N. "Millennial State of the Church." *Theological and Literary Journal* 2 (April 1850): 656–699.

Lord, L. C. "Kings and Thrones Are Falling." *Home Journal,* 21 September 1848.

Lossing, Benson J. "The Covenant." In Edward Walker, ed., *The Odd-Fellows' Offering, for 1850,* 102–108. New York, 1849.

———. "Peace." In Edward Walker, ed.,*The Odd-Fellows' Offering, for 1852,* 9–22. New York, 1851.

———. *Seventeen Hundred and Seventy-Six; or, The War of Independence.* New York: Edward Walker, 1847.

———. "The Two Feasts." In Paschal Donaldson, ed., *The Odd-Fellows' Offering, for 1849,* 282–286. New York, 1848.

Lubin, David M. *Picturing America: Art and Social Change in Nineteenth-Century America.* New Haven: Yale University Press, 1994.

Lubove, Roy. "The New York Association for Improving the Condition of the Poor: The Formative Years." *New-York Historical Society Quarterly* 43 (July 1959): 306–327.

Mackay, Charles. *Ballads and Lyrics.* London, 1859.

———. *Through the Long Day; or, Memorials of a Literary Life during Half a Century.* vol. 1. London, 1887.

Maclear, James F. "The Republic and the Millennium." In Elwyn A. Smith, ed., *The Religion of the Republic.* Philadelphia: Fortress Press, 1970.

Maddox, Kenneth W. "A. B. Durand's 'Progress': The Advance of Civilization and the Vanishing American." In Susan Danly and Leo Marx, eds., *The Railroad in American Art: Representations of Technological Change.* Washington, D.C.: National Museum of American Art, 1988.

Maizlish, Stephen E. *The Triumph of Sectionalism: The Transformation of Ohio Politics, 1844–1856.* Kent, Ohio: Kent State University Press, 1983.

Malcolm, Elizabeth. *"Ireland Sober, Ireland Free": Drink and Temperance in Nineteenth-Century Ireland.* Dublin: Gill and Macmillan, 1986.

"Man Who Is Not Going to California, A." *New York Herald,* 19 February 1849, 1.

Mann, Maybelle. *The American Art-Union.* Otisville, N.Y.: ALM Associates, 1977.

———. *Francis William Edmonds: Mammon and Art.* New York: Garland Publishing Co., 1977.

———. "The New-York Gallery of Fine Arts: 'A Source of Refinement.'" *American Art Journal* 11 (January 1979): 76–86.

Manthorne, Katherine Emma. *Tropical Renaissance: North American Artists Exploring Latin America, 1839–1879.* Washington, D.C.: Smithsonian Institution Press, 1989.

Marks, Arthur S. "The Statue of King George III in New York and the Iconology of Regicide." *American Art Journal* 13 (Summer 1981): 61–82.

Martinez, Katharine Ann. "The Life and Career of John Sartain (1808–1897): A Nineteenth Century Philadelphia Printmaker." Ph.D. diss., George Washington University, 1986.

———. "'Messengers of Love, Tokens of Friendship': Gift-Book Illustrations by John Sartain." In Gerald W. R. Ward, ed., *The American Illustrated Book in the Nineteenth Century.* Charlottesville: University of Virginia Press, 1987.

Matteson, Lynn Robert. "Apocalyptic Themes in British Romantic Landscape Painting." Ph.D. diss., University of California, Berkeley, 1975.

———. "John Martin's The Deluge: A Study in Romantic Catastrophe." *Pantheon* 39 (July/August/September 1981): 220–228.

May, Herbert G., and Bruce M. Metzger, eds. *The New Oxford Annotated Bible.* New York: Oxford University Press, 1973.

McConachie, Bruce A. *Melodramatic Formations: American Theatre and Society, 1820–1870.* Iowa City: University of Iowa Press, 1992.

————. "'The Theater of the Mob': Apocalyptic Melodrama and Preindustrial Riots in Ante-bellum New York." In Bruce A. McConachie and Daniel Friedman, eds., *Theatre for Working-Class Audiences in the United States, 1830–1890*. Westport, Conn.: Greenwood Press, 1985.

McIlwaine, Shields. *The Southern Poor White from Lubberland to Tobacco Road*. Norman: University of Oklahoma Press, 1939.

McKinsey, Elizabeth. *Niagara Falls: Icon of the American Sublime*. Cambridge: Cambridge University Press, 1985.

McKivigan, John R. *The War against Proslavery Religion: Abolitionism and the Northern Churches, 1830–1865*. Ithaca: Cornell University Press, 1984.

McL[aughlin], J[ames]. *Memoir of General Hector Tyndale*. Philadelphia, 1882.

Mead, Leon. "The Apprenticeship of an Academician." *The American Magazine* 9 (December 1888): 192–200.

Mehl, Dieter. "King Lear and the 'Poor Naked Wretches.'" In Hermann Heuer, ed., *Deutsche Shakespeare-Gesellschaft West Jahrbuch 1975*. Heidelberg: Quelle and Meyer, 1975.

Mercantile Beneficial Association of Philadelphia. *Annual Reports of the Mercantile Beneficial Association of Philadelphia*. Philadelphia, 1923.

Merck, Frederick. "Dissent in the Mexican War." *Massachusetts Historical Society Proceedings* 81 (1969): 120–136.

Metzger, Bruce M., and Michael D. Coogan, eds. *The Oxford Companion to the Bible*. New York and Oxford: Oxford University Press, 1993.

Miller, Angela. *The Empire of the Eye: Landscape Representation and American Cultural Politics, 1825–1875*. Ithaca and London: Cornell University Press, 1993.

————. "The Imperial Republic: Narratives of National Expansion in American Art, 1820–1860." Ph.D. diss., Yale University, 1985.

Miller, Lillian B. *Patrons and Patriotism: The Encouragement of the Fine Arts in the United States, 1790–1860*. Chicago: University of Chicago Press, 1966.

Mitchell, Edward P. [Ralph Roanoke, pseud.]. "Random Leaf from the Life of Ralph Roanoke." *Knickerbocker Magazine* 40 (September 1852): 196–203.

Mitchell, James T. "The Golden Age." *Knickerbocker Magazine* 43 (June 1854): 599–601.

"Model Artists Again." *New York Herald*, 5 February 1849, 2.

Moore, James C. "The Storm and the Harvest: The Image of Nature in Mid-Nineteenth-Century American Landscape Painting." Ph.D. diss., Indiana University, 1974.

Moore, R. Laurence. "The End of Religious Establishment and the Beginning of Religious Politics: Church and State in the United States." In Thomas Kselman, ed., *Belief in History: Innovative Approaches to European and American Religion*. Notre Dame: University of Notre Dame Press, 1991.

Moore, T. V. "Unity of the Human Race." *Methodist Quarterly Review* 33 (July 1851): 345–377.

Moorhead, James H., *American Apocalypse: Yankee Protestants and the Civil War 1860–1869*. New Haven: Yale University Press, 1978.

————. "Between Progress and Apocalypse: A Reassessment of Millennialism in American Religious Thought, 1800–1880." *Journal of American History* 71 (December 1984): 524–542.

"The Moral Aspects of California: A Thanksgiving Sermon of 1850, with an Introduction by Clifford Merrill Drury." *California Historical Society Quarterly* 19 (December 1940): 299–307.

Morgan, David. *Visual Piety: A History and Theory of Popular Religious Images*. Berkeley, Los Angeles, and London: University of California Press, 1998.

Morris, Richard B., ed. *Encyclopedia of American History*. 6th ed. New York: Harper and Row, 1982.

"Mortality on Steamboats." *Louisville Journal*, 21 May 1849.

Moses, Wilson Jeremiah. *Black Messiahs and Uncle Toms: Social and Literary Manipulations of a Religious Myth*. University Park, Pa.: Pennsylvania State University Press, 1993.

Mott, Frank Luther. *A History of American Magazines.* 5 vols. Cambridge: Harvard University Press, 1930–1968.

Mounger, Dwyn Mecklin. "Samuel Hansen Cox: Anti-Catholic, Anti-Anglican, Anti-Congregationalist Ecumenist." *Journal of Presbyterian History* 55 (Winter 1977): 347–361.

Munson-Williams-Proctor Institute. *A Retrospective Exhibition of the Work of Frederick R. Spencer, 1806–1875.* Utica, N.Y.: Munson-Williams-Proctor Institute, 1969.

Myerson, Joel, ed. *Antebellum Writers in New York and the South.* Vol. 3 of *Dictionary of Literary Biography.* Detroit: Gale Research Co., 1979.

National Cyclopaedia of American Biography. New York: James T. White and Co., 1892.

"National Retribution." *National Era,* 5 August 1847, 1.

"New Feature in Our Plan, A." *Philadelphia Art Union Reporter* 1 (March/April 1851): 39.

"Newsboy, The." *Literary World,* 2 December 1848, 879.

"Newsboy, The." *The Ruby for 1850.* New York, 1849.

"Newspaper Literature of America, The." *Foreign Quarterly Review* 30 (October 1842): 197–222.

"Newspaper Press, The." *Independent,* 7 December 1848, 2.

"Newspapers." *Arcturus* 1 (January 1841): 69–75.

"Newspapers in the United States." *United States Democratic Review* 24 (March 1849): 219–224.

"New York Abolitionists, The." *Louisville Journal,* 4 February 1845.

Nicholson, Asenath, Mrs. *Lights and Shades of Ireland: Annals of the Famine of 1847, 1848, and 1849.* 2nd ed. New York, 1851.

N. M. S. "Everyday Apocalypse, The." *Christian Observer,* 3 February, 1849, 1.

Noah, Manuel M. "The Day of Vengeance." In Edward Walker, ed., *The Odd-Fellows' Offering, for 1852,* 294–298. New York, 1851.

Nochlin, Linda. *The Politics of Vision: Essays on Nineteenth-Century Art and Society.* New York: Harper and Row, 1989.

———. *Realism.* Harmondsworth, England: Penguin Books, 1971.

Nord, David Paul. "The Evangelical Origins of Mass Media in America, 1815–1835." *Journalism Monographs* no. 88 (May 1984): 1–31.

Noyes, John Humphrey. *History of American Socialisms.* 1870. Reprint, New York: Hillary House, 1961.

Numbers, Ronald L., and Jonathan M. Butler. *The Disappointed: Millerism and Millenarianism in the Nineteenth Century.* Knoxville: University of Tennessee Press, 1993.

Nutty, Carolyn Sue Himelick. "Joseph Harrison, Jr. (1810–1874): Philadelphia Art Collector." Ph.D. diss., University of Delaware, 1993.

Odell, George C. D. *Annals of the New York Stage.* 15 vols. New York: Columbia University Press, 1927–49.

O'Leary, Stephen D. *Arguing the Apocalypse: A Theory of Millennial Rhetoric.* New York and Oxford: Oxford University Press, 1994.

Olson, Theodore. *Millennialism, Utopianism and Progress.* Toronto: University of Toronto Press, 1982.

"Onward March of Revolutions, The." *Christian Watchman and Reflector,* 14 September 1848, 146.

"Opinions of the Press on the Late Occurrences in Astor Place." *New York Herald,* 16 May 1849, 1.

Ormond, Richard. *Sir Edwin Landseer.* London: The Tate Gallery, 1981.

"Orval Prophecy, The." *United States Catholic Magazine and Monthly Review* 7 (August 1848): 429–432.

"Our Private Collections. No. II." *Crayon* 3 (February 1856): 57–58.

Paley, Morton D. *The Apocalyptic Sublime.* New Haven: Yale University Press, 1986.

Parmly, Eleazar. *Thoughts in Rhyme.* New York, 1867.

Parry, Ellwood C., III, *The Art of Thomas Cole: Ambition and Imagination*. Newark, Del.: University of Delaware Press, 1990.

"Past Year, The." *Christian Watchman and Reflector*, 4 January 1849, 2.

Patterson, Henry S. "Address Before the Art Union of Philadelphia." *Philadelphia Art Union Reporter* 1 (January 1851): 16–19.

Payne, John Howard. "The Beggar Ship." *Union Magazine* 3 (September 1848): 98.

Peterson, Thomas Virgil. *Ham and Japheth: The Mythic World of Whites in the Antebellum South*. Metuchen, N.J.: Scarecrow Press, 1978.

Pickard, John B., ed. *The Letters of John Greenleaf Whittier*. Cambridge: Harvard University Press, Belknap Press, 1975.

"Policy of Removing Slaves from Kentucky—Our Position." *Louisville Journal*, 6 October 1845.

"Political Destination of America, and the Signs of the Times, The." *Massachusetts Quarterly Review* 5 (December 1848): 3–31.

"Popular Institutions." *Graham's Magazine* 38 (March 1851): 185–190.

Postgate, Raymond. *Story of a Year: 1848*. New York: Oxford University Press, 1956.

Potter, David M. *The Impending Crisis, 1848–1861*. Completed and edited by Don E. Fehrenbacher. New York: Harper and Row, 1976.

Powell , Richard J. "Cinqué: Antislavery Portraiture and Patronage in Jacksonian America." *American Art* 11 (Fall 1997): 48–73.

Prentice, George D. *The Poems of George D. Prentice*. Edited and with an introduction by John James Piatt. Cincinnati, 1876.

"Present Condition of Pope Pius IX, with References to the Prophecies, The." *New York Herald*, 18 February 1849, 2.

"President's Recommendation—This Day, The." *Louisville Journal*, 3 August 1849.

Price, Roger, ed. *1848 in France*. Ithaca: Cornell University Press, 1975.

Prichard, James Cowles. *The Natural History of Man; Comprising Inquiries into the Modifying Influence of Physical and Moral Agencies on the Different Tribes of the Human Family*. 2nd ed. London, 1845.

Priest, Josiah. *Bible Defense of Slavery; or The Origin, History, and Fortunes of the Negro Race*. Glasgow, Ky., 1853.

"Private Art-Collections of Philadelphia: I. Mr. James L. Claghorn's Gallery." *Lippincott's* 9 (April 1872): 437–446.

"Private Art-Collections of Philadelphia: X. Additional Galleries" *Lippincott's* 10 (December 1872): 705–710.

Promey, Salley M. *Spiritual Spectacles: Vision and Image in Mid-Nineteenth-Century Shakerism*. Bloomington and Indianapolis: Indiana University Press, 1993.

"Prophecies for the Present." *Blackwood's Edinburgh Magazine* 64 (December 1848): 703–713.

"Protestant Judgmment and Prophecy." *United States Catholic Magazine and Monthly Review* 7 (June 1848): 314–317.

Prucha, Francis Paul. *Indian Policy in the United States: Historical Essays*. Lincoln: University of Nebraska Press, 1981.

Quintin, Felix. "Peace; or, The Soldier's Return." In Edward Walker, ed., *The Odd-Fellows' Offering, for 1850*, 112–117. New York, 1849.

Read, Thomas Buchanan. *Lays and Ballads*. Philadelphia, 1849.

"Reformer's Vision, The." *Knickerbocker Magazine* 27 (April 1846): 303–306.

Reilly, Bernard F., Jr. *American Political Prints, 1776–1876: A Catalog of the Collections in the Library of Congress*. Boston: G. K. Hall & Co., 1991.

"Religion and Politics." *Christian Watchman and Reflector*, 21 September 1848, 150.

"Return of the Dove to the Ark, The." *Pennsylvania Freeman*, 1 February 1849, 2.

Reynolds, David S. *Beneath the American Renaissance: The Subversive Imagination in the Age of Emerson and Melville*. New York: Alfred A. Knopf, 1988.

Rogers, Millard F. "Fishing Subjects by Julius Brutus Stearns." *Antiques* 102 (August 1970): 246–250.

Rosenberg, Charles E. *The Cholera Years: The United States in 1832, 1849, and 1866.* Chicago: University of Chicago Press, 1987.

Rosengarten, Joseph G. "Memoir of P. F. Rothermel, Read before the American Philosophical Society, November 1, 1895." *Proceedings of the American Philosophical Society* 34 (1895): 393–396.

Ross, Joel H. *What I Saw in New-York; or, A Bird's Eye View of City Life.* Auburn, N.Y., 1851.

Rossiter, Thomas Pritchard. *A Description of Rossiter's Scriptural Paintings: The Return of the Dove to the Ark; or, The Triumph of Faith; and Miriam the Prophetess Exulting over the Destruction of Pharaoh's Host. Together with a Sketch of the Life of the Artist, Notices of the Press, etc. etc.* New York: [1851–1852].

——. *A Description of the Picture of the Home of Washington After the War. Painted by T. P. Rossiter and L. R. Mignot with Historical Sketches of the Personages Introduced.* New York, 1859.

——. *A Description of Three Scriptural Pictures . . . Painted by Thomas P. Rossiter, N.A.* New York, 1860.

——. "Notes on the Universal Exposition of Fine Arts in Paris." *Crayon* 2 (19 December 1855): 390–391.

"Rossiter's New Picture." *New-York Daily Tribune,* 22 November 1848, 2.

"Rothermel's Last Picture." *Philadelphia Art Union Reporter* 1 (January 1851): 19.

Rutledge, Anna Wells, ed. *Cumulative Record of Exhibition Catalogues: The Pennsylvania Academy of the Fine Arts, 1807–1870; The Society of Artists, 1800–1814; The Artists' Fund Society, 1835–1845.* Philadelphia: American Philosophical Society, 1955.

Sager, Eric W. "The Social Origins of Victorian Pacifism." *Victorian Studies* 23 (Winter 1980): 211–236.

Sandeen, Ernest R. "Millennialism." In Edwin S. Gaustad, ed., *The Rise of Adventism: Religion and Society in Mid-Nineteenth-Century America.* New York: Harper and Row, 1974.

——. *The Roots of Fundamentalism: British and American Millenarianism, 1800–1930.* Chicago: University of Chicago Press, 1970.

Sartain, Harriet. Harriet Sartain Papers. Historical Society of Pennsylvania. Microfilm in the Archives of American Art.

Sartain, John. "Editorial. Notices of Art and Artists." *Sartain's Union Magazine* 4 (June 1849): 414.

——. *Reminiscences of a Very Old Man.* New York, 1899.

"Sartain, the Artist." *Nineteenth Century* 1 (1848): 365–371.

Satz, Ronald N. *American Indian Policy in the Jacksonian Era.* Lincoln: University of Nebraska Press, 1981.

Saum, Lewis O. *The Popular Mood of Pre-Civil War America.* Westport, Conn.: Greenwood Press, 1980.

Sawyer, John F. A. *Prophecy and Prophets of the Old Testament.* Oxford: Oxford University Press, 1987.

Saxton, Alexander. "Problems of Class and Race in the Origins of the Mass Circulation Press." *American Quarterly* 36 (1984): 211–234.

Schmandt, Raymond H. "A Philadelphia Reaction to Pope Pius IX in 1848." *Records of the American Catholic Historical Society* 88 (March/December 1977): 63–87.

"School of the Prophets, The." *London Times,* 3 November 1859.

Schroeder, John H. *Mr. Polk's War: American Opposition and Dissent, 1846–1848.* Madison: University of Wisconsin Press, 1973.

Schudson, Michael. *Discovering the News: A Social History of American Newspapers.* New York: Basic Books, 1978.

Schwarzlose, Richard A. *The Nation's Newsbrokers.* Vol. 1, *The Formative Years, from Pretelegraph to 1865.* Evanston: Northwestern University Press, 1989.

Scott, Leonora Cranch. *Life and Letters of Cristopher Pearse Cranch.* 1917. Reprint, New York: AMS Press, 1969.

Senior [pseud.]. "A Poem, A Painting, A Prophecy." *National Era,* 27 February 1851, 1.

Serlio, Anne Marie. *Political Cartoons in the 1848 Election Campaign.* Washington, D.C.: Smithsonian Institution Press, 1972.

"Sermon on California." *Home Journal,* 20 January 1849, 2.

Sessions, Frances C. "Art and Artists in Ohio." *Magazine of Western History* 4 (June 1886): 157–159.

Sheldon, George W. *The Story of the Volunteer Fire Department of the City of New York.* New York, 1882.

Simpson, Henry. *The Lives of Eminent Philadelphians, Now Deceased. Collected from Original and Authentic Sources by Henry Simpson, Member of the Historical Society of Pennsylvania.* Philadelphia, 1859.

"Slavery and Emancipation." *Louisville Journal,* 21 August 1849.

Slavin, Barbara J. "Thompkins [*sic*] Harrison Matteson: Illustrator of Mid-Nineteenth Century America." Master's thesis, State University of New York at Oneonta, 1969.

Small, William F. "Rothermel's Apotheosis of Labor. Or, 'The Labourer's Vision of Human Progress.'" *Sartain's Union Magazine* (April 1851): 277–279.

Smedley, Audrey. *Race in North America: Origin and Evolution of a Worldview.* Boulder, San Francisco, Oxford: Westview Press, 1993.

Smith, David E. "Millenarian Scholarship in America." *American Quarterly* 17 (Fall 1965): 535–549.

Smith, Timothy L. *Revivalism and Social Reform: American Protestantism on the Eve of the Civil War.* Baltimore: Johns Hopkins University Press, 1980.

Smyth, Thomas. *The Unity of the Human Races, proved to be the Doctrine of Scripture, Reason, and Science, with a Review of the Present Position and Theory of Professor Agassiz.* New York, 1850.

Somkin, Fred. *Unquiet Eagle: Memory and Desire in the Idea of American Freedom, 1815–1860.* Ithaca: Cornell University Press, 1967.

Spann, Edward K. *The New Metropolis: New York City, 1840–1857.* New York: Columbia University Press, 1981.

"Spirit of the Age, The." *United States Catholic Magazine and Monthly Review* 4 (December 1845): 749–757.

Sprague, William B. *Annals of the American Pulpit,* New York, 1869.

Stansell, Christine. *City of Women: Sex and Class in New York 1789–1860.* Urbana and Chicago: University of Illinois Press, 1987.

Stebbins, Theodore, Jr. *The Life and Works of Martin Johnson Heade.* New Haven: Yale University Press, 1975.

Steinfels, Peter. "Gulf War Proving Bountiful for Some Prophets of Doom." *New York Times,* 2 February 1991.

Stocking, George W., Jr. *Researches into the Physical History of Man, James Cowles Prichard.* Chicago and London: University of Chicago Press, 1973.

Stone, Edward. "Kossuth's Hat: Foreign Militants and the American Muse." *Emerson Society Quarterly* 23 (1977): 36–40.

Stone, Horatio. *Freedom.* Washington, D.C., 1864.

Stowe, Harriet Beecher. *Uncle Tom's Cabin: or, Life among the Lowly.* New York, 1852. Reprint, Franklin Center, Pa.: The Franklin Library, 1984.

Strout, Cushing. "Uncle Tom's Cabin and the Portent of Millennium." *Yale Review* 57 (Spring 1968): 375–385.

Sturges, Mary Cady [Mrs. Jonathan]. *Reminiscences of a Long Life.* New York, 1894.

Sweeney, J. Gray. "The Advantages of Genius and Virtue: Thomas Cole's Influence, 1848–1858." In William H. Truettner and Alan Wallach, eds., *Thomas Cole: Landscape into History,* 113–135. New Haven: Yale University Press, 1994.

——— "'Endued with Rare Genius.' Frederic Edwin Church's 'To the Memory of Cole.'" *Smithsonian Studies in American Art* 2 (Winter 1988): 45–71.

———. "The Nude of Landscape Painting: Emblematic Personification in the Art of the Hudson River School." *Smithsonian Studies in American Art* 3 (Fall 1989): 43–65.

———. *Themes in American Painting*. Grand Rapids: Grand Rapids Art Museum, 1977.

Talbot, William Silas. "Jasper F. Cropsey, 1823–1900." Ph.D. diss., New York University, 1972.

Tatham, David. "Edward Hicks, Elias Hicks and John Comly: Perspectives on the Peaceable Kingdom Theme." *American Art Journal* 13 (Spring 1981): 36–50.

———. "Thomas Hicks at Trenton Falls." *American Art Journal* 15 (Autumn 1983): 5–20.

Taylor, Joshua C. *William Page: The American Titian*. Chicago: University of Chicago Press, 1957.

Taylor, Joshua C., Robin Bolton-Smith, and William H. Truettner. *Lilly Martin Spencer 1822–1902: The Joys of Sentiment*. Washington, D.C.: National Collection of Fine Arts, 1973.

"Thanksgiving Day." *Episcopal Recorder*, 18 November 1848, 143.

Thistlethwaite, Mark E. *The Image of George Washington: Studies in Mid-Nineteenth-Century American History Painting*. New York: Garland Publishing Co., 1979.

———. *Painting in the Grand Manner: The Art of Peter Frederick Rothermel (1812–1895)*. Chadds Ford, Pa.: Brandywine River Museum, 1995.

———. "Peter F. Rothermel: a Forgotten History Painter," *Antiques* 125 (November 1983): 1016–1022.

———. "Picturing the Past: Junius Brutus Stearns's Paintings of George Washington." *Arts in Virginia* 25 (1985): 12–23.

Thomas, John L. "Romantic Reform in America, 1815–1865." *American Quarterly* 17 (Winter 1965): 656–681.

Thompson, J. P. "Ancient Nineveh: A Lecture Suggested by the Recent Discovery of the Ruins of That City." *New-York Daily Tribune*. 23 May 1849.

Thompson, Ralph. *American Literary Annuals and Gift Books, 1825–1865*. New York: H. W. Wilson Company, 1936.

Tocqueville, Alexis de. *Democracy in America*, vol. II. Edited by Phillips Bradley. New York: Alfred A. Knopf, 1963.

Toledo Museum of Art. *American Painting*. Toledo, Ohio: Toledo Museum of Art, 1979.

"Topics of the Month: The Cholera." *Holden's Dollar Magazine* 1 (February 1848): 125.

"Treatise on the Theory and Practice of Landscape Gardening, A." *Louisville Journal*, 15 January 1845.

Truettner, William H., ed. *The West as America: Reinterpreting Images of the Frontier, 1820–1920*. Washington, D.C.: National Museum of American Art, 1991.

Truettner, William H., and Alan Wallach, eds. *Thomas Cole: Landscape into History*. New Haven: Yale University Press, 1994.

Tuckerman, Henry T. *Book of the Artists: American Artist Life*. New York, 1867.

Turner, Willis Lloyd. "City Low-life on the American Stage to 1900." Ph.D. diss., University of Illinois, 1956.

Tuveson, Ernest Lee. *Millennium and Utopia: A Study in the Background of the Idea of Progress*. Berkeley: University of California Press, 1949.

———. *Redeemer Nation: The Idea of America's Millennial Role*. Chicago: University of Chicago Press, 1966.

Tyrell, Alexander. "Making the Millennium: The Mid-Century Peace Reform Movement." *Historical Journal* 20 (1978): 75–95.

Tyrell, Ian R. *Sobering Up: From Temperance to Prohibition in Antebellum America*. Westport, Conn.: Greenwood Press, 1979.

Van Amringe, H. H. "God's Methods in Reform." *Nineteenth Century* 2 (1848): 601–616.

Van Amringe, William Frederick. *An Investigation of the Theories of the Natural History of Man*. New York: Baker & Scribner, 1848.

[Van Amringe, William Frederick]. "Natural History of Man." *United States Magazine and Democratic Review* 29 (October 1851): 319–336.

Van Tassel, David D. "Benson J. Lossing: Pen and Pencil Historian." *American Quarterly* 4 (Spring 1954): 32–44.

Vaux, Richard. "The Mexican News." In *Ornaments of Memory*. New York, 1854.

Verdi, Richard. "Poussin's 'Deluge': The Aftermath." *Burlington Magazine* 123 (July 1981): 389–400.

"Visit to a Gallery of Art." *Western Journal and Civilian* 6 (April 1851): 64.

Von Erffa, Helmut, and Allen Staley. *The Paintings of Benjamin West*. New Haven: Yale University Press, 1986.

"Voyage of Life, The." *Philadelphia Public Ledger and Transcript*, 1 January 1848.

"Wages of War, The." *Harbinger*, 26 June 1847, 42–43.

Wainwright, Nicholas B. "Joseph Harrison, Jr., a Forgotten Art Collector." *Antiques* 102 (October 1972): 660–668.

Wallace, William W. "The Spirit of the Age, and Its Connection with the Spirit of Association." In Paschal Donaldson, ed., *The Odd-Fellows' Offering, for 1849*, 251–266. New York, 1848.

Walters, Ronald G. *American Reformers, 1815–1860*. New York: Hill and Wang, 1978.

——. *The Antislavery Appeal: American Abolitionism After 1830*. Baltimore: The Johns Hopkins University Press, 1976.

"War and Its Conclusion," *Home Journal*, 22 July 1848, 2.

Waterfield, Gordon. *Layard of Nineveh*. London: John Murray, 1963.

Weber, Bruce. "Henry Peters Gray: The Ideal Painter." Unpublished paper, Graduate Center, City University of New York, 1975.

Wees, J. Dustin. *"Darkness Visible": The Prints of John Martin*. Williamstown, Mass.: Sterling and Francine Clark Art Institute, 1986.

Weidman, Bette S. "Charles Frederick Briggs." In *Dictionary of Literary Biography*, vol. 3. Detroit: Gale Research, Inc., 1979.

"Welcome to Kossuth, The." *New York Times*, 8 December 1851 and 12 December 1851.

Weld, H. Hastings. "Religion and Art." In Weld, ed., *The Sacred Annual: A Gift for All Seasons*, 119–125. Philadelphia, 1850.

——, ed. *Scenes in the Lives of the Patriarchs and Prophets*. Philadelphia, 1847.

——, ed. *The Women of the Scriptures*. Philadelphia, 1848.

Whalen, Robert Kieran. "Millenarianism and Millennialism in America, 1790–1880." Ph.D. diss., State University of New York, Stony Brook, 1971.

"What the Press Say of Us." *Philadelphia Art Union Reporter* 1 (January 1852): 154.

Whittier, John Greenleaf. *The Complete Poetical Works of John Greenleaf Whittier*. Cambridge Edition. Boston: Houghton Mifflin, Co., 1894.

Williamson, I. D. "Tribute to a Bygone Year." In Edward Walker, ed., *The Odd-Fellows' Offering, for 1851*, 85–88. New York, 1850.

Wills, Gary. *Under God: Religion and American Politics*. New York: Simon and Schuster, 1990.

Wilson, Christopher Kent. "The Landscape of Democracy: Frederic Church's 'West Rock, New Haven.'" *American Art Journal* 18 (1986): 20–39.

Wilson, James Grant, and John Fiske, eds. *Appleton's Cyclopaedia of American Biography*. 6 vols. New York: D. Appleton and Co., 1888.

Winward, Stephen F. *A Guide to the Prophets*. Richmond, Va.: John Knox Press, 1968.

Wirt, William. *Sketches of the Life and Character of Patrick Henry*. 9th ed. Philadelphia, 1845.

Wolf, Bryan J. "All the World's a Code: Art and Ideology in Nineteenth-Century American Painting." *Art Journal* 44 (Winter 1984): 328–337.

Woodham-Smith, Cecil Blanch. *The Great Hunger: Ireland 1845–1849*. London: H. Hamilton, 1962.

Woodward, Helen B. *The Bold Women*. New York: Farrar, Strauss and Young, 1953.

Wooten, Hugh Hill. "Western Migration from Iredell County, 1800–1850." *North Carolina Historical Review* 30 (January 1953): 61–71.

W. W. "Western Emigrants—A Picture by Beard." *Cincinnati Gazette*, 29 August 1845.

Yarnell, James L., and William H. Gerdts, comps. *The National Museum of American Art's Index to American Art Exhibition Catalogues from the Beginning through the 1876 Centennial Year.* 6 vols. Boston: G. K. Hall and Co., 1986.

Zamora, Lois Parkinson, ed. *The Apocalyptic Vision in America: Interdisciplinary Essays in Myth and Culture.* Bowling Green, Ohio: Bowling Green University Popular Press, 1982.

Zennie, Campbell. *Landseer: The Victorian Paragon.* London: Hamilton Hamish, 1976.

Manuscript Sources

Beard, Daniel Carter. Papers. Manuscript Collection, Library of Congress.

Bush-Brown, Henry Kirke. Papers. Manuscript Collection, Library of Congress.

Child, Lydia Maria. Correspondence. Manuscript Collection, Library of Congress.

Claghorn, James. Papers. Microfilm in Archives of American Art.

Cole, Thomas. Papers. New York State Library, Albany. Microfilm in Archives of American Art.

Cropsey, Jasper F. Cropsey. Correspondence, diaries, sketchbooks. Collection of Mrs. Arthur Ellsworth and Mrs. John Newington. Microfilm in Archives of American Art.

Harrison, Joseph, Jr. Letterbooks. Historical Society of Pennsylvania, Philadelphia.

Hart, Charles H. Autograph Collection, Archives of American Art.

Kensett, John F. Papers. Archives of American Art.

Leffingwell Collection. New Haven Colony Historical Society.

Longworth, Nicholas. Papers. Cincinnati Historical Society.

Mount, William Sidney. Miscellaneous Manuscripts. New-York Historical Society.

New York Public Library Papers. Microfilm in Archives of American Art.

North American Phalanx Collection. Monmouth County Historical Society, Freehold, N.J.

Osborn Papers. New-York Historical Society.

Powers, Hiram. Correspondence. Cincinnati Historical Society.

Raritan Bay and Eagleswood Military Academy Collection, New Jersey Historical Society, Newark.

Read, Thomas Buchanan. Family correspondence. Collection of Denison L. Burton, Chatham, N.J. Microfilm in Archives of American Art.

Riche Correspondence. Historical Society of Pennsylvania.

Rothermel, Peter F. Papers. Archives of American Art.

Sartain Family. Letters, monographs, and memorabilia. Historical Society of Pennsylvania, Philadelphia. Microfilm in Archives of American Art.

Sartain, Harriet. Papers. Historical Society of Pennsylvania.Microfilm in Archives of American Art

Sartain, John. Works. Pennsylvania Academy of the Fine Arts. Microfilm in Archives of American Art.

Sartain, Samuel. Correspondence. Moore College of Art, Philadelphia. Microfilm in Archives of American Art.

Sill, Joseph. Diary. Historical Society of Pennsylvania.

Spencer, Lilly Martin. Family Papers and correspondence. Campus Martius Museum, Ohio Historical Society, Marietta, Ohio. Microfilm in Archives of American Art.

Tyndale Family Papers. Collection of Judy Van Skike, Santa Ana, Calif.

Index

LIBRARY OF CONGRESS CATALOGING-IN-PUBLICATION DATA

Husch, Gail E., 1953–

 Something coming : apocalyptic expectation and mid-nineteenth-
century American painting / Gail E. Husch.

 p. cm.

 Includes bibliographical references and index.

 ISBN 1–58465–005–2 (cloth : alk. paper). — ISBN 1–58465–006–0
(pbk. : alk. paper)

 1. Apocalyptic art—United States. 2. Painting, American.
3. Painting, Modern—19th century—United States. I. Title.

ND1431.5.H87 2000

759.13'09'034—dc21 99–36691